Thomas Bodkin
FOUR IRISH LANDSCAPE PAINTERS

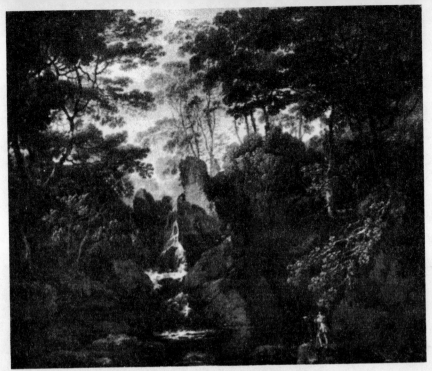

A VIEW IN THE DARGLE
By George Barret, R.A.

In the possession of the author.

Oils on canvas. 24 inches high by 29 inches wide.

This picture is possibly the one which Barret brought with him to London and showed at the Society of Artists Exhibition in 1784, (No. 4). The scene, in the Powerscourt demesne, is easily identified at the present time; though one hundred and fifty years have wrought great changes in the growth and decay of the trees. The sky is full of delicate, evening hues of pale blue and pink. The water in the pool is brown. The cascade, in the high lights, has a warm blue tinge. The trees wear their full summer foliage. The little fiigures are by Barret himself and among the best of those he has done. The one over the main mass of rock wears scarlet. The two in the foreground wear deep blue and light brown-yellow respectively.

The picture was formerly in the possession of Sir Edward Wingfield Verner, Bart., a connection of the Powerscourt family.

FOUR
IRISH LANDSCAPE
PAINTERS

GEORGE BARRET, R.A.
JAMES A. O'CONNOR
WALTER F. OSBORNE, R.H.A.
NATHANIEL HONE, R.H.A.

by
THOMAS BODKIN

with an Introduction by
JULIAN CAMPBELL

IRISH ACADEMIC PRESS

First edition Dublin and London 1920
This, second, edition Dublin 1987

This edition, issued with the permission of the
Bodkin Literary Trust, is a photolithographic facsimile of
the first edition.

© Irish Academic Press Limited 1987

ACKNOWLEDGEMENT
The colour reproductions in this edition
are taken from paintings in and published with the permission
of The National Gallery of Ireland.

BRITISH LIBRARY CATALOGUING IN PUBLICATION DATA
Bodkin, Thomas
Four Irish landscape painters.
1. Landscape painting, Irish.
2. Landscape painting — 18th century — Ireland.
I. Title
758ʹ1ʹ 09415 ND1364.17
ISBN 0-7165-2405-8

Printed by Antony Rowe Ltd,
Chippenham, Wilts.

Introduction

Four Irish Landscape Painters was first published in 1920, when its author Thomas Bodkin was only thirty three years old. It was his first book on art, to be followed by other publications including *The Approach to Painting* (1927), *Hugh Lane and his Pictures* (1932) and *The Paintings of Jan Vermeer* (1940). Bodkin had given a series of Hermione lectures on four Irish landscape painters — George Barret, James Arthur O'Connor, Walter Osborne and Nathaniel Hone (the Younger) — at Alexandra College in Dublin in 1917, and subsequently developed these into the four chapters in his book. He included illustrations, catalogue entries and appendices.

Thomas Bodkin was born in 1887. He was only five years younger than James Joyce and was educated at the same institutions — Belvedere College, Clongowes Wood and University College, Dublin. He first studied law, and practised as a barrister from 1911 to 1916 before turning his attention to art history. He gave the Hermione lectures on art in 1917 and became a governor and guardian of the National Gallery of Ireland. He was Director of the National Gallery from 1927-1935, when he took up the Directorship of the Barber Institute in Birmingham.

The publication of the *Dictionary of Irish Artists* by W.G. Strickland in 1913 had provided two thoroughly researched and comprehensive volumes on Irish artists, and had given a formal stamp to Irish art history. Strickland was one of the sources used by Bodkin for his own research. But in the Preface to *Four Irish Landscape Painters*,

he is apologetic presenting himself as an amateur writing for other amateurs. He is aware of modern art and modern terminology, yet fears "that this book may seem out-of-date and dull to many of its readers." Dull it hardly is. Bodkin has aspirations as a poet and writer as well as an art historian. There is an elegant literary feel to the book, and in the chapter on Hone, for example, he does not always observe the strictest chronology, but moves back and forth between the artist's life and qualities as a painter. Nevertheless, as he remarks, "In writing about Barret, O'Connor, Osborne and Hone I have endeavoured to devote my attention to facts rather than theories". Strickland had discussed the first three artists, but Bodkin's book became the fullest account of Nathaniel Hone that had yet been published. Moreover, he includes useful catalogue notes to each illustration, and very comprehensive catalogues of each artist's work in his appendices.

Bodkin observes that Irish people are lovers of landscape. Landscape is an enduring theme for Irish artists, and in the neighbourhood of Dublin alone there is "a treasury of subjects." All four painters worked abroad and travelled widely, yet had a special feeling for the Irish landscape. Some of their best work was done in the neighbourhood of Dublin and Wicklow:

> Barret and O'Connor both worked for years in Powerscourt Demesne. Hone painted continuously in his homelands at Malahide and in the Dublin mountains. Osborne was fascinated … by the coast around Howth.

In his catalogue for the recent James Arthur O'Connor retrospective exhibition (National Gallery of Ireland, 1985), John Hutchinson refers to O'Connor's painting trips to celebrated beauty spots such as the Dargle, the Devil's Glen and the Meeting of the Waters in Co. Wicklow, or to the Lakes of Killarney in Kerry:

In so doing, he was following a well-trodden path that had been frequented by tourists ever since the 1780s, for Kerry and County Wicklow were constantly visited by those in search of the "Sublime" and the "Beautiful". These fashionable excursions were facilitated by improvements in coach-building and road construction, such as the extensive Military Road that opened up County Wicklow. . . .

By Hone and Osborne's time, interest in landscape was more 'naturalistic' than picturesque, Hone, for instance, had a deep attachment to the Malahide landscape and coastline, yet his representation of that locality is general rather than topographical. In art historical terms, Bodkin's four artists can now be seen as representing different trends in Irish and European painting — Barret as a Classical or 'ideal' landscape painter, O'Connor as a topographical and Romantic landscapist, Hone as a nineteenth century Naturalist of the Barbizon School, and Osborne as a Realist who developed into an Impressionist.

In a sense, the four artists fall into two categories — the two earlier figures of Barret and O'Connor, and the two contemporaries, Hone and Osborne. Bodkin gives the principal dates of Barret's and O'Connor's lives, and mentions his sources (although he does not always say where he derived particular information). He compares Barret with English contemporaries, Gainsborough and Wilson. He comments on the hundreds of small paintings by O'Connor:

> They are exactly the sort of things which help to stimulate the love of landscape and landscape painting in simple, unsophisticated people.

Walter Osborne had been living during Bodkin's lifetime and, after his early death in 1903, was still an influential figure among Irish

artists. Bodkin was aware that initially Osborne may have seemed an odd-man-out among the other three painters, in that he was a portraitist and genre painter as well as a landscapist; however, "landscape won his earliest and his lasting affection and in his landscapes there is much more than mere accomplishment...". In her recent publications on Osborne (Ballycotton, 1974; and National Gallery of Ireland, 1983) Jeanne Sheehy has reinforced Bodkin's view, pointing out how Osborne had to paint portraits to earn a living, but his real love was for landscape. Bodkin notes: "His landscapes almost invariably contained figures which were beautifully drawn and placed." This is particularly true of his charming studies of women and children in parks and gardens. Bodkin praises Osborne's unrivalled versatility and variety of technique. Just as he discerned Barret's feeling for light, especially the light of clear afternoons, so he perceptively notes Osborne's "advanced" treatment of light, even in an early picture such as *A Glade in the Phoenix Park*.

Bodkin's essay on Hone is perhaps the most valuable in the book. Strickland had omitted this artist from his Dictionary, presumably because Hone was still living at the time of writing. So, for many years Bodkin's chapter was the only full published account of the artist. Bodkin in fact, met Hone personally. In his eighty-seventh year Hone had written to him to invite him to visit him at home. Perhaps he had intimations that he did not have long to live. Bodkin published an article in the *Irish Times* (16 October 1917) entitled 'Mr Hone and his Art. A Visit to St Doulough's." (This, and the chapter in *Four Irish Landscape Artists*, was based on a typescript of his conversation with Hone a few weeks before his death). His comments on Hone in France are thus based on first-hand reports of the artist's time in Paris and Barbizon. With characteristic modesty, Hone does not talk about himself or his art, but relates humorous anecdoes about some of the great figures of nineteenth century French art — for example Corot, Courbet, Milletand Manet — and his

personal friendship with Harpignies. Were it not for Bodkin, these would have been lost for ever. He has obvious sympathy for Hone's natural abilities as a painter and for his strength as a colourist: "his art was lyrical or emotional rather than didactic or intellectual." Interestingly, Bodkin recognised the worth of Hone's watercolours, which were scarcely known during his lifetime: "The germ of all his great pictures is to be found among these sketches. . . . In number alone they form an impressive life work." Although the perception of Hone as a "gentleman-farmer" as well as a painter has lingered on inexplicably, Bodkin rightly dismisses the notion of Hone as 'a gifted amateur". He concludes *Four Irish Landscape Artists* on a personal note:

> I think it is a privilege to be able to close this book with a tribute of profound admiration for the artist and the man — Nathaniel Hone.

It is worth remembering that Bodkin's book was written in the first quarter of the century, with the aesthetic and art historical perceptions of the time. He does not say why he selects these four painters in preference to other Irish artists. He treats the four in a certain amount of isolation from their contemporaries. Barret, it is true, he compares with Wilson, but not with other Irish painters of the eighteenth century such as Thomas Roberts. He mentions O'Connor's Irish friends, Petrie and Danby, but does not dwell on the English influences on his work. He refers to Osborne's admiration for English painters such as Constable, and his contemporaries Clausen and La Thangue, but makes no mention of his Irish colleagues, J.M. Kavanagh and Nathaniel Hill. In fact, in spite of the title of his book Bodkin admits of Osborne's painting that there is

nothing distinctly *Irish* in its author. He does not seem to have

any special sympathy or understanding for Irish character or even for Irish landscape.... His faith, upbringing and environment certainly cut him off ... from close contact with the majority of his fellow-countrymen.

In discussing Osborne he makes an interesting contrast with Jack B. Yeats pointing out the "Irishness" of Yeats' romantic studies of West of Ireland types and landscapes. Bodkin is overly dismissive of the effects of Hone's French teachers, Yvon and Couture: "His mature work does not show the slightest trace of their influence nor the slightest sympathy with any of their productions" — or the influences of Hone and the Barbizon school. He adds that "Manet and his contemporaries did not affect it [i.e. Hones painting] in any way." As can be seen now, Osborne and Hone are more complex artists than might appear in Bodkin.

Continued research on Irish art, particularly in the past fifteen years has provided a deeper and fuller view of these artists. Anne Crookshank's, the Knight of Glin's and Michael Wynne's studies of George Barret and Thomas Roberts have added considerably to our knowledge of eighteenth century Irish landscape. In their book *The Painters of Ireland c. 1660-1920* (London 1978), Crookshank and Glin discuss Barret in the context of eighteenth century Irish landscape. In his catalogue on O'Connor John Hutchinson writes:

Until about ten years ago, when his popularity was surpassed by that of Walter Osborne, James Arthur O'Connor was possibly the best-loved of all Irish painters. This affection for O'Connor's work was not based on any real knowledge of his paintings, but on an affinity with the lyrical mood of his most common Irish landscapes....

Hutchinson fills out the details of O'Connor's biography, and presents

him against the background of English and European Romanticism. He charts his development from a young topographical artist into a full Romantic. Jeanne Sheehy's studies of Osborne, particularly her catalogue for the Walter Osborne retrospective exhibition at the National Gallery of Ireland (1983), have uncovered new information about the artist's life; she points out the Continental influences on his work and the importance of his English contemporaries. Bodkin describes *The Thornbush* as Osborne's "masterpiece". But taste has changed in the past sixty years, and a present-day audience would probably prefer his charming genre scenes and his later 'impressionistic' garden paintings. It is hard to believe now Bodkin's words, written in 1920, that Osborne "is not yet known, either as a landscape artist or as a portrait painter, to the extent that his work deserves", and that during seven years in his life Osborne did not sell a single important landscape. Along with Jack B. Yeats, Osborne is now the most popular and sought-after of Irish artists.

Nathaniel Hone does not have the wide popular appeal of Osborne but is still one of the most highly regarded of Irish painters. The Irish Impressionists' Exhibition at the National Gallery in 1984 concentrated on the early, French part of his career, and viewed him as a kind of "Father figure" to the many Irish students who went to Paris to study in the late nineteenth century. Like Osborne, Hone's paintings were under-valued in the early part of the century.

His finished pictures seldom found purchasers even at the modest prices he was accustomed to ask for them.

Bodkin's comments on O'Connor are likewise surprising:

There must be hundreds of his smaller pictures extant. They are not likely to become scarce nor even valuable in the near future, and room may be found with advantage for a few more in public galleries, at least in those of Ireland.

In fact, at the time of writing, there was already a good collection of paintings and drawings by Barret, O'Connor and Osborne in the National Gallery. The large Magdalen Hone bequest of oils and watercolours to the National Gallery had just been made the previous year, 1919. (In his appendices Bodkin publishes Dermod O'Brien's catalogue of the Bequest, and this remains the fullest catalogue of Hone's paintings extant.) In subsequent years the Gallery has considerably expanded its collection of paintings by O'Connor and Osborne. There are other fine examples of Hone's and Osborne's work in the Hugh Lane Municipal Gallery of Modern Art, Dublin, of Osborne in the Ulster Museum and Crawford Art Gallery, Cork, and of O'Connor in Fota House and other public collections in Ireland. Bodkin would have been pleased; a number of the paintings of the four artists which he illustrates were in his own possession. Others were in the collections of friends. His choice of Barret, O'Connor, Osborne and Hone as four Irish landscape painters has stood the test of time.

His comments, too, on Irish landscape hold true. He forecast that there would be a revival in landscape painting. Landscape has remained a vital theme running through twentieth century Irish painting. One of the most distinguished living Irish painters, Patrick Collins, has spoken with admiration of Nathaniel Hone and Paul Henry. Osborne, Hone, Henry and Jack B. Yeats have remained an important source of inspiration for Irish landscapists throughout the century, both for the more academic painters associated with the Royal Hibernian Academy and for the more loosely affiliated "abstract landscapists" such as Collins, Nano Reid, Camille Souter, Tony O'Malley and Sean McSweeney. Younger artists such as Cecily Brennan, Lorraine Wall and Gwen O'Dowd are investigating landscape in a more abstract manner, yet their work still shows the strong feeling for landscape and environment that is shared by Irish painters and poets alike.

Finally, it is worth pointing out a few minor errors that occur in the first edition of Bodkin's book. For instance, Bodkin remarks that O'Connor departed from England in 1821 and did not return to Ireland. In fact, O'Connor probably arrived in England in 1822 and did return to Ireland later. Osborne studied at the Academie Royale des Beaux Arts in Antwerp under Verlat (not in Amsterdam, as Bodkin claims); Hone's teacher in Paris was Thomas Couture (not Coture). Bodkin's off-quoted remark, that not more than one hundred of Hone's paintings passed into private possession, is an under-estimation.

Four Irish Landscape Painters by Thomas Bodkin was first published in 1920, by the Talbot Press in Dublin, and T. Fisher Unwin in London. Although long since out of print, it is still one of the classic books on Irish art. It remains a ground-work on which subsequent studies of Irish art have been able to build, and continues to be in regular usage by art lovers and scholars, art galleries and art dealers alike. The initiative of the Irish Academic Press in re-publishing "Bodkin" after a period of sixty seven years is to be warmly welcomed, and the inclusion of some colour illustrations adds greatly to the value and charm of the edition.

<div align="right">

Julian Campbell
Dublin, July 1987

</div>

TO MY WIFE

" In an artistic sense the majority and backbone of the world have not yet begun to be artistically civilized. Ages must elapse before such civilization can make any appreciable headway. And in the meantime the little hierarchy of art, by which alone art lives and develops, exists precariously in the midst of a vast dangerous population—a few adventurous whites among indigenous hordes in a painful climate."—ARNOLD BENNETT.

* * * * * *

" Sans doute les hommes capable de goûter de très belles œuvres d'art sont rares; et, d'ailleurs, dans les musées ou même sur les places publiques elles ne sont regardées que par un nombre restreint de spectateurs. Mais les sentiments qu'elles contiennent ne finissent pas moins par s'infiltrer jusque dans la foule. Au-dessous des génies, en effet, d'autres artistes de moindre envergure reprennent et vulgarisent les conceptions des maîtres; les écrivains sont influencés par les peintres, comme ceux-ci par les littérateurs : il y a un continuel échange de pensées entre tous les cerveaux d'une génération ; les journalistes, les romanciers populaires, les illustrateurs, les dessinateurs d'images mettent à la portée de la multitude les véritiés que de puissantes intelligences ont découvertes. C'est comme un ruissellement spirituel, comme un jaillisement qui se déverse en de multiples cascades, jusqu' à former la grande nappe mouvante qui représente la mentalité d'un temps."—AUGUSTE RODIN.

* * * * * *

" If we are to be excused for rejecting the arts, it must not be because we are contented to be less than men, but because we long to be more than men."—WILLIAM MORRIS.

vii.

PREFACE

I FEAR that this book may seem out-of-date and dull to many of its readers. Certainly it should prove so to those subtle moderns who love to worry the topic of art with such terms as " dynamic hieroglyph," " rhythmic relativity," " plastic integration," or " primordial volume." It was written for people further behind the times; principally, for such Irishmen and Irishwomen as entertain a vague but honest liking for pictures, and want to know a little more about the painters whom their own country has produced. I believe that these people are numerous. I met some of them when I had the privilege of delivering the Hermione lectures on art at Alexandra College, Dublin, three years ago : and it is due to their representations that the fourth of those lectures, that on Irish landscape painters, is here developed and put in print.

The Irish are regarded, generally, as a people without talent for the art of painting, but Ruskin, who did not find the Irish temperament congenial, and whose critical

utterances were usually the fruit of his prejudices, could yet say truthfully: " In the eighth century Ireland possessed a school of art in her manuscripts and sculpture which, in many qualities—apparently in all essential qualities of decorative invention—was quite without rival, seeming as if it might have advanced to the highest triumphs in architecture and painting."

Sir Walter Armstrong, another, but more friendly, Englishman, testified that " there has been a race inhabiting this country for more than a thousand years which has got very exceptional artistic powers. It is one of the very few races in the world which have shown real originality in their art, and the art of which bears examination as to quality very deeply indeed."

Both of these eulogia were written with reference to the art of the ancient Irish, manifested principally in their manuscript illuminations. It was not till the end of the eighteenth century that the early promise of the race showed any signs of fulfilment.

There exist, undoubtedly, strong oppositions of opinion as to the causes of the long period of stagnation in the art of Ireland, and as to the causes of the apathy which many of the best of modern Irishmen show to so important a matter as the cultivation of art. I will not here develop my own theories on those questions, for I

wish this book to be as uncontroversial and as inoffensive as possible.

When Irishmen, after seven centuries began again to paint and to admire pictures, they broke completely with the technical tradition of the past. It was lost beyond the possibility of recapture. In the long interval art had become a cosmopolitan thing, and painting, in particular, a universal language, evolved, by practice and experiment, into an almost limitless power of expression. Irishmen looked to Italy, to France, and, chiefly, to England to learn about the new wonder which had grown up while they were otherwise occupied.

There is some excuse for those who persist in classing the Irish painter with the " English School " : for he learned the elements of his craft from itinerant English artists who came to Dublin in the reigns of the Georges. But he soon dispensed with his English masters, and went himself to England, called thither by prospects of greater fame and wealth than he could hope for in his native place. Nathaniel Hone, R.A.; George Barret, R.A.; James Barry, R.A.; Sir Martin Archer Shee, P.R.A.; William Mulready, R.A., and a host of minor men were thus lost to their country. The exodus still continues : and the Irish now look with regretful pride to Sir William Orpen, R.A.; Sir John Lavery, R.A.; Mr. J. J. Shannon,

R.A., and their other numerous compatriots who maintain abroad the reputation of Irish art.

It may be noticed that most of the emigrants are portrait or figure painters. England has always proved to be the happiest of hunting grounds for the wandering portraitist. There, from the days of Lely to those of Laszlo, the foreigner with a talent for painting faces and clothes has never lacked recognition and riches.

No such welcome is extended to foreign landscape painters; and little encouragement is given even to native English practitioners of the gentler art. Gainsborough had starved had he confined his work to landscape. Wilson starved because he did so. Constable died poor and disappointed. Mr. Mark Fisher is only admitted to the full membership of the Royal Academy on the eve of his eightieth year. There is nothing in such a record to draw the Irish landscape painter oversea.

So he remains at home. The Royal Hibernian Academy shows his work in excess of all other kinds of exhibit. He is prominent in their councils. Yet he does not prosper.

Irish people distrust their instinct woefully in matters of art; though Dublin must be one of the best places on earth in which to sell worthless old paintings. The Irish will back their fancy for anything but a modern

picture. Scores of college professors, doctors, and bar-
risters in Dublin are fully persuaded that they are the
happy possessors of " Old Masters." They can see little
or no technical difference between their treasures and the
admitted masterpieces which hang in the excellent
National Gallery of Ireland. They argue, in their
hearts, that even if their "Rembrandt" or their "Titian"
be spurious, it is, at all events, the sort of thing which
they are expected, by the learned and judicious, to like.
To purchase a modern picture would be an adventure far
beyond their range. They have no tests nor standards
for such articles since " The Lane Gift" was lost to
Ireland through their lethargy.

They may, in truth, prefer something sunny and fresh
to a dark, worm-eaten panel; but they feel a sort of shy-
ness in declaring their taste; they wait for someone else to
lead the way : they wait till the artist dies, and his work
appears in a public gallery. When that happens they
will—as the case of Hone proves—buy his pictures at ten
times the price which the artist himself would have asked.

This attitude of mind is not peculiar to Ireland, nor
so base as the bare description of it might suggest. It is
laudable, so far as it reflects a deference to authority and
an anxiety to give admiration only where admiration is
due. But it is deplorably bad, inasmuch as it sets an

example—far too frequently followed in Ireland—to those who, in default of any education in art, see no decipherable signposts to set them on the proper way.

The remedies for this condition of things are so obvious that they are often overlooked. A slightly more generous endowment of our various schools of art; a new type of art teacher, better trained, paid and treated; a determined effort to popularise our few picture galleries; an increase in the number of lectures and books on Irish painters and pictures should work wonders for us in a couple of years. The Irish passion for graphic art, of which Ruskin and Walter Armstrong spoke, is still strong, though it is starved. There is plenty of material wealth at present in the country wherewith to provide for its gratification.

I fancy the first signs of a revival will be shown in the direction of landscape painting. The main tendency of the art of painting in every country during the last century has been in that direction. Landscape is no longer a mere background accessory. Turner, Constable, Corot, and Monet have made it the prime, vital matter of great masterpieces. The Irish, by taste and opportunity are landscape lovers. Their country provides almost every form of landscape dear to the painter.

The neighbourhood of Dublin, for example, is a

treasury of subjects which, I feel sure, cannot be paralleled in such a narrow space elsewhere in the world. The broad pastures and rich farms that lie round Raheny; the dazzling strands at Portmarnock and Malahide; the cliffs at Howth; the woods of Glendhu and Powerscourt; the Dargle, the Liffey, and the Dodder rivers with their high falls and quiet reaches; the incomparable Bay of Killiney; the Vale of Shanganagh; the Golden Spears; the picturesque ruins of the Hellfire Club, Mount Pelier, and Mount Venus; the lonely mountains and bogs that cluster about Cruagh and Kippure, and the two mysterious lakes at Glencree—all these may be reached in three or four hours' walk from the centre of the city.

Barret and O'Connor both worked for years in Powerscourt Demesne. Hone painted continually in his homelands at Malahide and in the Dublin mountains. Osborne was fascinated at times by the coast around Howth. But they were only pioneers in this delectable country. There are estates and to spare for ten thousand followers.

In writing about Barret, O'Connor, Osborne, and Hone I have endeavoured to devote my attention to facts rather than theories. It seemed to me that I should be always alert to jettison a paragraph of criticism in

favour of a couple of dates. Books about painters are so
often made dull by the wanton intrusion of their author's
opinions that I sought to guard against dullness of that
sort, even though the fault should overcome me in another
form. Thus it is that my appendices are very bulky;
but I could not bring myself to sacrifice any part of them,
as I believe them to be the most valuable portion of the
book.

I hope that the small size of the illustrations will be
excused in consideration of their clarity and, also, because
they face the text and, so, can be studied without the
necessity of turning the book on its side. The actual
measurements of each original picture which I have
reproduced are given, as without them it would be im-
possible to form any adequate notion of the way in which
each subject is treated. It is amazing how often essential
information of this sort is omitted by even the most
careful and learned writers.

My descriptions of the colour scheme of each picture
afford me little satisfaction. Indeed I hesitated, for a
while, to insert them at all; for words are poor materials
with which to convey an idea of colour. However, as each
description was written in front of the picture described,
its errors are limited to those of omission. The only

possible alternative, the three-colour process block, too
often errs by crude mis-statement.

I have found so many blunders among the existing
brief accounts of Barret, O'Connor, and Osborne that I
feel I must crave the reader's indulgence for such as I
have inevitably committed myself. They are to be attri-
buted to lack of capacity rather than to want of care. The
task of compiling this book, though self-imposed and
pleasant enough, was more exacting than may appear, or
than I anticipated. No one will realise better than myself
how far my endeavour outstripped my performance. No
one will be more ready than I am to admit that Barret,
O'Connor, Osborne, and Hone deserved a better biog-
rapher. But I take the liberty of doubting if anyone
could ever be found more jealously anxious to secure their
just reputation than is their present apologist,

THOMAS BODKIN.

1st September, 1920.

ACKNOWLEDGMENTS

Were I scrupulously honest, I should put many names with my own on the title-page of this book : for it may be said to be a work of collaboration. It could not have been written without the unstinted help which I received from all quarters to which I applied.

The Directors and Curators of Galleries containing works by Barret, O'Connor, Osborne, or Hone spared neither time nor trouble in giving me assistance. I may mention in particular : Cambell Dodgson, Esq., O.B.E., Keeper of Prints and Drawings at the British Museum; James L. Gaw, Esq., Director of the National Gallery of Scotland; Martin Hardie, Esq., A.R.E., Assistant Keeper of the Department of Engraving, Illustration, Design and Paintings, at the Victoria and Albert Museum; Arthur Bolton, Esq., F.S.A., F.R.I.A.; Curator of Sir John Soane's Museum; Sydney C. Cockerell, Esq., M.A., Director of the Fitzwilliam Museum, Cambridge; G. H. Wallis, Esq., F.S.A., Director of the Nottingham Gallery; Butler Wood, Esq., F.R.S.L., Director of the

Bradford Corporation Art Gallery; W. B. Barton, Esq., Director of the Harris Art Gallery, Preston; A. G. Quigley, Esq., Curator of the Walker Gallery, Liverpool; Mrs. Ellen Duncan, Curator of the Dublin Municipal Art Gallery; and Arthur Deane, Esq., Curator of the Municipal Art Gallery of Belfast.

Those who gave me liberty to reproduce their pictures were : Miss Jane French, Mrs. Bury, The Right Honourable The Speaker, The Right Honourable Jonathan Hogg, The Right Honourable Laurence A. Waldron, The Right Honourable Lord Justice O'Connor, Sir George Brooke, Bart., Barrington Jellett, Esq., my colleagues on the Board of the National Gallery of Ireland, and Mr. Joseph Egan.

Others to whom I am under obligation are : Mrs. Noël Guinness, Miss G. Reilly, Sir William Corry, Bart., Lieutenant-Colonel Sir W. Hutcheson Poë, Bart, C.B., D.L.; His Honour Judge Parry, K.C.; Monsieur E. Thoumy, Le Commissaire Genéral de la Société des Artistes Français; Captain Stephen Gwynn, Walter G. Strickland, Esq., M.R.I.A.; Herbert Hone, Esq.; Algernon Graves, Esq., F.S.A.; Dermod O'Brien, Esq., P.R.H.A.; Emery Walker, Esq., F.S.A.; W. M. Crofton, Esq., M.D.; Thomas Ulick Sadleir, Esq., Barrister-at-Law; Edmund Lupton, Esq., K.C.; R. B. Falkiner, Esq.; Henry C. Drury,

Esq., M.D.; Arthur Bennett, Esq.; W. J. Morgan, Esq., the Secretary of the North British Academy of Arts; Nassau Blair Browne, Esq., R.H.A., the Secretary of the Royal Hibernian Academy; W. H. Hillyard, Esq., the Secretary of the Water-colour Society of Ireland; Thomas W. Lyster, Esq., M.A., Librarian of the National Library of Ireland; his assistants, R. Lloyd Praeger, Esq., B.A., B.E.; W. K. Magee, Esq., B.A., and R. I. Best, Esq., M.R.I.A.; and Messrs. Mawson, Swan and Morgan, Ltd. of Newcastle-on-Tyne.

To all these I owe and tender my sincere thanks.

THOMAS BODKIN.

CONTENTS

LIST OF ILLUSTRATIONS

COLOUR ILLUSTRATIONS

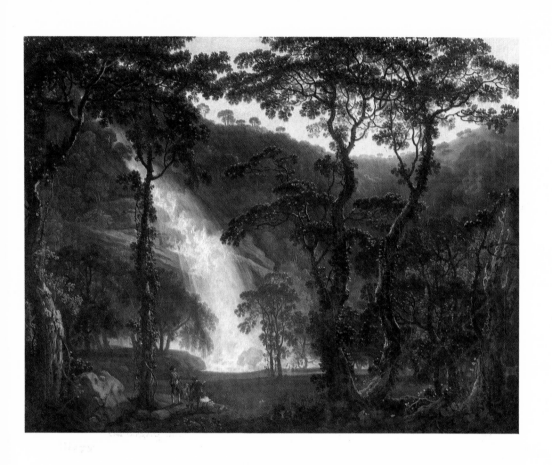

GEORGE BARRET
View of Powerscourt Waterfall

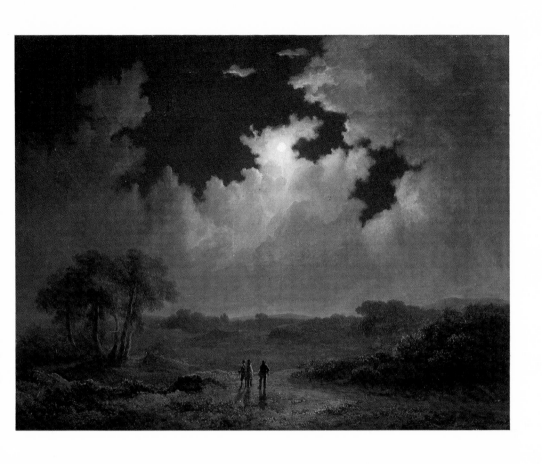

JAMES ARTHUR O'CONNOR
The Poachers

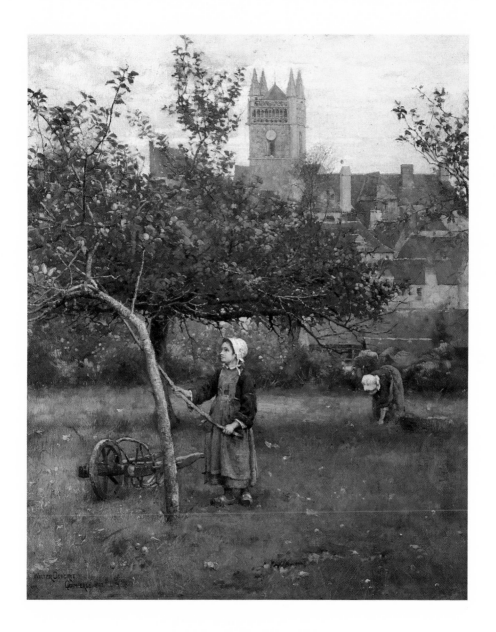

WALTER FREDERICK OSBORNE
Apple Gathering, Quimperte

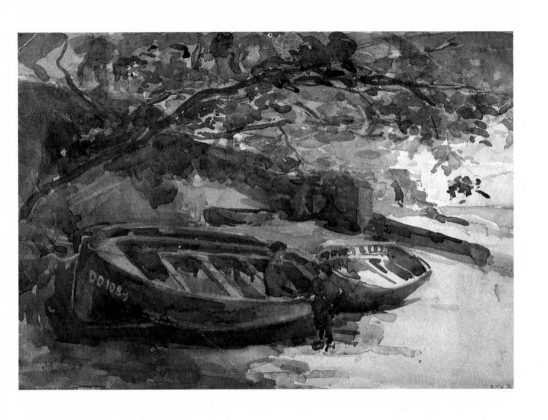

NATHANIEL HONE
Dinghies on a Normandy Beach

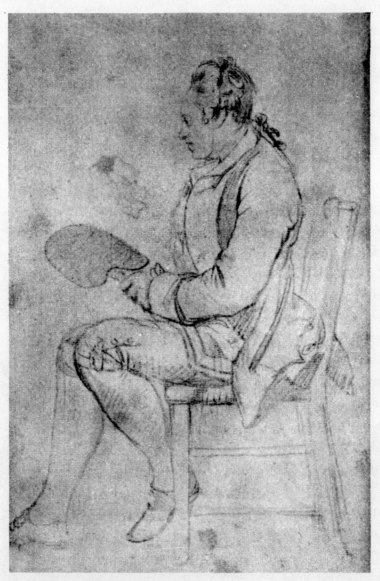

GEORGE BARRET, R.A.
Pencil drawing on paper by himself. In Sir John Soane's Museum.
Size of original; 11 inches high by $7\frac{1}{2}$ inches wide.
Reproduced by kind permission of the trustees of
Sir John Soane's Museum.

GEORGE BARRET, R.A.

GEORGE BARRET, the elder, was reputed in his day, to be the greatest landscape painter whom Ireland, England, or Scotland had till then produced. His fame suffered a sudden eclipse. Alan Cunningham, with characteristic complacency, described him, in 1833, as a "worthless dauber"; and writers on art since Cunningham's time have shown a similar reckless ignorance of his work. Sir Walter Armstrong never even mentioned Barret's name in either of his two big discursive volumes on Barret's famous contemporaries, and fellow foundation members of the Royal Academy, Reynolds and Gainsborough. Those critics who do refer to him at all, do so for the purpose of making his painting the subject of an invidious comparison with that of Richard Wilson.

The only oil paintings by Barret to be found at present in the public galleries of England and Scotland are one in the Walker Gallery, Liverpool, another in the Gallery of the City of Nottingham, and a, doubtful, third in the Fitzwilliam Museum, Cambridge. He is one of the

very few Royal Academicians unrepresented in the Diploma Gallery of the Royal Academy. In the National Gallery of his native country there are but two pictures by him, both in his early manner. One of these is badly damaged and badly repaired.

Barret was born at Dublin probably in the year 1732, though, according to some authorities, in the year 1728. He was the son of a clothier in the Liberties. His name is variously spelt ' Barret' and ' Barett,' both by himself and by others. ' Barret' would appear to be the more correct form. As a boy he was apprenticed to a maker of women's stays. But that employment did not last long, for in 1747 he is found learning to draw in Robert West's famous academy in George's Lane. While there he was awarded a prize by the Dublin Society. His first earnings were gained by colouring prints for Thomas Silcock, a local printseller. Then he became a drawing teacher in a school. Edmund Burke observed his talents and was, as usual, ready to extend encouragement and friendship where he discerned merit. He wisely advised Barret to go to Nature for further instruction. Barret took the advice and for several years painted assiduously in the County Wicklow, particularly in the neighbourhood of the picturesque Dargle River and the splendidly wooded demesne of Powerscourt through which it flows. He

confined his work to landscapes, and developed an attractive and accomplished style.

In 1762 he printed and circulated a proposal to have four of his landscapes, of the Dargle and Powerscourt, engraved, under his own supervision by John Dixon, and published to subscribers. It would seem that this project did not receive sufficient encouragement : and the plates were not engraved. The only landscapes by Barret ever engraved were six done by William Watts which appeared in his *Views of the Seats of the English Nobility and Gentry*, 1779—86, and three done by Samuel Middiman, which appeared in his *Select Views in Great Britain*, 1783—1789.*

As Dublin would not employ Barret adequately, he sailed for London in 1762, bringing with him his wife, whom he had married in 1757, and some of his best

*The six prints after Barret in the *Views of the Seats of the English Nobility and Gentry* are : Plate VI., Claremont ; Plate XII., Burton Constable ; Plate XVI., The Lodge in Richmond Park ; Plate XXII., Kedleston House ; Plate XXIV., Cadland Park ; Plate XXXI., Trentham.

The three prints after Barret in the *Select Views in Great Britain* are : Plate I., Winnandermere (*sic*) Lake, Westmoreland ; Plate VI., Ulleswater (*sic*) ; Plate XXXIV., View on Shanklin Chine. Of these Plates No. I. is described as painted by " G. Barrett, R.A." ; Nos. VI. and XXXIV. as by " G. Barrett." They would all, however, seem to be after George Barret, R.A. They are very characteristic of his work. One of those attributed to " G. Barret," if done by George Barret, junior, must have been done when he was, at most, seventeen years of age, for it was first published by Boydell in 1784.

pictures. The exhibition of the Society of Artists of
Great Britain in 1764 contained four of his works, includ-
ing views of the Dargle and Powerscourt Waterfall. In
that year he also showed at the Free Society a large work
entitled simply "A Landscape with Figures," and gained
with it a premium of fifty pounds offered, for a landscape,
by the Royal Society. He acquired instant popularity
and commissions were poured upon him; while Richard
Wilson maintained with difficulty a poverty-stricken and
obscure existence, being reduced at times to barter his
pictures for bread and cheese. James Barry, that caustic
critic of his contemporaries, wrote to his friend Dr.
Sleigh, in Ireland, declaring " Barret does no small
honour to landscape painting among us. I have seen
nothing to match his last year's premium picture. . . .
It has discovered to me a very great want in my favourite
Claude's performances."

The prices Barret commanded are always alleged to
have been, for the period, huge. Reynolds, who himself
was accustomed, in his heyday, to ask only £200 for a full-
length portrait, could buy from Gainsborough for sixty
guineas the picture which he described as "by far the best
that Gainsborough ever painted or, perhaps, ever will."
About the same time Barret was reputed to have been
paid £1,500 by Lord Dalkeith for three landscapes. This

is a story often repeated, yet one I find hard to credit. Entries in the Royal Academy catalogue for 1775 show that he was then, five years after he had painted the Dalkeith pictures, willing to accept eighty guineas for each of two, presumably, important pieces; and seventy-five guineas for a third. There is no extant evidence that he lived in an exceptionally extravagant way, yet he was on the verge of bankruptcy when he died. Had his prices run to hundreds of pounds, we would not read, as we do, of a picture by him selling for the paltry sum of one pound three shillings at a notable auction held within twelve years of his death. That was not an age of such quickly veering tastes.

During the seven years that elapsed between Barret's arrival in London and the first exhibition of the Royal Academy he continued to exhibit regularly with the Society of Artists of Great Britain. He formed the plan for the institution of the Royal Academy, which was taken up by Sir William Chambers and carried into effect. He was nominated a member in the King's instrument of foundation. Thenceforth he sent pictures regularly to the Academy's annual exhibitions until 1782, two years before his death. The last, done when his health was failing, was entitled "A Sun-set."

Old exhibition and sale catalogues show that he

enjoyed, at least, his fair share of patronage. Lord Powerscourt, The Duke of Portland, for whom he did twelve pictures; The Duke of Buccleuch, Sir George Colebrook, William Lock of Norbury Park and William Constable of Burton Constable were chief among those who employed him to do pictures of their demesnes. Lord Albemarle and Lord Lansdowne increased his fame by including his works in their collections. He was said to have made, in his prime, £2,000 a year : but, if so, he spent more than he made and was never clear of financial embarrassment. When Edmund Burke came to enjoy his one brief spell of patronage he remembered Barret; and, in 1782, secured his appointment to the lucrative and almost sinecure post of Master Painter to Chelsea Hospital. It is this appointment, probably, that accounts for the presence of three drawings by Barret, one a portrait of the artist, in the Soane Museum. For Sir John Soane was then Clerk of the Works and Resident Architect at Chelsea Hospital.

There is no record of Barret's having ever left Great Britain after he settled there. He travelled extensively up and down England; the Lake District was the source of inspiration of many of his best pictures. He also visited, and painted in, Wales and the Isle of Wight. In 1768 or 1769, he went to Scotland, to paint Melrose

Abbey and Dalkeith for the Duke of Buccleuch. A landscape entitled " Tivoli" and attributed to him, which was shown at the loan exhibition held in the Whitechapel Art Gallery in 1913, might give some ground for a belief that he had visited Italy. But it is more likely to have been the work of his son and namesake, who certainly did paint many pictures of Tivoli, which became a fashionable subject when the Temple of the Sibyls was bought by the Earl of Bristol. Ruskin described George Barret the younger as " aiming high, but generally put off with stale repetitions—the Temple of Tivoli, etc." One of his water-colours of Tivoli is in the Victoria and Albert Museum.

In 1772 George Barret the elder settled at Westbourne Green, near the then country village of Paddington. He went there for the sake of his health, as he suffered severely from asthma, and he took a house with a fine prospect where he enjoyed frequent visits from his fellow-painters, with whom he was always most popular. " He was well-informed, an enthusiast in his art, and a delightful companion," says Henry Angelo. Fuseli describes him as " a man remarkably kind and friendly, gentle in manners, with a vast flow of spirits even to playfulness, and a strong turn to wit and humour." Perhaps the best evidence of his amiability is found in the

fact that the acrimonious Barry on his way to Rome wrote him a long pleasant letter from Paris; and, waiving his usual ungracious formality, subscribed himself thereto as "yours most affectionately."

Only three portraits of Barret exist. One is his own pencil sketch of himself seen in profile, full-length, seated, which by the kindness of the Trustees of the Soane Museum I have reproduced as an illustration. A rough pencil profile, of the head only, by John Greenwood is in the British Museum. He also appears in Zoffany's group of the Royal Academicians in His Majesty the King's collection at Windsor Castle. The latter two likenesses show him to have had a mobile, intelligent countenance, though one too careworn and haggard for his age.

He died at Paddington on May the 29th, 1784, leaving his widow and nine children destitute. The Royal Academy granted the widow a pension of thirty pounds a year. In the course of time, several of the children adopted their father's profession; and the eldest made, in his turn, the name of George Barret again familiar. His landscapes in water-colour are among the best and best known of the English School, and his work is often confused with that of his father.

George Barret the elder, painted in both oils and water-colours and was masterly in both media. He also etched

a few plates, which are of small importance. There seems
to be no solid foundation for the statement of a recent
writer on Gainsborough to the effect that "George Barret
realised quite a small fortune by the sale of his small
landscape studies and etchings." According to Edwards
in the *Anecdotes of Painting*, no prints from his etchings
were published until after his death, when the plates were
acquired by Paul Sandby, R.A. Two views of Hawarden
Castle, drawn and etched by him, were certainly pub-
lished by Boydell in 1773; but as regards the rest of his
etchings, Edwards is borne out by the appearance of the
impressions in the British Museum, one of which is
described in old manuscript as "a proof" from an
etching by "the late George Barrett." Excepting the
Boydell prints, none of them bears any publishers name.

His water-colours are rare, 'and far surpass those of
his contemporaries. They are painted with great fluency
and grace, and break further away from the brown con-
vention of the time than do his oil paintings. They are
also less formal in design. The bold blueness of their
skies, though usually now much faded, excites particular
admiration, when the distaste of the eighteenth century
public for primary colour in landscape is remembered.
Like John Sell Cotman, he was fond of painting water-
colour landscapes in monochrome. These were executed

at times in Indian ink, and at times in washes of pale pure blue. Occasionally they were drawn on an almost miniature scale. It has been said " that his studies from Nature with a blacklead pencil are excellent." Ephraim Hardcastle, in *The Somerset House Gazette and Literary Museum: or Weekly Miscellany of Fine Arts, Antiquities and Literary Chit-Chat* for 1824 declares " that he painted in body-colours, or what is termed by the French who excel in that process *gwash*": but I cannot trace any of his landscapes in either pencil or gouache.

To our modern eyes, taught by Monet to perceive the vivid yellows and violets that glow in all sunny scenes, Barret's oil paintings often appear too heavy and dark in tone, too pervaded with sombre, olive tints. It comes as a great surprise to find critics near his own time lauding, as they invariably do, the freshness and greenness of his scenery. In Pilkington's *Dictionary of Painters* he is praised for the " dewy freshness" of his colour. Samuel Redgrave declares that " he represents English scenery in its true freshness and richness, excelling in the verdure peculiar to Spring." When his work is compared with that of other popular eighteenth century landscape painters, the reason for such eulogies becomes more clear. Sir George Beaumont, that clever amateur painter and critic, who exercised such influence

on the taste of his time, always painted his trees brown with deliberate intention. Even Gainsborough's trees are sometimes brown in spite, as it were, of his better self. As a rule, the general aspect of an Irish woodland scene is noticeably more moist and vivid than anything of the sort to be seen in England, and Barret's early studies in the Wicklow woods probably kept him from being overwhelmed by the example of his English colleagues, who rendered the foliage of ash, oak, elm and willow alike in bituminous gloom.

Still more remarkable than the comparatively bright colour of Barret's oil paintings is the fine feeling for light which they display. Not Wilson, nor even Claude, could convey the clear level light of a warm afternoon with more competent assurance than does Barret. He never rises to the heights occasionally attained by such Masters; but the standard of his later work is far beyond the reach of talent untouched by inspiration.

The composition of his oil paintings, as distinguished from the water-colours, which are less formal, is usually a curious blend of the artificial and the well-observed. His rocks, trees and clouds are often arranged in an improbable fashion, but they are always drawn with great understanding of their structure.

The technique of his painting shows that dexterous

ease which comes from long years of labour praised and well-rewarded. His brushwork is sure, light and expressive. His glazing is unusually skilful. The paint, save in the high-lights of a cloud, a rock, or a tree trunk is thin, yet always satisfying.

The little figures which enliven most of his landscapes were sometimes done by himself; but more often by his friend and fellow-Academician, Sawrey Gilpin. In return, he frequently painted the landscapes in Gilpin's pictures of animals. Gilpin was not the only Academician who so assisted him. One of his best pictures, a view looking towards Knipe Scar and Lowther Park, which is in the possession of the Right Honourable the Speaker, and which, with his kind permission, I reproduce as an illustration, represents a cluster of hills through which some sportsmen and their dogs are advancing. The dogs were painted by George Stubbs, A.R.A., and the sportsmen by Philip Reinagle, R.A. In the room which he decorated at Norbury Park in Surrey he was assisted by Gilpin, Cipriani and Pastorini—Cipriani doing the figures, Gilpin the cattle, and Pastorini the sky. A painting by him, sold in 1802, contained figures then attributed to Francis Wheatley, R.A., who had only died the year previously.

Such collaborations afford proof of Barret's desire for

friendly intercourse with his fellows, rather than of his incapacity to complete his own work. The figures in some of his early landscapes, such as those in the " Powerscourt Waterfall" of the Irish National Gallery and those in my own picture reproduced as a frontispiece to this book, were done by himself and often well done too; and Edwards says " he sometimes painted animals which he executed in a bold and masterly manner." He did a portrait of a spaniel for Lord Edward Bentinck, which was in the exhibition of the Society of British Artists in 1768, and was afterwards engraved by James Watson; and a picture of "A Bull" which was in the Academy exhibition of 1770. The figures and horses in the two of his water-colours in the Victoria and Albert Museum, which are also reproduced here, were competently done by himself.

His pictures are rarely signed in any way, and sometimes merely initialled. The example in the Nottingham Gallery is signed in full " G Barret" and dated 1777 : but no signature appears for Gilpin, who did the horses and the figures therein.

Few things could be more to the credit of Barret's mind and taste than the fact that the beauty of Wilson's painting so wrought on him that his own work, towards the end of his career, began to show the strongest resem-

blances to that of his more gifted, but poor and unpopular, rival. Barret's first style had pleased the public and brought him success. He abandoned it, to follow a failure whom he knew to be his superior. Wilson and he were personal friends; which goes to show that he was not chary with his praise, for Wilson was a fiery spirit who chafed under neglect. The friendship between the despised genius and the man of fully, if not over-rated talent, is a clear proof of the high character of both. Many a " Wilson " has since their deaths been sold as a " Barret" to purchasers, who were, nevertheless, not without taste and knowledge. If Barret while living was unduly exalted above Wilson, the growth of Wilson's fame has had the curious effect of gradually, but effectively, obliterating Barret's reputation.

Were more of his pictures accessible in the public collections this state of things would cease. There is no just antithesis between the two men's works. Barret set narrower limits to his aims, but within his limits he was a master of his art. The Speaker lent the " View looking towards Knipe Scar" to the National Gallery during part of the War. It hung in a room with many excellent pictures of the English school, including a couple by Wilson, and held its own in that distinguished company.

The Speaker owns a companion picture, a view of

Keswick and Derwentwater, which he lent to the White-chapel Exhibition of 1913. Other notable pictures by Barret in England are to be seen in the collection of the King at Windsor Castle, and in the collections of the Duke of Portland and the Duke of Buccleuch.

Norbury Park, near Leatherhead, in Surrey, which contains Barret's well-known decorated room, has been acquired recently by Sir William Corry, Bart. The room was done to the order of the Reverend John Lock. It measures twenty-nine feet by twenty-three feet and is fourteen-and-a-half feet high. The decoration takes the form of a species of panorama of Cumberland scenery, divided into panels by slender, pictured pilasters and trellis work. The ceiling depicts the interior of a roof with an oval opening to the sky in the centre. The whole is intended to represent a prospect seen from a light summer-house. The work was painted directly on a stucco ground in oils, and must have been done with uncommon technical skill, for it survives in almost perfect preservation to the present day. It is curious to note that the *Victorian History of Surrey*, which records so much of little interest, does not mention this remarkable room. John Britton and Edward W. Brayley, in 1801, referred to it in the volume of *The Beautys of England and Wales*, which is devoted to

Surrey. But they err in stating that Barret decorated more than one room at Norbury Park.

Acknowledged works by Barret are not as plentiful in Ireland as might be imagined, considering that he did not leave the country till he was thirty. Yet his name is heard constantly in Irish auction rooms, for it is customary there to attribute to him every mediocre eighteenth century landscape : a practice which, naturally, has tended to increase his disrepute. Two undoubtedly original paintings by him are in the Royal Dublin Society's premises at Leinster House. Two are at Castletown, Co. Kildare; and two at Donacomper in the same county. The Right Hon. Laurence A. Waldron owns a very attractive view of Powerscourt Waterfall seen from a distance. It is unusually small, measuring only twenty-eight-and-a-half inches high by twenty-seven inches wide. The Castletown pictures and one from Donacomper were lent, by their respective owners, Captain Connolly and Mr. Kirkpatrick, to the Irish International Exhibition of 1907, and were admired there.

It is to be hoped that the Governors of the National Gallery in Dublin will soon find an opportunity of acquiring, by gift or purchase, a really representative work by Barret, for he was a painter of whom the Irish people have sound reason to be proud.

George Barret, R.A.

Plate II

A VIEW LOOKING EAST TOWARDS KNIPE SCAR FROM LOWTHER PARK.

In the Collection of the Right Honourable James
William Lowther, P.C., D.C.L., LL.D. Speaker of the House of Commons.
Oils on canvas.
44 inches high by 63½ inches wide.
Unsigned.

This picture was painted from Naddle Forest, just above Haweswater, Westmoreland. The Speaker tells me that the bottom of the valley depicted may soon be turned into a lake, as the Manchester Corporation design to acquire it for the purpose of forming a gigantic reservoir for the supply of water to Manchester and other Lancashire towns.

The quality of the painting shows Barret's matured technique at its best. The tone of the picture is a luminous golden brown, with a warm, grey autumn sky. The sportsmen were painted by Philip Reinagle, R.A., and the animals by George Stubbs, A.R.A. They are all so well placed, and their colouring so harmonised with the landscape, that Barret must be supposed to have planned their position and treatment. The foremost man wears a black hat, a white choker with a blue ribbon, a buff suit, and boots with pink tops. The second man's suit is of French grey. The third man, on horseback, wears a suit of pale blue-grey.

This picture was lent by the Speaker to the London National Gallery for some time during the War.

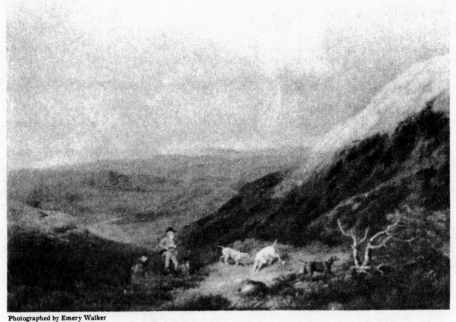

A VIEW LOOKING EAST TOWARDS KNIPE SCAR FROM LOWTHER PARK
By George Barret, R.A.

George Barret, R.A.
Plate III

SUNSET AND RUINS.
In the possession of the author.
Oils on canvas.
25 inches high by 30 inches long.
Unsigned.

This picture was evidently a late work of Barret's, and one in which he was much influenced by Richard Wilson, R.A. It depicts a sunset scene. The sky, flooded with orange light, merges into a cool blue in the top right corner. The ruin against the sky is a warm reddish grey: the near isolated block is covered with ivy. The low trees and bushes fringing the pool are most carefully distinguished in colour and form; and rendered, in an accomplished way, by glaze after glaze of translucent tints. The rocks, creepers and roots in the foreground are drawn with great freedom, in a solid, satisfying impasto. The tree on the shoulder of the hill, and the outline of the principal tree in the foreground are painted with the thinest possible rubbing of paint, to produce the effect of being suffused with the light of the setting sun. The line of mountains in the extreme background is soft blue. The figures and boat were not done by Barret himself. They are probably the work of Sawrey Gilpin. The sitting man in the stern of the boat wears a red coat: the standing man, wielding the fishing rod, wears a blue coat and buff breeches.

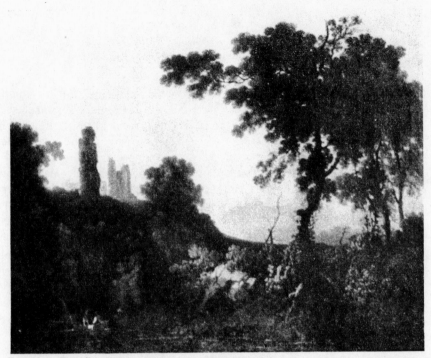

SUNSET AND RUINS
By George Barret, R.A.

George Barret, R.A.

Plate IV

LANDSCAPE WITH RIVER AND HORSES WATERING.

In the National Gallery of British Art, Victoria and Albert Museum, South Kensington, (No. 257/'75).
Watercolour on paper.
14⅝ inches high by 21 inches wide.

Mr. Martin Hardie, A.R.E., the Assistant Keeper of the Department of Engraving, Illustration, Design and Painting in the Museum, has kindly given me the following description of this drawing, as it is many years since I have seen it myself and it is not at present accessible to the public owing to the closing of part of the Museum during the War.

"The drawing has faded considerably, and indigo in sky, distance and trees, has probably disappeared. The whole scheme of colour is very pale, giving an effect of earth colours and greys, with a suggestion of autumn tints. The foliage of the right-hand tree of the three trees on the left, and of the trees to the right on the cliffs, is blue-grey in tone. The man on the near horse, which is of a brownish tint, wears red waistcoat and blue breeches: the further horse is in pale yellow ochre.

There is no pen-work in this drawing."

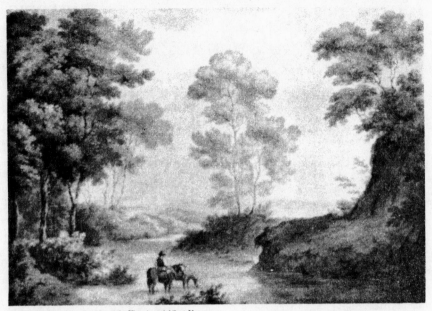

LANDSCAPE WITH RIVER AND HORSES WATERING
By George Barret, R.A.

George Barret, R.A.
Plate V

LANDSCAPE WITH RIVER AND FIGURES.

In the National Gallery of British Art, Victoria and Albert Museum, South Kensington, (No. 1722/'71). Portion of the William Smith Bequest. Watercolour on paper.

14¾ inches high by 21¼ inches wide.

Signed, in lower right corner, in pencil—"G. Barrett, 1782."

Mr. Martin Hardie, A.R.E., the Assistant Keeper of the Department of Engraving, Illustration, Design and Painting in the Museum, has also kindly given me the following description of this drawing.

"This drawing, though fresher than the other," (Plate IV), "is also in pale autumnal tints. The foliage on the trees to the left is definitely a pale brown. The trees to the right still retain a certain amount of grey-green.

The rushes in the foreground are a golden ochre. The horse in the centre is white, the other two a yellowish colour repeating tones in the trees and foreground.

The rider on the left wears a red coat.

The figures and horses are outlined with pen and ink."

This drawing was reproduced as a full-page illustration in the first edition of Mr. Cosmo Monkhouse's *The Earlier English Water-colour Painters* (1890). It was omitted from the second edition.

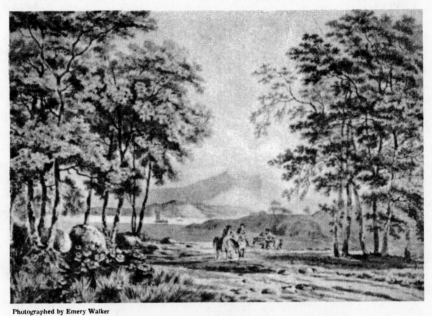

LANDSCAPE WITH RIVER AND FIGURES
By George Barret, R.A.

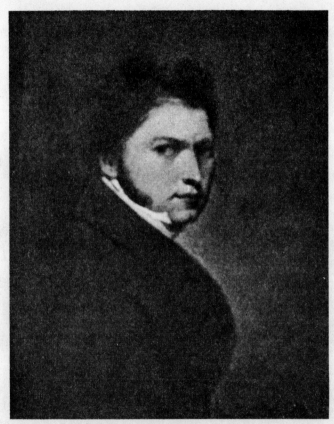

JAMES ARTHUR O'CONNOR
Oil painting on millboard by himself.
Size of original; 4½ inches high by 3½ inches wide.
In the possession of Mrs. Bury and reproduced by her kind permission.

JAMES ARTHUR O'CONNOR

JAMES ARTHUR O'CONNOR was born in Dublin in 1792. He was the son of a printseller and engraver who at that time was established in 15, Aston's Quay. The son probably got his first impulse towards painting from the study of his father's wares. The only formal teaching he ever enjoyed was received from William Sadler, the second, whose small copies after old masters, and little paintings on panel of Irish town and country scenery, are so well known and popular in Ireland. Sadler was an indifferent artist; but he had a good workmanlike way of handling paint which he succeeded in communicating to his pupil, who eventually surpassed him in every artistic quality.

Like Barret, O'Connor was attracted to the Dargle in his student days and did many landscape studies there. But his first exhibit, evidently, was not a landscape. It was entitled "Card Players" and shown at the exhibition of the Society of Artists of Ireland in 1809, when he was seventeen. He continued to exhibit, confining himself

for the future to landscapes, with fair regularity at the annual exhibitions of the various Societies of Irish painters, until the year 1821, when he left Ireland never to return.

The project of settling in England was conceived by him early in his career. He attempted in 1813, for the first time, to put it into execution; and in company with George Petrie and Francis Danby, both artist friends of his, the latter also in some degree his pupil, he went to London in the June of that year. They got little encouragement there. Petrie soon returned home, and became, in due course, president of the Royal Hibernian Academy. O'Connor and Danby made their way together on foot to Bristol, where they arrived without a shilling. Danby, however, managed to sell a couple of his studies of Wicklow scenery and emboldened by this success elected to remain where he was and to try his fortune afresh. He obtained patronage there, and afterwards became a popular Associate of the Royal Academy. O'Connor had had no such encouragement, and was reduced to such straits that it was only with Danby's assistance that he was able to return to Ireland.

His failure on this occasion is not so surprising as those who only know his later work might think. I have seen a collection of ten landscapes all done by him before

his twenty-fifth year. They show nothing more than promise, and a great resemblance to the uninspired manner of his master, Sadler. In only one, and that the latest, can a trace of his own natural feeling and pleasant handling be discerned. He was an artist who developed with unusual slowness.

On his return to Dublin he set up as a landscape painter, first at Aston's Quay and afterwards in Dawson Street and painted, with unremitting labour, scenery round Dublin and in Wicklow. There was little demand for his work. In 1818 and 1819 he toured and painted in the west of Ireland. The Lords Sligo and Clanrickard of the time purchased some of the pictures done on this tour. A couple of them are still in the collection of the present Lord Sligo. Four drawings done on the same occasion are in the British Museum.

In 1820 O'Connor received a premium of twenty-five guineas from the Royal Irish Institute, which, however, does not seem to have improved either his practice or his prospects. He had married; and felt himself driven again to try his chance in a larger sphere. So, in 1822, he went once more to London. He began to show his work immediately in the Royal Academy exhibition and sold several pictures. From thenceforth to his death he continued to be a constant contributor at the annual exhibi-

tions of the Royal Academy, the British Institution, and the Society of British Artists. He became a member of the last-mentioned body. He exhibited in the Royal Hibernian Academy only twice in his lifetime, sending, from London, a single landscape to the exhibition of 1830 and three landscapes to that of 1840.

His second migration to London proved successful to the extent of encouraging him to adventure further afield. In May, 1826, he went to Belgium for a year, in the company of a French dealer named Collier, and there painted and disposed of many pictures. His success was clouded : for while in Brussels he was swindled of a considerable sum of money. He seems to have been always easily duped.

Henry Ottley in his *Dictionary of Recent and Living Painters*, published in 1866, refers to a second Belgian trip which, according to him, took place in 1830. O'Connor, he declares, was driven back to England by the Revolution of that year. Ottley is sometimes inaccurate, and I can find no evidence to support these statements.

In 1832 O'Connor, accompanied by his wife, went to Paris where he painted for eight months, probably, with even better success than he had had in Brussels, for the French had been fired with an enthusiasm for British landscape painting by the Constable pictures shown in the

exhibition of 1824. From Paris he intended to go to Italy. But on the eve of his departure, while dining with his wife at a restaurant outside the city, he met a plausible stranger who professed great interest in his art and persuaded him instead to go to Germany. This person, who called himself Eliott, promised him introductions, among others, to a certain Herr Boch Bushman, whom he described as an important resident of Metlach. The name might have put O'Connor on his guard : it has a farcical and suspicious aspect. But there was, in fact, a Herr Boch Bushman at Metlach, who happened to be the Burgomaster of the district. When O'Connor presented his credentials he learned, to his horrified surprise, that "Mr. Eliott" was the alias of a notorious scamp whom the Burgomaster had orders to arrest on sight. The adventure ended well for the artist and his wife. Herr Bushman was charmed with them, entertained them as his guests for three weeks and then sent them on their way rejoicing, armed with fresh letters of introduction written by himself. It is customary with O'Connor's biographers to denounce "Mr. Eliott" severely. But the fact remains that no one ever proved of greater use to him.

O'Connor's itinerary on this trip comprised Chalons-sur-Marne, Saarbruck, Metzig Saarlouis, Metlach, Treves, Cocheim, Coblentz, Bingen, Mayence, and Frank-

fort. During this period he painted some of his best and most important works, many of which, in all probability, still remain in Germany.

When he came back to England in November, 1833, he did not succeed in improving his position further, and his eyesight began to fail. No greater calamity could fall upon an artist. He struggled valiantly and painted incessantly : but in 1839 his health showed signs of collapse. After a life of hard labour and little recognition he died on the 7th of January, 1841, in the cheap lodging at 6, Marlborough Street, off College Street, Brompton, where he was then living with his wife. This lodging was his eleventh successive residence in London, which goes to show what a troubled and restless life his must have been.

Several of his works were exhibited at the Royal Hibernian Academy exhibitions of 1842 and 1843.

He left his wife without any means of support. In 1845 a movement was set on foot by his countryman, Sir Martin Archer Shee, then President of the Royal Academy, and other influential persons to buy an annuity for her benefit. The Prince Consort headed the list of subscriptions with a donation of twenty-five guineas. The appeal circulated in the *Art Union Journal* for April 1st, 1845, on this occasion, began by declaring that

" There are few who love art who have not some
acquaintance with the admirable works of James O'Con-
nor. They are becoming scarce—and will ere long be
very valuable notwithstanding that he produced so
many." It went on to complain that he " was never able
to extricate himself from the hands of dealers," and con-
cluded with the following extraordinary quatrain, mis-
quoted from Moore's threnody on Sheridan :

" In the plains of the East there are insects who prey
On the brain of the elk till his very last sigh;
Oh, Genius! thy patrons more cruel than they
First feed on thy brain and then leave thee to die."

Sir Martin Archer Shee, who had a solid literary reputa-
tion to lose, can hardly have taken much interest in the
drafting of this petition.

Most of O'Connor's work, and all that by which he
is best known, is in oils. He also painted in water-colours.
In his youth, he did a few etchings of figures. Three
of these were published in Dublin in 1810. They repre-
sent peasants of a rather Dutch type. Though not ill-
drawn they are in no way remarkable as works of art.
The magazine *Hibernia*, referring to them, ' ventured to
predict the success of this young artist, if by constantly
uniting literary study with professional practice he en-

deavoured to deserve it.' Five more etchings by him, of a similar character, were published in London by T. North probably in, or about, the year 1824.

O'Connor painted in oils on millboard, panel, or canvas. His happiest and most characteristic work is found, as a rule, on little panels of oak prepared with a thin gesso-like priming. His earlier pictures are stiff and hard in drawing and too topographical. The catalogue of the Irish National Gallery is wrong in declaring that they are his best. Sadler's influence was but a passing phase. He was of a more romantic temperament than Sadler and was never really at ease in his teacher's cheap and empty convention. Barret's work influenced him later to better purposes : and Constable's, which he became acquainted with in his maturity, left a lasting, though not always fortunate, effect. His later pieces show, occasionally, as the result of his study of Constable's work, a calculated dramatic stress altogether alien to his placid spirit. This can be noticed in such a fine picture as " The Devil's Glen," lately given to the National Gallery of Ireland by its Director, Captain R. Langton Douglas.

In one branch of O'Connor's art we have to search for a predecessor as far back as Aart Van der Neer : for O'Connor was the only landscape painter in these islands

who painted moonlight scenes with anything like the truth and force of the Dutchman who was the first to essay them seriously. He, also, often closely observed and cleverly reproduced the misty effects of early morning.

Many of his pictures show a trick of art which he was particularly fond of, the introduction into the land-scape of a little figure in a red cloak or wearing a red cap, by which device of contrast he gave his greens great value and brilliancy. Indeed, his greens are often so brilliant that some of the critics of his time, Samuel Redgrave included, were inclined to charge him with overdoing that colour. The device is one well known to forgers of O'Connor's work, and I have seen many pictures con-fidently attributed to him on no better ground than that of a little figure flaunting a scarlet garment.

The way in which O'Connor handled paint was very workmanlike, and particularly adapted to his smaller scale pictures. He developed a deft, rapid touch, indi-cating foliage with peculiar crispness. Oak trees were his speciality. He used his colours rather dry and liked a good impasto in the more highly keyed passages. In his sketches the clouds are put in, at times, with the palette knife. His shadows are thinly laid; they tend to a golden brown tone: and some bituminous pigment which he used for that effect has caused many of them

to crack, though not seriously. His little figures are excellently drawn and placed. When a young man he collaborated once or twice with Joseph Peacock, afterwards a Royal Hibernian Academician, who probably contributed the figures to his landscapes : but he stood thenceforth upon his own unaided merits.

His more important pictures are generally signed in full 'J. A. O'Connor' and dated. Less important ones are often only initialled 'J. A. O'C.', but they, too, are usually dated.

He painted only one portrait, so far as I know. It was of himself, before he left Ireland, and is at present in the possession of Mrs. Bury of Ardilaun Terrace, the North Circular Road, Dublin, whose late husband is said to have bought it, many years ago, from the painter's sister. Mrs. Bury has kindly allowed me to reproduce it among the illustrations to this book. It is on millboard and measures three-and a-half inches by four-and-a-half. He shows himself in a blue coat and high white stock, aged about thirty, with fine eyes, a sensitive mouth, a straight nose and a broad forehead. But his look is troubled, as though he presaged his sad career.

All who knew him united to praise him as a man. Henry Ottley, who apparently never met him, is alone in suggesting that his death was due to in-

temperate habits. A flamboyant eulogy of his charm
of mind and manner appeared in the *Dublin Magazine*
for April, 1842, signed " M." The initial probably
stood for George Mulvany, a member of the Royal
Hibernian Academy, who afterwards became the first
Director of the Irish National Gallery. He was
a life-long friend of O'Connor's and described him as
" a spirit of exceeding mildness; manly, ardent, unob-
trusive and sincere; generous in proclaiming contem-
porary merit and unskilled and reluctant to put forth his
own." Danby, in a letter to Petrie, refers to him after his
death as " our dearly remembered friend, poor James
O'Connor."

O'Connor is well represented in the public collections
of both England and Ireland. The South Kensington
Museum contains nine of his oil paintings. The Mappin
Art Gallery at Sheffield contains two. The Nottingham
Gallery holds one example; and so does the Fitzwilliam
Museum at Cambridge. Eight of his drawings are in the
British Museum. The National Gallery of Ireland has
five oil paintings, six water-colour drawings, of which
three are in sepia; and thirty-two most interesting pen
and pencil sketches from his note-book. He died at an
early age, but he worked very hard all his life, and, as his
pictures are generally on a small scale, he must have pro-

duced great numbers of them. He exhibited, in various
societies, over one hundred and twenty works. Nearly
all these were what he would consider his more important
pieces. The British Institution alone recorded the size
of exhibits, and many of his works sent there were,
according to the catalogues, over nine square feet in area.
One shown in 1830, was over sixteen square feet. Any-
thing smaller than four square feet was exceptional.

It is by his little pictures, measured in inches, that his
fame is best secured. These he did not care generally to
exhibit : but they formed the larger part of his output.
" His landscapes," wrote Richard Garnett, in *The
Dictionary of National Biography*, " were usually small
and unpretending, but, to judge by the specimens now
accessible, of extraordinary merit. . . . He was
a poet with the brush and exquisitely reproduced the
impressions inspired by the more romantic and solemn
aspects of nature."

There must be hundreds of his smaller pictures
extant. They are not likely to become scarce nor very
valuable in the near future, and room might be found
with advantage for a few more in public galleries, at
least in those of Ireland. They are exactly the sort of
things which help to stimulate the love of landscape and
landscape painting in simple, unsophisticated people.

James Arthur O'Connor

Plate VI

A VIEW IN CASTLE COOTE DEMESNE.

In the possession of the Right Honourable Lord Justice O'Connor, P.C.

Oils on canvas.

24½ inches high by 30 inches wide.

Signed in the lower right corner:-

"J. A. O'Connor, 1840."

The tone of the picture is golden brown: there is a very faint touch of blue in the sky. It is painted in a vigorous, easy style, with good solid impasto. It contains no figure, an unusual omission in pictures by O'Connor.

This, in all probability, was O'Connor's last work; and, if so, it was done for Captain Chidley Coote, of Huntingdon, Queens County, his most consistent and generous patron. Captain Coote, hearing of his illness, sent him some money; and, during a period of relief, O'Connor, in return, painted for him what George Mulvaney, R.H.A., described as "a very able picture which he valued at Twenty Guineas."

It afterwards came into the possession of the late Charles Bennett, Esq., who exhibited it at the Dublin Exhibition of Arts and Industries in 1872. It was sold by auction, in August 1918, to a dealer who, in his turn, sold it to Lord Justice O'Connor.

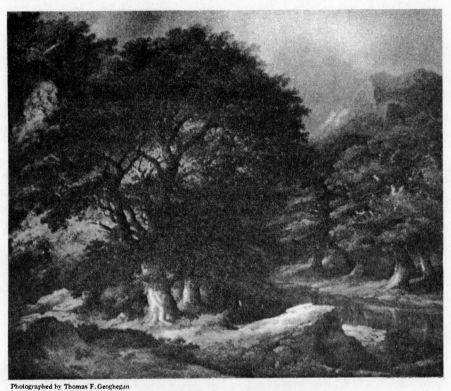

A VIEW IN CASTLE COOTE DEMESNE
By James Arthur O'Connor

James Arthur O'Connor
Plate VII

THE POACHERS.

In the National Gallery of Ireland.

Oils on canvas.

27½ inches high by 33 inches wide.

Signed: "J. A. O'Connor, 1835," in the lower right corner.

This is probably O'Connor's best moonlight piece, if not the best picture he ever painted. It is not, as so many admired "moonlights" are, a mere monochrome of silvery blue. The landscape is studied with great care and is full of cool greens. The handling of the paint is masterly. If the picture has a fault, it is that the moon is too white, with a whiteness accentuated by the naturalistic, faint touch of warm orange in the surrounding cloud. I think the composition might have been improved by pulling a denser veil of cloud across the moon. The figures are admirably drawn, and placed with great dramatic effect. The late Sir Richard Garnett, C.B., LL.D., in his article on O'Connor in the Dictionary of National Biography, justly described this picture as a "composition steeped in Irish sentiment." It is badly hung in the Gallery, the moon being on the level of the spectator's eyes, and the figures and the landscape lost in reflected lights from the floor and balustrade.

It was acquired from the late Lord Powerscourt in 1879 for the sum of twenty-six pounds. Another picture in the Irish National Gallery, entitled "Moonlight" (No. 158), measuring 7 inches by 6½ inches, was possibly used as a study for the more important work.

"The Poachers" was lent by the Governors and Guardians of the National Gallery of Ireland to the Exhibition of Works by Irish Artists held in the Guildhall, London, in 1904. It was reproduced in half-tone in the catalogue of that exhibition.

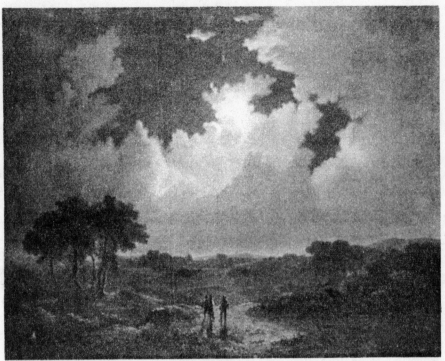

THE POACHERS
By James Arthur O'Connor

James Arthur O'Connor

Plate VIII

A RIVER IN A WOODY GLEN.
In the possession of the author.
Oils, on an oak panel prepared with a gesso-like priming.
9 inches high by 11 inches wide.
Signed in the lower right corner:-
"J. A. O'Connor. 183(?)".

A lowering grey sky hangs over distant trees and a leaden-coloured hill. The water is brown, running rapidly, with touches of pure white in the cascade. The rest of the picture is in varying tints of brown. The bluff behind the centre figures is a little cracked, owing to the use of some bitumenous pigment to which the artist was addicted. The figures are very well and crisply drawn. The sitting man wears a blue-grey coat, with buff breeches. The woman leading the child wears the usual red cloak.

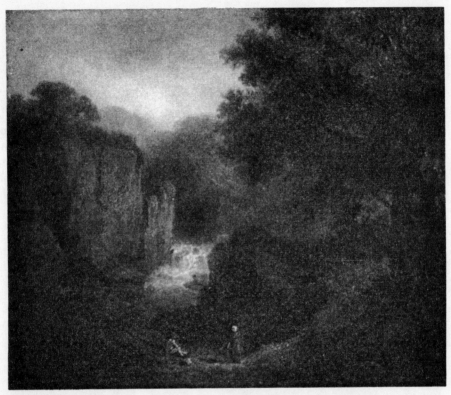

Photographed by Thomas F. Geoghegan

A RIVER IN A WOODY GLEN
By James Arthur O'Connor

James Arthur O'Connor

Plates IX and X

LANDSCAPE AND FIGURE.
In the Collection of the Right Honourable Laurence A. Waldron, P.C.
Oils on millboard.
8 inches high by 12 inches wide.
Signed: "J. A. O'C. 1839" in the lower right corner.

This is an unusually bright picture for O'Connor. The sky is warm and clouded, with blue and mauve tints. The oak on the left, and the woods in the middle distance are full of finely arranged greens. The road in the foreground, and the rock, are in warm golden yellows and browns. The little figure wears a blue bonnet, blue-green dress, and the usual scarlet cloak.

It is a charming and typical example of O'Connor's art, in exceptionally perfect preservation.

A SKETCH.
In the author's possession.
Oils on an oak panel.
4½ inches high by 6½ inches long.
Unsigned.

This was probably a sketch composition for a larger picture. The sky is greenish blue, with a warm cream-coloured cloud. The distance, middle distance and foreground are in varying shades of yellow-green. The two figures in the foreground are in grey-green. The figure seen on the left, near the approach to the bridge, wears a red garment.

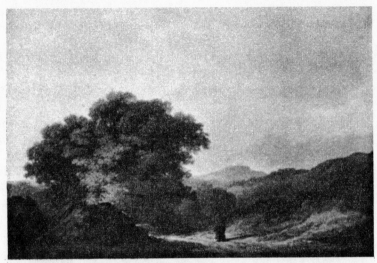

LANDSCAPE AND FIGURE
By James Arthur O'Connor

A SKETCH
By James Arthur O'Connor

WALTER FREDERICK OSBORNE, R.H.A.
Oil painting on canvas by himself. In the National Gallery of Ireland.
Size of original; 17 inches high by 13½ inches wide.
Reproduced by kind permission of the Governors and Guardians
of the National Gallery of Ireland.

WALTER FREDRICK OSBORNE,
R.H.A.

I FEAR that those of my readers who are fortunate enough
to possess portraits by Walter Osborne will take excep-
tion to my ranking him among landscape painters.
They will desire to remind me that most of the important
works of the latter part of his career were portraits.
Doubtless, he was a thoroughly accomplished portrait
painter, and as such was chiefly patronised. But land-
scape painting won his earliest and his lasting affection;
and in his landscapes there is much more than accomp-
lishment. Had he obtained the encouragement and
reward to which his talents in that branch of art entitled
him, I fancy he would not now be known at all as a por-
trait painter. He is not yet known, either as landscape
painter or as portrait painter, to the extent his work
deserves.

In the latest edition of *Bryant's Dictionary of
Painters and Gravers*, published in 1904, the year after
his death, he is described as " Walter P. Osborne, an
Englishman who settled in Ireland." His full name was
Walter Fredrick Osborne, and he was born at Castlewood

Avenue, Rathmines, Co. Dublin, on the 17th of June, 1859. His father, himself of Dublin birth, was a popular artist and a Royal Hibernian Academician, who is now chiefly remembered as a painter of dogs and horses; but who could also paint an excellent equestrian portrait. The father's pictures are sometimes confused with the early work of his more distinguished son who, as a student, felt his influence greatly. The similarity of their signatures makes the confusion worse confounded.

Walter Osborne once told a friend that as a boy he felt no desire to adopt his father's profession. However, he must have made up his mind to do so long before he reached manhood, for when he was seventeen he entered the school of the Royal Hibernian Academy. A few months afterwards he showed at the Academy exhibition a little picture of the family fox terrier, " Zoë," and modestly priced it at five guineas. He called himself in the catalogue " Fred Osborne," probably to avoid confusion between his name and his father's. It was not till 1885 that he appears as Walter F. Osborne.

In the second year of his studentship he was represented at the Academy by two landscapes and a study of a collie dog. He won a silver medal at the Academy school in the same year; and in 1880 was awarded the Albert Prize for a large landscape in oils which he

entitled "A Glade in the Phœnix Park." It represents
a pool, closely fringed with willows and ash trees, in
which a wading boy fishes with rod, line, and float. On
the bank, a little mongrel terrier guards his coat and
bottle of bait. The distance is closed with a rustic bridge
shining in a shaft of sunlight. This painting was after-
wards in my own possession for a while, and I remember
Sir Hugh Lane remarking—with reference to its close
detail—that it afforded yet another proof of the fact that
good landscape painters generally commence their career
as pre-Raphaelites. The work is certainly an astonish-
ing one for a youth of twenty who had received little
instruction. It measures about thirty inches by forty
inches. Every leaf in the glade seems to have been
separately studied; and yet the whole effect is quite broad
and harmonious. It shows, too, a preoccupation with
difficult problems of lighting which was far in advance
of his time.

Miss Jane French is the fortunate owner of an early
sketch book of the artist's, which contains several careful
pencil studies for this picture. The boy and the dog are
drawn in a variety of poses. In one design a fishing net
is sketched as an alternative to the rod. In another
a second boy is introduced as a spectator. All through
his subsequent career Osborne showed a similar assiduity

in the preparation of plans for his more important pictures.

He followed up his success with the " Glade in the Phœnix Park" by winning the Taylor Scholarship of the Royal Dublin Society in 1881, and again in 1882.

Later in 1882 he went to Amsterdam to study under Charles Verlat, with whom he remained for two years. Verlat was a painter with a great love for sunlight and a great power of painting it, both of which he probably acquired during a long sojourn in the Holy Land. He strengthened and developed Osborne's own natural love of sunlight, and many of his pupil's subsequent landscapes are remarkable for the ease and truthfulness with which they convey warm, sunny effects.

Osborne was elected, during his absence abroad, early in 1883, an Associate of the Royal Hibernian Academy, and sent home to the Academy exhibition next following his election, eleven paintings of Belgian scenery, some of them being little more than sketches. The year after he was represented by no fewer than fifteen landscapes, which included Breton as well as Belgian views. In 1885 he sent landscapes from Surrey and Warwickshire. In 1886 he was elected a full member of the Hibernian Academy, presumably on the merits of his landscapes alone.

About this time he established a custom of spending his summers, as a boarder, in secluded English farmhouses, particularly in those of Surrey, Sussex, Oxfordshire, Berkshire, Warwickshire, and Norfolk. The fruits of these holidays mingled with pictures of scenes in the Dublin streets were shown every spring in the Hibernian Academy exhibitions and brought him considerable reputation but indifferent material success.

His landscapes almost invariably contained figures which were beautifully drawn and placed. Sometimes he even made the landscape subservient to the figures, as in one or two of his admirable pictures of the benches in Stephen's Green. More rarely still, and generally in his earliest period, he painted interiors in which figures were of prime importance. A noticeable example of this phase is in the possession of the Royal Irish Yacht Club. He also did several small portraits where the setting was at least as carefully treated as the sitter. One of the best of these is that of Captain Stephen Gwynn, representing— in the Captain's own words—"a very young man smoking a pipe while he reads, seen up against a studio table littered with brushes and palettes and a wall nailed over with sketches." Another is of Mr. J. B. S. MacIlwaine, R.H.A., sitting in summer sunshine in a garden.

Osborne does not seem to have thought seriously

about portraiture, in the usual sense of the word, until the "eighteen-nineties" were well begun. The first important portrait in oils which he exhibited was one of the late Dr. Anthony Corley. It was shown at the Royal Hibernian Academy exhibition in the year 1889. In 1890 he showed no portrait. In the next year a competent but rather dull portrait of Edward Dowden—now in the National Gallery of Ireland—created the vogue which kept him busily occupied until his premature death, wasting his talent in immortalising the people of reputation, rank, or fashion in Dublin. He painted over a hundred of them in little more than ten years. I am not suggesting that many of these portraits are not most cleverly done. Occasionally he rises in them to a high degree of excellence, for example, in his portraits of Mrs. Noël Guinness and her Daughter, of Miss Honor O'Brien, of Sir Walter Armstrong, and of Canon Travers Smith. But his heart was not thoroughly in them. He openly confessed that he went to them with feelings of real distaste.

For a while his landscape painting continued to flourish beside his essays in portraiture. In 1895 he went on a tour in Spain with Sir Walter Armstrong, then Director of the Irish National Gallery; and, in the year following, on a tour to Holland with the same companion. Landscapes painted in both these countries were duly

exhibited in the Hibernian Academy. They were almost the last of their kind. In 1898 four, of his total of five, exhibits were portraits. From thenceforth his landscape work was relegated to the second place in his endeavours. He still painted landscapes in his holidays, and still, occasionally, sent one or two to the exhibitions. But he felt, as a greater master of both landscape and portraiture, Thomas Gainsborough, must have felt when he showed his landscapes to the Lord Lansdowne of his time saying: "People won't buy 'em, you know. I'm a landscape painter, and yet they come to me for portraits." Osborne had more reason to regret the public's predilections than had Gainsborough, for, unlike Gainsborough, he was far greater in his landscapes than in his portraits. He knew this himself and deplored the disloyalty to his art into which he was led by a most chivalrous loyalty to his family. Yet when seven years had passed without his being able to sell a single important landscape, he wrenched himself from what he truly loved and turned unflinchingly to what he thought was duty.

Like many good painters, Osborne possessed a shrewd business sense, and took every legitimate opportunity of increasing his reputation, showing his wares wherever and whenever he could. As a result, notwithstanding the moderate prices he asked for them, and the still more

moderate prices he generally received, he left a fortune of close on £4,000.

In 1881 he commenced to exhibit in England, sending a picture to the Walker Art Gallery of Liverpool, which institution he continued to favour with fair regularity until his death. His work found plenty of admirers and an occasional purchaser in Lancashire, though the Liverpool Corporation never thought fit to add an example of it to their permanent collection. In 1884 he first sent pictures to London, to the Institute of Painters in Oil Colours which is now known as the Society of Oil Painters. In 1886, the year of his election to the full membership of the Royal Hibernian Academy, he began his series of contributions to the Royal Academy exhibitions which continued, annually, as long as he lived. The Royal Birmingham Society of Artists attracted his notice in 1888, and he exhibited with them on eight occasions during the next decade. He sent pictures at longer intervals to the New English Art Club, and to Newcastle-on-Tyne. The Grosvenor Gallery, The New Gallery and Bradford all displayed examples of his art at least once. During the ten years' life of the Dublin Arts Club, Osborne contributed no fewer than eighty-two pictures to its annual shows. He acted as honorary secretary of the fine art section of the club for the year 1892—93.

The trustees of the Chantry Bequest conferred distinction on him in 1892 by purchasing, for twenty-five guineas, a pastel shown in the Royal Academy exhibition of that year. It is entitled "Life in the Streets—Hard Times," depicting a winter scene in a busy back street near Saint Patrick's Cathedral, and is one of the best, and at the same time most popular, of the more modern drawings in the Tate Gallery. I think that Mildred Butler and Edwin Hayes are the only two other Irish names which appear on the list of Chantry purchases since the fund was inaugurated in 1877. No oil painting by an Irish artist has ever been purchased therefrom.

At the Paris International Exhibition of 1900 his portrait of " Mrs. Noel Guinness and her Daughter" was adjudged worthy of a bronze medal, and its frame was labelled by the authorities to that effect. But at the close of the exhibition Osborne was invited to forward the cost of the medal he had won; and, as he very properly refused to do so, he never received his prize. Another honour, one rarely conferred on an Irish artist, was offered to him in the same year when Lord Cadogan, the Viceroy, wished to make him a knight in recognition of his merits as a painter. He modestly declined the dignity.

On the 24th April, 1903, Osborne died suddenly of

double pneumonia, in the house where he was born and where all his life was spent. He was only forty-three years of age when he died, and was unmarried. His father had predeceased him two years before, but his mother lived for seven years longer. As he had always shown a generous temperament, a sense of fun and a spirit of sportsmanship, he left a wide circle of personal friends to whom his charming personality had endeared him. These were by no means all artists or art-lovers, for he had no inveterate taste for such company.

Many of his friends knew him principally as a cricketer. Indeed, Sir Walter Armstrong, in his article on Osborne in the *Dictionary of National Biography*, records a general belief that had he not won a reputation at the easel he might have done so on the crease. Captain Stephen Gwynn says: " He was by nature the most destructive kind of left-hand bowler."

His death was a serious injury to art in Ireland. He was the one Irish artist who, with a great and growing reputation in England, elected to live and work in his own country; and his influence there grew steadily from year to year. Had he lived out the normal span of life he could scarcely have failed to raise the general level of Irish taste, and might even, at last, have excited in Irish people an impulse to patronise living painters.

Shortly after his death a memorial exhibition of his work was organised at the Royal Hibernian Academy. The exhibits covered his whole career, and numbered two hundred and sixty-nine.

Osborne worked in most media. He painted with equal facility in both oils and water-colour : he also did many fine drawings in pastel and, at least, two etchings. There is no Irish painter who comes near rivalling his versatility, either in range of subject or in variety of technique. His work shows the most scholarly appreciation of the possibilities and limitations of each method. His landscapes in oil are, at times, perhaps too fluidly painted; and in some cases they show a tendency to crack. They never show a trace of underpainting nor of ill-considered arrangement. His manner of laying paint became broader and more free with each succeeding year —not less careful but more skilful. The way in which he signed his pictures reflects this gradual change. The works of his early and middle period are usually signed with his full name and the date, in slender printed capitals, at the bottom of the picture. Towards the end of his life the signature is always in cursive script, often of a dashing and undecipherable kind, and is placed in whatever corner it would best suit the general composition. Excellent work was often left unsigned, or merely

initialled. His water-colours were often signed in ink with a pen.

Osborne's larger pictures were all on canvas. The small ones and sketches are often found painted directly on unprimed white wood panels.

Water-colours did not appeal to him as much as oils. He has not left many water-colour drawings, and, apparently, produced very few until comparatively late in life. All I have seen are bold and direct in handling. He was not of the school that eschews the use of body colour as something entirely noxious. There are passages of opaque pigment in many of his water-colour drawings; yet he could manage the dangerous matter without the slightest loss of that transparent luminous effect which gives distinguishing charm and character to the best water-colour work. In one of them at least, " The Dolls' School," of the Irish National Gallery, he has reinforced the paint with a few deft touches of pastel.

His pastels were more popular in England than in Ireland : and some of his warmest admirers consider him at his happiest in this medium, though I cannot agree with them in that opinion. He seems to have sometimes neglected to mount and frame them properly. In damp climates like our own pastels have an extraordinarily precarious existence, and I have seen several excellent ones

by Osborne spotted by mildew, which, when it once attacks such things, almost inevitably causes irretrievable ruin.

In most cases, however, his work of every kind stands perfectly, and will improve with time, for he laboured with full knowledge of the means to his end and laid his colours surely and cleanly.

He is very well represented in the two Dublin Galleries. Thanks to the generosity of Sir Hugh Lane, the Municipal Gallery has three of his works, one of which, now called "The Fishmarket," but originally entitled "Life in the Streets : Musicians," ranks among his best achievements. The National Gallery of Ireland has seven oil paintings, sixteen pencil, chalk and water-colour sketches, and two finished water-colours. The latter two, entitled respectively "The Dolls' School" and "The House Builders," show his powers of tender observation, rich and sympathetic colour and thorough craftsmanship in their matured perfection. London possesses, in addition to the pastel in the Tate Gallery, an excellent large landscape in oils entitled "An October Morning," which is described as "Presented by a community of Artists, as a memorial of the esteem and regard in which the late Walter Osborne was held by them." Sad to say, there is not one Irish name upon the list of donors. The

Corporation of Preston showed commendable enterprise when they purchased, in 1901, his " Summer Sunshine," a fine painting of slum children in a public park.

Many most interesting scraps of information as to Osborne's tastes and temperament can be gleaned from the collection of his catalogues which his mother presented to the National Library of Ireland soon after his death. Several of them are elaborately annotated, and contain excellent sketches, a few of which are originals. He liked a " story picture," domesticities or military subjects for preference. Early catalogues show that Alma Tadema, R.A., H. Woods, R.A., Marcus Stone, R.A., and Miss Maude Goodman captured his youthful sympathies. But he also records that Mr. Mark Fisher, R.A., as far back as 1883, was painting things " rather like Constable's work," and that " Day Dreams" by Mr. George Clausen, R.A., was " by far the best picture in the Exhibition" of the Society of Oil Painters in the same year. He was an admirer of both these artists and of Mr. La Thangue, R.A., and Professor Fred Brown at the very start of their careers.

Those catalogues in the National Library which contain his sketches should, if possible, be duplicated there. They are not often consulted : but as the sketches, with one exception, are in pencil, they suffer a little with

every handling. One sketch, that of an old man, entitled
"A Lover of Art," on the fly leaf of the catalogue of the
1894 exhibition of the New English Arts Club, is well
worthy of being framed and glazed. The Catalogue of
the Dublin Loan Exhibition of 1899 is particularly rich
in illustrations by Osborne. It contains careful little
drawings of Millais' " The Gambler's Wife " and
" Stella," Leighton's " Bather," Millet's "L'Amour
Vainqueur," and Whistler's " Miss Alexander," all in
pencil; and of Orchardson's " Master Baby" in pen-and-
ink. His admiration of the " Miss Alexander" must, I
think, have been the limit of his concession to modernity.

The study of Osborne's work discovers nothing dis-
tinctively Irish in its author. He does not seem to have
any special sympathy or understanding for Irish char-
acter, or even for Irish landscape. I think his ancestry must
have been predominantly English. His faith, upbring-
ing, and environment certainly cut him off, to a consider-
able extent, from close contact with the majority of his
fellow-countrymen. He was what " John Eglinton"
calls an Anglo-Irishman, what a Sinn Feiner would prob-
ably describe contemptuously as " a West Briton." His
pictures of the Dublin streets show careful observance :
but it is the trained, detached observance of an intelligent
foreigner. For all his interest in humanity, he never

seems to see Dublin with native eyes. Obviously he was happier in Rye or Walberswick than in Galway. He did some pictures in Galway in 1893 : but one need only compare his western types'with those of Mr. Jack Yeats to realise Osborne's lack of anxiety to depict anything more than the mere appearance of his models. His peasants, even in the picturesque costume—tall' hat, frieze coat and knee breeches—which then survived, are not nearly as Irish nor as romantic as those painted by Mr. Yeats in their present-day suits of shoddy tweed and their hideous artisan's cloth caps.

At least three portraits of Osborne exist. They are all in the nature of sketches. The self-portrait in oils in the National Gallery of Ireland, which I reproduce by kind permission of the Governors and Guardians, is a brilliant, slick piece of painting, but, judging from a pencil sketch, also in the National Gallery, by Nathaniel Hill, his friend and fellow-pupil in Antwerp, Osborne was not particularly concerned in it to do full justice to his own countenance. The third portrait, a clever and very interesting one in oils, by William Stott of Old-ham, is in the possession of Miss Manning. None of these portraits seems to satisfy memories which his many friends and sitters cherish of a pleasant face and an attractive nature.

Erratum.—For "William Stott of Oldham" read "Edward Stott, A.R.A."

Walter Frederick Osborne, R.H.A.

Plate XI

THE FERRY.

In the Collection of the Right Honourable Jonathan Hogg, P.C.
Oils on canvas.
36 inches high by 48 inches wide.
Signed "Walter Osborne" in upright capitals,
about an inch and a half high, in the lower right corner.

This picture was painted in 1889 or '90, and is the most important large landscape of Osborne's earlier work. It is painted in a smooth manner and is a little over anxious in handling and too obvious in composition. He had not at this time quite attained the dexterity of technique and facility in composition which his latter works display.

The dominant tints in the picture are the cool grey-green of the water, the silvery greys of the sky and the low-toned browns of the massed fishing vessels. These are relieved by the pink striped shawl which the old woman in the foreground wears, the boy's blue muffler, and the little girl's neckwear delicately coloured with touches of pink, yellow and pale, bright blue.

The picture was shown in 1890 at the exhibition of the Royal Academy (No. 1113), and later in the same year at the Walker Art Gallery Liverpool, (No. 923), where it was priced one hundred guineas. In 1891 it appeared at the exhibition of the Royal Hibernian Academy (No. 32), priced eighty-four pounds; and in the autumn of that year it was shown at the exhibition of the Royal Birmingham Society of Artists with the same price affixed. In 1893 Osborne sent it to the Chicago Exhibition. He did not sell it during his lifetime: and it was shown by his executors at the Memorial Exhibition of his works held in the Royal Hibernian Academy in the winter of 1903, (No.20), where they also showed a sketch of the same subject, (No. 20), now in the possession of Mr. Herbert Hone. A reproduction from a pen-and-ink drawing by the artist appeared in Henry Blackburn's "Academy Notes" for 1890; and a reproduction by photographic half-tone process appeared in an illustrated souvenir of the Chicago Exhibition, entitled "The World's Columbian Exhibition, Art Gallery, 1893": published by G. Barrie, at Philadelphia.

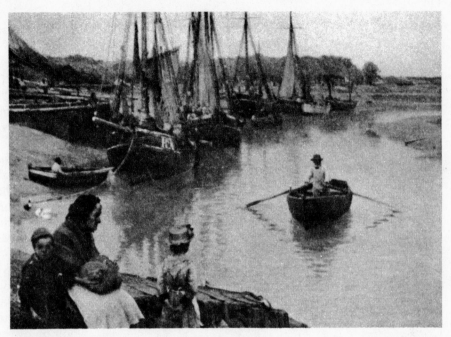

THE FERRY
By Walter Frederick Osborne, R.H.A.

Walter Frederick Osborne, R.H.A.
Plate XII

PUNCH AND JUDY ON THE SANDS — HASTINGS.
In the collection of the Right Honourable Lord Justice O'Connor, P.C.
Oils on canvas.
12½ inches high by 15½ inches wide.
Signed in upright capitals in the lower left corner:- "Walter Osborne".

This picture, though carefully studied, has all the freshness and spontaneity of a sketch; and I know of no other which expresses better Osborne's remarkable power of rendering transient effects of light. It is late in the afternoon. The sky is blue, with faint lavender-coloured clouds. The corner house of the street, running at right angles to the pier, is a warm pink with weather-worn blue-green shutters and canopy. The house in the extreme distance is pale green. The woman nearest the spectator wears a rich crimson dress, against which is outlined a black and white Dalmatian dog. The seat behind her is bright green.

This work was shown at the Royal Hibernian Academy exhibition of 1892 (No. 280). An interesting sketch, the first plan of the final picture, is in the National Gallery of Ireland, inscribed in pencil: "Hastings. 20.11.91. Clouds working up sky seen through warm clouds cold at base. Glow on houses." The sketch measures 9½ inches high by 7 inches wide.

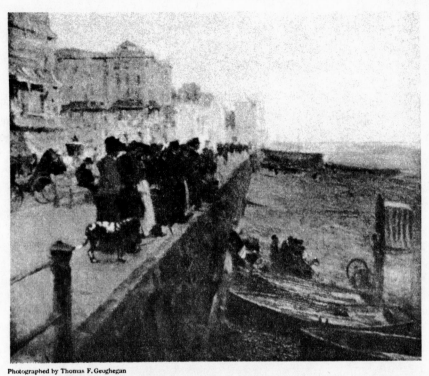

PUNCH AND JUDY ON THE SANDS -- HASTINGS
By Walter Frederick Osborne, R.H.A.

Walter Frederick Osborne, R.H.A.

Plates XIII and XIV

THE NEGLECTED GARDEN.

In the possession of the author.
10 inches high by 16 inches wide.
Signed in the lower left corner:- "W O" and inscribed on the back of the stretcher in Osborne's handwriting:- "The Neglected Garden. W. Osborne. (15 gns.)"

This little picture was evidently begun and finished in the open air. It represents the remnants of a garden swamped by a luxurious, and rather rank-growing, meadow. Behind the hedge, in the distance, is a line of blue hills. The sky is cool grey, painted largely with the palette knife, and its tint is repeated with emphasis in a line of roofs beyond the hedge towards the right. I know of no work of Osborne's painted with more certainty or gusto, and think it must have been begun and finished out of doors. It is remarkable among his landscapes in oils in showing no figure.

Mr. R. Lloyd Praeger, the distinguished Irish botanist, is inclined to think that it was painted towards the end of a hot June. The sow-thistle on the right, the oriental poppies, and the feathered grasses all point, by their state of development to that season. The big dock on the left is rust-red, as it would not normally be till the late autumn. But Mr. Praeger conjectures, in explanation, that the plant withered, by mischance, prematurely.

I cannot trace this picture as having been ever exhibited. It was possibly given to someone by Osborne as a present. I bought it by auction for a trivial sum in 1918. Its authenticity was not then known nor, apparently, suspected.

LANDSCAPE NEAR MALAHIDE.

In the possession of Mr. Joseph Egan.
Watercolour on paper.
11 inches high by 15 inches wide.
Signed in the lower right corner in cursive characters:- "Walter Osborne".

This picture is a view of Malahide Estuary, and is the best watercolour landscape by Osborne which I have seen. It shows to the full his mastery in this medium. In general tone and range of colour it is not unlike "The Neglected Garden".

Photographed by Thomas F. Geoghegan

THE NEGLECTED GARDEN
By Walter Frederick Osborne, R.H.A.

Photographed by Thomas F. Geoghegan

LANDSCAPE NEAR MALAHIDE
By Walter Frederick Osborne, R.H.A.

Walter Frederick Osborne, R.H.A.

Plate XV

THE THORNBUSH.
In the possession of M. Barrington Jellett, Esq., J.P.
Oils on canvas.
28 inches high by 36 inches wide.
Signed in the lower left corner, in cursive script:-
"Walter Osborne -94."

This picture is regarded by many as Osborne's masterpiece. I cannot think of any landscape by which he might be more fitly represented.

It was painted at Foxrock, near Dublin, towards the close of summer. The inextricable tangle of weeds and grasses in the foreground is wonderfully rendered both as to line and colour. Black-and-white goats, red-and-white cattle, the blue-shirted boy, the pink-frocked smaller child, the Thornbush itself, are all placed with great skill to emphasise the suggestion of a confused and spacious wilderness. The composition of the picture is as subtle as it is effective. The way in which the paint is laid is accomplished in the extreme; and yet conveys a first impression of delightful, almost careless, ease.

"The Thornbush" was shown at the exhibition of the Royal Academy in 1894 (No. 43), and at the exhibition of the Royal Hibernian Academy in 1895 (No. 47). It was there priced fifty guineas. It was lent by its late owner, Canon Harris, to the Dublin International Exhibition of 1907. A reproduction from a pen-and-ink drawing by the artist appeared in Henry Blackburn's "Academy Notes" for 1894. Another reproduction in half-tone appeared in "The Palace of Fine Arts Souvenir, The Irish International Exhibition 1907, a Folio of Famous Pictures."

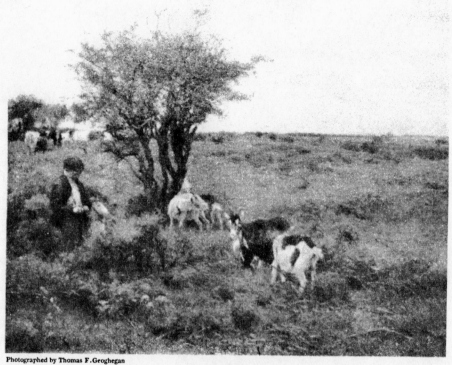

Photographed by Thomas F. Geoghegan

THE THORNBUSH
By Walter Frederick Osborne, R.H.A.

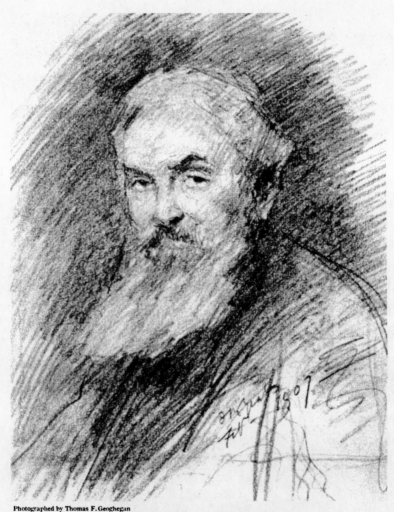

NATHANIEL HONE, R.H.A.
By John Butler Yeats, Esq. R.H.A.

This pencil drawing on paper, measuring 11 inches high by 9 inches wide, was done in 1907. It is in the possession of Miss Jane French, by whose kind permission it is reproduced.

NATHANIEL HONE, R.H.A.

THE Hone family was first heard of in Holland. Some of its members went thence, with the Vanderbilts, to America and helped to found New York. Others, about three hundred years ago, emigrated to Ireland. The Irish branch has produced many painters, including three notable ones; a Lord Mayor of Dublin, several Governors of the Bank of Ireland, and merchants and sportsmen in profusion.

The father of Nathaniel Hone, R.H.A., was a well-known Dublin merchant, and a direct descendant of one Berkeley Hone, a pin manufacturer who was established in business, about the middle of the eighteenth century, on the Dublin quays. This Berkeley was a brother of Nathaniel Hone, a foundation member of the Royal Academy. Nathaniel the first was a painter of great skill, and a character of brilliant and impetuous parts. Such pictures as the portrait of his son Camillus Hone, in the character of "The Piping Boy," now in the National Gallery of Ireland; the self-portrait, recently

bequeathed by Mrs. Hone to the same institution; and the superb " Mrs. Blake Foster," in Lord Revelstoke's collection quite justified the high reputation as a painter which he enjoyed in the opinion of the best judges of his generation. After a long and undeserved period of neglect, collectors have recently begun again to clamour for his works.

Nathaniel had another brother, Samuel, who was also an artist, though of far less ability. Horace Hone the miniaturist was Nathaniel's eldest son. His great grand-nephew and namesake, the subject of this memoir, was born at Fitzwilliam Place, Dublin, on October 26th, 1831.

Notwithstanding his family's traditional prowess in the art of painting Nathaniel Hone, the second, studied engineering at Trinity College, Dublin, and commenced life as an engineer. He worked on the making of the Midland Great Western Railway of Ireland and afterwards laid a light line, I think, in Cavan. When these railways were finished he thought for a while of going to South America, or some such foreign part, where important works of constructive engineering were then in progress. But his profession, by constantly bringing him into the open country, and an early passion for yachting, by familiarising him with the sea, must both have done much to develop his latent love of art. In 1853, when he

was twenty-two years of age, he abandoned, finally, all projects of going to America and went instead to Paris to study painting.

His first master was Adolphe Yvon, an artist celebrated in his time, who painted large ceremonial pictures and big battle-pieces in a mood of heroic sentiment. One of Yvon's best-known pictures is " The Retreat from Moscow," now in the Nottingham Gallery; another is that of Napoleon III. handing an Imperial Decree to Baron Haussmann, which can be seen in the Hotel de Ville of Paris. Hone selected him as a master on the casual advice of a close friend of his, William Armitage, a brother of Edwin Armitage, R.A. Afterwards, he studied for a while under Thomas Coture, another historical painter, famous for his huge canvas " The Romans of the Decadence," which hangs in the Louvre.

Hone was not a pupil of either of these men in the modern sense of the word. His mature work does not show the slightest trace of their influence nor the slightest sympathy with any of their productions. Neither of them arranged any course of study for him, nor undertook a definite obligation to teach him. The old atelier system which prevailed in his time was worked by some one student, who had a business sense, getting a number of others together, hiring a studio and models on their

behalf, and inviting a well-known painter to visit them
and criticise their work, once or twice a week. The
master got nothing for it except honour and glory, and
a vague claim on their votes when the election for the
jury of the Salon fell due.

Mention of the names of Yvon and Coture prompted
me once to ask Hone if he had started his term of study
with the fixed intention of becoming a landscape painter;
and he told me that he had worked rigorously for three
or four years, drawing and painting from the model and
copying in the Louvre, before he even thought of painting
landscapes. He was always insistent on the necessity, for
a student, of constantly copying from the Old Masters.
He held that every painter must learn his craft by copy-
ing some of the masterpieces of the great Venetians. In
his house were to be seen a number of most careful, yet
spirited, copies done by him in his student days. When
he died they were sold by auction with his furniture, and
not generally recognised as from his hand. Among them
were copies of pictures so diverse in style as Murillo's
"Beggar Boy"; Gericault's "Equestrian Portrait of M.
Dieudonné, an Officer of Chasseurs of the Imperial
Guard"; Raphael's "Portrait of a Young Man"; two
children and a dog from Veronese's "Supper at
Emmaus," and a beautifully painted head of a saint, with

a scrap of sunlit, sapphire mountain in the background, from Giorgione's " Holy Family." The originals of all these copies are in the Louvre.

Two of the best of Hone's early copies were retained by Mrs. Hone's executor, acting under the terms of her bequest to the National Gallery of Ireland. Neither, as it happens, are from Venetian paintings; and both are landscapes. One is of Ziem's " Venice," now in the Louvre, and was done when Ziem was a comparatively young and unknown man. The other is of Claude's famous " Vue du pont, effet du Soleil levant." Both were painted when Hone had nothing more to learn from his masters. They show the most careful and competent craftsmanship, and are as fresh and rich in colour to-day as they could have been on the day they were finished. The elaborate architectural drawing of Claude is reproduced with an ease and accuracy which would surprise some of those critics who are pleased to assert that Hone, if a great colourist, was no draughtsman. These two copies must have proved important factors in directing his attention to the pictorial possibilities of landscape.

When his period of study in Paris was over, he moved out to the village of Barbizon, the chosen home of the great contemporary school of French landscape painters, and settled there close to Jean François Millet and

Charles Jacque. Thenceforth he devoted himself, almost exclusively, to landscape painting.

This is not the place in which to recall at length his reminiscences of the Barbizon masters. He knew them all well, and his memory of their ways and works remained clear till he died. Millet, he has told me, was glad to sell a picture for forty francs in the early days of their acquaintanceship. The models used to hawk them about to likely purchasers. Corot was more prosperous. He and Hone often dined with each other. Henri Harpignies was his chief friend among the French; and used always to come to the railway station to welcome him back to France, on his return from visits home to Ireland. Rousseau he knew later, when he went to Fontainebleau; but never well, for Rousseau was a morose and solitary man.

Hone stayed in France for seventeen years, living, for the most part, at Barbizon or Fontainebleau. While there he came in touch with the leaders of the Impressionist movement as well as with those of the Barbizon School. He knew Manet in particular, and told me with amusement that Manet was a regular dandy in appearance and looked much more the man of fashion than the artist.

Every painter is affected, whether consciously or unconsciously, willingly or unwillingly, by the achievement of his precursors. Art is a matter of evolution. Yet it is very difficult to say from which of Hone's artistic forerunners he derived most aid. Felix Ziem, who was only ten years his senior, undoubtedly exercised some slight influence upon his work. So did the Barbizon painters, though, perhaps, to a lesser degree. Manet and the Impressionists did not affect it in any way. After his long residence in France he spent a year and a half in Italy; but neither did any Italian painter perceptibly sway him. Constable's work played a relatively important part in moulding his style. He copied both " The Haywain" and " The Valley Farm" superbly. The latter shows the boldest handling which I have ever seen in a copy. It is painted to a great extent with the palette knife, in the technique so loved by Constable himself. But even Constable had little permanent effect on Hone.

It was not from want of appreciation of the merits of other people's painting that Hone showed such fidelity to the methods he had adopted at the beginning of his career. He had always the greatest interest in, and sympathy with, good painting, no matter in what manner : but he had the sense and character to adhere unswervingly to the way he had found best for the

expression of his own personality. The many extant
pictures of his early continental period, those scenes from
Barbizon, Fontainebleau, and the Mediterranean coast
show his work to have been sure and tender, strong and
capable, comprehensive and observed, to degrees that
young men can seldom attain. His landscapes were never
mere excuses for architectural or anecdotal interests.
They are filled with sincere emotion without the aid of
any sidelong glances at humanity. Mr. C. J. Holmes
declares in his admirable book, *Notes on the Science of
Picture-making*, that all great pictures possess in some
degree these four qualities : unity, vitality, infinity, and
repose. There are very few of Hone's pictures that do
not possess, in serene amplitude, all four. It is as
a colourist he is pre-eminent, for his art was lyrical or
emotional rather than didactic or intellectual. He could
draw well, as he proved in many pictures, but he was not
primarily concerned with contour nor with detail. The
green of the tree delighted him more than its grace; the
blue of the sea more than the tracery of its waves; the
yellow of the strand more than its curves and folds.

To his deep feeling for the colour of a landscape and
his marvellous power to reproduce it, he joined a talent
for bold design, a breadth of vision and a vigour of
execution that combined to lift him to a foremost place

among the landscape painters of his age, no matter what their country.

While in France, Hone sent nothing to Irish exhibitions. He exhibited in the Salons of 1867, '68, and '69, sending in all six pictures. He showed one picture, and one only, in the Royal Academy. This was sent in 1869 from No. 44, Rue Notre Dame de Lorette and was entitled simply a " Study from Nature." It was " skied." Mrs. French, who remembers seeing it on exhibition, tells me that it represented a sunny courtyard enlivened with a flight of pigeons. One of the pictures forming part of Mrs. Hone's bequest to the Irish National Gallery answers to this description.

When he returned home from his long absence abroad he settled down at Malahide, Co. Dublin, where he resided until the end of his life. He contributed to the exhibitions of the Royal Hibernian Academy; to those of the Dublin Art Club, during its brief existence between 1886 and 1895; and, occasionally, to various loan exhibitions at home and abroad; sending paintings first from Seafield, in 1876, then from Moldowney in 1894, and after 1895 from Saint Doulough's Park, which he inherited from his uncle. He lived there quietly, occupying himself with painting and farming. Many of his finest pictures are from scenes in the neighbourhood. Of these the best and

best-known are "The Pasture at Malahide" in the
National Gallery of Ireland, and the "Evening, Malahide
Sands" in the Dublin Municipal Gallery, both of which
were presentations by himself. "The Pasture at
Malahide" was admitted into the National Collection in
1907 during the lifetime of its artist, and it is the only
picture that was ever so distinguished.

He married in 1872 Magdalene, daughter of John
Jameson. They had no children, but enjoyed a happy
married life of great mutual devotion for forty-five years.
Though Mrs. Hone was twelve years' younger than her
husband she died within eighteen months of his death.

Between the Royal Hibernian Academy exhibitions
of 1879 and 1880 Hone was elected to both the Associate-
ship and the full membership of the Academy. In 1894
he was elected its Professor of Painting, on the death of
Sir Thomas A. Jones, the President, his predecessor in
the office.. He held the professorship until his own death
in 1917.

Irish scenes were but a part and that, perhaps, not
the greater part of Hone's work. He travelled much in
his prime and painted beautiful things in England, from
Norfolk to Devon; in France, from the Norman Coast to
the Riviera; and in Italy, Turkey, Holland, Greece, and
Egypt. On all the walls, and in most of the corners, of his

house at Saint Doulough's Park were splendid pieces brought home from these various journeyings. Pictures of the Portico of the Priestesses on the Acropolis, of the woods at Bougival, of the Sphinx, of the shore at Scheveningen, and of the Porte d'Aval at Étretat proved his capacity to translate the most diverse climes and subjects into masterpieces of painting. He had a special fancy for Egypt as a painting ground; and when I last saw him he spoke to me of his intention (which unfortunately he did not live to fulfil) of working up some of his Egyptian sketches during the coming winter. An excellent example of his Egyptian work is the view on the Nile in blazing sunlight which was part of Sir Hugh Lane's bequest to the Municipal Gallery of Dublin.

Because he was a rich man and chose to live his life in his own simple fashion, painting for pure love of his art and courting neither fame nor money, an idea obtained for a long time in his own country, where gross ignorance of all that concerns art is so prevalent, that he was only a gifted amateur. His finished pictures seldom found purchasers even at the modest prices he was accustomed to ask for them. I think £60 was his maximum price, one very seldom sought; and his minimum was £15, at which figure pictures of Villefranche, Bundoran, and Portmarnock were offered by him as late as 1909. His

sketches in oils were often to be had for as little as £5, at the Dublin Art Club exhibitions. Towards the end of his career, when he had ceased to paint much, there were signs of better sense among the public. He still continued to send annually three or four pictures, the work of earlier times, to the Hibernian Academy; but they were not offered for sale. The moment they became difficult to obtain they were eagerly desired.

His output was copious, yet the number of his paintings publicly exhibited in his lifetime did not, I think, nearly total two hundred. Of these probably not more than one hundred have passed into private possession. It was generally rumoured, soon after his death, that Mrs. Hone intended to bequeath her collection of his work to the Irish National Gallery. But even those who knew him best were scarcely prepared for the quality and extent of her bequests. The collection comprised no fewer than five hundred and fifty works in oils; eight hundred and eighty-seven water-colours, nearly one hundred of which have separate scenes painted on the reverse; and seventeen sheets of miscellaneous studies. The bequests are couched in the following, not too clear, terms : " I bequeath to the Governors and Guardians of the National Gallery of Ireland Paintings and Pictures at Saint Doulough's the works of my late husband

Nathaniel Hone, such Paintings and such Pictures to be selected by the said William George Jameson" (her brother and executor). " Dermod O'Brien, R.H.A., and James Wilcox, Esq., to act as advisors to him. If any question arises on this bequest, the decision shall be left to the said William George Jameson." . . . " I bequeath to the National Gallery, London, two good pictures by my late husband to be selected by the said William George Jameson." Mrs. Hone also left the sum of £1500 to be used towards providing such additional accommodation in the Irish National Gallery as this accretion to its contents would make necessary.

At the time of writing the final selection from these pictures has not been made. It is not yet settled, whether the trustee shall retain the complete collection for the nation, as apparently he has power to do, or whether some portion of it shall be sold with a view to enhancing Hone's fame outside his native country, and to providing additional accommodation, so badly needed, for the gallery. Pending a decision on these difficult points, the whole collection has been removed for safe keeping to the National Gallery, but no portion of it has yet been shown to the public. It covers all phases of Hone's activity. Through the courtesy of Mr. Dermod O'Brien I am en-

abled to print in an appendix the complete catalogue
which he has so carefully compiled.

The section of this catalogue which will surprise
everybody is that devoted to water-colours. I have never
seen a water-colour drawing by Hone exhibited. Indeed,
though I had several times visited his house and been
shown his pictures by himself, I had never been shown,
nor seen, any of his water-colours. Mine was the common
experience of those who knew him much more intimately
than I did. We had all heard that he painted in water-
colour : but when he was questioned about this branch of
his art he used to put us off by growling good-humouredly,
"Ah! only studies! Little watery blots!"

The water-colours are nothing more than studies
in intention, but they have in quintessential degrees
many of the qualities of great art. They are mostly
small, measuring on an average four and seven-eighth
inches by six and three-quarter inches; and are done,
obviously, with slashing rapidity and from a palette of
not more than three or four tints. Nevertheless, in
accuracy of drawing and brilliancy of colour they are
completely satisfying. They convey the stark power of
the man who did them as vividly as do any of his most
carefully considered masterpieces. The germ of all his

great pictures is to be found among these sketches. They
were the vital sparks that set on fire the memory and
imagination which he brought to making of his large oil
paintings.

The oil paintings bequeathed constitute a wonderful
achievement. In number alone they form an impressive
life work. In merit, almost any one of them entitles their
author to take rank as a notable artist.

They cannot easily be classified into periods. Hone
was a master of his medium from the start of his career;
though his mastery grew with time and can be traced in
steady progression from the firm, if slightly too de-
liberate, handling of his Barbizon days, to the culminat-
ing grace and strength shown in the closing years of the
last century and the opening ones of this.

His best work is painted in rich, liquid pigment, laid
on thinly and boldly, with that caressing ease which only
comes through ceaseless effort. With the matured tech-
nique may be noticed a tendency to simplification in sub-
ject and composition, and that love and understanding
of loneliness which age often brings to great men.

His water-colours are never signed. His oil paint-
ings often bear the simple initials NH . A few are
signed in full. I have seen pictures by him on which the

signature was scratched; and one which was signed with a pen and ink. The superb work which he presented to the Royal Irish Yacht Club is signed "N Hone, R H A"; and the "Evening, Malahide Sands," which he presented to the Dublin Municipal Gallery is signed "Nathl Hone R.H.A." But he followed no principle in the matter. Many of his best things, and in particular the unsurpassed "Pasture at Malahide," which he presented to the National Gallery of Ireland, are not even initialled.

All the oil paintings in Mrs. Hone's bequest are landscapes, as are most of the water-colours. On the reverse of very many of the latter are careful pencil sketches of cows in every posture. Among the sheets of studies are several excellent drawings of figures. One, of peasants in a French farm-cart, deserves particular attention.

It is curious to observe how little interest Hone showed in figure painting, which his rigorous apprenticeship had made him so competent to practice. He seldom, and only in his early period, introduced human figures into his landscapes, though when he did so the figures left nothing to be desired. I only know of one oil painting by him which might fairly be called a figure-piece. Sir George Brooke owns this, a small picture of a peasant girl, "Rosalie," which is wholly delightful.

His painting of Saint Patrick and his companions, a lunette twenty feet long and eight feet high, done for the decoration of a ward in Sir Patrick Dun's Hospital, Dublin, where it may be seen at present, is unique in another fashion. It was painted for the Kyrle Society and first shown in the Dublin Art Club exhibition of 1889, entitled " Saint Patrick." The title it bears to-day is " Saint Patrick with Seven Missionaries take the form of Deer to pass through a Hostile Country." The central figure is a magnificent stag of fourteen points, leading a little herd of smaller stags and does through an autumn-coloured glen. Two huge snakes occupy the corners of the composition. The design is a most striking one, and the painting is vigorous in the extreme. It is on canvas. But it is now a ruin, blackened almost beyond hope of restoration, as are the works of other artists, which form part of the same decorative scheme. Possibly the ward in which they are placed was disinfected at some time with a chemical injurious to paint.

The Hone bequests will, no doubt, cause much stir when they come to be set on view in London and Dublin. They will also make those who knew and revered Hone as an artist in his lifetime, regretful that he did not live to enjoy the honours which he deserved. No one could have been more genuinely modest than he was about his own

work. But he was too great an artist not to know its worth, and it would be nonsense to pretend that the public distaste for it did not affect him. The artist who declares he is indifferent to his audience denies the first cause and reason of his art. Hone was frankly pleased when any-one showed an honest admiration of his painting : and he was frankly disturbed at the prospect of any of it falling into unsympathetic ownership. He himself said as much to me when we were discussing the raffling of one of his seascapes for some charity. His feeling on the matter is further shown in the story told by a relation of his to whom he presented six pictures and who treated these pictures with proper respect, having them handsomely framed, and installing a special system of lighting to display them in the evening. Hone was so touched and pleased by this unusual appreciation that he sent a gift of six more pictures to his discriminating and fortunate kinsman.

Had he been given during his lifetime the honour which was his due, and which will soon be paid in part to his memory, he had almost certainly responded to the stimulus by surpassing even the best of his existing work.

There were a few who always knew him for what he was. The late Mr. John Jameson, Mr. George, Mr. Andrew, and Mr. William Jameson, Sir George Brooke,

Bart.; Lieutenant-General Sir H. M. Lawson, and Mr. John Quin of New York have each acquired many excellent examples of his art. His fellow-artists never failed to recognise his merit.

One of them, Miss Purser, H.R.H.A., organised in 1901 an exhibition of his works and those of Mr. John Butler Yeats, R.H.A., in the latter's studio at 6, Stephen's Green, Dublin. Twenty-eight of Hone's pictures were there shown. These, with six exceptions, were lent by the artist himself. Five of the six exceptions were the property of practising artists. Mr. George Moore contributed to the catalogue a rather overbearing prefatory note entitled "Modern Landscape Painters—apropos of Mr. Hone." He declared that Mr. Hone's painting was " not very special," that " the influence of France is not apparent in his work," but that it was "more interesting than Maris." He was sure that " we do not find in Mr. Hone that intensity of observation which is necessary in cultured art." Mr. Moore now, twenty years after, would probably wish to revise these rash opinions.

A critic of more discrimination, the late Sir Hugh Lane, constantly visited this exhibition, and was from thenceforth an ardent admirer of the artist's work and one whose admiration I know was particularly valued by the artist. No one did more to spread Hone's reputation.

In the exhibition of the works of Irish artists which Lane organised at the London Guildhall in 1904 Hone was represented by nine works. At the Franco-British Exhibition of 1908 Lane displayed fifteen. He failed, it is true, to convince the trustees of the National Gallery of British Art at Milbanke that they should have Hone worthily represented in such a collection. But the Ministry of Fine Arts in Paris showed no such fatuity, and one of his best works is to be seen in the Luxembourg. Lane, in 1908, presented his picture " The Derelict" to the Scottish Modern Art Association, who show it from time to time in the Scottish National Gallery, and in the art galleries of Glasgow, Dundee, Stirling, and Aberdeen. Another picture by him hangs in that Municipal Gallery of Modern Art which Johannesburg owes to Lane's taste and energy. The University of Wisconsin acquired, in 1914, through the generosity of Mr. Frank Cantwell, his " Ships on the Beach." The Dublin Municipal Gallery is very rich in Hone's work. It holds ten examples, of which five were presentations from Lane in his life or by his will. The unsuitable temporary premises in which they are housed prevents them from being properly seen.

No other public honour of any kind was paid to Hone during his long life. He died on October the 14th, 1917,

at the patriarchal age of eighty-seven, almost unknown beyond the circle of his acquaintances.

At least six portraits in oil of him exist. The earliest of these is a small painting, signed "Ed. Brandon, 1870," which was done in Paris and is a very attractive piece of work—Jacob-Edouart Brandon was a well-known pupil of Picot and of Corot. It is reputed to be an excellent likeness of Hone at the time. He is bearded, wears a dark coat, light trousers, and high-heeled French boots, and leans back in a red armchair smoking a pipe. On the wall behind him hangs a sombre canvas in a massive frame. At his left hand is a case stuffed with portfolios and papers. This portrait is in the possession of Hone's heir, Mr. Herbert Hone, who also owns a pen-and-ink sketch for it, dated 1868. The next portrait, in chronological order, is an important and pleasing three-quarter length done by Walter Osborne, R.H.A., in the "eighteen nineties." This, too, is in Mr. Herbert Hone's possession. Miss Elsie Hone owns another portrait by Osborne, a charming small picture depicting Hone, wearing a hat and seated in a bright garden. It was presented by the artist to Mrs. Hone. The next, a half-length, was done by Sir William Orpen, R.A., to the order of Sir Hugh Lane in 1907, and was presented by the latter to the

Dublin Municipal Gallery of Modern Art. It is an able sketch, but does not do justice to its subject. It was painted in the Dublin Metropolitan School of Art, at a single sitting. Two other portraits, a half-length and a bust, were painted by Mr. Wilcox in the year before Mr. Hone's death. One of these is in the possession of Mr. Herbert Hone; the other is at present lent by the artist to the Dublin Municipal Gallery. In my opinion neither is good as likeness or as picture, but it is only fair to add that my opinion on this point has been disputed. Miss Jane French possesses two pencil sketches by Mr. John Butler Yeats, R.H.A., which give an even better idea of the man than do any of the more elaborate works. She has kindly allowed me to reproduce the more characteristic of the pair.

Mr. Dermod O'Brien, soon after Hone's death, commissioned Mr. Oliver Shepperd, R.H.A., to do a posthumous portrait, in the form of a bronze medallion eighteen inches in diameter. This was cast in September, 1920. Technically, it is an excellent piece of modelling : but, like most posthumous portraits, it is not entirely successful as a likeness.

Of Hone's personality, I, who knew him so slightly, am not the one to speak. I may say, however, that whenever I met him his charming simple ways, his superb gifts

as an artist, his great age and venerable appearance produced in me a feeling of reverence which will not soon, nor easily, be forgotten. I think it is a privilege to be able to close this book with a tribute of profound admiration for the artist and the man—NATHANIEL HONE.

Nathaniel Hone, R.H.A.
Plate XVI

PASTURE AT MALAHIDE.
In the National Gallery of Ireland. (No. 588).
Presented by the artist in 1907.
Oils on canvas.
32½ inches high by 49 inches wide.
Unsigned.

The heavy rain cloud to the right is of a reddish hue, merging into cool purple grey. There is a little clean blue sky in the left upper corner. A burst of sunlight illuminates the ploughed upland. The long grove of trees in the background is dark, luscious green, composed mainly of a mixture of chrome yellow and ivory black. The patches of ragweed scattered through the pasture are painted with the same colour. The cows are red and white.

The work was done very rapidly and dexterously with fluid paint richly, but thinly, laid. The canvas shows through the paint here and there, particularly, and designedly, in the cow to the extreme left.

This picture was shown by the artist in the exhibition of works by Irish painters organized by Sir Hugh Lane at the Art Gallery of the Corporation of London in 1904, (No. 25), and in the Irish International Exhibition, Dublin 1907, (No. 80). Its measurements in the official catalogue of both these exhibitions vary slightly from those given above, and were evidently "sight" measurements.

It was reproduced in half-tone in "The Palace of Fine Arts Souvenir, The Irish International Exhibition 1907, a Folio of Famous Pictures." It is also reproduced in half-tone in the official catalogue of the National Gallery of Ireland.

"The Pasture at Malahide" is generally recognized to be the artist's masterpiece.

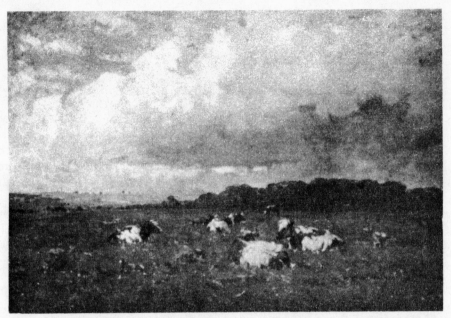

PASTURE AT MALAHIDE
By Nathaniel Hone, R.H.A.

Nathaniel Hone, R.H.A.
Plates XVII and XVIII

PETITE AFRIQUE. From Saint Jean, near Nice, Provence.

In the possession of the author.

Oils on canvas.

25 inches high by 39 inches wide.

Unsigned.

This picture was done in or about the year 1872, the year of the artist's marriage. I do not know any other work of his more sumptuous in colour. The sky is a hot summer sky veiled with opalescent mist. The sea is warm blue. The cliff in the background runs from shades of pink to biscuit, with high lights of white. Its hollows and crest are violet-grey. The strand fringing the bay is yellow-brown, barred with heavy brown shades. The undergrowth is yellowish green. The tree trunks are clear grey in their high lights. The foliage of the trees is a bluish green. The figure of a woman in the middle distance was probably sketched from Mrs. Hone, who appears in several of the artist's watercolours done about this time.

This picture was never exhibited. Mrs. Hone allowed me to choose it, after her husband's death, from a selection of almost all the works by him then in her possession.

THE COAST AT KILKEE.

Part of Mrs. Hone's bequest to the National Gallery of Ireland.

Not yet exhibited there.

No. 531 in Mr. Dermod O'Brien's catalogue of the Hone Bequest.

Oils on canvas.

24 inches high by 38 inches wide.

Unsigned.

The grey, clouded sky, has slight touches of pure blue. The sea is grey-green. The rocks in the middle distance are warm brown, with splashes of ochre weed. The rocks in the foreground are slate blue, with a patch of yellow-green weed under the flying bird.

I believe this picture was exhibited at the exhibition in aid of the Belgian Relief Fund held, in 1915, at the Royal Hibernian Academy. If so, it was then entitled "Near Kilkee". But Hone painted and exhibited so many pictures with similar titles, that it is impossible, in most cases, to be sure of their identification.

This picture was not in Saint Doulough's Park when he died, but in his house "Moldowney", at Malahide.

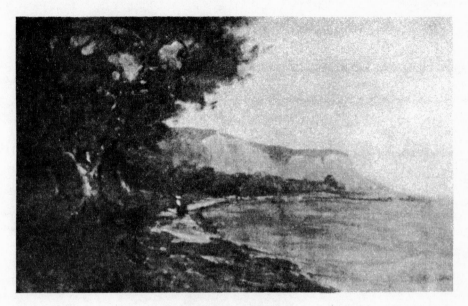

PETITE AFRIQUE
By Nathaniel Hone, R.H.A.

Photographed by Thomas F. Geoghegan

THE COAST AT KILKEE
By Nathaniel Hone, R. H. A.

Nathaniel Hone, R.H.A.

Plates XIX and XX

ERRIS, COUNTY MAYO.
In the collection of Sir George Brooke, Bart., D.L.
Oils on canvas.
24 inches high by 35 inches wide.
Signed in the lower right corner:- "N H"

A wet afternoon sky rises above a line of blue hills which are lost in the left distance. Warm pink light shines from the slopes facing the right. The bog in the middle distance is red-brown, with soft, very vivid, light yellow-green growth in the cutaway hollow. The foreground is blue-purple with bright touches of pure blue, and yellow rushes.

This picture was acquired by Sir George Brooke from the artist, and exhibited by him at the Irish Art Gallery, Ballymaclinton, in the Franco-British Exhibition of 1908, (No. 56): at the Whitechapel Art Gallery 1913, (No. 109): and in the Royal Hibernian Academy exhibition 1917, (No. 34).

THE BOUNDARY FENCE, FOREST OF FONTAINEBLEAU.
In the collection of Sir George Brooke, Bart., D.L.
Oils on canvas.
16 inches high by 25 inches wide.
Signed in the lower right corner:- "N H"

This picture is painted almost entirely in two colours, an astonishingly fine green and a dark purplish grey. The deer, the tree trunks, the branches and the boundary fence are all in the latter colour. The little portion of sky shown is overcast. Though so few colours are used Hone has divided them into an infinity of tints, obtaining an amazing effect of depth and recession.

This picture may be the one exhibited at the Salon of 1869 under the title "Lisière de bois". It was acquired from the artist by Sir George Brooke, and exhibited by him in the Irish International Exhibition of 1907, (No. 132), in the exhibition of the works of Irish painters organized by Sir Hugh Lane at the Corporation of London Art Gallery in 1908, (No. 39): and at the Whitechapel Art Gallery in 1913, (No. 115).

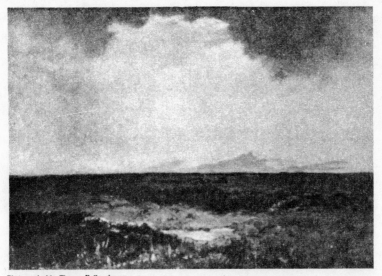

ERRIS, COUNTY MAYO
By Nathaniel Hone, R.H.A.

THE BOUNDARY FENCE, FOREST OF FONTAINEBLEAU
By Nathaniel Hone, R.H.A.

Nathaniel Hone, R.H.A.

Plates XXI and XXII

THE SPHINX AND PYRAMID.

Part of Mrs. Hone's bequest to the National Gallery of Ireland.
Not yet exhibited.
No. 557 in Mr. Dermod O'Brien's catalogue of the Hone Bequest.
Watercolour on cartridge paper, taken from one of the artist's sketch books.
4⅞ inches high by 6¾ inches wide.
Unsigned.

This is one of the artist's working sketches, the existence of some thousand of which was hardly suspected before his death. It is painted in the most rapid, cursory manner possible; probably not more than three colours—cobalt, light red and yellow ochre—being employed. Hone was accustomed to speak deprecatingly of such sketches as "little watery blots", yet they give ample evidence of his artistry. An important picture, now in the National Gallery of Ireland but not yet exhibited there, was painted from this sketch.

AN OASIS.

Part of Mrs. Hone's bequest to the National Gallery of Ireland.
Not yet exhibited.
No. 572 in Mr. Dermod O'Brien's catalogue of the Hone Bequest.
Watercolour on cartridge paper, taken from one of the artist's sketch books.
4⅞ inches high by 6¾ inches wide.
Unsigned.

The same description of colour and technique applies to this sketch as to the one reproduced above.

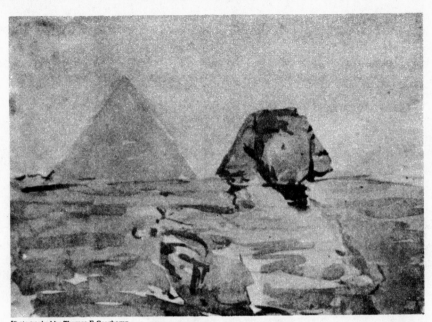

Photographed by Thomas F. Geoghegan

THE SPHINX AND PYRAMID
By Nathaniel Hone, R.H.A.

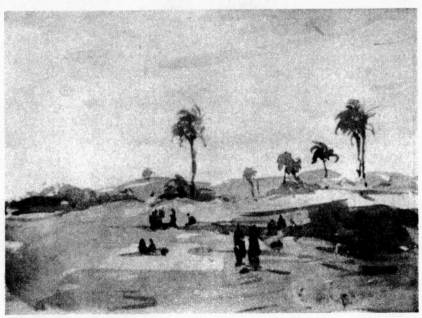

Photographed by Thomas F. Geoghegan

AN OASIS
By Nathaniel Hone, R.H.A.

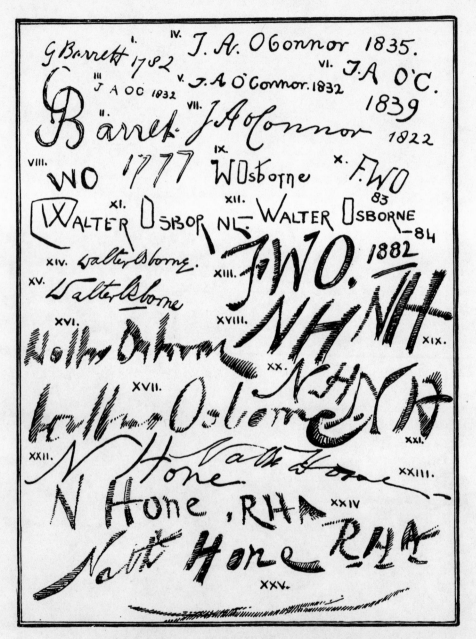

A SELECTION OF SIGNATURES BY BARRET, O'CONNOR, OSBORNE AND HONE
I. Pencil on paper, actual size. II, III, IV, V & VI. oils, actual size. VII. pen-and-ink, actual size. VIII. oils, actual size. IX. pencil on wood, actual size. X. oils, actual size. XI. pen-and-ink, actual size. XII. oils, actual size. This signature is found in all sizes up to 2 inches high. XIII. oils, actual size. XIV & XV. pen-and-ink, actual size. XVI, XVII & XVIII. oils, about one quarter actual size. XIX. oils, about one half actual size. XX. oils, actual size. XXI. oils, about one half actual size. XXII. pen-and-ink on painting in oils, actual size. XXIII. pen-and-ink written a month before the artists death, actual size. XXIV. oils, ½ actual size. XXV. oils, actual size.

APPENDICES.

NOTE:—In the following appendices, catalogues—whether of public galleries, of artists' exhibitions, or of loan exhibitions—are textually quoted, except where the contrary is stated or distinctly implied. I, however, am solely responsible for the various notes. Works, not otherwise described, are oil-paintings on canvas.

T. B.

APPENDIX I.

BIBLIOGRAPHY.

The following are the principal books consulted on the lives and works of Barret, O'Connor, Osborne and Hone. They are, with few exceptions, very meagre in their information. I think that I have, in this book, set out all the facts they contain, and corrected many of their more patent errors :—

An Authentic History of the Professors of Painting, Sculpture and Architecture, who have Painted in Ireland. By Antony Pasquin, London. No date.

("Antony Pasquin" was John Williams, not unfairly described by Macaulay as "a malignant and filthy baboon." The *Authentic History* was published in 1796.)

Anecdotes of Painters who have Resided or been Born in England. By Edward Edwards, A.R.A. London, 1808.

A Dictionary of Painters. By the Rev. M. Pilkington, A.M. With additions by Henry Fuseli, R.A. London, 1810.

(Matthew Pilkington was Vicar of Doneraile, Co. Dublin. An earlier edition of his work, published in 1798, contained a supplement by James Barry, R.A.)

A Dictionary of Recent and Living Painters. By Henry Ottley. London, 1866.

A Critical and Commercial Dictionary of the Works of Painters. By Fredrick Peter Seguier. London, 1870.

A Dictionary of Artists of the English School. By Samuel Redgrave. 1874.

Cyclopedia of Painters and Painting. By J. D. Champlin and C. C. Perkins. London and New York, 1888.

Art Sales. By George Redford, F.R.C.S. London, 1888.

A Century of Painters of the English School. By Richard and Samuel Redgrave. London, 1890. (Second edition.)

A History of the Old Watercolour Society. By L. Roget. London, 1891.

A Dictionary of Artists who exhibited in London, 1760-1893. By Algernon Graves, F.S.A. London, 1895.

The Royal Academy Exhibition, 1709-1914. By Algernon Graves, F.S.A. London, 1905-1906.

The Society of Artists and the Free Society. By Algernon Graves, F.S.A. London, 1907.

The British Institution, 1806-1867. By Algernon Graves, F.S.A. London, 1908.

A Century of Loan Exhibitions, 1813-1912. By Algernon Graves, F.S.A. London, 1913-1914.

Art Sales. By Algernon Graves, F.S.A. London. Vol. I. 1918. In course of publication.

(All Mr. Graves' works are monuments of accurate industry.)

The Royal Academy and its Members. By J. E. Hodgson, R.A. and Fred A. Eaton, M.A. London, 1905.

Bryant's Dictionary of Painters and Engravers. Revised by George C. Williamson, Litt.D. London, 1913-1915.

A Dictionary of Irish Artists. By W. G. Strickland. Dublin, 1913. (An essential book for all serious students of Irish Art.)

Imaginations and Reveries. By A.E. Dublin, 1915. (Contains a short appreciation of some of Hone's pictures.)

The Dictionary of National Biography. London.

Capt. Stephen Gwynn has written a pleasant account of Walter Osborne in an essay entitled " Garden Wisdom," which will have appeared in *The Englishwoman* before the publication of this book.

APPENDIX II.

WORKS BY GEORGE BARRET, R.A.
FORMING PART OF PUBLIC COLLECTIONS.

THE NATIONAL GALLERY OF IRELAND.

174. POWERSCOURT WATERFALL. 3 ft. 3½ in. H., 4 ft. 2 in. W. The Waterfall is seen through trees which occupy the foreground.

175. VIEW NEAR OVOCA, IN THE COUNTY WICKLOW. 1 ft. 10 in. H. 2 ft. 4¼ in. W. The river flowing between precipitous rocks, at the foot of which is a wooden stage or wharf and a water wheel connected with the machinery of a mine above. Both purchased in 1880. They are examples of his earlier style.

(From the Official Catalogue.)

Note.—Both these pictures were purchased at "Christie's" in 1880 : No. 174 for £23 1s. and No. 175 for £13 13s.

Note.—A third oil-painting by Barret.

A LANDSCAPE WITH A RIVER IN THE FOREGROUND, is to be found in the cellars of the National Gallery, though no mention of it appears in the current official catalogue. It is a large, dull work, measuring 3 ft. 2 in. by 4 ft. 4 in. It was presented by Thomas S. Berry, LL.D.

THE NATIONAL GALLERY OF BRITISH ART.— VICTORIA AND ALBERT MUSEUM.

WATER-COLOUR AND OTHER DRAWINGS.

1722—'71. LANDSCAPE WITH RIVER AND FIGURES. 14¾ in. by 21¼ in. Signed and dated 1782. *William Smith Gift.*

344—'72. TREES AND HORSES. The horses are by Sawrey Gilpin, R.A., *q.v.* 13¼ in. by 10½ in. Dated 1872. In circulation.

257—'75. LANDSCAPE, WITH RIVER, AND HORSES WATERING. 14⅝ in. by 21 in.

191—'14. A LAKE SCENE. Indian ink. 9¾ in. by 14½ in. In circulation.
Given by Mr. J. E. Taylor.

(*From the Official Catalogue.*)

Note.—Numbers 1722 and 257 are illustrated in this book. No. 1772 was illustrated in the first edition of *The Earlier English Water-Colour Painters* by Cosmo Monkhouse (1890), but not in the subsequent edition. It is signed by " G. Barett, 1872."

THE BRITISH MUSEUM : DEPARTMENT OF PRINTS AND DRAWINGS.

1. LANDSCAPE WITH FIGURES. A torrent foaming from rocky, tree-hung heights, crowned with a castle, *r.*, into a deep hollow, the view of which is intercepted by a high bank in the foreground, *l.*, A road leads down to the hollow, and a shepherd drives his sheep along it, while a man and woman are seated at the roadside, *r.* ; in the distance a wooded plain and an isolated mountain. Water-colours. 14¼ in. x 20¾ in. Purchased August, 1861.

(*From the Official Catalogue of Drawings by British Artists. Vol. I.*)

UNCATALOGUED ETCHINGS.

(From particulars kindly given by Cambell Dodgson, Esq., O.B.E., Keeper of the Department of Prints and Drawings.)

1. A set of five, uniform in size and appearance, with a border-line (about 5 in. x 7½ in.) some way inside the plate mark.. The titles are :—

(*a*) ON THE HARROW ROAD.
(*b*) SOUTHALL.
(*c*) THE GREEN MAN, HARROW ROAD.
(*d*) WILLESDEN CHURCH, MIDDLESEX.
(*e*) MICKLEHAM CHURCH, SURREY.

(*a*) and (*b*) are in two states : 1st, before letters ; 2nd, with the title engraved in centre at foot of plate, in open letters, and with " Etched by George Barrett " in italics on the right. (*c*), (*d*) and (*e*) are before letters. The plates measure about 5¾ in. x 7⅞ in.

2. NORBURY PARK, with groups of horses under trees. Plate size, $8\frac{1}{8}$ in. x $11\frac{1}{4}$ in. In two states : before letters and with " Norbury Park " in centre, and " Etched by G. Barrett " in italics on right, similar to left, but without border-line.

3. LANDSCAPE (unnamed). A stream flowing between great oaks through a wooded dell. Two men on the right bank, one standing, the other seated. No signature or name. $8\frac{1}{2}$ in. x $11\frac{1}{4}$ in. to outer border-line (of several), cut within plate mark. Bought in 1852 with Set 1 in first state. (In the opinion of Mr. Dodgson, the attribution to Barret is correct.)

4. TWO VIEWS, numbered 3 and 4, entitled, " A View of Part of Hawarden Castle in Flintshire " and " A View of Hawarden Castle in Flintshire." With engraved inscription : " G. Barett delint. et fecit. Published March 1st, 1773 by J. Boydell, Engraver in Cheapside, London." Plate, 9 in. x $11\frac{1}{2}$ in. Subject, $8\frac{1}{4}$ in. x $10\frac{3}{4}$ in.

5. A LARGE ETCHING. Three impressions. One bears at foot an old manuscript inscription : " An Etching, by the late George Barett, of Roach Abbey, Yorkshire (a proof)." This print differs from the second state only by containing a few very lightly etched pieces of foliage between the branches of a tree ; and certain scribbles with the needle outside the border-line, which have been cleaned away before the more neatly printed second state was issued. The latter has no inscription. Size of plate, 14 in. x 19 in. Size of subject to border-line, $12\frac{5}{8}$ in. x $17\frac{3}{4}$ in. The two impressions of the second state differ in showing various parts of the faint scribblings visible in the first state ; but, in Mr. Dodgson's opinion, these scribblings were not actually removed from the plate, but only prevented, in unequal degrees, from printing.

THE FITZWILLIAM MUSEUM, CAMBRIDGE.

7. THE FALLS OF CLYDE.

Note.—This picture is attributed to Barret in the Official Catalogue. It is unsigned, and Mr. Sydney Cockrell, the Director of the Gallery, tells me that it was formerly attributed to Richard Wilson, R.A. I have never seen the original ; but a photograph which Mr. Cockrell very kindly sent me leads me to believe that the present attribution is correct.

SIR JOHN SOANE'S MUSEUM, LONDON.

(From information kindly given by the Curator, Arthur Bolton, Esq.,
F.S.A., F.R.I.B.A.)

1. VIEW IN MR. LOCK'S PARK, LEATHERHEAD. 12¼ in. x 9½ in. Sepia and
 Chinese white (?) touches in parts.

2. WATER-COLOUR : A MAN ROLLING GRASS ON A LAWN : WITH ORNAMEN-
 TAL TREES. 7 in. x 11 in. Blue, green and brown in pale washes.

3. PENCIL PORTRAIT OF THE ARTIST. 7½ in. x 11 in. On rough paper.
 Slight. Side view seated figure in wood chair with rush seat.
 Dress : Knee-breeches, wig (?) with pigtail. Palette and brushes
 in hand.

 Note.—These drawings formerly hung in different rooms of
 Sir John Soane's house, 13 Lincoln's Inn Fields. They are now
 hung together in the anteroom. They are mentioned in the
 current catalogue of the Museum, but are not fully described.
 No. 3 is illustrated in this book.

CITY OF NOTTINGHAM ART GALLERY.

23. LANGDALE PIKES, WESTMORELAND. In the foreground is a party of
 sportsmen with horses and dogs, waiting to cross Lake Elterwater.
 Canvas height, 67¼ in. ; width, 48 in. Signed " G. Barrett "
 and dated 1777. Reg. No. '04—10, Richard Godson Milnes'
 Bequest. Figures and animals are by Sawrey Gilpin.

 (From the Official Catalogue.)

 Note.—The picture is actually signed " G. Barret."

THE WALKER ART GALLERY, LIVERPOOL.

(From information kindly given by the Curator, A. G. Quigley, Esq.)

POWERSCOURT WATERFALL. According to the old catalogues, this picture
was painted for Edmund Burke. In them it is described as a
" Waterfall called the Dargle." 3 ft. 3 in. x 4 ft. 1 in.

Note.—Not mentioned in the current official catalogue.

APPENDIX III.

WORKS BY GEORGE BARRET, R.A., EXHIBITED IN HIS LIFETIME.

THE FREE SOCIETY OF ARTISTS.

1764.—2. A LARGE LANDSCAPE AND FIGURES.

N.B.—The first Premium in Landscape-painting (Fifty Guineas) for the present year.

1779.—205. A LANDSCAPE.

1782.— 12. LANDSCAPE.

86. LANDSCAPE WITH CATTLE.

90. LANDSCAPE WITH CATTLE.

147. A FARMYARD.

148. A FARMYARD.

THE SOCIETY OF ARTISTS OF GREAT BRITAIN.

In Orchard Street, opposite North Audley Street, Oxford Road.

1764.—3. VIEW OF THE WATERFALL AT POWERSCOURT IN IRELAND.

4. VIEW IN THE DARGLE, BOTH ON THE ESTATE OF THE RT. HON. VISCOUNT POWERSCOURT.

5. A LANDSKIP (*sic*); three-quarters.

6. Do. smaller.

1765.—4. A LANDSCAPE: THE EFFECT OF A RAINBOW.

4.†HAWARDEN CASTLE.

1766.—1. A VIEW OF WELBECK PARK, THE SEAT OF THE DUKE OF PORTLAND.

2. A VIEW OF THE GREAT TREE IN WELBECK PARK.

3. A LANDSCAPE; STUDY FROM NATURE.

1767.—2. A VIEW IN CRESWELL CRAGGS, NOTTINGHAMSHIRE, WITH A WATERFALL.

3. A VIEW OF ROCH ABBEY.

4. A MOONLIGHT, WITH THE EFFECT OF A MIST, A STUDY FROM NATURE.

1768.—2. PORTRAIT OF A DOG BELONGING TO LORD EDWARD BENTINCK. (Brown and white. A water spaniel, who seems pursuing a wild duck.)

1768 (*Special*).—5. PORTRAIT OF A DOG BELONGING TO LORD EDWARD BENTINCK.

6. A SMALL MOONLIGHT.

7. TWO STUDIES FROM NATURE.

7.†A VIEW.

THE ROYAL ACADEMY.

Orchard Street, Portman Square.

1769.—5. A VIEW IN PENTON LYNN ON THE LIDDLE, THROUGH THE DUKE OF BUCCLEUCH'S ESTATE, etc.

6. PART OF MELROSE ABBEY BY MOONLIGHT, BELONGING TO THE DUKE OF BUCCLEUCH.

1770.—7. A VIEW OF THE DUKE OF BUCCLEUCH'S PARK AT DALKEITH, WITH PART OF ONE OF THE WINGS OF DALKEITH HOUSE.

8. A BULL.

9.—STUDY FROM NATURE ON LAKE ULSWATER (*sic*).

1771.—11. A VIEW IN THE DUKE OF BUCCLEUCH'S PARK, DALKEITH.

Westborne Green, near Paddington.

1772.— 9. A VIEW OF A GENTLEMAN'S PARK. (*Sir George Colebrook's at Gatton*). TAKEN FROM THE MANSION HOUSE.

10. ITS COMPANION, A VIEW OF THE MANSION HOUSE, PART OF THE PARK, ETC., FROM THE OPPOSITE BANKS OF THE LAKE.

11. A STUDY FROM NATURE, IN THE MOUNTAINS OF KESWICK CUMBERLAND.

1773.—6. A LANDSCAPE.

 7. Do.

 8. Do.

1774.—5. A VIEW OF THE VILLAGE OF STEEP HILL, AT THE BACK OF THE ISLE OF WIGHT.

1775.—12. MORNING.—A LANDSCAPE WITH CATTLE.

 13. MARES AND FOALS.—ITS COMPANION.

 14. A LANDSCAPE (With Waterfall—80 guineas).

 15. A LANDSCAPE. (75 Guineas.)

 15. Do. (with Southampton Water seen under the trees—80 guineas).

1776.—13. LLANBERIS POOL, IN THE MOUNTAINS OF SNOWDON.

 14. A GROUP OF BEECH TREES, IN THE PARK OF WILLIAM LOCKE, ESQ., SURREY—Water-colours.

1777.—16. A STORM; THE SCENE: LLANBERIS POOL, IN THE MOUNTAINS OF WALES.

 17. A VIEW ON DITTO—MORNING.

 18. A VIEW FROM RICHMOND HILL, OF THE QUEEN'S TERRACE.

 18.†A STUDY FROM NATURE; A SCENE IN THE PARK OF WILLIAM LOCKE, ESQ.

1778.—12. A MOONLIGHT.

1779.— 9. THE WEST FRONT OF BURTON CONSTABLE, THE SEAT OF WILLIAM CONSTABLE, ESQ., IN HOLDERNESS, YORKSHIRE.

 10. A GENERAL VIEW OF THE SAME.

1780.—115. A MOONLIGHT.

1781.—40. VIEW OF WINDERMERE LAKE, IN WESTMORELAND, THE EFFECT, THE SUN BEGINNING TO APPEAR IN THE MORNING, WITH THE MISTS BREAKING AND DISPERSING.

1782.—46. A WOOD SCENE, WITH A GROUP OF BEECH TREES IN NORBURY PARK, BELONGING TO WILLIAM LOCKE, ESQ.

 98. A SUN-SET.

APPENDIX IV.

WORKS BY GEORGE BARRET, R.A.

EXHIBITED IN LOAN EXHIBITIONS SINCE HIS DEATH

BRITISH INSTITUTION, 1817.

120. LANDSCAPE AND CATTLE. (Figures by Gilpin.)
Lent by B. West, P.R.A.

140. LANDSCAPE WITH FIGURES. (In collaboration with Cipriani.)
Lent by W. Smith, Esq.

142. SCENE IN POWERSCOURT. *Lent by Joseph Barret, Esq.*

LIVERPOOL ROYAL INSTITUTION, 1823.

108. RIVER LANDSCAPE. *Lent by John Moss, Esq*

BRITISH INSTITUTION, 1824.

153. WATERFALL AT POWERSCOURT. *Lent by Sir George Duckett.*

EXHIBITION AT SUFFOLK STREET, LONDON, 1832.

11. LANDSCAPE WITH CATTLE. (Figures by Gilpin.) *Lent by R. Clark, Esq.*

85. LANDSCAPE WITH CATTLE. (Figures by Gilpin.) *Lent by E. Childe, Esq.*

182. LANDSCAPE AND CATTLE. *Lent by Mr. Bryant.*

EXHIBITION AT SUFFOLK STREET, LONDON, 1833.

130. LANDSCAPE. *Lent by E. Childe, Esq.*

246. LANDSCAPE. *Lent by E. Hardman, Esq.*

EXHIBITION AT SUFFOLK STREET, LONDON, 1834.

110. SCENE IN CUMBERLAND. *Lent by G. Barret, Esq., Junior.*

GREAT INDUSTRIAL EXHIBITION, DUBLIN, 1853.

42. LANDSCAPE AND FIGURES. *Lent by William Antony, Esq.*

IRISH INSTITUTION, 1854.

129. CONWAY CASTLE. *Lent by the Earl of Charlemont.*

139. LANDSCAPE. *Presented to the Irish Institute for the National Gallery by Thomas Berry, LL.D.*
Note.—This picture which was, apparently, also shown in the Irish Institution exhibitions of 1855, 1856, and 1858 is now in the cellars of the National Gallery of Ireland. It is duly recorded in the Irish National Gallery catalogues of 1857, 1867 and 1871, but no mention of it appears in those of 1875 onwards.

IRISH INSTITUTION, 1855.

161. LANDSCAPE. *Presented to the Irish Institute by Thomas Berry, LL.D.*

BRITISH INSTITUTION, 1855.

84. LANDSCAPE. *Lent by the Marquis of Westminster.*

IRISH INSTITUTION, 1856.

30. LANDSCAPE AND FIGURES. *Lent by the Lord Chancellor.*
103. LANDSCAPE IN THE POSSESSION OF THE IRISH INSTITUTION.

ROYAL DUBLIN SOCIETY ART EXHIBITION, 1858.

119. LANDSCAPE. *Lent by C. Brien, Esq.*
169. LANDSCAPE WITH MOUNTED PEASANTS. By Barrett and Gilpin. *Lent by R. Cash, Esq.*

IRISH INSTITUTION, 1858.

5. LANDSCAPE. 3 ft. 2 in. high x 4 ft. 4 in. width.
Canvas presented by Thomas S. Berry, LL.D., for the National Gallery of Ireland.

ROYAL DUBLIN SOCIETY EXHIBITION OF FINE ARTS, 1861.

339. LANDSCAPE. *Lent by the Royal Dublin Society.*
453. LANDSCAPE. *Lent by C. Brien, Esq.*

BRITISH INSTITUTION, 1862.

197. LANDSCAPE. *Lent by J. H. Anderton.*

DUBLIN EXHIBITION OF ARTS AND INDUSTRIES, 1872.

231. RIVER VIEW AND WATERFALL. *Lent by H. Quinn, Esq.*
240. VIEW IN DARGLE, CO. WICKLOW. *Lent by H. Quinn, Esq.*

LIVERPOOL ART CLUB, 1881.

96. LANDSCAPE AND HORSES. *Lent by Enoch Harvey.*

IRISH EXHIBITION, LONDON, 1888.

204. LANDSCAPE : RIVER SCENE WITH FIGURES. *Lent by C. D. Crews, Esq.*
Note.—Possibly by George Barret, junior.

LOAN COLLECTION, BELFAST, 1888.

56. LANDSCAPE. *Lent by Sir Charles Lanyon, J.P.*

WHITECHAPEL (ST. JUDE'S), LONDON, 1889.

83. RIVER SCENE. *Lent by Lewis Fry, Esq.*

CENTURY OF BRITISH ART, GROSVENOR GALLERY, 1889.

140. DOLBARDEN CASTLE ON LLANBERIS LAKE. 48½ in. x 38½ in.
Lent by H. Graves, Esq.

Note.—Mr. Algernon Graves, F.S.A., in his *A Century of Loan Exhibitions*, records another picture as by George Barret, R.A., in this exhibition. He is, however, in error. The other picture, a river scene, was by George Barret, junior.

ROYAL HIBERNIAN ACADEMY EXHIBITION OLD MASTERS, 1902-03.

94. A CLASSICAL LANDSCAPE. Canvas, 34 in. x 43 in.
Lent by Mrs. A. R. Kirkpatrick.

WORKS BY IRISH PAINTERS AT THE GUILDHALL, LONDON, 1904.

317. TAL Y NYN. (Water-colour.)
Lent by Lt.-Col. W. Hutcheson Poe, C.B.
355. A CLASSICAL LANDSCAPE. Lent by Lt.-Col. W. Hutcheson Poe, C.B.

Note.—Both these works are water-colours and—in spite of their attribution—by George Barret, junior. No. 317 was illustrated in the official catalogue.

IRISH INTERNATIONAL EXHIBITION, DUBLIN, 1907.

183. A WATERFALL. 49 in. x 63 in. Lent by J. C. Nairn, Esq.
187. LANDSCAPE, WITH VIEW OF CASTLETOWN HOUSE, CO. KILDARE.
28 in. x 38 in. Lent by Captain Connolly.
193. LANDSCAPE, VIEW NEAR LEIXLIP. 28 in. x 38 in.
Lent by Captain Connolly.
205. LANDSCAPE. 37 in. x 49 in. Lent by the Rev. Wm. Shaw Darley.
208. CLASSICAL LANDSCAPE. 34 in. x 43 in. Lent by Mrs. Kirkpatrick.

ROYAL ACADEMY WINTER EXHIBITION, 1910.

192. WINDSOR CASTLE. 51 in. x 77 in. Lent by Athol Thorne, Esq.

WHITECHAPEL ART GALLERY, 1913.

54. WOODED LANDSCAPE. *Lent by The Savoy Hotel, Ltd.*

57. KESWICK LAKE. *Lent by The Right Hon. The Speaker.*

60. SHORE SCENE WITH CATTLE. *Lent by The Misse Rutley.*

61. CLASSICAL LANDSCAPE. *Lent by W. T. Kirkpatrick, Esq.*

69. TIVOLI. *Lent by Alfred J. Sanders, Esq.*

THE NATIONAL GALLERY, LONDON, 1918.

A VIEW LOOKING EAST TOWARDS KNIPE SCAR AND LOWTHER PARK FROM NADDLE FOREST NEAR HAWESWATER. (Figures by Richard Reinagle ; dogs and horses by Sawrey Gilpin.)

Lent by The Right Hon. James W. Lowther, P.C., D.C.L., The Speaker of the House of Commons.
Note.—Illustrated in this book.

APPENDIX V.

A SELECTION OF THE PRICES REALISED FOR WORKS BY GEORGE BARRET, R.A., AT AUCTION SALES SINCE HIS DEATH.

Note.—No painter of his time has fallen further in public repute than has George Barret, R.A., if auction prices be a fair criterion of public opinion. Only five times since his death has a picture by him realised more than £100. The following list does not include all sale records in my possession. But it may be taken as representative :—inclusive of many of the best-known of his pictures and of both the highest and lowest prices his pictures have fetched. Sale catalogues are so seldom accurate in their allocation of water-colour drawings between George Barret, R.A. and his son, George Barret, that I have judged it better to exclude all reference to water-colours from the subjoined list, as such would only lead to confusion. The water-colours attributed to George Barret, R.A., in George

Redford's *Art Sales*, published in 1888, should all be assigned to George Barret, junior.

Sale, 1796.

(From Jacob More's Collection.)

A VIEW IN A WOOD £1 3 0

Sale, 1802.

VIEW OF VALLECRUCIS ABBEY, NEAR LLANGOLLEN, DENBIGH-
SHIRE. FIGURES BY WHEATLEY £6 16 6

Sale, 1805.

VIEW OF A FERRY IN CUMBERLAND. WITH MOUNTAINOUS
SCENERY and Figures by Gilpin £37 16 0

Sale, 1806.

(From the Marquis of Lansdowne's Collection.)

A VIEW IN WALES, With Cattle and Figures by Gilpin ... £37 16 0

Herbert's Sale, Dublin, 28th January, 1819.
(From Charles Ormsby's Collection.)

LANDSCAPE £2 16 10

LANDSCAPE AND FIGURES £3 19 7½

T. Jones' Sale, Dublin, 23rd February, 1820.
(From William Osborne's Collection.)

LANDSCAPE £4 10 0

T. Jones' Sale, Dublin, 2nd March, 1820.
(From the Russell and Donnelly Collections.)

LANDSCAPE, BRIDGE AND TOWN }
LANDSCAPE, FISHERMEN, etc. } £2 15 0

LANDSCAPE, TOWN ... }
LANDSCAPE, BRIDGE AND RUINS} £4 12 0

" Christie's " Sale, June 23rd, 1820.
(From Sir Benjamin West's Collection.)

GROUP OF COWS. Painted with Gilpin. 43 in. x 34 in. £64 1 0

Sale, 1830.

(From Sir Thomas Lawrence's Collection.)

A STUDY OF A PLANE TREE £2 12 6
Note.—Probably a drawing.

Sale, 1863.

(From John Allnut's Collection.)

A LANDSCAPE, WITH HORSES, CATTLE AND SHEEP ON THE
BANK OF A RIVER. Animals by Gilpin £20 9 6

A LANDSCAPE, WITH HORSES, CATTLE AND SHEEP ON THE
BANK OF A RIVER. Animals by Gilpin £42 0 0

" *Christie's* " *Sale, March* 29*th*, 1877.

(From Sir W. H. Feilden's Collection)

THE UMBRELLA PICTURE £60 18 0

" *Christie's* " *Sale, April* (?), 1880.

POWERSCOURT WATERFALL. £23 1 0
VIEW NEAR AVOCA, IN THE COUNTY WICKLOW. £13 13 0

" *Christie's* " *Sale, February* 24*th*, 1883.

(From W. Angerstein's Collection.)

LANGDALE PIKES £99 15 0
THE LONG WALK, WINDSOR, WITH BROOD MARES AND FOALS
(ONE, " ECLIPSE.")£346 10 0
Note.—Originally in Lord Albemarle's Collection : bought for the Queen.
VIRGINIA WATER £194 5 0

" *Christie's* " *Sale, June* 30*th*, 1883.

CLASSICAL LAKE SCENE £420 0 0 (Bought in).

" *Christie's* " *Sale, March* 29*th*, 1890.

(From Colonel Thornton Woodhouse's Collection.)

GOING OUT FROM THORNTON CASTLE. 44 in. x 63 in. ... £141 15 0
RETURN AT DULNON CAMP. 44 in. x 63 in. £168 0 0
THE DEER SHOOTERS. 44 in. x 63 in. £126 0 0

Note.—The three preceding pictures were all painted with Sawrey Gilpin and Philip Reinagle. They came into the possession of Sir Walter Gilbey subsequently, and were sold again, on March 12th, 1910, at " Christie's " after his death, when they realised, respectively, £28 7s; £47 5s.; and £35 14s.

<div align="center">

" Christie's " Sale, December 7th, 1907.

(From the Collection of Thomas Richardson.)
</div>

WINDSOR CASTLE. 51½ in. x 77 in. £18 18 0

<div align="center">

" Christie's " Sale, May 11th, 1908.
</div>

WOODY LANDSCAPE. Painted with Gilpin. 24½ in. x 29½ in. £1 6 0

<div align="center">

" Christie's " Sale, February 6th, 1909.
</div>

VIEW FROM RICHMOND HILL. Painted with Gilpin. 37 in.
 x 54 in. £54 12 0

<div align="center">

" Christie's " Sale, March 23rd, 1910.
</div>

VIEW FROM RICHMOND HILL. 29 in. x 47 in. £11 11 0

<div align="center">

" Sotheby's " Sale, March 24th, 1911.
</div>

RIVER, WITH MAN FISHING. Signed " G.B." 14 in. x 19 in. ... £2 4 0

<div align="center">

" Christie's " Sale, April 12th, 1911.
</div>

LANDSCAPE, WITH TWO FIGURES. 23 in. x 28 in. £6 6 0

<div align="center">

" Christie's " Sale, June 19th, 1911.
</div>

VIEW ON THE DARGLE ON LORD POWERSCOURT'S IRISH ESTATE.
 39 in. x 49 in. £15 15 0

<div align="center">

Messrs. Bennett and Son's Sale, Dublin, February 8th, 1912.

(From the Collection of Augustine Roche, M.P.)
</div>

VIEW OF CASTLE TOWNSHEND £3 5 0

<div align="center">

Messrs. Bennett and Son's Sale, Dublin, April 2nd, 1912.

(From Lord Powerscourt's Collection.)
</div>

LANDSCAPE AND RUINS. (A Pair) £16 16 0
THE DARGLE, CO. WICKLOW £8 10 0
A PAIR OF LANDSCAPES £8 0 0

Messrs. Bennett and Son's Sale, Dublin, September 1st, 1915.
(From Dr. Minchin's Collection.)

LANDSCAPE AND FIGURES £2 0 0

Messrs. Adams and Son's Sale, Dublin, 1916.

LANDSCAPE AND RUINS, WITH FISHERMEN ON A POOL.... £4 10 0
Note.—Illustrated in this book.

Messrs. Bennett and Son's Sale, Dublin, June 19th, 1917.
(From Sir Benjamin Whitney's Collection.)

LANDSCAPE AND FIGURES £6 10 0

Messrs. Bennett and Son's Sale, Dublin, May 19th, 1920.
(From Sir Edward Wingfield Verner's Collection.)

A VIEW IN THE DARGLE. £13 0 0
Note.—Illustrated in this book.

" Sotheby's " Sale, August 23rd, 1920.
(From W. K. D'Arcy's Collection.)

RIVER SCENE IN WALES, MOUNTAINS IN THE DISTANCE, STORMY
EVENING 39 in. x 49 in. £16 0 0

APPENDIX VI.

WORKS BY JAMES ARTHUR O'CONNOR

FORMING PART OF PUBLIC COLLECTIONS.

THE NATIONAL GALLERY OF IRELAND.

163. A VIEW IN THE GLEN OF THE DARGLE. 1 ft. 2¼ in. H., 1 ft. 7¾ in. W.
The river is seen flowing between its rocky banks, overshadowed
with trees. Two large trees stand out boldly in the foreground.
Signed, and dated 1834. Purchased in 1873.

158. MOONLIGHT. 7 in. H., 6½ in. W. A clear moon, with clouds wildly drifting about it ; a solitary wayfarer is seen in the foreground walking on a road which from the foreground recedes into the distance. Signed. Purchased in 1872.

18. THE POACHERS. 2 ft. 3½ in. H., 1 ft. 9 in. W. A moonlight scene, somewhat similar to the above, with a group of men with guns in the foreground. Signed, and dated 1835. Purchased in 1879.
Note.—Illustrated in this book.

489. LANDSCAPE. 12½ in. H., 17 in. W. On millboard. A country lane between two high sandbanks, with trees. Purchased in Dublin in 1900.

(From the Official Catalogue.)

Note.—No. 163 was purchased at " Christie's " for £31 and No. 158 for £12. No. 18 was purchased in April, 1879, from Viscount Powerscourt for £26. No. 489 was purchased on March 18th, 1900, from Lieut.-Col. Hopetown Scott for £15.

2209. ROCHESTER CASTLE.
VIEW AT OSPRINGE, NEAR FAVERSHAM, KENT.
ON THE BEACH AT SANDGATE.
Three Water-colour Sketches, in one frame.

2210. DOVER CASTLE, from the London Road.
DOVER, Shakespeare's Cliff in the distance.
DOVER CLIFF.
Three sketches in Sepia ; in one frame.

2211 to 2219. Thirty-two sketches in Pen and Pencil. All the above sketches are from the Artist's notebook. Purchased in London, from James Doyle, Esq., in 1873.
(From the Official Catalogue.)

i. THE DEVIL'S GLEN. 25 in. x 30½ in. Canvas. A torrent flowing through a rock gorge crowned with oaks. Stormy weather.

Presented in 1919 by Captain R. Langton Douglas, the Director of the National Gallery of Ireland.

(Not yet catalogued.)

Note.—The O'Connor drawings in the Gallery were all purchased for £10. They measure 3½ in. H. x 6½ in. W., and were taken

from a sketch-book dated " London, 1822." They are arranged in eleven frames, which are not separately numbered. Nos. 2209 and 2210 in the catalogue are exhibited in the Gallery beside a frame containing three carefully finished pen-and-ink Sepia drawings entitled, in O'Connor's autograph :—

" BROCKWEAR NEAR TINTERN."

" A VIEW ON THE WYE LOOKING SOUTH."

" CALDWELL ON THE WYE LOOKING NORTH."

The other drawings are stored away and arranged as follows :—(inscriptions in inverted commas are from O'Connor's own autograph).

4th Frame.

i. " ONE OF THE PONDS AT HAMPSTEAD."

ii. " A SCENE ON HAMPSTEAD HEATH."

iii. " A GROUP OF PINES AT HAMPSTEAD."

All carefully finished pen-and-ink compositions.

5th Frame.

iv. " AT HAMPSTEAD." Landscape study in pencil of a cottage and four trees.

v. STUDY OF A TREE IN PENCIL.

vi. " AT SEABROOK NEAR SANDGATE." pen-and-ink study of a tree-bordered road.

6th Frame.

vii. " WEST FRONT OF BOTSLEY (*sic*) HOUSE."

viii. " OAKS."

ix. " EAST FRONT, FROM NEAR THE BOAT HOUSE."
All pencil studies.

7th Frame.

x. " CLIFDEN ROCK."

xi. " PART OF CLIFDEN ROCK."

xii. " ROWNHAM FERRY, BRISTOL "—Particularly pleasant.

xiii. " BOTLEYS."

All carefully finished pen-and-ink compositions.

8th Frame.

xiv. ROUGH PENCIL COMPOSITION : ROAD OVERHANGING WITH ROCKS, right, AND WITH TREES, left.

xv. "HAMPSTEAD." Pencil sketch of village street.

xvi. "TOWN OF CHEPSTOW." River scene from height, rough pencil sketch.

xvii. "WEST FRONT OF BOTLEY HOUSE." Pencil composition, very similar to vii.

9th Frame.

xviii. "THE BATHING HOUSE."

xix. NORTH FRONT OF BOTSLEY (*sic*) HOUSE.

xx. STUDY OF OAKS.

xxi. STUDY IN A WOOD, WOODED HILL IN MIDDLE DISTANCE. All pencil compositions.

10th Frame.

xxii. "A SCENE FROM BOTLEY'S, NEAR CHIRTSEY." A wooded plain.

xxiii. "BOTLEYS" on a height.

xxiv. "BOTLEYS NEAR CHIRTSEY."

xxv. "A SCENE AT BOTLEYS." All carefully finished pen-and-ink compositions.

11th Frame.

xxvi. "THE BOATHOUSE." The same as in xviii., seen nearer.

xxvii. "A SCENE IN GREENWICH PARK." A glade.

xxviii. "SEABROOK NEAR SANDGATE, KENT." Road and cottages.

xxix. "THAMES DITTON." River and barges ; particularly good. All carefully finished pen-and-ink compositions.

THE NATIONAL GALLERY OF BRITISH ART.— VICTORIA AND ALBERT MUSEUM.

577—'70. LANDSCAPE. A Mountain in the distance ; two figures in the foreground. Panel, $5\frac{1}{2}$ x $7\frac{3}{4}$. Signed, and dated 1839.

Parsons Bequest.

30—'73. TOWN OF WESTPORT AND CLEW BAY, CO. MAYO. Canvas, 20¼ x 30⅝. Signed, and dated 1825. *In circulation.*

1841.—'00. THE DEVIL'S GLEN, CO. WICKLOW. Canvas, 13½ x 17⅛. Signed, and dated 1828. *Ashbee Bequest.*

F. 25. MORNING. Canvas, 13½ x 16½. *Forster Bequest.*

F. 26. NIGHT. Canvas, 13½ x 16½. *Forster Bequest.*

F. 27. WATERFALL. Millboard, 9½ x 7½. Signed, and dated 1838.
 Forster Bequest.

F. 28. WATERFALL. Canvas, 11 x 9. *Forster Bequest.*

F. 29. LANDSCAPE WITH STREAM AND WOODS. Panel, 8¼ x 10½.
 Forster Bequest.

F. 30. LANDSCAPE WITH TREES IN FOREGROUND, AND DISTANT HILLS. Panel, 7¼ x 11¼. *Forster Bequest.*

578.—'70. LANDSCAPE. Tower on the bank of a river; two men fishing. Attributed to O'Connor. Panel, 6½ x 7¾. *Parsons Bequest.*

(*From the Official Catalogue.*)

THE BRITISH MUSEUM.—DEPARTMENT OF PRINTS AND DRAWINGS.

1. WESTPORT, CO. MAYO. View from rising ground looking down on the town, lying towards the *l.* among undulating, wooded country, with estuary and islands beyond, and a conical hill on the coast *l.* Signed *J. A. O'Connor, delt.* Inscribed *The Marquis of Sligo's house and demesne with the town and bay of Westport, Co. Mayo.* Pen-and-ink. roy, 6⅞ x 10⅝ in.

2. Two on one mount, roy., viz. :—

 (*a*) DELPHI COTTAGE, CO. MAYO. Part of a reedy estuary, with the cottage on the further shore at the foot of the mountains ; a man in a boat in the foreground. Signed *J. A. O'Connor, delt.*, and inscribed *Finloch with Delphi Cottage, the Fishing Seat of the Marquis of Sligo, Co. Mayo.* Pen-and-ink. 4¾ x 6⅝ in.

 (*b*) BEN GRUGAAN, CO. MAYO. Part of a lake with a mountain *l.* Signed *J. A. O'Connor, delt.*, and inscribed *Ben Grugaan ; with part of Dooloch, Co. Mayo.* Pen-and-ink. 4¾ x 6⅝ in.

3. Two on one mount, roy., viz. :—

(a) MOUNT BROWNE, CO. MAYO. View over a wooded park to a mansion
placed in a lap of the hills, with a higher range beyond and a conical
peak, *r.* Signed *J. A. O'Connor, delt.* and inscribed *Mount Browne,
the Seat of the Right Honble. Dennis Browne, Co. Mayo.* Pen-and-
ink. 4⅛ x 7⅛ in.

(b) RUDESHEIM. View looking up the Rhine from the bank near Bingen,
with Rudesheim on the opposite bank *l.* ; a boat and rafts of timber
in the foreground. Inscribed *At Bingen on the Rhine. The town
of Rudesheim to the left. July,* 1833.—*J. A. O'Connor.* Pencil.
4⅜ x 11⅜ in.

4. Two on one mount, roy., viz. :—

(a) BINGEN. View on the bank of the Rhine looking up the river to
Bingen. Inscribed *The town of Bingen on the Rhine with the ruins
of the Castle of Klopp and Mausthurm.* July, 1883. (sic.) *J. A.
O'Connor.*
Pencil. 4 x 5¼ in.

(b) RHEINSTEIN. View on the Rhine, flowing between hills, on a wooded
spur of which, at the *l.* is the Castle of Rheinstein. Inscribed
*The Castle of Rheinstein on the Rhine, the property of Prince
Fredrick of Prussia. July,* 1883. (sic) *J. A. O'Connor.*

Numbers 1–4 were purchased February 1872.

Note.—As O'Connor died in 1841, "July, 1883," should
evidently be "July, 1833."

5. (*Ob.*) KILLINEY BAY. View looking S. along the coast ; a hillside in the
foreground sloping up *r.* ; two conical hills in the distance. In-
scribed *Killiney Bay, Co. Dublin.* Sepia wash and pen ; roy.
4½ x 7⅜ in.

(*Rev.*) CASTLE TRORY ON THE SHANNON. A near view of the ruined
castle standing *r.* on the river bank ; in the distance wooded
shores and Mount Shannon among trees, beyond, the Keeper
Mountain. Inscribed below *Castle Trory on the Shannon ;* and
above *Keeper Mountain* and *Mount Shannon, Lord Clare's.* Sepia
wash and pen. Purchased June, 1881.

6. CORFE CASTLE. View looking across a hollow to the great mound en-
circled by the castle walls and surmounted by the ruined keep

standing against the yellow sunset sky ; in the foreground *r*. a road crosses the hollow and passes under the entrance gate ; at the *l*. a man walking away along the bottom of the valley. Signed and dated *J. A. O'Connor*, 1830. Water-colours ; imp. 14⅝ x 20½ in. Purchased October, 1875.

(*From the Official Catalogue of Drawings by British Artists. Vol. III.*)

UNCATALOGUED ETCHINGS.

(From particulars kindly given by Campbell Dodgson, Esq., O.B.E., Keeper of the Department of Prints and Drawings.)

Five etchings, all single figures of men. Plate 4⅝ x 3¼. Subject 4¼ x 2⅞ (varying). With border-line. Published " London, T. North, 162 Fleet St." All signed " J. A. O'Connor, delt." One dated 1824. Subjects :—

(*a*) Old man in hat, stick in hand, walking to *r*. along a road.

(*b*) Man in profile to *l*., sitting on a bank, holding hat in both hands, stick leaning against the bank.

(*c*) Man sitting asleep, leaning forward, head on arms, across a table.

(*d*) Man in profile to *r*., holding a rake in *l*. hand.

(*e*) Man facing to front, holding a rake in *l*. hand, under a tree. This is dated 1824.

CITY OF NOTTINGHAM ART GALLERY.

503. THE EDGE OF A FOREST, STORM COMING ON. Canvas : height 22½ in., width 26¾ in. Signed " J. A. O'Connor, 1826." Reg. No. '04.—59.

Richard Godson Milnes Bequest.

(*From the Official Catalogue.*)

MAPPIN ART GALLERY, SHEFFIELD.

18. LANDSCAPE. Canvas, 15 H. x 19 W.

190. THE DARGLE COUNTRY. Canvas, 29 H. x 38 W. Signed, and dated 1829.

(*From the Official Catalogue.*)

FITZWILLIAM MUSEUM, CAMBRIDGE.

IV. 471. RIVER SCENE WITH FIGURES. A winding river crosses the picture disappearing on *r.* On this side in *r.* corner an oak tree and a man in a blue coat with a fishing rod on his shoulder walking to *l.* On river to *l.* a man in a boat. On the other side, oak trees and three deer. The far side is flat, the nearer broken and rising to *r.* Bright yellow evening light from *r.* Signed lower *l.* corner, " J. A. O'C., 1839." Canvas, 1 ft. 0½ in. by 1 ft. 3¼ in. *Ellison.*

(*From the Official Catalogue.*)

APPENDIX VII.

WORKS BY JAMES ARTHUR O'CONNOR

EXHIBITED IN HIS LIFETIME.

Note.—None of the Irish libraries possess complete sets of the early catalogues of exhibitions of paintings in Ireland. Through the kindness of Mr. Walter G. Strickland, I am enabled to give a list of most of O'Connor's early exhibits with the Society of the Artists of Ireland and the Hibernian Society of Artists. But neither he nor I can come on catalogues for the years 1816 and 1817.

EXHIBITION HELD AT THE DUBLIN SOCIETY'S HOUSE IN HAWKINS STREET.

J. O'Connor, 15 Aston's Quay.

1809.—164. CARD-PLAYERS, A SKETCH.

EXHIBITION OF THE SOCIETY OF THE ARTISTS OF IRELAND.

J. O'Connor, an Associate Exhibitor.

1810.—52. SEA VIEW AND MARTELLO TOWER.

J. A. O'Connor, Aston's Quay, an Associate Exhibitor.

1811.—81. A RUSTIC FIGURE, SKETCHED WITH A PEN.

82. COMPANION.

98. SUNSET COMPOSITION.

1812.— 4. LANDSCAPE COMPOSITION.

5. LANDSCAPE COMPOSITION.

7. LANDSCAPE COMPOSITION.

11. LANDSCAPE COMPOSITION.

186. LANDSCAPE COMPOSITION.

J. A. O'Connor, Aston's Quay, Member of the Society

1813.—44. ITALIAN SEAPORT—MOONLIGHT.

45. LANDSCAPE COMPOSITION.

54. SMITH'S FORGE—MOONLIGHT.

59. MOONLIGHT—COMPOSITION.

86. VIEW OF THE SALMON LEAP, LEIXLIP.

92. LANDSCAPE AND FIGURES.

— COMPOSITION.

109. HISTORICAL LANDSCAPE. AENEAS AND DIDO—LAND STORM.
Note :—With quotation from Virgil.

122. LANDSCAPE COMPOSITION.

137. MOONLIGHT AND SMITH'S FORGE.

HIBERNIAN SOCIETY OF ARTISTS.

J. A. O'Connor, Aston's Quay.

1814.—11. A TRAVELLING MENDICANT.

16. LANDSCAPE AND FIGURES.

17. LANDSCAPE AND FIGURES.

30. LANDSCAPE AND FIGURES.

35. LANDSCAPE.

46. LANDSCAPE COMPOSITION.

163. GIPSY AND CHILD.

172. BACK VIEW OF A COTTAGE.

217. SUN-RISE, COMPOSITION.

1815.—18. VIEW OF BRISTOL CHANNEL.

 46. LANDSCAPE COMPOSITION.

 47. „ AND FIGURE COMPOSITION.

> *Note.*—In the index, No. 33 is also attributed to O'Connor: but in the body of the catalogue it is affixed to the title of a picture by Miss Welch.

1816. Catalogue missing.

1817. Catalogue missing.

1818. No exhibition.

EXHIBITION OF THE ARTISTS OF IRELAND AT THE DUBLIN SOCIETY'S HOUSE.

J. A. O'Connor, 18 *Dawson Street.*

1819.—24. OLD COURT CASTLE, CO. WICKLOW.

 29. LANDSCAPE COMPOSITION.

 33. VIEW FROM KILLINEY LOOKING TO BRAY.

 36. LANDSCAPE COMPOSITION.

 38. VIEW IN THE DARGLE, CO. WICKLOW.

 46. VIEW OF THE SALMON LEAP, LEIXLIP.

 51. VIEW OF ROCKINGHAM HOUSE AND DEMESNE, CO. ROSCOMMON, THE SEAT OF THE RIGHT HON. LORD VISCOUNT LORTON.

 61. LANDSCAPE COMPOSITION. (J. A. O'Connor and J. Peacock.)

 63. LANDSCAPE COMPOSITION. (J. A. O'Connor and J. Peacock.)

THE ROYAL ACADEMY.

32 *Upper Marylebone Street.*

1822.—368. VIEW IN THE DARGLE, CO. WICKLOW.

1823.—203. LANDSCAPE AND FIGURES, A SCENE IN THE COUNTY OF DUBLIN.

 324. THE LOVERS' LEAP IN THE DARGLE, CO. WICKLOW.

1824.—265. WATER-MILL AT ARUNDEL, SUSSEX.

 348. LANDSCAPE.

29 *Fredrick Street, Hampstead Road.*

1825.—178. LANDSCAPE AND FIGURES.

14 *Mornington Crescent.*

1826.—369. LANDSCAPE.
 884. LANDSCAPE—EVENING.

8 *Soho Square.*

1828.—333. THE TROUT STREAM.

67 *Clarendon Street.*

1829.—476. THE SEQUESTERED GLEN.
1830.—445. THE GLEN OF THE ROCKS.
1831.—290. SCENE IN THE DARGLE, CO. WICKLOW.

39 *Charing Cross.*

1832.—118. A LANDSCAPE.

61 *Seymour Street, Euston Square*

1834.— 77. LANDSCAPE—EVENING.
 115. LANDSCAPE.
1835.—230. LANDSCAPE. SUNSET.

67 *Clarendon Street, Somer's Town.*

1836.—436. LANDSCAPE.

13 *Rathbone Place.*

1837.—316. AN IRISH GLEN.
1838.—527. A LANDSCAPE—MOONLIGHT.
1839.—547. ON THE LYNN, NORTH DEVON—MOONLIGHT.
1840.—294. LANDSCAPE.

THE BRITISH INSTITUTION.

33 *Upper Marlebone* (sic) *Street.*

1823.—213. LANDSCAPE AND FIGURES, EVENING; A SCENE IN WICKLOW.
 I. 9 X 2. 0

 301. LANDSCAPE, WITH A MILL: A VIEW AT MILTOWN, DUBLIN.
 2. 9 X 3. 2

1824.— 29. LANDSCAPE AND FIGURES. 2. 1 x 2. 7

291. A SCENE IN AN OAK WOOD AT OFFINGTON, SUSSEX. 2. 2 x 2. 8

300. MORNING ; A VIEW OF PART OF THE TOWN AND CASTLE OF ARUNDEL. 1. 8 x 2. 0

351. LANDSCAPE AND FIGURES. 2. 2 x 2. 8

1825.— 39. LANDSCAPE AND FIGURES. 3. 2 x 2. 1

1825.— 63. WEST PORT BAY, FROM THE NEW-PORT ROAD, MAYO. 1. 8 x 2. 0

148. LANDSCAPE AND FIGURES, HAMPSTEAD HEATH. 2. 2 x 2. 8

384. SANDY MOUNT BEACH, DUBLIN. 1. 8 x 2. 0

26 Frederick Street.

1826.—104. LANDSCAPE AND FIGURES. EVENING. 3. 2 x 3. 9

175. LANDSCAPE. 2. 1 x 2. 7

245. LANDSCAPE, EVENING. 2. 9 x 3. 2.

305. LANDSCAPE. 1. 8 x 2. 0

Mornington Crescent.

1827.—261. LANDSCAPE. 3. 4 x 4. 0

8 Soho Square.

1828.—253. A VIEW IN THE DEVILS GLEN, WICKLOW. 1. 2 x 1. 4

67 Clarendon Street, Somer's Town.

1829.—226. RIVER SCENE. MOONLIGHT. 2. 7 x 3. 1

395. THE MOUNTAIN GLEN. 3. 0 x 3. 6

461. THE MOUNTAIN TORRENT. 3. 6 x 2. 11

1830.—124. THE TIRED FISHERMAN. 3. 5 x 4. 1

386. LANDSCAPE. 3. 1 x 3. 6

454. THE DEVILS GAP. 2. 4 x 2. 5

499. THE GLEN OF OAKS. 3. 3 x 3. 11

1831.—224. LANDSCAPE. 3. 2 x 3. 10

325. THE FORD. 3. 6 x 4. 2

1832.— 65. LANDSCAPE. 2. 1 x 1. 10

66. THE WOODCUTTER. 2. 1 x 1. 10

477. SCENE IN THE DARGLE, WICKLOW. 3. 6 x 3. 0

495. MOONLIGHT. 3. 4 x 2. 11

5 *Polygon, Somer's Town.*

1833.— 6ɔ. THE EAGLE'S CRAG. 2. 6 x 2. ɔ

1834.—523. A VIEW IN THE VALLEY OF TIEFERBACH ON THE MOSELLE.
3. o x 3. 6

67 *Clarendon Square.*

1835.—427. LANDSCAPE, STORM COMING ON. 3. o x 3. 6

453. LANDSCAPE, MOONLIGHT. 3. o x 3. 6

525. SCENE ON THE RIVER AVONMORE, CO. WICKLOW. 3. o x
3. 5

1836.—375. A LANDSCAPE, TWILIGHT. 3. o x 3. 5

1837.—325. A LANDSCAPE. I. 3 x I. 5

13 *Rathbone Place.*

1838.—119. AN IRISH GLEN. 3. 7 x 3. 2

1839.—139. THE CHATEAU D'ARRAS, RHENISH PRUSSIA. I. 2 x I. 4

THE SOCIETY OF BRITISH ARTISTS.

O'Connor, T. (siç), 167 (sic) *Clarendon Street, Somer's-Town.*

1829.—171. THE BROKEN BRIDGE.

67 *Clarendon Street, Somers-Town.*

1830.—384. THE WATER FALL.

466. SCENE IN THE DEVILS GLEN, COUNTY OF WICKLOW.

1831.—347. SOLITUDE.

498. A SCENE IN THE MOUNTAINS.

1832.— 67. LANDSCAPE ; A SHOWER COMING ON.

85. MOONLIGHT.

209. COAST SCENE—MORNING.

5 *Polygon, Somers-Town.*

1833.—269. MOUNTAINOUS SCENERY : WINDY DAY.

376. THE PRECIPICE : MOONLIGHT.

61 *Seymour Street, Euston-Square.*

1834.—330. LANDSCAPE—MOONLIGHT.

384. SAARBOURG, ON THE SAAR, RHENISH PRUSSIA.

489. THE MOUNTAIN PASS.

67 Clarendon Street, Somers-Town.

1835.—172. LANDSCAPE.

1836.—527. LANDSCAPE ; THE BATHING-PLACE.

13 Rathbone Place.

1838.—417. THE FISHERMAN'S CAVE.

Note.—According to Mr. Algernon Graves' *Dictionary of Artists* (1895), O'Connor exhibited 18 pictures at "Suffolk Street" (Society of British Artists). I think 18 must be a printer's error for 16.

ROYAL HIBERNIAN ACADEMY.

67 Clarendon Street, Somer's-Town, London.

1830.—THE GLEN OF OAKS—A STORM COMING ON.

3 (sic) *Rathbone Place, London.*

1840.— 9. LANDSCAPE.

78. LANDSCAPE, MOONLIGHT.

91. LANDSCAPE, THE MOUNTAIN PASS.

APPENDIX VIII.

WORKS BY JAMES ARTHUR O'CONNOR

EXHIBITED SINCE HIS DEATH.

THE ROYAL HIBERNIAN ACADEMY, 1842.

OILS.

32. A RIVER SCENE.

WATER-COLOURS.

340. THE PARK AT BRUSSELLS (*sic*).

I

341. THE PARK AT BRUSSELLS (*sic*).
342. AT TERVUEREN (*sic*) NEAR BRUSSELLS (*sic*).
343. LA PLACE DU SABLON NEAR BRUSSELLS (*sic*).
346. IN THE MARKET AT BRUSSELLS (*sic*).
347. SUNSET ON THE COAST OF HOLLAND.
348. HAMPTON COURT.
349. ROCHESTER CATHEDRAL AND CASTLE.
 Note.—All described as " by the late J. A. O'Connor."

THE ROYAL HIBERNIAN ACADEMY, 1843.

 68. SUNSET.
162. SEAPIECE.
164. HAMPSTEAD.
454. COMPOSITION.
523. A WATERFALL.
578. COMPOSITION.
 Note.—All described as " by the late James Arthur O'Connor, 41 Lisle Street, Leicester Square, London."

INDUSTRIAL EXHIBITION, DUBLIN, 1853.

 9. LANDSCAPE. *Lent by the Right Hon. More O'Ferrall.*
24. VIEW IN THE COUNTY WICKLOW. *Lent by the Rev. J. A. Mallet, F.T.C.D.*

MANCHESTER ART TREASURES, 1857.

512. RIVER SCENE IN IRELAND. *Lent by John Fernley, Esq.*

ROYAL DUBLIN SOCIETY ART EXHIBITION, 1858.

45. VIEW IN THE COUNTY OF WICKLOW: MEETING OF THE WATERS.
 Lent by J. A. Journeaux.
88. ROCKY LANDSCAPE. *Lent by Capt. Shedden.*
207. SALMON LEAP. *Lent by Miss Fitzgerald.*

219. LANDSCAPE. *Lent by Miss Fitzgerald.*
220. LANDSCAPE : RIVER SCENE. *Lent by Miss Fitzgerald.*
228. LANDSCAPE. *Lent by Miss Fitzgerald.*
246. VIEW IN THE PARK. *Lent by Miss Fitzgerald.*

IRISH INSTITUTION, 1859.

69. RIVER SCENE. *Lent by the Earl of Charlemont.*
75. VIEW IN CONNEMARA. *Lent by Wm. Jenkins, Esq., LL.D.*
134. WOODY LANDSCAPE—RIVER SCENE. *Lent by Col. Chidley Coote.*

ROYAL DUBLIN SOCIETY EXHIBITION OF FINE ARTS, 1861.

5. POWERSCOURT WATERFALL. *Lent by Captain Shedden.*
19. A GLEN SCENE. *Lent by Captain Shedden.*
88. LANDSCAPE, CO. WICKLOW. *Lent by B. Watkins, Esq.*
227. LANDSCAPE. *Lent by J. H. Read, Esq.*
229. A LAND STORM. *Lent by Captain Shedden.*
264. A SEA VIEW. *Lent by — Taylor, Esq.*
291. LANDSCAPE. *Lent by J. A. Journeaux.*
297. LANDSCAPE. *Lent by George Austin, Esq.*
301. LANDSCAPE. *Lent by J. A. Journeaux.*

ROYAL DUBLIN SOCIETY EXHIBITION OF FINE ARTS, 1864.

241. LANDSCAPE. *Lent by E. H. Madden, Esq.*
256. MOONLIGHT. *Lent by Captain Shedden.*
270. VIEW OF CASTLE PRIORY. *Lent by T. Geoghegan, Esq.*

DUBLIN INTERNATIONAL EXHIBITION, 1865.
MODERN ARTISTS.

30. THE CADI'S COURT.
79. LANDSCAPE. *Lent by Mrs. Atkinson.*

Note.—Both these pictures are described in the Catalogue simply as by " O'Connor."

ANCIENT MASTERS.

62. LANDSCAPE. *Lent by Henry Devit.*

DUBLIN EXHIBITION OF ARTS AND INDUSTRIES, 1872.

198. LANDSCAPE. *Lent by the Right Hon. More O'Ferrall.*
207. LANDSCAPE. *Lent by the Right Hon. More O'Ferrall.*
213. VIEW IN CASTLE COOTE DEMESNE. *Lent by C. Bennett, Esq.*
 Note.—Sold August 17th, 1918. Now in the Collection of the Right Hon. Lord Justice O'Connor. Illustrated in this book.
214. THE DEVIL'S GLEN. *Lent by Captain Shedden.*
 Note.—Now in the National Gallery of Ireland.
218. LANDSCAPE. *Lent by the Right Hon. More O'Ferrall.*
256. LANDSCAPE. *Lent by Captain Shedden.*
259. POWERSCOURT WATERFALL. *Lent by Captain Shedden.*
260. FROST PIECE. *Lent by C. Bennett, Esq.*
261. STORMY EVENING IN THE WOOD. *Lent by Captain Shedden.*
262. THUNDERSTORM. *Lent by Captain Shedden.*
263. IN THE VALE OF GLENMALURE. *Lent by Captain Shedden.*
264. MOONLIGHT. *Lent by Captain Shedden.*
265. VIEW IN COUNTY WICKLOW. *Lent by Captain Shedden.*
266. VIEW IN COUNTY WICKLOW. *Lent by Captain Shedden.*
268. LANDSCAPE. *Lent by Col. Chidley Coote.*

DUBLIN LOAN MUSEUM OF ART TREASURES, 1874.

486. LANDSCAPE. *Lent by Col. Chidley Coote.*

WREXHAM, 1876.

496. WATERFALL. *Lent by Mr. Potts.*
808. TREES. (A DRAWING.) *Lent by J. W. Safe.*

CORK EXHIBITION, 1883.

389. THE GAP OF BARNAGHEE, CO. MAYO. *Lent by Sir Thornley Stoker.*
400. CASTLE CARROW, CO. MAYO. *Lent by Sir Thornley Stoker.*

Note.—Both sold November 8th, 1910. Now in the collection of the Hon. Gerald FitzGerald, K.C., Judicial Commissioner.

LOAN EXHIBITION AT CLYDE ROAD VICARAGE, DUBLIN, 1884.

47. LANDSCAPE. *Lent by Canon Smith.*
56. LANDSCAPE. *Lent by Canon Smith.*

CENTURY OF BRITISH ART, GROSVENOR GALLERY, 1887-88.

55. LANDSCAPE WITH A FIGURE IN A RED CLOAK.
 Lent by Richard Gibbs, Esq.
270. A MOUNTAIN SCENE. *Lent by Richard Gibbs, Esq.*

MANCHESTER (JUBILEE EXHIBITION), 1887.

1. PENTONVILLE BY SUNSET. *Lent by Isaac Holden.*
224. MARKET PLACE, VINCENZA. *Lent by Isaac Holden.*

Note.—O'Connor was never in Italy. These pictures are attributed in the catalogue of the exhibition to J. O'Connor. Though Mr. Algernon Graves, in his *A Century of Loan Exhibitions*, assigns them to James H. (*sic*) O'Connor, I think they must have been painted by John O'Connor, A.R.H.A. (1830-1889).

IRISH EXHIBITION IN LONDON, 1888.

178. LAKE SCENE : SUNSET. *Lent by W. M. King, Esq.*
179. TWILIGHT. *Lent by George Andrews, Esq.*
180. LANDSCAPE. *Lent by M. H. Colnaghi, Esq.*
181. WOOD, ROAD SCENE. *Lent by M. H. Colnaghi. Esq.*

182. LANDSCAPE WITH FIGURES AND SHEEP. *Lent by M. H. Colnaghi, Esq.*

183. COAST VIEW: SUNSET. *Lent by M. H. Colnaghi, Esq.*

184. MOONLIGHT. *Lent by George Andrews, Esq.*

185. LANDSCAPE WITH FIGURES. *Lent by M. H. Colnaghi, Esq.*

186. LANDSCAPE AND WATERFALL: A PICNIC PARTY.
Lent by W. M. King, Esq.

187. LANDSCAPE: BAY OF NAPLES IN DISTANCE.
Lent by Stephenson Clarke, Esq.

188. LANDSCAPE: MOONLIGHT SCENE. *Lent by M. H. Colnaghi, Esq.*

189. LANDSCAPE AND WATERFALL WITH HIGHLANDER.
Lent by W. M. King, Esq.

190. WOODY LANDSCAPE WITH FIGURE IN FOREGROUND.
Lent by M. H. Colnaghi, Esq.

191. MOUNTAIN AND LAKE SCENE: WAGGONHORSE, AND FIGURE ON ROAD. *Lent by M. H. Colnaghi, Esq.*

192. MOONLIGHT SCENE. *Lent by M. H. Colnaghi, Esq.*

193. NORWOOD GIPSIES: A SKETCH ON THE SITE OF THE CHRYSTAL (*sic*) PALACE. *Lent by W. M. King, Esq.*

195. SUNSET. *Lent by George Andrews, Esq.*

196. SHORE SCENE: SUNSET. *Lent by M. H. Colnaghi, Esq.*

197. MORNING: IRELAND'S EYE IN THE DISTANCE.
Lent by George Andrews, Esq.

210. LANDSCAPE. *Lent by M. H. Colnaghi, Esq.*

211. NEAR TEMPLEOGUE, CO. DUBLIN. *Lent by George Andrews, Esq.*

EARLSCOURT EXHIBITION, 1897.

4. PEASANT AND DOG. *Lent by the Countess of Normanton.*

WORKS BY IRISH PAINTERS AT THE GUILDHALL, LONDON, 1904.

98. THE POACHERS. *Lent by the National Gallery of Ireland.*
Note.—Illustrated in the official catalogue.

103. LANDSCAPE. *Lent by the Right Hon. Jonathan Hogg, P.C., D.L.*

MUNSTER-CONNACHT EXHIBITION, LIMERICK, 1906.

18. LANDSCAPE. *Lent by the Right Hon. Jonathan Hogg.*
26. LANDSCAPE. *Lent by the Right Hon. Jonathan Hogg.*

ᴄᴀɪꜱᴅᴇᴀ́ɴᴄᴀꜱ ᴀɴ ᴏɪꞃᴇᴀᴄ́ᴄᴀɪꜱ
DUBLIN, 1911

1. MOONLIT LANDSCAPE. *Lent by Miss Mansfield.*
2. LANDSCAPE. *Lent by Prof. J. M. O'Sullivan.*
3. „ *Lent by Prof. J. M. O'Sullivan.*

WHITECHAPEL ART GALLERY, 1913.
IRISH ART.

22. LANDSCAPE. *Lent by the Maharajah Gaekwar of Baroda, G.C.S.I.*
23. LAKE SCENE. *Lent by Col. J. L. Rutley, V.O.*
26. LANDSCAPE. *Lent by the Right Hon. Jonathan Hogg.*
138. FRAME CONTAINING FOUR SKETCHES.
 Lent by the National Gallery of Ireland.
155. FRAME CONTAINING FOUR SKETCHES.
 Lent by the National Gallery of Ireland.

THE NATIONAL GALLERY OF IRELAND, 1918.

POWERSCOURT WATERFALL. 6 in. x 8 in. Millboard.
 Lent by Captain R. Langton Douglas.
THE STORM. 12 in. x 14 in. Signed, and dated 1839.
 Lent by Captain R. Langton Douglas.
 Note.—Now in the possession of the author.
THE DEVIL'S GLEN. 25 in. x 30½ in.
 Lent by Captain R. Langton Douglas.
 Note.—Now in the permanent collection of the National
Gallery of Ireland. Presented by Captain Douglas.
A SCENE IN WICKLOW. 4½ in. x 5½ in. Millboard.
 Lent by Captain R. Langton Douglas.
 Note.—Now in the collection of Henry MacDermott, Esq., K.C.

APPENDIX IX.

A SELECTION OF PRICES REALISED FOR WORKS
BY J. A. O'CONNOR,
AT AUCTION SALES SINCE HIS DEATH.

Note.—Most of these prices are a good deal above the average for works by O'Connor. His pictures fetch at auction, as a rule, not more than a couple of pounds, particularly when, as sometimes happens, they are unsigned.

L. Redpath's Sale, 1857.

WATERFALL AND ROCKY RAVINE. £86 2 0

Hill's Sale, 1875.

A FOREST SCENE WITH FIGURES. £120 15 0

" Christie's " Sale, 1872.

MOONLIGHT. 7 in. x 6½ in. Signed. £12 0 0
Note.—Now in the National Gallery of Ireland.

" Christie's " Sale, 1873.

A VIEW IN THE GLEN OF THE DARGLE. 26½ in. x 31¾ in.
Signed, and dated 1834. £31 0 0
Note.—Now in the National Gallery of Ireland.

W. B. White's Sale, 1879.

WOODY RIVER SCENE. £110 5 0

Messrs. Bennett and Son's Sale, Dublin, 16th May, 1907.
VIEW ON THE SAAR, RHENISH PROVINCES. Signed, and dated
1833 £7 10 0

" Christie's " Sale, December 2nd, 1907.
A WOODY LANDSCAPE. 24 x 29 £2 2 0

" Christie's " Sale, December 6th, 1909.
LANDSCAPE WITH FIGURES, WICKLOW, IRELAND. 19 x 23¼ ... £2 12 6

Messrs. Bennett and Son's Sale, Dublin, March 10th, 1910.
(From the collection of Sir E. Hudson Kinahan.)
STREET SCENE, MOONLIGHT. £10 10 0

" Christie's " Sale, June 10th, 1910.
LANDSCAPE (1839). 19 x 23¼ £3 13 6
LANDSCAPE AND RIVER VIEW, MAN FISHING. £10 15 0

Messrs. Bennett and Son's Sale, Dublin, 8th November, 1910.
(From the collection of Sir Thornley Stoker.)
GAP OF BARNAGHEE, CO. MAYO. 17 in. x 12 in. £20 0 0
CASTLE CARROW, LOUGH CARROW. 17 in. x 12 in. £21 0 0
Note.—Both abovementioned works are now in
the collection of the Hon. Gerald FitzGerald, K.C.,
Judicial Commissioner.
LANDSCAPE. 7 in. x 6 in. Upright £3 0 0
VIEW IN CO. MAYO. Signed " J. A. O'Connor." 14 in. x 11 in. £5 5 0
Note.—Both abovementioned works are now in
the collection of Professor J. M. O'Sullivan,
M.A., PH.D.

Messrs. Bennett and Son's Sale, Dublin, June 20th, 1911.
(From the collection of Ambrose More O'Ferrall.)
WOODED LANDSCAPE : WATERFALL AND FIGURES. Signed,
and dated 1830 £10 0 0
LANDSCAPE, WITH CASTLE TO THE LEFT AND FIGURES IN
THE FOREGROUND. Signed, and dated 1838 ... £31 10 0

LANDSCAPE AND RIVER VIEW, WITH MOUNTAINOUS BACK-
GROUND. Signed, and dated 1830 £12 0 0

LANDSCAPE : MOONLIGHT. £15 0 0

" Christie's " Sale, April 17th, 1914.

RIVER SCENE WITH FIGURES BY J. A. O'CONNOR, 1828 ; AND
A LANDSCAPE ON PANEL BY P. DE LOUTHERBOURG,
R.A. (together) £7 7 0

Messrs. Bennett and Son's Sale, Dublin, October 22nd, 1917.
(From the collection of Sir John Olphert.)

MOUNTAINOUS LANDSCAPE, WITH FIGURE IN THE FORE-
GROUND. Signed £21 0 0

Messrs. Bennett and Son's Sale, Dublin, August 17th, 1918.

VIEW IN CASTLE COOTE DEMESNE. Signed, and dated 1840. £44 2 0
Note.—Illustrated in this book.

Messrs. Bennett and Son's Sale, Dublin, November 5th, 1919.

LANDSCAPE WITH FIGURE. Signed with initials £21 1 0

LANDSCAPE WITH FIGURES. Signed " J. A. O'Connor
183(2 ?)." £8 8 0
Note.—Illustrated in this book.

APPENDIX X.

WORKS BY WALTER FREDRICK OSBORNE, R.H.A., FORMING PART OF PUBLIC COLLECTIONS.

THE NATIONAL GALLERY OF IRELAND.

553. THE LUSTRE JUG. 2 ft. 6 in. H. x 2 ft. W. Three little girls leaning
over a tea-table, one of them holding a brown lustre jug. Purchased
in 1903.

554. A GALWAY COTTAGE. 1 ft. H. x 1 ft. 3 in. W. Panel. Interior of a cottage, with a man and woman seated by the fire. Purchased in 1903.

612. A SKETCH AT RYE. 5 in. H. x 8¾ in. W.
Bequeathed by Miss Charlotte O'Brien, 1910.

635. A COTTAGE GARDEN. 26½ in. H. x 19½ in. W. A corner of a garden, with a group of white lilies and other flowers in the foreground. Purchased in 1912.

555. WALTER FREDRICK OSBORNE, R.H.A., OIL PICTURE, BY HIMSELF. Head only ; full face.
Presented by his mother, Mrs. Wm. Osborne, in 1903.

601. SIR THOMAS W. MOFFETT, LL.D. Oil Picture. 7 ft. H. x 5 ft. W. Full length, seated at a table, in robes as LL.D.
Presented by Lady Moffett.

SIR FREDERICK FALKINER.

2535. THE DOLL'S SCHOOL. Water Colour. Purchased in 1903.

2536. THE HOUSE BUILDERS. Water Colour. Purchased in 1903.

2538 to 2549. SKETCHES. Twelve Sketches and Studies in Pencil. Purchased in 1903.

2628. RYE HARBOUR. Indian Ink Wash. Purchased in 1907.

2682. PORTRAIT OF JOHN HUGHES, R.H.A. Water Colour Sketch.
Bequest of Sir Thornley Stoker, 1912.

2550. MARGARET STOKES. Sketch in Chalks. Purchased in 1903.

2350. THOMAS HENRY BURKE. Pencil Sketch. Done partly from an oil picture by Augustus Burke (also the property of the Gallery, but not publicly exhibited) and partly from photographs and memory. It is an excellent likeness.
Presented by the Artist in 1899.

(*From the Official Catalogue.*)

Notes.—(i.) No. 553 is in oils on canvas, and was purchased on November 19th, 1903, from the artist's executors, together with Nos. 554, 2535, 2536—which are all signed in full—and 2538 to 2549, for the sum of £131 16s. (ii.) No. 612 measures 5 in. x 8½ in., and is not at present publicly exhibited. It represents a few people resting on a long, curved seat, bordering a sunny path, with a mill in the background. (iii.) The frame of No. 635 is inscribed with the title " Lillies." It is signed in full : and was purchased for £25 from Mrs. E. Catterson Smith. (iv.) No. 555

measures 17 in. high x 13½ in. long, and is signed in full. (v.) The
portrait of Sir Frederick Falkiner, K.C., late Recorder of Dublin,
is in oils on canvas, signed in full, and measures 45½ in. x 38 in.
(sight measurements). It is lent to the gallery by the Rev. Travers
Falkiner. (vi.) No. 2535 measures 17¾ in. x 23 in., and No. 2536
measures 18½ in. x 23 in. ; both are signed in full, and dated,
respectively, 1900 and 1902. (vii). Nos. 2538 to 2549 are as
follows :—(inscriptions in inverted commas are from Osborne's
autograph).

2538. " HASTINGS 20/11/91. Clouds working up sky seen through warm
clouds cold at base. Glow on houses." It is a study for the picture
" Punch and Judy on the sands, Hastings," exhibited in the
Royal Hibernian Academy, 1892. 9½ in. x 7 in.

2539. OLD PATRICK STREET. 9½ in. x 7 in.

2540. STUDY OF OLD PEASANT MAN, " battered top hat turning green,
old blue cloth coat and waistcoat, Corduroy trousers & Frieze
stockings." 9½ in. high x 7 in. long.

2541. OLD PEASANT WOMAN. " White cap, black cloak, plaid shoulder
shawl." 9½ in. x 7 in.

2542. " GALWAY 2/9/93." Study of fisherwomen and men. 7 in. x 9½ in.

2543 STUDY OF FISH-WIFE FOR PICTURE ENTITLED " THE FISH MARKET,"
now in the Dublin Municipal Gallery of Modern Art. 7 in. x 9½ in.

2544. STUDY FOR THE PICTURE ENTITLED " MOTHER AND CHILD," now in
the Dublin Municipal Art Gallery. 6½ in. x 4 in.

2545. STUDY OF STREET SCENE. 5 in. x 7 in.

2546. STUDY OF STREET SCENE. " Heads near on level with bottom of
distant brick." 5 in. x 7 in.

2547. STUDY OF TWO COWS, with pencilled colour notes. 7 in. x 9½ in.

2548. STUDY OF FLOWER GIRLS. 7 in. high x 5 in. long.

2549. STUDY OF FIGURES ON THE BENCHES IN STEPHEN'S GREEN. Pencilled
colour notes and " Shabby women resting shady side." 7 in. x
9½ in. Osborne painted several pictures of similar scenes.

All above are in pencil.

(viii.) No. 2628 measures 14 in. high x 9 in. long, and is signed
in full. It was purchased for £5 5s. from Charles Russell, R.H.A.
(ix.) No. 2682 measures 23 in. high x 17¾ in. long. It is inscribed :
" This is my portrait by Walter Osborne one of the last pictures
he painted. Presented by me to Lady Stoker, May, 1903. John

Hughes." The sculptor is shown working at his group, " Orpheus and Eurydice." (x.) No. 2550 is an oval sketch in red and black chalks, and measures 20 in. x 15½ in. (xi.) No. 2350 measures 11 in. x 8½ in.

There is also in the National Gallery of Ireland a portrait in oils of

EDWARD DOWDEN, LL.D.,

on canvas, measuring 37¾ in. x 29½ in., signed in full. It was presented in 1916 by Miss Hilda Dowden, and is not yet catalogued. It was exhibited by Osborne in the Royal Hibernian Academy exhibition of 1891.

THE NATIONAL GALLERY OF BRITISH ART : THE TATE GALLERY.

1712. LIFE IN THE STREETS : HARD TIMES. In an old Dublin street, near St. Patrick's Cathedral a man with blue apron sits smoking a clay pipe on an old box in the gutter in charge of his barrow of oranges and apples ; notwithstanding the wet and slush, the people gather round an old woman's stall of earthenware, jugs and tea-pots ; snow is on roofs and awnings, and a church tower is seen against the sky which is clearing.—Signed " Walter Osborne." Pastel. 21½ x 14. Ex R.A. and Chantrey Purchase, 1892.

(From the Official Catalogue.)

BRITISH MUSEUM : DEPARTMENT OF PRINTS AND DRAWINGS.

UNCATALOGUED ETCHINGS.

(From particulars kindly given by Cambell Dodgson, ESQ., O.B.E., Keeper of the Department of Prints and Drawings.)

1. " THE FLEMISH CAP." Plate, 8¾ in. x 6 in. Head of old woman looking down towards the left, in large white cap, with flaps covering her ears and hanging over the shoulders. Signed, near the top left corner, " F. W. Osborne, 1882."

2. HEAD OF TERRIER. Plate, 6⅝ in. x 5¾ in. Signed towards the left, low down, " F. W. Osborne."

 Note.—Both were etched on zinc, and are said to have been done at Antwerp when Osborne was studying with Verlat. They were presented in January, 1902, by Dr. Wm. Booth Pearsall.

THE CORPORATION OF LONDON GALLERY, THE GUILDHALL, LONDON.

829. An October Morning. Oil Painting. Canvas, 28 in. x 36 in. Presented in 1904 by a Community of Artists, represented by A. Chevallier Tayler, R.B.A., Honorary Secretary of the Memorial Committee, as a memorial of the esteem and regard in which the late Walter Osborne was held by them. Their names are as follows :—

E. A. Abbey, R.A.
Sir Lawrence Alma-Tadema, R.A., O.M.
Austin Batchelor.
Frank Baxter.
Reginald Blomfield, A.R.A.
Percy J. Bovill.
Robert Brough, A.R.A. (the late).
Amesby Brown, A.R.A.
Gerald Chowne.
J. Ronald Clive.
T. Watt Cope.
Herbert J. Draper.
Alfred Drury, A.R.A.
Joseph Farquharson, A.R.A.
Stanhope A. Forbes, R.A.
Henry J. Ford.
George Gascoyne, R.E.
T. C. Gotch.

Fred Hall.
Herbert Hampton.
Everart Hopkins.
R. M. Hughes.
G. P. Jacomb-Hood, R.O.I.
The Hon. Walter J. James.
H. H. La Thangue, A.R.A.
L. W. Lund.
H. L. Morris.
L. C. Nightingale.
Alfred Parsons, A.R.A.
John R. Reid, R.I., R.O.I.
Edward Stott, R.A.
Arthur Studd.
G. Hillyard Swinstead, R.I., R.B.A.
F. H. Townsend.
H. S. Tuke, A.R.A.
Spencer Watson.

(*From the Official Catalogue.*)

THE PRESTON CORPORATION ART GALLERY.

218. Summer Time. Canvas, 41½ in. x 47 in. Purchased by the Corporation, 1901.

(*From the Official Catalogue, in which an illustration appears.*)

Note.—Mr. W. B. Barton, the Director of the Gallery informs me that this picture was bought at the Royal Academy exhibition of 1901, and, in a very interesting descriptive note, which I wish I had space to quote at length, tells me that the scene of the picture is said to be laid in the Phœnix Park.

THE DUBLIN MUNICIPAL GALLERY OF MODERN ART.

12. THE FISHMARKET. Canvas, 24 in. x 31 in. The old Fish Market, Patrick Street, demolished to make room for Lord Iveagh's buildings. *Lane Gift.*

34. TEA IN THE GARDEN. A large study. *Lane Gift.*

35. MOTHER AND CHILD. 17¼ in. x 13¼ in. *Lane Gift.*

(From the Official Catalogue, which has been out of print for many years.)

Note.—No. 12 is now wrongly entitled. Osborne called it " Life in the Streets-Musicians." It is signed, " Walter Osborne, 93." No. 34 measures 67½ in. x 54 in. No. 35 is illustrated in the Catalogue.

Since the Catalogue has been out of print the following items have been added to the Collection :—

(i.) THE CORNFIELD. 14 in. x 10¾ in.
Presented by Dr. Travers R. M. Smith.

(ii.) ROCKS IN SUNSHINE. 5¾ in. x 4¾ in.
Lent by J. B. S. MacIlwaine, Esq., R.H.A.

(iii.) PORTRAIT OF J. B. S. MACILWAINE, ESQ., R.H.A. 19 in. x 23 in. Signed in full. *Lent by J. B. S. MacIlwaine, Esq., R.H.A.*

(iv.) PORTRAIT OF COLONEL MAURICE MOORE. 23¼ in. x 27½ in.
Presented by Colonel Moore.

(v.) PENCIL DRAWING OF MISS MAUD GONNE, NOW MADAME GONNE MACBRIDE. 5¾ in. x 9 in. *Presented by Cecil Armstrong, Esq.*

(vi.) PENCIL DRAWING : MRS. MACILWAINE AND HER SON, J. B. S. MACILWAINE, ESQ., R.H.A. 9½ in. x 7 in.
Lent by J. B. S. MacIlwaine, Esq., R.H.A.

(vii.) PASTEL PORTRAIT OF MRS. MACILWAINE. 9¾ in. x 14½ in.
Lent by J. B. S. MacIlwaine, Esq., R.H.A.

(viii.) PORTRAIT OF MRS. G. FORBES BIRDWOOD. 3 ft. 1 in. x 2 ft. 3 in.
Lent by Mrs. French.

Note.—No. (iii.) is inscribed " To my friend, J. B. S. MacIlwaine, 1892 "; No. (iv.) is signed in full; No. (v.) is dated 1/11/'95; No. (vi.) is dated 15/10/'92.

The particulars not appearing in the Catalogue, I owe, for the most part, to the courtesy of Mrs. Duncan, the Curator of the Gallery.

APPENDIX XI.

WORKS BY WALTER FREDRICK OSBORNE, R.H.A.,

EXHIBITED IN HIS LIFETIME.

Note.—The particulars in this appendix are derived, largely, from Osborne's own catalogues, which were presented by his mother soon after his death to the National Gallery of Ireland. Osborne was an excellent business man, and his collection of the catalogues of those exhibitions in which his own work was shown is almost complete. This is fortunate, for it is a regrettable fact that those in control of public libraries, including even the British Museum, do not bother to complete sets of catalogues of important, picture exhibitions. The want of anything like a complete set of catalogues of Irish picture exhibitions has proved an immense difficulty in the preparation of this book.

Osborne, as will be seen, was accustomed to keep his unsold pictures moving about. I have noted, as far as is possible without making this appendix unduly bulky, the various peregrinations of each individual work during his lifetime ; and have, with that object, begun this appendix with the record of pictures shown by him at the exhibitions of the Royal Hibernian Academy. For these exhibitions, sooner or later, included the majority of his principal works.

ROYAL HIBERNIAN ACADEMY.

5 Castlewood Avenue, Rathmines, E. Dublin.

1877.—312. NORAH.		£5 0 0
1878.—458. STUDY OF OLD ANCHOR WHITEPOINT, QUEENS-TOWN.		£3 0 0
460. VIEW FROM WHITEPOINT, QUEENSTOWN.		£3 0 0
488. HEAD OF A SCOTCH COLLIE DOG.		£8 0 0
1879.—360. THE MORNING MEAL.		£15 15 0

1880.—160. HEAD OF FOX TERRIER. £5 5 0

259. A GLADE IN THE PHŒNIX PARK. £20 0 0

Note —Awarded the Albert Scholarship for 1880. Sold, October 15th, 1918, for 72 Guineas. Now in the Collection of M. Barrington Jellett, Esq., J.P.

283. HUSSY. £5 5 0

555. STUDY OF A TIGER'S HEAD FROM LIFE. ... £5 5 0

1881.— 66. ZOE : A STUDY FROM LIFE. £7 0 0

Note.—The Osbornes' fox terrier.

221. THE BEST ASS IN THE PARISH. £15 0 0

360. ROUGH AND READY. £20 0 0

361. " THE SLEEPY POOL ABOVE THE DAM "—
TENNYSON. £20 0 0

624. PEPPER. £7 0 0

1882.— 80. PORTMARNOCK FROM HOWTH. £10 0 0

147. TENANTLESS. £10 0 0

273. PATH ROUND THE CLIFFS, HOWTH. £10 0 0

303. BARNEY.

587. OLD FISHING BOATS, BALDOYLE £5 0 0

608. LEAVES FROM A SKETCH BOOK, COAST CO.
DUBLIN. £8 0 0

1883.— 48. BENEATH ST. JAQUES, ANTWERP. £30 0 0

85. A SKETCH IN THE WOOL MARKET, BRUGES. ... £8 8 0

102. A CORNER OF AN OLD ALMSHOUSE, BRUGES. ... £30 0 0

129. A TEMPTING BAIT. £30 0 0

Note.—Shown in the previous year at the Walker Art Gallery, Liverpool, priced £42. Sold August 1st, 1916, for £14 10s. and again March 26th, 1920, for £29 8s.

144. A GARDEN PARTY. £21 0 0

150. THE PUMP OF ST. NICHOLAS, ANTWERP. ... £10 0 0

174. THE INTERIOR OF A COWSHED, MERZEM, NEAR
ANTWERP. £15 0 0

284. A MOMENT OF REST—SKETCH IN A CORN MILL NEAR ANTWERP £10 0 0

290. A SUNNY DAY AT AN OLD BELGIAN FARMSTEAD. £15 0 0

324. A HOME ON THE WATERS, BRUGES. £15 0 0

629. ANTWERP FROM A BEND OF THE SCHELDT. ... £5 5 0

1884.— 63. IN THE SUNLIGHT, PONT AVEN. The property of W. Geale Wybrands, Esq., J.P.

83. DRIVING A BARGAIN. £31 10 0

90. APPLE GATHERING, QUIMPERLE, BRITTANY. ... £31 10 0

> *Note.*—Shown in the same year at the Walker Art Gallery, Liverpool.

99. A GREY MORNING IN A BRETON FARMYARD. —

> *Note.*—Shown in the same year at the Walker Art Gallery, Liverpool.

154. IN THE MARKET PLACE OF BRUGES. £20 0 0

220. LA RUE DE L'APPORT, DINAN. £15 15 0

243. AN INTRUDER. £12 12 0

256. EARLY MORNING IN THE MARKETS, QUIMPERLE. £21 0 0

268. MARIE. A SKETCH. £8 8 0

> *Note.*—Shown in 1903, under the title, "A Brittany Girl," at the memorial exhibition of the artist's works. Afterwards in the collection of Nathaniel Hone, R.H.A. Now in the possession of Edmond Lupton, Esq., K.C.

283. A NOVEMBER MORNING, QUIMPERLE. ... £8 8 0

296. A HILLY STREET, DINAN. £12 12 0

309. PONT AVEN, FROM THE RIVER. £9 9 0

> *Note.*—Shown in the same year at the Walker Art Gallery, Liverpool, priced £10 10s.

323. A NARROW STREET, QUIMPERLE. £10 10 0

> A prize in the Irish Art Union Drawing, won by the Earl of Wicklow.

333. SUNSHINE AND SHADOW, DINAN. £21 0 0

361. A SKETCH IN THE MARKETS, QUIMPERLE. ... £8 8 0

1885.— 58. THE POACHERS. £42 0 0
 Note.—Shown in the same year at the
 Walker Art Gallery, Liverpool ; priced £30.

96. A TALE OF THE SEA. £36 15 0
 Note.—Illustrated in the *Dublin University
 Review Art Supplement* 1886, from a pen-and-
 ink sketch by the artist.

150. WALBERSWICK, EARLY MORNING. £21 0 0
187. ON THE SANDS, SOUTHWOLD. £9 9 0
188. IN A SUFFOLK GARDEN. £15 15 0
233. LINCOLN FROM THE WITHAM. £8 8 0
484. A CORNER OF THE PLANTYN MUSEUM, ANTWERP. £9 9 0
522. IN THE MEADOW. £8 8 0

1886.— 58. PRIMARY EDUCATION. £36 15 0
161. COUNTING THE FLOCK. £20 0 0
 Note.—Shown in the same year at the
 Walker Art Gallery, Liverpool ; priced £15.

258. SPOILED PETS. £15 15 0
 Note.—Illustrated in the *Dublin University
 Review Art Supplement* 1886, from a pen-and-
 ink sketch by the artist.

362. ON THE HAMPSHIRE DOWNS. £6 6 0
 Note.—Shown in the same year at the
 Walker Art Gallery, Liverpool ; priced £20.
 Also shown in 1887 at the Grosvenor Gallery.

365. ROMSEY ABBEY FROM THE GARDENS. £5 5 0
383. STRATFORD-ON-AVON, FROM THE MEADOWS. £5 5 0
434. ROMSEY ABBEY FROM THE GARDENS. £5 5 0

1887.— 9. TIRED OUT. £50 0 0
 Note.—Shown in the same year at the
 Walker Art Gallery, Liverpool ; priced £45.
 Shown in the previous year at the Royal
 Academy exhibition.

184. WHO'LL BUY. £20 0 0
 Note.—A prize in the Irish Art Union
 Drawing, won by Miss Close, Scotch Quarter,
 Carrickfergus.

220. PASTEL STUDY. £10 0 0
272. THE CLOISTERS, LINCOLN CATHEDRAL. ... £15 0 0

Note.—Shown in 1885 at the Walker Art Gallery, Liverpool; priced £15 15s. Also shown in 1884 at the exhibition of the Institute of Painters in Oil Colours.

300. ON THE SUFFOLK SANDS. £25 0 0

Note.—Shown at the Walker Art Gallery, Liverpool, in the same year; priced £20.

314. THE LAZY MODEL. £10 0 0
316. A NEW PET. £10 0 0

Note.—A prize in the Irish Art Union drawing, won by T. D. Ingram, Esq., Wellington Road, Dublin.

1888.— 49. OCTOBER BY THE SEA. £50 0 0

Note.—Shown in the same year at the Walker Art Gallery, Liverpool; priced £40.

58. INTRUDERS. £25 0 0

Note.—Shown in the same year at the exhibition of the Royal Birmingham Society of Artists; priced £20.

93. THE LOCK GATES. £31 10 0

Note.—Shown in the same year at the Walker Art Gallery, Liverpool.

95. NEAR ST. PATRICK'S CLOSE.—AN OLD DUBLIN STREET. £42 0 0

Note.—Shown in 1887 at the Walker Art Gallery, Liverpool; priced £50. Shown in the previous year at the Royal Academy exhibition.

115. BED-TIME. £9 9 0
131. HOMEWARDS. £21 0 0
205. GOSSIPS—A PASTEL STUDY. £25 0 0
246. WILLIAM OSBORNE, R.H.A. A PORTRAIT SKETCH —PASTEL.
272. BIRD NESTING. £12 12 0

1889.— 11. FAST FALLS THE EVENTIDE. £26 5 0

21. IDLE SHEPHERDS. £42 0 0

Note.—Shown in the same year at the Walker Art Gallery, Liverpool; priced £31 10s.

46. A BACHELOR'S GARDEN. £36 15 0

Note.—Shown in the same year at the exhibition of the Royal Birmingham Society of Artists; priced £26 5s.

109. LOST SHEEP. £21 0 0

138. SHY. £25 0 0

188. CATS—A PASTEL STUDY. £21 0 0

218. ANTHONY H. CORLEY, Esq., M.D., F.R.C.S.I.

220. LOITERERS. £15 15 0

1890.—107. A CHILDREN'S SERVICE. £21 0 0

Note.—Shown in the previous year at the exhibition of the Royal Birmingham Society of Artists.

109. LOW TIDE. £15 15 0

199. BOAT BUILDERS. £25 0 0

Note.—Shown in the previous year at the exhibition of the Institute of Painters in Oil Colours.

215. PLOUGHLAND. £21 0 0

236. EVENING LIGHT. The property of E. T. Bewley, Esq., Q.C.

1891.— 32. THE FERRY. £84 0 0

Note.—Shown in the previous year at the exhibition of the Royal Academy and at the Walker Art Gallery, Liverpool; where it was priced £105. Later in 1891 it was shown at the exhibition of the Royal Birmingham Society of Artists, and there priced £84. It was also shown in Chicago exhibition of 1893. Now in the possession of the Right Hon. Jonathan Hogg, P.C. Illustrated in this book; in Henry Blackburn's *Academy Notes* 1890, from a pen-and-ink sketch by the artist; and in *The*

World's Columbian Exhibition Art Gallery, 1893, published by G. Barrie at Philadelphia. A study for this picture is in the possession of Mr. Herbert Hone.

62. THE MICHAELMAS FAIR.	£21	0	0	
139. PROFESSOR DOWDEN, LL.D.	—			

> *Note.*—Now in the National Gallery of Ireland.

150. HUGH LANE (PASTEL)	—			

> *Note.*—Portrait of a Boy; not of the late Sir Hugh Lane.

222. THE END OF THE HARVEST.	£21	0	0	
224. HER GARDEN.	£10	10	0	
235. IN RURAL ENGLAND.	£21	0	0	
236. THE CHIMNEY CORNER—A STUDY.	£21	0	0	

> *Note.*—Shown in the same year at the exhibition of the Royal Birmingham Society of Artists; priced £15 15s.

1892.— 2. PARTING DAY.	£21	10	0	
5. SUNSHINE AND SHOWER.	£7	7	0	
87. JOE THE SWINEHERD.	£31	10	0	

> *Note.*—Shown in 1891 at the exhibition of the Royal Academy, and at the Walker Art Gallery, Liverpool, where it was priced £42. A picture with the same title was shown at the Dublin Art Club exhibition later in 1891, and priced £5 5s., probably a study for this.

99. PORTRAIT OF A LADY.	—			
140. T. DREW, ESQ., R.H.A.				
157. A NARROW THOROUGHFARE.	£26	5	0	

> *Note.*—Shown in the same year at the exhibition of the Royal Birmingham Society of Artists; priced £26 5s. Shown in the previous year at the exhibition of the Institute of Painters in Oil Colours; and illustrated in the catalogue. Shown in 1893 at the Walker Art Gallery, Liverpool, and there priced £25.

184. PASSING SHADOWS. £10 10 0
 Note.—Shown in the same year at the
 Walker Art Gallery, Liverpool ; priced £12 12s.

219. MISS STELLA DARLEY. —

234. THE TIMBER YARD. £15 15 0
 Note.—Shown in the same year at the
 exhibition of the Royal Birmingham Society
 of Artists.

261. HARVEST TIME. £15 15 0
 Note.—Shown in the previous year at the
 exhibition of the Royal Birmingham Society
 of Artists.

280. PUNCH AND JUDY ON THE SANDS—HASTINGS. £21 0 0
 Note.—Now in the collection of the Right
 Hon. Lord Justice O'Connor, P.C. Illustrated
 in this book. A pencil study for this picture
 is in the National Gallery of Ireland.

1893.— 15. " MISS MOLLIE," daughter of J. G. Nutting,
 Esq. —

47. WELCOME SHADE. £25 0 0
 Note.—Shown in the previous year at the
 Walker Art Gallery, Liverpool, and in 1891
 at the exhibition of the Institute of Painters
 in Oil Colours.

56. NO MAN'S LAND. £15 15 0
 Note.—Shown in the same year at the
 exhibition of the Royal Birmingham Society
 of Artists.

74. MISCHIEVOUS SPIRITS. £21 0 0

107. A QUIET HAVEN. £15 15 0
 Note.—Shown in the same year at the
 exhibition of the Royal Birmingham Society
 of Artists.

143. IN A VILLAGE STREET. £10 10 0

1894.— 8. THE FISH MARKET, GALWAY. £10 10 0

22. WHEN THE BOATS COME IN. £63 0 0
 Note.—Shown in 1892 at the Exhibition of
 the Royal Academy, and at the Walker Art

Gallery, where it was priced £100. Illustrated in Henry Blackburn's *Academy Notes* 1892, from a pen-and-ink sketch by the artist.

36. THE RT. HON. LORD JUSTICE FITZGIBBON. ...

113. MOONRISE. £21 0 0

> *Note.*—Shown in the same year at the exhibition of the Institute of Painters in Oil Colours.

154. MILKING TIME. £52 10 0

> *Note.*—Shown in 1893 at the Exhibition of the Institute of Painters in Oil Colours, and illustrated in the catalogue, at the exhibition of the Dublin Arts Club, priced £63 ; and in 1902, at the exhibition of the New English Arts Club. Illustrated also in *The Art Amateur*, volume 80, no. 1, December, 1893.

221. PORTRAIT OF A LADY. —

229. IN GALWAY TOWN. £10 10 0

239. A STUDY. —

258. PIPING TIMES. £26 5 0

> *Note.*—Shown in 1893 at the exhibition of the Institute of Painters in Oil Colours.

1895.— 47. THE THORN BUSH. £52 10 0

> *Note.*—28 in. x 36 in. Shown in the previous year at the exhibition of the Royal Academy. Now in the possession of Barrington Jellett, Esq., J.P. Sold in 1914. Illustrated in this book ; in Henry Blackburn's *Academy Notes* 1894, from a pen-and-ink sketch by the artist ; and in *The Palace of Fine Arts, Irish International Exhibition, A Folio of Famous Pictures,* 1907.

146. MRS. ABRAHAM STOKER.

> *Note.*—Shown in the previous year at the exhibition of the Royal Academy.

155. THE LATE ABRAHAM STOKER, ESQ. —

165. ON THE CANALS, AMSTERDAM. £10 10 0

> *Note.*—Shown in the previous year at the

exhibition of the Institute of Painters in Oil Colours.

206. IN THE STREETS, WINTRY WEATHER. £25 0 0

> *Note.*—Shown in 1893 at the Walker Art Gallery, Liverpool ; priced £26 5s.

1896.— 2. PORTRAIT OF A LADY. —

16. A VILLAGE FARM. £10 10 0

> *Note.*—Shown in the previous year at the exhibition of the Institute of Painters in Oil Colours. Illustrated in the catalogue and priced £13 13s.

19. MRS. BRAM STOKER. —

29. COLONEL H. MCCALMONT, C.B., M.P. —

115. ATLANTIC SHORES. £30 0 0

> *Note.*—Shown in the previous year at the exhibition of the Institute of Painters in Oil Colours ; priced £26 5s.

216. A SPANISH INN. £20 0 0

223. DOWN THE VILLAGE STREET. £10 0 0

> *Note.*—Shown in the previous year at the exhibition of the Institute of Painters in Oil Colours ; priced £13 13s.

237. LADY STOKER. —

1897.— 37. SIR THOMAS MOFFETT, LL.D., PRESIDENT OF QUEEN'S COLLEGE, GALWAY. —

> *Note.*—Now in the National Gallery of Ireland.

155. LOW TIDE. £21 0 0

240. AN OLD FOUNTAIN, MADRID. £25 0 0

> *Note.*—Shown in the same year at the exhibition of the Royal Birmingham Society of Artists ; priced £21.

1898.— 19. THE RT. REV. THE LORD BISHOP OF CASHEL. —

27. MRS. JOHN MULHALL. —
> *Note.*—Shown in 1896 at the exhibition of the Royal Academy.

81. WILLIAM OSBORNE, ESQ., R.H.A. —

Note.—44 in. x 34 in. Shown in the previous year at the exhibition of the Royal Academy. Illustrated in Blackburn's *Academy Notes* 1897, from a pen-and-ink sketch by the artist. Destroyed in the fire which consumed the Royal Hibernian Academy premises in the Rebellion of 1916. A reproduction of this picture, but cut to an oval shape, is in Mr. Strickland's *Dictionary of Irish Artists.*

132. A CONNEMARA VILLAGE, EVENING. £21 0 0

Note.—Shown in the previous year at the exhibition of the Institute of Painters in Oil Colours.

251. MASTER ARTHUR STUART BELLINGHAM AND HIS DOG, DICK. —

1899.— 6. MRS. NOEL GUINNESS AND HER LITTLE DAUGHTER. —

Note.—54 in. x 60 in. Shown in the previous year at the exhibition of the Royal Academy. Illustrated in Henry Blackburn's *Academy Notes* 1898, from a pen-and-ink sketch by the artist; in Cassell's *Royal Academy Pictures* for the same year, in half-tone process; in the catalogue of the Guildhall Loan exhibition, 1904, in photogravure; and in *Great Pictures in Private Collections*, Cassell, 1904, in colour.

34. J. HATCHELL, ESQ., D.L. —

115. MISS HONOR O'BRIEN. —

Note.—Osborne has a particular regard for this portrait, which is one of his best. Shown in the previous year at the Royal Academy exhibition and at the Walker Art Gallery, Liverpool.

150. A CONNEMARA VILLAGE—THE WAY TO THE HARBOUR. £25 0 0

Note.—Shown in the previous year at the exhibition of the Society of Oil Painters; illustrated in catalogue and priced £31 10s.

253. IN A FREE LIBRARY. £42 0 0

 Note.—A scene in Marsh's Library, Dublin. Shown in the same year at the Walker Art Gallery, Liverpool. Shown in the previous year at the exhibition of the Society of Oil Painters, priced £47 5s. Now in the author's possession.

1900.— 1. MISS GLADYS THOMPSON. —

 Note.—Shown in the year following at the exhibition of the Royal Academy.

21. MRS. MEADE. —

 Note.—Shown in the previous year at the exhibition of the Royal Academy, and at the Walker Art Gallery, Liverpool; priced £200.

43. A MAN WHO HAS SEEN A LEPRECHAUN. ... £45 0 0

 Note.—Shown in the previous year at the exhibition of the Royal Academy, and at the Walker Art Gallery, Liverpool; priced £73 10s.

142. THE REV. C. E. OSBORNE. —

 Note.—Shown in 1902 at the exhibition of the Royal Academy.

257. A SUMMER NIGHT. £52 10 0

1901.— 90. SIR ANDREW REED, K.C.B., LL.D. —

 Note.—Now in the Officers' Mess, Royal Irish Constabulary Depot, Phœnix Park, Dublin.

107. HUGH STUART MOORE, ESQ., M.A. —

 Note.—Now in the possession of the Incorporated Law Society of Ireland.

122. A PORTRAIT. —

128. A CHILDREN'S PARTY. £50 0 0

 Note.—Shown in the previous year at the Walker Art Gallery, Liverpool; priced £63.

230. IN A CONNEMARA COTTAGE. £21 0 0

1902.— 21. MRS. CHADWYCK HEALEY AND HER DAUGHTER —
 Note.—54 in. x 46 in. Shown in 1900, at

the exhibition of the Royal Academy, and at the Walker Gallery, Liverpool. Illustrated in Cassell's *Royal Academy Pictures* 1900.

28. THE LUSTRE JUG £47 5 0

 Note.—Now in the National Gallery of Ireland.

73. SIR MALCOLM INGLIS, D.L., J.P., CHAIRMAN OF THE DUBLIN CHAMBER OF COMMERCE. ... —

97. PORTRAIT OF A CHILD. —

211. ACROSS THE SANDS. £20 0 0

223. REV. CANON R. T. SMITH, D.D. —

1903.— 4. MRS. C. LITTON FALKINER. —

 Note.—72 in. x 48 in. Shown in the previous year in the Royal Academy, and at the Walker Art Gallery, Liverpool. Illustrated in Cassell's *Royal Academy Pictures* 1902. An interesting study for this picture was in the Collection of NATHANIEL HONE, R.H.A.

47. LIEUTENANT-COLONEL MOORE, C.B. (CONNAUGHT RANGERS). —

 Note.—Presented by Colonel Moore to the Dublin Municipal Art Gallery.

70. ON THE SANDS, EVENING. £45 0 0

137. A ROADSIDE STUDY. £10 10 0

217. MILKING TIME. £42 0 0

 Note.—Shown in the previous year at the exhibition of the New English Arts Club.

1904.— 26. THE VENERABLE THE ARCHDEACON OF DUBLIN. —

 Note.—A memorial Exhibition of Osborne's work was held in the Royal Hibernian Academy's premises in 1903. The catalogue is reproduced in Appendix XII.

THE ROYAL ACADEMY.

5 Castlewood Avenue, Rathmines, Dublin.

1886.— 573. TIRED OUT.

1887.— 387. NEAR ST. PATRICK'S, AN OLD DUBLIN STREET.

 1159. AN OLD WOMAN'S HEAD, PASTEL.

1888.—1365. DAFFODILS ; PASTEL.

1889.— 399. THE DUBLIN STREETS ; A VENDOR OF BOOKS.

1890.—1113. THE FERRY.

 1208. THE VILLAGE INN. (PASTEL.)

1891.— 137. RAGS, BONES AND BOTTLES.

 Note.—Shown in the exhibition at the Walker Art
 Gallery, Liverpool in 1891 ; priced £25.

 613. JOE, THE SWINEHERD.

 1222. A BIT OF OLD DUBLIN.

 Note.—A Pastel. Shown in the exhibition at the Walker
 Art Gallery, Liverpool, in 1891 ; priced £25. Now in the
 Collection of E. E. Legatt, Esq.

1892.— 318. WHEN THE BOATS COME IN.

 784. WATER SPRITES.

 1198. LIFE IN THE STREETS, HARD TIMES. (Purchased for the
 Chantry Bequest at twenty-five guineas.)

1893.— 303. A PORTRAIT.

 670. IN THE STREETS—A TOUCH OF WINTER.

 980. MISS NELLY O'BRIEN.

1894.— 43. THE THORN BUSH.

 284. MRS. ABRAHAM STOKER.

 823. LIFE IN THE STREETS.—MUSICIANS.

 Note.—24 in. x 32 in. Shown in the exhibition at the
 Walker Art Gallery, Liverpool, in 1894, priced £73 10s. ;
 and in Bradford the year following. Now in the Dublin
 Municipal Gallery of Modern Art, entitled " The Fish
 Market, Patrick Street." Illustrated in Henry Blackburn's
 Academy Notes 1894, from a pen-and-ink sketch by the
 author ; and in the official catalogue of the loan exhibition
 at the Guildhall, 1904.

1895.— 405. MRS. BRAM STOKER.

 631. PORTRAITS.

 Note.—20 in. x 24 in. Illustrated in Henry Blackburn's

Academy Notes for 1895 from a pen-and-ink sketch by the artist.

782. IN A DUBLIN PARK—LIGHT AND SHADE.
Note.—28 in. x 36 in. Illustrated in Cassell's *Royal Academy Pictures* for 1896.

1896.— 369. WALTER ARMSTRONG, ESQ.
Note.—Illustrated in *The Palace of Fine Arts Souvenir, Irish International Exhibition*, 1907, *A Folio of Famous Pictures.*

409. MRS. ANDREW JAMESON AND HER DAUGHTER VIOLET.
Note.—48 in. x 64 in. Illustrated in Blackburn's *Academy Notes* 1896, from a pen-and-ink sketch by the artist, and in Cassell's *Royal Academy Pictures* of the same year.

979. MRS. JOHN MULHALL.

980. MRS. MCNEILL.

1897.— 171. MRS. WALTER ARMSTRONG.
Note.—50 in. x 40 in. Illustrated in Cassell's *Royal Academy Pictures* 1897.

392. WILLIAM OSBORNE, ESQ.

1048. MRS. T. HONE.

1898.— 367. MISS HONOR O'BRIEN.

597. MRS. NOEL GUINNESS AND HER LITTLE DAUGHTER.

858. LIFE IN CONNEMARA ; A MARKET DAY.

1899.— 5. A MAN WHO HAS SEEN A " LEPRECHAUN."

222. LORD ASHBOURNE, LORD CHANCELLOR OF IRELAND.
Note.—95 in. x 59 in. Illustrated in Henry Blackburn's *Academy Notes* 1899, from a pen-and-ink sketch by the author, and in Cassell's *Royal Academy Pictures* of the same year.

948. MRS. MEADE.

1900.— 248. MRS. CHADWYCK HEALEY AND HER DAUGHTER.

284. DOROTHY AND IRENE, DAUGHTERS OF C. L. FALKINER, ESQ.

492. REV. J. P. MAHAFFY, D.D.

1901.— 119. MISS GLADYS THOMPSON.

346. VISCOUNT POWERSCOURT, K.P.
Note.—52 in. x 36 in. Illustrated in Cassell's *Royal Academy Pictures* for that year.

599 SUMMER TIME.

> *Note.*—Bought by the Corporation of Preston for the Preston Art Gallery. Illustrated in Cassell's *Royal Academy Pictures* 1901, and in the Preston Gallery catalogue.

1902.— 214. MRS. C. LITTON FALKINER.

 652. REV. C. E. OSBORNE (THE LATE).

1903.— 379. LADY LUCY HICKS-BEACH.

 597. MISS DEENA TYRRELL.

 678. SIR FREDERICK FALKINER, K.C., RECORDER OF DUBLIN.

> *Note.*—Now in the National Gallery of Ireland. Illustrated in Cassell's *Royal Academy Pictures* 1903, and in *The Palace of Fine Arts Souvenir, Irish International Exhibition,* 1907, *A Folio of Famous Pictures.*

WALKER ART GALLERY, LIVERPOOL.

Autumn, 1881.— 332. STUDY OF A GROUP OF LIONS, FROM SPECIMENS IN THE COLLECTION OF THE ROYAL ZOOLOGICAL SOCIETY OF IRELAND.		£40 0 0
Autumn, 1882.— 693. A TEMPTING BAIT.		£42 0 0
Autumn, 1884.— 884. A GREY MORNING IN A BRETON FARMYARD.		—
888. APPLE GATHERING QUIMPERLE, BRITTANY.		£31 10 0
905. A FLEMISH HOMESTEAD.		£12 12 0
949. PONT AVEN, FROM THE RIVER. ...		£10 10 0
Autumn, 1885.—1003. THE POACHERS.		£30 0 0
1281. THE CLOISTERS, LINCOLN CATHEDRAL.		£15 15 0
Autumn, 1886.— 177. ON THE HAMPSHIRE DOWNS.		£20 0 0
219. COUNTING THE FLOCK.		£15 0 0
Autumn, 1887.— 172. TIRED OUT.		£45 0 0
291. ON SUFFOLK SANDS.		£20 0 0
298. NEAR ST. PATRICK'S CLOSE—AN OLD DUBLIN STREET.		£50 0 0
Autumn, 1888 — 144. MAY I VENTURE.		£42 0 0

	186. The Lock Gates.	£31	10 0
	986. October by the Sea.	£40	0 0
Autumn, 1889.—	12. The Dublin Streets : A Vendor of Books.	£50	0 0
	1121. Idle Shepherds.	£31	10 0
Autumn, 1890.—	255. The Village Inn. (Pastel)... ...	£15	15 0
	923. The Ferry.	£105	0 0
Autumn, 1891.—	262. Rags, Bones and Bottles.	£25	0 0
	660. A Bit of Old Dublin. (Pastel) ...	£25	0 0
	1155. Joe the Swineherd.	£42	0 0
Autumn, 1892.—	295. When the Boats come in.	£100	0 0
	329. Welcome Shade.	£25	0 0
	434. Passing Shadows.	£12	12 0
Autumn, 1893.—	91. A Narrow Thoroughfare.	£25	0 0
	954. In the Streets, Wintry Weather.	£26	5 0
Autumn, 1894.—	98. Life in the Streets, Musicians. ...	£73	10 0
Autumn, 1898.—	20. Miss Honor O'Brien.	—	
Autumn, 1899.—	45. In a Free Library.	£42	0 0
	112. Mrs. Meade.	£200	0 0
	975. A Man who has seen a Leprechaun.	£73	10 0
Autumn, 1900.—	1086. Mrs. Chadwyck Healey and her Daughter.	—	
	1152. A Children's Party.	£63	0 0
Autumn, 1902.—	906. Mrs. C. Litton Falkiner.	—	

THE ROYAL BIRMINGHAM SOCIETY OF ARTISTS.

Autumn, 1888.—	287. Intruders.	£20	0 0
	580. Summer Days, Newbury.	£15	15 0
Autumn, 1889.—	221. A Bachelor's Garden.	£26	5 0
	245. A Sheep Farm.	£7	7 0
	489. A Children's Service.	£21	0 0
Spring, 1889.—	115. In the Vale of Whitehorse : A Noonday Rest.	£15	15 0

235. IN A BERKSHIRE VILLAGE : AN EVENING
 AFTER RAIN. £10 10 0

Spring, 1890.— 26. LOW TIDE : A SKETCH. £7 7 0

138. THE HIGH STREET, RYE : A STUDY. ... £10 10 0

Autumn, 1891.—238. THE CHIMNEY CORNER : A STUDY. ... £15 15 0

537. HARVEST TIME. £15 15 0

629. THE FERRY. £84 0 0

Autumn, 1892.— 43. A NARROW THOROUGHFARE. £26 5 0

467. THE TIMBER YARD. £15 15 0

Autumn, 1893.—224. A QUIET HAVEN. £15 15 0

531. NO MAN'S LAND. £15 15 0

Autumn, 1897.— 61. PORTRAIT OF WILLIAM OSBORNE, R.H.A. —

541. AN OLD FOUNTAIN, MADRID. £21 0 0

DUBLIN ART CLUB.

1886.— 6. ON THE PIER : A STUDY. £5 5 0

17. A SEA URCHIN. £5 5 0

33. EVENING, WELLS NEXT THE SEA. £5 5 0

39. JOYOUS SUMMER. £10 0 0

71. A SUMMER MORNING. £5 5 0

77. MORNING LIGHT.—A STUDY ON THE BEACH. ... £5 5 0

126. THE VILLAGE INN. £5 5 0

1887.— 74. A PASTEL STUDY :
 " When yellow leaves, or none, or few, do hang
 Upon those boughs which shake against the cold." £10 10 0

78. IN A BERKSHIRE VILLAGE—PASTEL. £7 7 0

107. PORTRAIT OF A LADY—PASTEL. —

123. NOVEMBER SUNSHINE. £5 5 0

125. TOWARDS EVENING, NEWBURY. £5 5 0

129. A BIT OF SUTTON COURTNEY, A VILLAGE BY THE
 THAMES. £12 12 0

137. RURAL WINCHESTER. £5 5 0

161. DOWN AN OLD COURT, NEWBURY. £7 7 0

1889.—	13. RAINY WEATHER.		£5 5	0
	24. A COUNTRY PARISH.		£5 5	0
	26. FOLLOWING THE PLOUGH.		—	
	30. POTATO GATHERING.		£31 10	0
	42. AFTER RAIN, TOWARDS EVENING.		£15 15	0
	46. SCARECROWS.		£5 5	0
	48. IN THE VALE OF THE WHITEHORSE.		£5 5	0
	57. A PORTRAIT—PASTEL.		—	
	72. WILLIAM CHARLES PEARSALL.—(PASTEL).		—	
1890.—	2. A STUDY.		£5 5	0
	31. NOONDAY.		£5 5	0
	32. A STUDY.		£5 5	0
	34. HASTINGS—A STUDY.		£15 15	0
	65. THE VILLAGE INN.		£25 0	0
	99. NOVEMBER MISTS.		£15 15	0
	103. " MUSIC HATH CHARMS."		£15 15	0
	112. THE TOLL-GATE.		£5 5	0
	137. RYE HARBOUR.		£5 5	0
1891 —	9. EVENING MISTS.		£5 5	0
	20. GREY WEATHER.		£21 0	0
	49. RICHARD THEODORE STACK, M.D.		—	

Presented by his colleagues at the Dental
Hospital of Ireland, Dublin.

	125. THE SHEPHERD AND HIS FLOCK.		£21 0	0

Note.—Sold April 14th, 1914, by auction for £10.

	130. HARROWING.		£21 0	0

Note.—Shown at the New Gallery, London,
in the same year.

	140. JOE THE SWINEHERD.		£5 5	0
	145. IN A BERKSHIRE VILLAGE.		£5 5	0
	147. PEACEFUL EVE—A STUDY.		£15 15	0
	158. DOROTHY.		—	
1892.—	6. A PORTRAIT SKETCH—PASTEL.		—	

31. SCHOONER UNLOADING—A STUDY. £10 10 0
47. WATER SPRITES. £42 0 0
78. SHOWERY WEATHER. £8 0 0
119. AN UNFREQUENTED BYEWAY—EVENING. ... £15 15 0
121. MISS SYLVIA BAKER. —
123. A BREEZY MORNING. £5 5 0
125. RYE HARBOUR, EVENING. £5 5 0
134. A STUDY FROM NATURE. £5 5 0
138. LOAFERS. £5 5 0
145. DRYING SAILS. £5 5 0

DUBLIN ARTS CLUB.

1893.— 12. A STUDY. £5 5 0
16. A SKETCH IN THE FISH MARKET, GALWAY. ... £5 5 0
17. A BIT OF OLD GALWAY. £5 5 0
36. THE HOUR OF REST. £15 15 0
56. SHOWERY WEATHER. £5 5 0
57. UPLANDS. £26 0 0
83. MILKING TIME. £63 0 0
99. A SUMMER'S EVENING. £5 5 0
104. J. B. S. MACILWAINE, ESQ. —

Note.—At present on loan at the Dublin Municipal Gallery of Modern Art.

109. A STUDY. £5 5 0
111. A PORTRAIT—PASTEL. —
1894— 9. PARTING GLEAMS. £5 5 0
22. " MUSIC HATH CHARMS." £84 0 0
37. THE HORSE FAIR, GALWAY. £8 8 0
39. ON THE QUAYS, GALWAY. £8 8 0
62. GOSSIPS. £8 8 0
73. PEACEFUL EVE. £31 10 0
85. THE CLADDAGH, GALWAY. £5 5 0

		£	s	d
92. PLOUGHING—A STUDY.		£15	15	0
106. ON THE ROCKS—EVENING.		£5	5	0
118. IN THE STREETS—A SKETCH.		£5	5	0
157. "TWO'S COMPANY"—PASTEL.		£12	12	0
1895.— 10. AT RENVYLE, CONNEMARA.		£5	5	0
21. RETURNING FROM MARKET, GALWAY.		£15	15	0
28. THE FISH MARKET, GALWAY—A BREEZY DAY. ...		£15	15	0
36. IN CONNEMARA.		£5	5	0
40. AN OLD COURTYARD, ANTWERP.		£7	7	0
106. GALWAY TOWN.		£5	5	0
112. PORTRAITS.		—		
118. RECEDING TIDE.		£5	5	0

THE INSTITUTE OF PAINTERS IN OIL COLOURS.

1884.—203. THE CLOISTERS, LINCOLN CATHEDRAL.

531. AN OLD WATERWAY, LINCOLN.

1885.—314. THE RETURN OF THE FLOCK.

Note.—Illustrated in the catalogue from a line drawing by the artist.

1886.—804. AN OLD BYE-WAY, WELLS-NEXT-THE-SEA.

1887.— 16. REFLECTIONS.

646. ON THE KENNET. TOWARDS EVENING.

1889.—243. BOAT BUILDERS.

300. CHERRY RIPE.

Note.—Described in the artist's catalogue, in his autograph, as "Too hot—too red." Reproduced in colours as a supplement to the June number of the *Boy's Own Paper*, 1895.

1890.—178. ACROSS THE DOWNS.

312. PLOUGHING, A STUDY.

378. DAINTY MORSELS.

Note.—Illustrated in the catalogue from a line drawing by the artist.

1891.—250. A NARROW THOROUGHFARE.
 Note.—Illustrated in the catalogue from a line drawing by the artist.

 286. WELCOME SHADE.

 412. PASSING SHADOWS.

1893.— 9. IN GALWAY TOWN, (A SKETCH.)

 326. PIPING TIMES.

 585. MILKING TIME.

1894.— 8. THE FISH MARKET, GALWAY.

 14. ON THE CANALS, AMSTERDAM.

 451. MOONRISE.

1895.—114. A VILLAGE FARM. £13 13 0

 133. DOWN THE VILLAGE STREET. £13 13 0

 240. ATLANTIC SHORES. £26 5 0

1897-8.—160. The PIPE OF PEACE. £15 15 0

 242. A CONNEMARA VILLAGE : EVENING. £21 0 0

THE SOCIETY OF OIL-PAINTERS.

1898.—176. IN A FREE LIBRARY. £47 5 0
 Note :—Sold in 1919 for £19 19s. 0d.

 199. A CONNEMARA VILLAGE—THE WAY TO THE HARBOUR. £31 10 0

1901.—191. UNDER THE TREES. £52 10 0

 252. THE FOUR COURTS, DUBLIN. £35 0 0

THE NEW ENGLISH ART CLUB.

1893.—10th Exhibition.— 22. SHOWERY WEATHER. £6 6 0

1899.—22nd Exhibition.— 7. THE MARKETS, BORDEAUX.

 30. AT A CHILD'S BEDSIDE.

1899.—23rd Exhibition.—120. A SUMMER'S NIGHT.
 (November).

1902.—28th Exhibition.— 1. SHOWERY WEATHER.

 26. A PORTRAIT SKETCH.

 117. MOONLIGHT.

1902.—29th Exhibition—14. HOUSEBUILDERS.
 (November).

> *Note.*—Shown in the following year at the exhibition of
> the Water-Colour Society of Ireland. Now in the
> National Gallery of Ireland.
>
> 69. MILKING TIME.

THE GROSVENOR GALLERY.

1887.—Summer Exhibition.—110. ON THE HAMPSHIRE DOWNS.

> *Note.*—" Skied " in Osborne's autograph on his catalogue.

THE NEW GALLERY.

1891.—Summer Exhibition.—64. HARROWING.

BRADFORD ART GALLERY.

(From information kindly given by Butler Wood, Esq.,
 Director of the Corporation Art Gallery, Bradford.)

1895.—Spring.—LIFE IN THE STREETS £73 10 0

NEWCASTLE-ON-TYNE.

Note.—Mr. W. G. Strickland, in his admirable *Dictionary of Irish
Artists,* refers to the following four pictures as having been exhibited by
Osborne at Newcastle-on-Tyne :—

1894. A TOUCH OF WINTER.

A WARM THOROUGHFARE.

> *Note.*—Query : " A Narrow Thoroughfare " ?

1895. WHEN THE BOATS COME IN.

GALWAY FISHWIVES.

Mr. Strickland tells me he cannot now trace the references. Nor can I.
Further, I have written to Mr. W. S. Morgan, the Secretary of the North
British Academy of Arts, who, after search and many enquiries, cannot
find any catalogues of exhibitions held in these years at Newcastle-on-
Tyne. Messrs. Mawson, Swan and Morgan, the well-known local Art
Dealers, also write to me :—" We regret we have no record of Exhibitions
of pictures held in Newcastle. It is just possible that the pictures referred
to were exhibited in what was known as the Old Art Gallery, which was

purely a private concern. It has been out of existence for many years, and we do not know of any record of the pictures exhibited." The collection of Osborne's own catalogues in the National Library of Ireland does not include any of Newcastle-on-Tyne. I repeat Mr. Strickland's information, confident that it is founded on fact.

THE WATER-COLOUR SOCIETY OF IRELAND.

(From information kindly given by W. H. Hillyard, Esq., the Secretary of the Society.)

1897.— 86. THE MARKETS, BORDEAUX : A STUDY.

112. AN OLD CANAL : AMSTERDAM.

123. AT ZAANDAM, HOLLAND.

1899.— 91. RENVYLE, CONNEMARA.

1901.— 5. NEAR ZAANDAM, HOLLAND.

12. A DOLL'S PARTY.

15. AT A CHILD'S BEDSIDE.

1903.— HOUSEBUILDERS.

CORK EXHIBITION, 1883.

28. HEAD OF A COCKER DOG.

37. AFTERNOON TEA.

CORK INTERNATIONAL EXHIBITION, 1902.

187. THE MAN WHO HAD SEEN THE LEPRECHAUN.

193. A CHILDREN'S PARTY.

217. MISS HONOR O'BRIEN.

251. SUMMER SUNSHINE.

Lent by the Corporation of Preston.

CHICAGO EXHIBITION, 1893.

363. THE FERRY.

PARIS INTERNATIONAL EXHIBITION, 1900.

MRS. NOËL GUINNESS AND HER DAUGHTER.

Note.—Awarded a " Medaille de Bronze " by the French Jury

APPENDIX XII.

WORKS BY WALTER OSBORNE, R.H.A., EXHIBITED IN LOAN EXHIBITIONS SINCE HIS DEATH.

THE ROYAL HIBERNIAN ACADEMY WINTER EXHIBITION, 1903.

1. BOY AND DOG. *Lent by Nathaniel Hone, Esq., R.H.A.*
2. REV. J. P. MAHAFFY, D.D., S.F.T.C.D. *Lent by Dr. Mahaffy.*
3. BY THE RIVER SIDE. *Lent by T. F. Geoghegan, Esq.*
4. VIEW IN ANTWERP. *Lent by Rev. Canon Travers Smith, D.D.*
5. SYLVIA. *Lent by Arthur W. W. Baker, Esq., M.D.*
6. MRS. JOHN MULHALL. *Lent by John Mulhall, Esq.*
7. MASTER BELLINGHAM AND HIS DOG.
Lent by Mrs. Bellingham, Howth.
8. PORTRAIT. *Lent by Trustees.*
9. UPLANDS. *Lent by Mrs. Gwynn.*
10. HARVEST TIME. *Lent by W. E. Purser, Esq.*
11. BRAY HEAD. *Lent by R. G. Herdman, Esq., J.P., Cultra.*
12. VISCOUNT POWERSCOURT, K.P. *Lent by Viscount Powerscourt.*
13. ON THE SANDS. *Lent by W. P. Geoghegan, Esq.*
14. ROAD LEADING TO THE STRAND, ST. MARNOCK'S.
Lent by John Jameson, Esq.
15. ON THE SHORE ROAD LOOKING TOWARDS IRELAND'S EYE.
Lent by John Jameson, Esq.
16. PORTRAIT OF STEPHEN GWYNN, ESQ. *Lent by Mrs. Gwynn.*
17. THE LATE JOHN HATCHELL, ESQ., D.L.
Lent by L. Perrin Ha'chell, Esq.

140

18. ON THE SANDS : EVENING. · *Lent by George Jameson, Esq.*

19. THE RIGHT HON. GERALD FITZGIBBON, P.C.
Lent by Mrs. Gerald Fitzgibbon.

20. THE FERRY. *Lent by the Trustees.*
Note.—Now in the collection of the Right Hon. Jonathan Hogg, P.C.

21. A GREY MORNING IN A BRETON FARM. *Lent by H. D. Brown, Esq., B.L.*

22. SIR FREDERICK FALKINER, K.C., RECORDER OF DUBLIN.
Lent by the Recorder.

23. SEA AND SAND. *Lent by the Trustees.*

24. SKETCH OF SHORE. *Lent by the Trustees.*

25. HUGH STUART MOORE, M.A.
Lent by the Incorporated Law Society of Ireland.

26. FISH MARKET, DUBLIN. *Lent by the Trustees.*

27. PORTRAIT. *Lent by Sir Thornley Stoker.*

28. ACROSS THE SANDS. *Lent by the Trustees.*

29. STUDY OF SHORE. *Lent by Dermod O'Brien, Esq.*

30. ON THE BERKSHIRE DOWNS. *Lent by Sir G. F. Brooke, Bart.*

31. REV. CHARLES E. OSBORNE. *Lent by Mrs. Osborne.*

32. THE LUSTRE JUG. *Lent by the National Gallery of Ireland.*

33. "SCRUB." *Lent by Lady Drew.*

34. MRS. NOEL GUINNESS AND DAUGHTER. *Lent by Noel Guinness, Esq.*

35. PORTRAIT. *Lent by Mrs. Osborne.*

36. "RAGS." *Lent by Lady Drew.*

37. THE MUSIC LESSON. *Lent by the Trustees.*

38. MASTER J. W. SCHARFF. *Lent by Dr. Scharff.*

39. ROAD ACROSS THE DOWNS. *Lent by the Trustees.*
Note.—Afterwards in the collection of Nathaniel Hone, R.H.A.
Now in the possession of Edmond Lupton, Esq., K.C.

40. SKETCH. *Lent by W. P. Geoghegan, Esq.*

41. ST. ANNE'S. *Lent by the Trustees.*

42. GEN. SIR HUGH M'CALMONT, K.C.B. *Lent by Sir H. M'Calmont.*

43. MILKING TIME IN ST. MARNOCK'S BYRE.
Lent by John Jameson, Esq.

44. REV. J. P. MAHAFFY, D.D., S.F.T.C.D. *Lent by Rev. J. P. Mahaffy.*

142 APPENDICES

45. THUNDER CLOUD. *Lent by the Trustees.*
46. RISING MOON. *Lent by John Jameson, Esq.*
47. THE LATE WILLIAM OSBORNE, R.H.A.
 Lent by the Royal Hibernian Academy.
48. A CHILDREN'S PARTY. *Lent by D. J. Daly, Esq.*
49. PORTRAIT OF MISS GLADYS THOMSON.
 Lent by Sir William Thomson, C.B.
50. CATTLE : ST. MARNOCK'S. *Lent by John Jameson, Esq.*
51. PORTRAIT OF THE LATE ANDREW MARSHALL PORTER, ESQ.
 Lent by the Right Hon. A. M. Porter.
52. A PAIR OF POMERANIANS. *Lent by Sir Thornley Stoker.*
53. ST. PATRICK STREET. *Lent by Right Hon. Gerald Fitzgibbon.*
54. COW SHED. *Lent by Right Hon. Jonathan Hogg, D.L.*
55. RIGHT HON. THE O'CONOR DON. *Lent by the Trustees.*
56. SIR ANDREW REED, K.C.B.
 Lent by Officers, Royal Irish Constabulary Depot.
57. SIR THOMAS DREW, P.R.H.A. *Lent by Lady Drew.*
58. THE SHEEP FOLD *Lent by W. Booth Pearsall, H.R.H.A.*
59. SLUMBER. *Lent by Sir J. B. Dougherty, C.B.*
60. DOROTHY AND IRENE. *Lent by C. Litton Fajkiner, Esq.*
61. PORTRAIT. *Lent by Mrs. Osborne.*
62. LADY ARMSTRONG. *Lent by Sir Walter Armstrong.*
63. MILKING TIME. *Lent by Miss Clare Galwey.*
64. SEA SHORE. *Lent by the Trustees.*
65. THE LATE FREDERICK NIVEN, ESQ.
 Lent by the Directors of the Royal Bank of Ireland.
66. A BIT OF ANTWERP. *Lent by Raymond de la Poer, Esq.*
67. PORTRAIT OF THE LATE WALTER OSBORNE, R.H.A.
 Lent by the National Gallery.
68. A FLEMISH TOWN. *Lent by Raymond de la Poer, Esq.*
69. MRS. MEADE COFFEY. *Lent by Mrs. Meade Coffey.*
70. EVENING. *Lent by J. Joly, Esq.*
71. FEEDING TIME. *Lent by M Parker. (sic).*

72. HEWITT POOLE JELLETT, ESQ., K.C.
 Lent by the Honourable Society of the King's Inns.

73. MY BROWN BOY. *Lent by Lieut. Col. Congreve.*

74. THE EVE OF THE FAIR. *Lent by J. Joly, Esq.*

75. CUPBOARD LOVE *Lent by W. H. Lynn, Esq., R.H.A.*

76. THE LATE SIR MALCOLM INGLIS, D.L. *Lent by Lady Inglis.*

77. GENERAL CHARLES WILLIAM FORREST, C.B. LATE HON. COL. 11TH
 HUSSARS. *Lent by Mrs. Forrest, Winchester.*

78. DR. STACK. *Lent by Mrs. Stack.*

79. MOONLIGHT, RUSH HARBOUR. *Lent by the Trustees.*

80. PORTRAIT OF THE LATE ANDREW MARSHALL PORTER, ESQ. (Unfinished.)
 Lent by the Right Hon. Sir A. M. Porter.

81. ST. NICHOLAS' FOUNTAIN, ANTWERP.
 Lent by the Right Hon. Gerald Fitzgibbon.

82. A COUNTRY ROAD. *Lent by J. Joly, Esq.*

83. SKETCH. *Lent by Andrew Jameson, Esq.*

84. STUDY FROM NATURE. *Lent by P. Vincent Duffy, Esq., R.H.A.*

85. THE LATE ROBERT REEVES, ESQ. *Lent by Mrs. Robert Reeves.*

86. GROUP OF WILLOW TREES. *Lent by P. Vincent Duffy, Esq., R.H.A.*

87. MISS MOLLIE. *Lent by Sir J. G. Nutting, Bart.*

88. A SMALL HARBOUR. *Lent by J. Joly, Esq.*

89. IN A FRENCH WOOD, 1884. *Lent by W. Booth Pearsall, H.R.H.A.*

90. EVENING. *Lent by Sir J. B. Dougherty, C.B.*

91. A RAILWAY STATION. *Lent by Right Hon. Jonathan Hogg, D.L.*

92. THE LATE ANTHONY H. CORLEY, ESQ., M.D., F.R.C.S.I.
 Lent by Mrs. Corley.

93. REV. CANON TRAVERS SMITH, D.D. *Lent by Canon Travers Smith.*

94. STARLIGHT. *Lent by Andrew Jameson, Esq.*

95. STUDY OF SEA. *Lent by F. Purser, Esq.*

96. PATRICK STREET. *Lent by E. J. French, Esq.*

97. THE PORCH. *Lent by the Trustees.*

98. DAFFODILS. *Lent by the Trustees.*

99. A TEA PARTY. (Unfinished.) *Lent by L. C. Purser, Esq.*
 Note.—Now in the Dublin Municipal Gallery of Modern Art.

100. Sir Walter Armstrong, J.P. *Lent by Sir W. Armstrong.*
101. Practising. *Lent by the Trustees.*
102. Welcome Shade. *Lent by Andrew Jameson, Esq.*
103. Portrait. *Lent by Mrs. Osborne.*
104. Mrs. Andrew Jameson and her Daughter, Violet.
 Lent by Andrew Jameson, Esq.
105. A Bit in Co. Wicklow. *Lent by Miss Parker.*
106. Sea and Rocks. *Lent by the Trustees.*
107. Waves. *Lent by the Trustees.*
108. St. Patrick's Cathedral. *Lent by G. Dixon, Esq.*
109. Mrs. Litton Falkiner. *Lent by C. Litton Falkiner, Esq.*
110. A Small Harbour. *Lent by Sir E. T. Bewley.*
111. Portrait of a Lady. *Lent by Sir Thornley Stoker.*
112. Boat Builders. *Lent by Augustine Orr, Esq.*
113. Study from Nature. *Lent by Nathaniel Hone, R.H.A.*

Note.—A portrait of Nathaniel Hone, R.H.A. inscribed " Walter Osborne, à Mrs. Hone," measuring about 14 in. x 12 in. Now in the possession of Miss E. Hone.

114. Ploughing : A Study. *Lent by Vivian Inglis, Esq.*
115. Mother and Child. *Lent by the Trustees.*
116. Tea Time. *Lent by the Trustees.*
117. The Rehearsal. *Lent by J. D. Spence, Esq.*
118. Study from Nature. *Lent by Nathaniel Hone, Esq., R.H.A.*
119. Sheep. *Lent by the Trustees.*
120. Brittany Girl. *Lent by Nathaniel Hone, Esq., R.H.A.*

Now in the collection of Edmond Lupton, Esq., k.c.

121. Barney. *Lent by Nathaniel Hone, Esq., R.H.A.*
122. Cottage near St. Marnock's. *Lent by John Jameson, Esq.*
123. Mrs. Birdwood. *Lent by J. A. French, Esq.*
124. Portrait Sketch of Lady Thomson.
 Lent by Sir William Thomson, C.B.
125. An English Garden. *Lent by Mrs. Catterson Smith.*
126. Old Well, Belgium. *Lent by J. D. Spence, Esq*

127. GEORGE BROOKE, IRISH GUARDS. *Lent by Sir G. F. Brooke, Bart.*

128. "HUSSIE." *Lent by Sir Thomas Drew, P.R.H.A.*

129. BRUGES : STUDY FROM NATURE, 1882.
 Lent by W. Booth Pearsall, H.R.H.A.

130. SKETCH IN THE ORCHARD. *Lent by the Trustees.*

131. A HARBOUR VIEW. *Lent by W. H. Lynn, Esq., R.H.A.*

132. PORTRAIT. *Lent by J. Joly, Esq.*

133. PORTRAIT OF A LADY. *Lent by Sir Thornley Stoker.*

134. THE VENERABLE THE ARCHDEACON OF DUBLIN.
 Lent by Archdeacon Scott.

135. GALWAY HARBOUR, MOONLIGHT. *Lent by the Trustees.*

136. RUSH HARBOUR. *Lent by Mrs. Ryan.*

137. SKETCH OF SHIPPING. *Lent by Augustine Orr, Esq.*

138. STUDY. *Lent by Mrs. Gwynn.*

139. RUSH VILLAGE. *Lent by Dermod O'Brien, Esq.*

140. PORTRAIT OF NATHANIEL HONE, ESQ., R.H.A. *Lent by N. Hone, Esq.*

Note.—Now in the possession of Herbert Hone, Esq.

141. PORTRAIT. *Lent by Sir Thornley Stoker.*

142. PORTRAITS. *Lent by Mrs. Osborne.*

143. PORTRAIT OF A LADY. *Lent by Sir Thornley Stoker.*

144. MRS. THOMAS H. CARSON. *Lent by Mrs. Carson.*

145. VILLAGE STREET, LUSK. *Lent by Sir G. F. Brooke, Bart.*

146. SKETCH, CONNEMARA. *Lent by Sir Thornley Stoker.*

147. SUNSET. *Lent by the Trustees.*

148. "A GARDEN PARTY." *Lent by Henry R. Kelly, Esq.*

149. LADY BROOKE AND CHILD. *Lent by Sir George Brooke, Bart.*

150. THE FISH MARKET, GALWAY. A BREEZY DAY.
 Lent by W. H. Lynn, Esq., R.H.A.

151. A WET DAY. *Lent by Mrs. Corley.*

152. TOWARDS EVENING, NEWBAY, 1887.
 Lent by W. Booth Pearsall, H.R.H.A.

153. SKETCH. *Lent by R. E. Hearn, Esq., M.D.*

154. SKETCH, GALWAY. *Lent by Miss Nellie O'Brien*

155. PENCIL, STUDY. *Lent by the Trustees.*
156. PENCIL, STUDY. *Lent by the Trustees.*
157. ARDANOIR, FOYNES. *Lent by Miss Nellie O'Brien.*
158. PENCIL, STUDY. *Lent by the Trustees.*
159. FISHING VILLAGE. *Lent by James W. Drury, Esq.*
160. GREYSTONES. *Lent by Miss Nellie O'Brien.*
161. PORTRAIT. *Lent by Miss S. Purser, H.R.H.A.*
162. NOVEMBER SUNSHINE. *Lent by W. P. Geoghegan, Esq.*
163. OLD INN. *Lent by P. Chenevix Trench, Esq.*
164. BABY. *Lent by Mrs. Osborne.*
165. RYE. *Lent by G. B. Thompson, Esq.*
166. PLAY. *Lent by the National Gallery.*

Note.—Entitled " The Dolls' School " in the catalogue of the
National Gallery of Ireland.

167. THE LATE WILLIAM OSBORNE, R.H.A. *Lent by Mrs. Osborne.*
168. STUDY OF SHORE. *Lent by R. Caulfeild Orpen, Esq.*
169. PLAYING WITH PUSSY. *Lent by Andrew Jameson, Esq.*
170. PORTRAIT. *Lent by Mrs. Osborne.*
171. A STREET FOUNTAIN, MADRID. *Lent by Andrew Jameson, Esq.*
172. AT A CHILD'S BEDSIDE. *Lent by Mrs. Osborne.*
173. BUILDING CARD HOUSES. *Lent by the National Gallery.*
174. STUDY DRAWN AT NIGHT. 1889.
 Lent by W. Booth Pearsall, Esq., H.R.H.A.
175. CHURCHYARD. *Lent by the Trustees.*
176. ANNIE. A SKETCH. *Lent by the Trustees.*
177. PENCIL STUDY. *Lent by the Trustees.*
178. SKETCH ON BACK OF PROGRAMME.
 Lent by Arthur W. W. Baker, Esq., M.D.
179. MINIATURE OF A LADY. *Lent by Sir Thornley Stoker.*
180. JOHN HUGHES, ESQ., R.H.A. (Unfinished.) *Lent by Lady Stoker.*

Note :—Now in the National Gallery of Ireland.

181. NEAR ZAANDAM, HOLLAND. *Lent by Mrs. Osborne.*
182. ETCHING. *Lent by G. F. Dixon, Esq.*

183. ETCHING. *Lent by G. F. Dixon, Esq.*
184. PENCIL STUDY. *Lent by the Trustees.*
185. SKETCH IN ANTWERP. *Lent by Sir Thornley Stoker.*
186. RYE HARBOUR. *Lent by Chas. Russell, Esq., R.H.A.*
187. AUTUMN. *Lent by W. P. Geoghegan, Esq.*
188. BREAKERS. *Lent by the Trustees.*
189. SKETCH FOR " THE FERRY." *Lent by the Trustees.*

Note.—Now in the possession of Herbert Hone, Esq.

190. MISS NELLY O'BRIEN. *Lent by Miss O'Brien.*
191. SKETCH. *Lent by Augustine Orr, Esq.*
192. " SCARE CROWS." *Lent by P. Chenevix Trench, Esq.*
193. A CHILD. PORTRAIT STUDY. *Lent by W. Booth Pearsall, Esq., H.R.H.A.*
194. GOLF LINKS. *Lent by the Trustees.*
195. STUDY. *Lent by Mrs. Gwynn.*
196. TOMB OF THOMAS LAUGHTON, 1779, CLEVE PRIOR CHURCHYARD.
 Lent by J. M. Kavanagh, Esq., R.H.A.
197. STUDY. *Lent by J. Joly, Esq.*
198. STUDY. *Lent by Edward Dillon, Esq.*
199. WINDMILL. *Lent by the Trustees.*
200. PASTEL PORTRAIT. *Lent by Mrs. Lane.*
201. ST. MARNOCKS COTTAGES. TWILIGHT. *Lent by the Trustees.*
202. ON A SUFFOLK PIER. 1888. *Lent by W. Booth Pearsall, Esq., H.R.H.A.*
203. MOONRISE OVER SEA AND SAND. *Lent by the Trustees.*
204 and 205. MILKING TIME. *Lent by the Trustees.*
206. ST. MARNOCKS. *Lent by the Trustees.*
207. PASTEL PORTRAIT *Lent by Mrs. Lane.*
208. A CHILD. PORTRAIT STUDY.
 Lent by W. Booth Pearsall, Esq., H.R.H.A.
209 to 217. PENCIL STUDIES *Lent by the Trustees.*
218. MISS NELLY O'BRIEN. *Lent by Miss O'Brien.*
219. PENCIL STUDIES *Lent by Mrs. Osborne.*
220. PENCIL STUDIES. *Lent by the Trustees.*

221. PENCIL SKETCH. MRS. ARTHUR BELLINGHAM.
Lent by Mrs. Bellingham, Howth.

222. PENCIL SKETCH. *Lent by Sir Thornley Stoker.*

223. PENCIL SKETCH. *Lent by the Trustees.*

224. MISS CHARLOTTE O'BRIEN AND HER DOG. *Lent by Miss Nelly O'Brien.*

225 to 233. PENCIL STUDIES. *Lent by the Trustees.*

234. PENCIL DRAWINGS. *Lent by R. Caulfeild Orpen, Esq.*

235 and 236. PENCIL DRAWINGS. *Lent by the National Gallery.*

237. PENCIL SKETCH. THE FAIRY BOOK. *Lent by Mrs. Bellingham, Howth.*

238. PENCIL DRAWING OF AN OLD MAN. *Lent by Miss Gladys Thomson.*

239 to 241. PENCIL STUDIES. *Lent by the Trustees.*

242. BY THE ROAD SIDE. *Lent by Oliver Sheppard, Esq., R.H.A.*

243. BIT OF DUBLIN. *Lent by Mrs. Gwynn.*

244. CANAL, AMSTERDAM. *Lent by Nathaniel Hone, Esq.; R.H.A.*

245. POULTRY. *Lent by the Trustees.*

246. SKETCH. PORTMARNOCK. *Lent by Sir Thornley Stoker.*

247. STUDY. *Lent by J. Joly, Esq.*

248. FIELD SKETCH. *Lent by the Right Hon. Gerald Fitzgibbon.*

249. CAPTAIN BOYD'S MONUMENT, ST. PATRICK'S, 1884.
Lent by W. Booth Pearsall, Esq., H.R.H.A.

250. ANTWERP FROM THE RIVER SCHELDT, 1882.
Lent by W. Booth Pearsall, Esq., H.R.H.A.

251. STUDY OF CATTLE IN SEA. *Lent by Nathaniel Hone, Esq., R.H.A.*

252. SKETCH. *Lent by Miss Josephine Webb.*

253. MARKET GARDEN. *Lent by the Trustees.*

254. COWS IN SUNSHINE. *Lent by the Trustees.*

255. SKETCH FOR "MILKING TIME." *Lent by John Jameson, Esq.*

256. STUDY OF A VILLAGE. *Lent by J. Joly, Esq.*

257. WINTER, BRITTANY, 1883. *Lent by W. Booth Pearsall, Esq., H.R.H.A.*

258. SHEEP. *Lent by J. Joly, Esq.*

259. STUDY OF A WHARF. *Lent by J. Joly, Esq.*

260. VALE OF EVESHAM FARMYARD, 1888.
Lent by W. Booth Pearsall, Esq., H.R.H.A.

261. STUDY OF FOWL. *Lent by Miss Orpin. (sic).*
262. SKETCH AT RYE, SUSSEX *Lent by J. M. Kavanagh, R.H.A.*
263. STUDY OF SHEEP. *Lent by Miss French.*
264. STUDY. *Lent by F. Purser, Esq.*
265. MILKING TIME. *Lent by Mrs. Gwynn.*
266 and 267. SKETCHES. *Lent by John Jameson, Esq.*
268. STUDY OF POULTRY. *Lent by Lady Drew.*
269. STUDY FROM NATURE. *Lent by Nathaniel Hone, Esq., R.H.A.*
270. THE VISION OF ST. CATHERINE. *Lent by P. Vincent Duffy, Esq., R.H.A.*

WORKS BY IRISH PAINTERS AT THE GUILDHALL, LONDON, 1904.

26. REV. CANON R. TRAVERS SMITH, D.D. Canvas: 30 in. x 25 in.
Lent by Canon Smith.
39. FEEDING CHICKENS. Canvas : 36 in. x 28 in.
Lent by George McCulloch, Esq.
Note.—Sold at "Christie's" April 29th, 1910.
45. MRS. NOEL GUINNESS AND CHILD. Canvas : 55 in. x 61 in.
Lent by Noel Guinness, Esq.

Note.—Illustrated in the official catalogue.

66. MERVYN EDWARD VISCOUNT POWERSCOURT, K.P., P.C. Canvas, 51 in. x 36 in. *Lent by Viscount Powerscourt.*
130. THE EVE OF THE FAIR. Canvas : 12 in. x 14 in.
Lent by J. Joly, Esq., F.R.S.
143. THE STATION. Canvas : 37 in. x 28 in. *Lent by the Artist's Executors.*
155. SCARECROWS. *Lent by P. Chenevix Trench, Esq.*
161. AN OCTOBER MORNING. Canvas : 28 in. x 36 in.
The Property of the Corporation of London.
171. LIEUTENANT STEPHENS. Canvas : 24 in. x 20 in. *Lent by J. Joly, Esq.*
182. MISS HONOR O'BRIEN. Canvas : 27 in. x 20 in.
Lent by the Rev. Lucius O'Brien.

183. SIR FREDERICK FALKINER, K.C., RECORDER OF DUBLIN. Canvas: 48 in. x 40 in. *Lent by Sir Frederick Falkiner.*
Note.—Now in the National Gallery of Ireland.

M

185. THE FISH MARKET. Canvas : 31 in. x 24 in. *Lent by Hugh P. Lane, Esq.*

 Note.—Illustrated in the official catalogue. Subsequently presented by Sir Hugh Lane to the Dublin Municipal Gallery of Modern Art. Exhibited originally under the title, " Life in the Streets : Musicians," at the Royal Academy, 1894.

223. A GALWAY FISH MARKET. (OILS.) *Lent by W. H. Lynn, Esq.*

224. GREYSTONES, A SKETCH. *Lent by Miss Nelly O'Brien.*

ROYAL HIBERNIAN ACADEMY, 1904.

EXHIBITION OF PICTURES FORMING THE NUCLEUS OF THE DUBLIN MUNICIPAL GALLERY OF MODERN ART.

44. THE FISH MARKET ST. PATRICK STREET. *Lane Collection.*

70. MOTHER AND CHILD. *Lane Collection.*

218. THE TEA PARTY : A SKETCH. *Lane Collection.*

MUNSTER-CONNACHT EXHIBITION, 1906.

33. PORTRAIT OF SIR FREDERICK FALKINER.
 Lent by Sir Frederick Falkiner.

34. PORTRAIT OF SIR WALTER ARMSTRONG.
 Lent by Sir Walter Armstrong.

44. MISS HONOR O'BRIEN. *Lent by the Very Rev. Dean of Limerick.*

48. DAFFODILS. *Lent by Dermod O'Brien, A.R.H.A.*

72. RUSH VILLAGE. *Lent by Dermod O'Brien, A.R.H.A.*

115. HASTINGS RAILWAY STATION. *Lent by Dermod O'Brien, A.R.H.A.*

119. IN BERKSHIRE. *Lent by the Very Rev. Dean of Limerick.*

140. FLICKERING LIGHTS. *Lent by Dermod O'Brien, A.R.H.A.*

LOAN EXHIBITION, BELFAST, 1906.

95. THE FISH MARKET.

96. MOTHER AND CHILD.

 Note.—Both were lent by Sir Hugh Lane, and subsequently presented by him to the Dublin Municipal Gallery of Modern Art.

THE IRISH INTERNATIONAL EXHIBITION, DUBLIN, 1907.

49. PORTRAIT OF MISS E. WEBB. 23¼ in. x 19¼ in. *Lent by Miss Webb.*

62. PORTRAIT OF LADY STOKER. 15½ in. x 12½ in. *Lent by Lady Stoker.*

70. PORTRAIT OF SIR FREDERICK FALKINER, P.C., RECORDER OF DUBLIN. 45½ in. x 38 in. *Lent by Sir Frederick Falkiner.*

71. THE POMERANIANS. 29 in. x 24 in. *Lent by Sir Thornley Stoker.*

72. PORTRAIT OF THE LATE VISCOUNT POWERSCOURT, K.P. 50 in. x 35 in. *Lent by Viscount Powerscourt, M.V.O.*

73. THE THORN BUSH. 35 in. x 27½ in. *Lent by Canon Harris.*

74. PORTRAIT OF SIR WALTER ARMSTRONG. 37 in. x 30 in. *Lent by Sir Walter Armstrong.*

75. MOONLIGHT. 23½ in. x 19½ in. *Lent by Andrew Jameson, Esq.*

98. PORTRAIT OF SIR THORNLEY STOKER. 43 in. x 33 in. *Lent by Sir Thornley Stoker.*

108. PORTRAIT OF A CHILD. 35 in. x 24 in. *Lent by Sir John Nutting, Bart.*

125. PORTRAIT OF MRS. NOEL GUINNESS AND HER DAUGHTER. 54 in. x 59 in. *Lent by Noel Guinness, Esq.*

259. RYE. SUSSEX : WATER COLOUR. *Lent by George B. Thompson, Esq.*

264. PORTRAIT SKETCH OF JOHN HUGHES : WATER-COLOUR SKETCH OF THE SCULPTOR IN HIS STUDIO WORKING AT HIS GROUP, " ORPHEUS AND EURYDICE." *Lent by Lady Stoker.*
Note.—Now in the National Gallery of Ireland.

THE FRANCO-BRITISH EXHIBITION, 1908.

314. AN OCTOBER MORNING. *Lent by the Corporation of London.*

IRISH ART GALLERY, BALLYMACLINTON, FRANCO-BRITISH EXHIBITION, 1908.

58. THE OLD FISH MARKET : PATRICK STREET. (Now demolished for Lord Iveagh's improvements.)
Note.—Now in the Dublin Municipal Gallery of Modern Art.

60. SIR WALTER ARMSTRONG. *Lent by Sir Walter Armstrong.*

THE ROYAL ACADEMY WINTER EXHIBITION, 1909.

THE McCULLOCH COLLECTION.

FEEDING CHICKENS.

ᏟᏗᏂᏚᏸᏋᏗᏁᏟᏗᏚ ᏗᏁ ᎧᏗᏒᏋᏗᏟᏟᏗᏚ.

· 1911.

56. HARVEST.		*Lent by Professor Stockley.*
95. CHILD PORTRAIT.		*Lent by Miss Purser.*
133. CLOUD, SEA AND SAND.		*Lent by Mrs. Noel Guinness.*
142. STUDY.		*Lent by J. M. Kavanagh, Esq., R.H.A.*
209. LEAVES FROM A SKETCH-BOOK.		*Lent by R. C. Orpen, Esq.*
237. V.A.A.G. Aged 1 year 8 months.		

Note.—Described in catalogue as by W. Osborne, R.H.A., which description might stand for William Osborne, R.H.A.

INTERNATIONAL EXHIBITION, ROME, 1911.

70. AN OCTOBER MORNING. *Lent by the Corporation of London.*

WHITECHAPEL ART GALLERY, 1913.

18. THE HARROW.		*Lent by Henry W. Moss.*
119. SUMMER TIME.		*Lent by the Corporation of Preston.*
122. SIR WALTER ARMSTRONG.		*Lent by Sir Walter Armstrong.*
127. A BOY AND A DOG.		*Lent by Nathaniel Hone, R.H.A.*

APPENDIX XIII.

A SELECTION OF PRICES REALISED FOR WORKS

BY WALTER OSBORNE, R.H.A.,

AT AUCTION SALES SINCE HIS DEATH.

Messrs. " Christie's " Sale, April 29th, 1910.
(From the collection of George McCulloch.)

FEEDING POULTRY. Signed 1885. 35½ x 27½ £58 16 0

Messrs. Bennett and Son's Sale, Dublin, May 11th, 1911.

A VIEW OF THE FOUR COURTS. £1 10 0
NEAR STEPHEN'S GREEN. (AN IMPRESSION) £7 0 0

Messrs. Bennett and Son's Sale, Dublin, April 2nd, 1912.
(From the collection of Lord Powerscourt.)

YOUTH AND AGE. Signed 1882 £24 0 0

Messrs. Bennett and Son's Sale, Dublin, April, 1914.
(From the collection of Canon Harris.)

FISHING BOATS. £1 15 0
SHEEP. £6 5 0
COAST SCENE AND HARBOUR. £7 0 0
SHEPHERD AND FLOCK. Signed 1890. £10 0 0
STREET SCENE IN NORMANDY. Signed 1891. £13 0 0
THE THORNBUSH. £50 0 0
Note.—Now in the possession of Barrington Jellett, Esq., J.P.
COAST SCENE AND FIGURES £16 10 0

TERRIER AND COLLIE. 	£4	10	0
AN IRISH VILLAGE. 	£13	0	0

Note.—Now in the possession of James Sealy, Esq., K.C.

A GIRL READING A BOOK. 	£5	5	0
COAST SCENE AND FIGURES. 	£20	0	0

Note.—Now in the possession of James Sealy, Esq., K.C.

SHEEP RESTING NEAR A FARMYARD. 	£8	0	0
PATRICK'S CLOSE : WATER-COLOUR. 	£15	10	0
CAT AND KITTENS. 	£6	0	0

Messrs. Bennett and Son's Sale, Dublin, July 8th, 1915.

BOY TENDING SHEEP. 	£1	10	0
LANDSCAPE, COTTAGE AND SHEEP. 	£2	5	0
VIEWS IN VENICE. (A Pair) 	£21	0	0

Note.—These pictures measure about 4 ft. 6 in. x 3 ft. I am told they were done from photographs. Osborne never was in Venice. They subsequently came into the possession of Sir Robert Woods, who presented them to the University Club, Dublin.

Messrs. Bennett and Son's Sale, Dublin, December 3rd, 1915.

(From the collection of Sir Thornley Stoker.)

EIGHT SKETCHES AND A SKETCH-BOOK. 	£10	15	0

Messrs. Bennett and Son's Sale, Dublin, August 1st, 1916.

(From the collection of Sir William Findlater.)

A TEMPTING BAIT. 36 x 26 	£14	10	0

Note.—This picture was sold again by Messrs. Bennett and Son on March 26th, and its price then advanced to 28 guineas.

Messrs. Bennett and Son's Sale, Dublin, February 4th, 1918.

BILLY. 	£16	16	0

Note.—Now in the possession of William FitzSimon, Esq.

Messrs. Bennett and Son's Sale, Dublin, October 15th, 1918.

A GLADE IN THE PHŒNIX PARK. £75 12 0

Now in the possession of Barrington Jellett, Esq., J.P.

Messrs. Bennett and Son's Sale, Dublin, July 8th, 1919.

IN A FREE LIBRARY. £19 19 0

Now in the possession of the author.

APPENDIX XIV.

WORKS BY NATHANIEL HONE, R.H.A.,

FORMING PART OF PUBLIC COLLECTIONS.

THE NATIONAL GALLERY OF IRELAND.

588. PASTURE AT MALAHIDE. 32½ in. H., 49 in. W. A pasture field, with group of cattle lying down. In background a long grove of trees. Presented by the artist in 1907.

(From the Official Catalogue.)

Illustrated in the official catalogue and in *The Palace of Fine Arts Souvenir, Irish International Exhibition*, 1907, *A Folio of Famous Pictures.*

Note.—For other pictures soon to be included in the same collection see Appendix XVI.

THE LUXEMBOURG GALLERY, PARIS.

583. L'EPAVE. H. o m. 60., L. 1 m. 02.

Note.—These particulars are taken from *Le Museé du Luxembourg,* by M. Léonce Bénedite.

THE MUNICIPAL GALLERY OF MODERN ART DUBLIN.

1. THE DONEGAL COAST. Canvas, 26 in. x 40 in. (sight measure).
Lane Gift.

8. EVENING : MALAHIDE SANDS. Canvas, 34 in. x 50 in.
Presented by the Artist.

40. LANDSCAPE. *Presented by the Artist.*

41. VENICE. *Presented by the Artist.*

42. SEA PIECE. *Presented by the Artist.*

(From the official catalogue, which has been out of print for many years).

Note.—Since the catalogue has been out of print the following items have been added to the collection :—

i. A GREY DAY AT MALAHIDE. 18 in. x 27 in. *Lane Bequest.*

ii. VIEW OF HOWTH WITH CATTLE GRAZING. $18\frac{1}{2}$ in. x $29\frac{1}{2}$ in.
Lane Bequest.

iii. VIEW ON THE NILE. $23\frac{1}{2}$ in. x 40 in. *Lane Bequest.*

iv. MALAHIDE SANDS, STORMY WEATHER. $24\frac{1}{2}$ in. x 35 in.
Lane Bequest.

v. LANDSCAPE. $23\frac{1}{2}$ in. x $39\frac{1}{2}$ in. Three men reaping, group of trees centre back. Presented by the artist's widow in remembrance of Sir Hugh Lane.

No. 1 measures 23 in. x 40 in.; No. 8 measures 33 in. x 49 in.; No. 40 measures $33\frac{1}{2}$ in. x $47\frac{1}{2}$ in. It is illustrated in the catalogue. No. 41 measures $25\frac{1}{2}$ in. x 39 in. ; No. 42 is entitled " Off Lowestoft " and measures $33\frac{1}{2}$ in. x 50 in.

No. 8 is signed " Nath Hone R H A " ; No. 40 is signed " Nathl Hone R.H.A." ; Nos. 41, i, iii and iv. are signed " N H ".

The particulars not appearing in the catalogue I owe, for the most part, to the courtesy of Mrs. Duncan, the Curator of the Gallery.

THE MUNICIPAL GALLERY OF MODERN ART, JOHANNESBURG.

38. PASTURAGE AT MALAHIDE, CO. DUBLIN. From the official catalogue, in which an illustration of the picture appears.
Note.—Signed " N H."

THE SCOTTISH MODERN ARTS ASSOCIATION.

THE DERELICT. 33½ in. x 47½ in. (sight measurements). Signed " N H."
Note.—This picture, with others in the Association's collection, is shown in Edinburgh, at the Royal Scottish Academy's galleries, for six months in each year. It is shown at other times in art galleries of Aberdeen, Dundee, Stirling and Glasgow.

I am indebted to Mr. James L. Gaw, the Director of the Scottish National Gallery, for a description of the picture. He tells me it was presented to the Association by Sir Hugh Lane. An illustration of it appears in the jubilee issue of *The Irish Builder*, 1909, entitled " The Derelict, by N. Hone. Presented by Mr. Lane to the National Gallery, Edinburgh." Another and better illustration is in the catalogue of the Irish Art Gallery, Ballymaclinton, at the Franco-British Exhibition of 1908.

THE IRISH COLLECTION OF PAINTINGS AT THE UNIVERSITY OF WISCONSIN, U.S.A.

SHIPS ON THE BEACH. *Presented by Frank Cantwell, Esq.*

APPENDIX XV.

WORKS BY NATHANIEL HONE, R.H.A.,

EXHIBITED IN HIS LIFETIME.

SOCIÉTÉ DES ARTISTES FRANÇAIS (THE SALON.)

(From information kindly supplied by M. E. Thoumy, Le Commissaire General de la Société des Artistes Français.)

1867. LA MARE AUX FÉES.

DANS LES VIGNES.

1868. UNE VUE PRISE AUX ENVIRONS DE TROUVILLE.

LE PORT DE ROSCOFF (FINISTÈRE).

1869. LA MARE AUX FÉES : PONT DE FONTAINEBLEAU.

LISIÈRE DE BOIS.

THE ROYAL ACADEMY.

44 Rue Notre Dame de Lorette.

1869.—161. STUDY FROM NATURE.

THE ROYAL HIBERNIAN ACADEMY.

Seafield, Malahide.

1876.— 22. COAST NEAR BORDÉGHERA.	£50 0 0
54. STONE PINES NEAR CANNES.	£50 0 0
1877.—191. THE BAY OF NICE.	£25 0 0
1879.—109. MENTONE—EVENING.	£40 0 0
338. SAND HILLS.	£20 0 0
1880.— 51. ROAD TO THE MINES, GLENMALURE.	£40 0 0
144. A MISTY EVENING,—GLENMALURE.	£40 0 0
1881.— 1. MOUNTAIN ROAD—MORNING.	£40 0 0
24. VILLEFRANCHE, EVENING.	£50 0 0
55. MOOR IN ERRIS.	£40 0 0
1882.— 10. ON THE SEINE, NEAR BOUGIVAL—SPRING MORNING.	£50 0 0
36. A FECAMP LUGGER.	£50 0 0
92. A BARLEY FIELD, MALAHIDE.	£40 0 0
94. CHRYSANTHEMUMS.	£20 0 0
1883.— 19. BEAULIEU, NEAR NICE.	£50 0 0
34. SHOWERY WEATHER.	£50 0 0
72. BEACH, ETRÉTAT.	£50 0 0
125. SUNSET, MALAHIDE ESTUARY.	£50 0 0
1884.— 9. LOW TIDE.	£40 0 0
18. ON THE CLIFFS.	£40 0 0

Note.—A prize in Irish Art Union Drawing, won by N. H. T. Martin, Esq., Priory Lodge, Blackrock, Co. Dublin.

131. HASTINGS. £50 0 0
174. SANDHILLS. £30 0 0
1885.— 63. LOW TIDE. £50 0 0
134. BENVENUE. £40 0 0
137. SKETCH IN A CORNFIELD. £15 0 0

*Note.—*Illustrated in *Dublin University Review
Art Supplement*, 1885.

214. SEASHORE : MALAHIDE £20 0 0
1886.— 37. SANDS, PORTMARNOCK £40 0 0
49. MALAHIDE ESTUARY £20 0 0

*Note.—*Illustrated in *Dublin University
Review Art Supplement*, 1886.

138. A BARLEY FIELD. £50 0 0
267. SCHEVENINGE (*sic*). £10 0 0
282. SANDS AND BENT. £10 0 0
1888.— 33. TWILIGHT. £60 0 0
102. THE PONT DE GARDE. £60 0 0
108. SANDHILL. £60 0 0
1889.— 5. IRISH CHANNEL. £60 0 0
76. BREEZY DOWNS. £40 0 0
78. BLACK-WOOD · ROAD. £60 0 0
82. WIND AGAINST TIDE. £40 0 0
1891.— 78. A WHITE STRAND. £50 0 0
92. NEAR KILKEE. £60 0 0
300. BURROW, PORTMARNOCK. —
1893.— 22. SHOWERY WEATHER. £60 0 0
42. COAST, TO CLARE. £30 0 0
80. LANDSCAPE, · MALAHIDE. £40 0 0
116. AMALFI. £40 0 0
136. THE SPHYNX (*sic*). £30 0 0

Moldowney, Malahide.

1894.— 16. SUMMER IN THE SANDHILLS. £50 0 0

160 APPENDICES

58. Pasturage, Malahide.		£60 0 0
1894.— 62. Lock Swilly, near Portsalon.		£30 0 0
81. Coast near Scheveningen.		£30 0 0
93. Coast near Portrush.		£30 0 0
1895.— 10. Mouth of Lough Swilly.		£50 0 0
38. Pasturage, Malahide.		£40 0 0
74. Gannets.		£30 0 0
92. Sketch : German Ocean.		£10 0 0
121. Sand Downs.		£60 0 0

St. Dolough's Park, Raheny.

1896.— 11. Rough Sea, Bundoran.		£30 0 0
82. Pasturage, Malahide.		£60 0 0
1897.— 25. Sandhills.		£40 0 0
35. Pigeon Caves.		£50 0 0
45. Near Malahide.		£40 0 0
99. Landscape.		£40 0 0
143. Landscape.		£20 0 0
1898.— 6. Autumn.		—
34. Landscape.		—
67. A North-East Breeze.		—

Note.—A prize in Irish Art Union Drawing ; priced £30. Won by Miss Salmon, the Provost's House, T.C.D.

1899.— 7. Clovelly Pier.		—
35. Near Katwyk.		—
71. Ville Franche. (*sic*)		—
79. Pond, St. Doloughs.		—
96. Fairy Marsh, Fontainebleau.		—
1900.— 15. Pigeon cave, Bundoran.		—
34. Rocks, Kilkee.		—
39. Pasturage.		—
73. Landscape with Cattle.		—
99. Coast Bundoran.		—

1901.— 6. MALAHIDE SANDS. —
 36. LOUGH SWILLY. —
 83. TULLAN SAND HILLS. —
 213. ON THE YAR. —
 225. A NORTH-EASTER. —
1902.— 15. NEAR SOUTHWOLD. £30 0 0
 36. ST. DOLOUGH'S CHURCH. £30 0 0
 39. SOUTHWOLD FISHING BOATS. £30 0 0
 46. COAST KILKEE. £20 0 0
 127. MUCKROSS BAY, CO. DONEGAL. £30 0 0
1903.— 33. CATTLE AT SEASIDE. £30 0 0
 53. RUINS OF ARDMORE ABBEY. £20 0 0
 64. ENTRANCE TO YOUGHAL HARBOUR. £30 0 0
 98. A STORM AT BUNDORAN. £30 0 0
1904.— 60. NEAR SOUTHWOLD. £30 0 0
 65. ON NORFOLK BROADS. £30 0 0
 68. NEAR NORWICH. £50 0 0
 79. A BROKEN SEA, DONEGAL. £30 0 0
 222. A SILVER SEA. £20 0 0
1905.— 66. MUCKROSS BAY, CO. DONEGAL. £30 0 0
 75. ON SUFFOLK SEAS. £30 0 0
 96. AUTUMN,—ST. DOULOUGH'S. £30 0 0
 123. IN GLENMALURE, CO. WICKLOW. £30 0 0
1906.— 8. CLIFFS, CO. DONEGAL. £40 0 0
 46. ANTIBES. £30 0 0
 67. AUTUMN—ST. DOULOUGH'S. £30 0 0
 73. UNDER THE BEECH TREES. £40 0 0
 89. CHALK CLIFFS, ÉTRETAT. £10 0 0
 92. ROAD TO BOURRON. £20 0 0
1907.— 13. GREY DAY. BUNDORAN. £30 0 0
 34. TULLAN SAND HILLS. £30 0 0
 44. NEAR MALAHIDE. £40 0 0

	51.	STRAND, SHEEPHAVEN.	£40	o	o
	134.	NEAR SOUTHWOLD.	£40	o	o
1908.—	16.	IN LIGURIA.	£60	o	o
	21.	NEAR NORWICH.	£60	o	o
	41.	SOLITUDE.	£30	o	o
	187.	SANDS—MALAHIDE.	£30	o	o
1909.—	43.	CATTLE STRAYED.	£40	o	o
	47.	NEAR MALAHIDE.	£30	o	o
	59.	BREAKERS—KILKEE.	£30	o	o
	83.	A CALM OFF LOWESTOFT.	£40	o	o
	88.	SHEEPHAVEN, CO. DONEGAL.	£40	o	o
	115.	STRAND, PORTMARNOCK.	£15	o	o
	124.	QUAY, VILLEFRANCHE.	£15	o	o
	149.	STRAND, BUNDORAN.	£15	o	o
1910.—	51.	SHOWERY WEATHER.	£40	o	o
	58.	A CALM, SOUTHWOLD.	£40	o	o
	63.	SAND DOWNS.	£40	o	o
	67.	LANDSCAPE WITH CATTLE.	£40	o	o	
	182.	EVENING.	£40	o	o
	193.	THE FERRY, DOUARNENEZ.	£40	o	o	
1911.—	64.	SANDS—KILKEE.	£40	o	o
	57.	WAITING FOR THE FLOOD-TIDE.	£40	o	o	
	82.	COAST NEAR KILKEE.	£35	o	o
	102.	COAST NEAR KILKEE.	£40	o	o
	177.	OFF LOWESTOFT, MORNING.	£30	o	o	
	186.	ON THE YAR.	£30	o	o
1912.—	25.	GREY ROCKS.	£30	o	o
	30.	WRECKAGE.	£40	o	o
	42.	KERRY COWS.	£30	o	o
	52.	CLARE COAST.	£40	o	o
	71.	A SUMMER'S DAY.	£30	o	o
	163.	DUTCH BOATS, KATWYK.	£40	o	o	

172. CATTLE IN BENT GRASS. £40 0 0

1913.— 21. CLARE COAST. £30 0 0

 31. IRELAND'S EYE—DIRTY WEATHER. £30 0 0

 49. SEA SHORE—DONABATE. £40 0 0

 61. AT BOREGIVAL. (*sic*) £30 0 0

 69. AT ST. DOULOUGH'S. £30 0 0

 80. SHORE—BUNDORAN. £30 0 0

 134. ROUGH SEA. £40 0 0

 166. ON THE STARBOARD TACK. £30 0 0

1914.— 8. SAND AND SKY. —
 (The property of W. P. Geoghegan, Esq.)

 10. LANDSCAPE. —
 (The property of Miss Geoghegan.)

 61. PASTURE LAND : MALAHIDE. —
 (Property of Miss S. Purser, H.R.H.A.)

1915.— 7. CORNFIELD—MALAHIDE. —

 18. NEAR KILKEE. —
 Note.—Illustrated in this book.

 29. VILLEFRANCHE. —

 31. POND—ST. DOULOUGH'S. —

 57. NEAR NORWICH. —

 120. ON THE YAR. —

 128. PASTURAGE—MALAHIDE. —

 203. AT MALAHIDE. —

1916.— 52. WRECKAGE. —

 65. SCHEVENINGEN BEACH. —

1917.— 18. SEAWEED GATHERERS. —
 (Property of Sir George Brooke, Bart.)

 20. A MORNING DIP. —
 (Property of Sir George Brooke, Bart.)

 34. ERRIS, CO. MAYO. —
 (Property of Sir George Brooke, Bart.)

DUBLIN ART CLUB.

<div align="right">Moldowney, Malahide.</div>

1886.— 2. STUDY FROM NATURE.	£5 0 0	
22. STUDY FROM NATURE.	£5 0 0	
35. STUDY OF WAVES.	£10 0 0	
48. ON THE SAND HILLS.	£20 0 0	
156. STUDY FROM NATURE.	—	

<div align="center">(Lent by W. B. Pearsall.)</div>

1887.— 36. STUDY FROM NATURE.	—
42. STUDY FROM NATURE.	—
51. ON THE DUTCH COAST.	£21 0
128. STUDY FROM NATURE.	—
145. SAND HILLS, MALAHIDE.	£21 0 0
1889.— 28. STUDY NEAR MALAHIDE.	£5 5 0
40. STUDY NEAR MALAHIDE.	£10 0 0
45. STUDY NEAR MALAHIDE.	£5 5 0
65. ST. PATRICK—DECORATIVE PANEL.	—

<div align="center">This lunette will be placed in one of the wards of Sir Patrick Dun's Hospital by the members of the Kyrle Society.</div>

113. STUDY NEAR PORTMARNOCK.	£5 5 0
116. SEA SHORE—ÉTRETAT.	£20 0 0
1890.— 35. STUDY FROM NATURE.	£10 0 0
36. STUDY FROM NATURE.	£5 5 0
40. STUDY FROM NATURE.	£5 5 0
111. STUDY FROM NATURE.	£5 5 0
117. STUDY FROM NATURE.	£10 0 0
124. STUDY FROM NATURE.	£10 0 0
1891.— 27. MALAHIDE SANDS.	£10 0 0
58. LANDSCAPE.	£10 0 0
120. A HAYFIELD.	£20 0 0
132. LANDSCAPE.	£20 0 0

DUBLIN ARTS CLUB.

1893.— 15. COAST, CO. CLARE.	£30 0 0
29. COAST, CO. CLARE.	£30 0 0
93. CORNFIELD.	£30 0 0
100. COAST—MALAHIDE.	£30 0 0
1894.— 6. COAST NEAR PORTRUSH.	£20 0 0

Note.—Numbered 4 in index to catalogue.

51. LANDSCAPE WITH CATTLE.	£20 0 0
63. COAST, CO. CLARE.	£30 0 0

THE WATER COLOUR SOCIETY OF IRELAND.

1882.—381. THE LIVERPOOL MAIL NEAR ST. ALBAN'S. (Copy.)

383. PULLING UP TO UNSKID.

> *Note.*—I am obliged to Mr. W. H. Hilliard, the Secretary of the Society, for these particulars. He also informs me that neither of these pictures was mentioned in any of the three long articles on the Water-Colour Society's exhibition of 1882 which appeared in the Dublin papers at the time.

CORK EXHIBITION, 1883.

164. MOUNTAIN ROAD, CO. WICKLOW.

156. A FECAMP LUGGER.

A LOAN COLLECTION OF PICTURES BY J. B. YEATS, ESQ., R.H.A., AND NATHANIEL HONE, ESQ., R.H.A., AT 6 ST. STEPHEN'S GREEN, DUBLIN, 1901.

1. GLENMALURE.

3. EVENING.

4. VILLEFRANCHE NEAR NICE.

5. BREAKERS NEAR BUNDORAN.

6. MALAHIDE SANDS.

8. LANDSCAPE WITH CATTLE, ST. DOULOUGH'S.

9. COAST COUNTY CLARE. *Lent by Walter Osborne, R.H.A.*

10. THE MEADOW.

11. PATH NEAR MALAHIDE. *Lent by Dr. Pearsall.*

13. TULLAN SANDHILLS NEAR BUNDORAN.

35. MENAI BRIDGE.

40. LANDSCAPE. *Lent by Walter Osborne, R.H.A.*

42. COAST, KILKEE.

43. HAY CART. *Lent by Dr. Pearsall.*

44. STUDY FROM NATURE, PORTMARNOCK.

46. LANDSCAPE WITH CATTLE, MOLDOWNEY.

47. THE FAIRY MARSH, FONTAINEBLEAU.

49. THE SHOWER.

52. GLENMALURE, CO. WICKLOW.

54. LANDSCAPE WITH CATTLE, ST. DOULOUGH'S.

55. MALAHIDE SANDS.

56. SKETCH FROM NATURE, MALAHIDE.

58. VILLEFRANCHE.

59. COAST, CO. CLARE. *Lent by W. E. Purser, Esq.*

60. ESTUARY, MALAHIDE. *Lent by Miss Purser.*

64. SKETCH, DUTCH COAST.

67. SKETCH NEAR KATWYK.

70. SKETCH FROM NATURE NEAR FONTAINEBLEAU.

> *Note.*—All lent by the artist save when otherwise stated.

INTERNATIONAL EXHIBITION, CORK, 1902.

207. LOUGH SWILLY.

248. KILKEE COAST.

255. CATTLE IN PASTURE.

> *Note.*—This picture is numbered 253 in the index to the catalogue.

WORKS BY IRISH PAINTERS AT THE GUILDHALL, LONDON, 1904.

9. EVENING, MALAHIDE SANDS. 34 in. x 50 in. *Lent by the Artist.*

 Note.—Illustrated in official catalogue. Now in Dublin Municipal Gallery of Modern Art. Presented by the artist.

25. CATTLE, MALAHIDE. 33 in. x 50 in. *Lent by the Artist.*

37. THE IRISH CHANNEL. 26 in. x 40 in. *Lent by the Artist.*

52. THE DONEGAL COAST. 26 in. x 40 in. *Lent by Hugh P. Lane.*

 Note.—Now in the Dublin Municipal Gallery of Modern Art. Presented by Sir Hugh Lane.

ROYAL HIBERNIAN ACADEMY, 1904.

EXHIBITION OF PICTURES FORMING THE NUCLEUS OF THE DUBLIN MUNICIPAL GALLERY OF MODERN ART.

10. THE COAST NEAR MALAHIDE. *Lane Collection.*

38. SUNSET, MALAHIDE SANDS. *Presented by the Artist.*

 Note.—This is No. 9 in the Guildhall Exhibition list above.

BELFAST LOAN EXHIBITION, 1906.

48. COAST NEAR MALAHIDE.

MUNSTER-CONNACHT EXHIBITION, LIMERICK, 1906.

57. GLENMALURE—CO. WICKLOW.	£30 0 0
58. NEAR SOUTHWOLD.	£30 0 0
64. STRAND, MALAHIDE.	£10 0 0
67. A WAVE.	£30 0 0
70. LIGURIA.	—
86. HAYFIELD, MALAHIDE.	£10 0 0
89. MALAHIDE SANDS.	£10 0 0
118. ST. DOULOUGH'S.	£10 0 0
130. SCHEVENINGEN.	£15 0 0
146. DUTCH COAST.	£10 0 0

IRISH INTERNATIONAL EXHIBITION, DUBLIN,
1907.

77. LANDSCAPE. $15\frac{1}{2}$ x $12\frac{1}{2}$. *Lent by Andrew Jameson, Esq.*

79. BREAKERS. $25\frac{1}{2}$ x $29\frac{1}{2}$. *Lent by Andrew Jameson, Esq.*

80. PASTURAGE, MALAHIDE. 34 x 49. *Lent by the Artist.*

82. STONE PINES : CANNES. 33 x 49. *Lent by John Jameson, Esq.*

83. ROMAN AQUEDUCT, NEAR NISMES. 33 x 49.
 Lent by John Jameson, Esq.

 Note.—Exhibited at the Royal Hibernian Academy in 1888 as " No. 102. The Pont de Garde."

84. THE FAIRY MARSH. 25 x 39. *Lent by the Artist.*

123. NEAR MALAHIDE. 27 x 35. *Lent by the Artist.*

128. A GREY DAY. 25 x 28. *Lent by the Artist.*

130. ROAD NEAR MALAHIDE CASTLE. $16\frac{1}{2}$ x 25.
 Lent by Sir George F. Brooke, Bart.

132. BOUNDARY FENCE OF FONTAINEBLEAU FOREST. 16 x 25.
 Lent by Sir George F. Brooke, Bart.

230. ANTIBES AND ALPES MARITIMES. 12 x $17\frac{1}{2}$.
 Lent by Sir George F. Brooke, Bart.

231. EVENING. 12 x 18. *Lent by Sir George F. Brooke, Bart.*

232. A CALM DAY. $12\frac{1}{2}$ x 17. *Lent by Sir George F. Brooke, Bart.*

FRANCO-BRITISH EXHIBITION, LONDON,
1908.

149. DONEGAL BAY. *Lent by the Artist.*

IRISH ART GALLERY :—BALLYMACLINTON,
FRANCO-BRITISH EXHIBITION, 1908.

6. BALDOYLE ESTUARY. *Lent by Sir George Brooke, Bart.*

10. ANTIBES, ALPES MARITIMES. *Lent by Sir George Brooke, Bart.*

18. ROAD IN THE DONEGAL MOUNTAINS.
 Lent by Sir George Brooke, Bart.

 Note.—Illustrated in official catalogue.

19. MALAHIDE SANDS. *Lent by Hugh Lane, Esq.*

23. SANDHILLS, DONABATE, CO. DUBLIN.
 Lent by Sir George Brooke, Bart.

24. SEAWEED GATHERERS. *Lent by Sir George Brooke, Bart.*
 Note.—Illustrated in official catalogue.

33. A MORNING DIP. *Lent by Sir George Brooke, Bart.*

39. BOUNDARY FENCE, FOREST OF FONTAINEBLEAU.
 Lent by Sir George Brooke, Bart.

41. THE PATH THRO' THE WOOD. *Lent by Sir George. Brooke, Bart.*
 Note.—Illustrated in official catalogue.

42. VILLEFRANCHE. *Lent by Sir George Brooke, Bart.*

52. SUNSET, MALAHIDE, CO. DUBLIN.
 Lent by the Dublin Municipal Art Gallery.

53. THE DERELICT. *Lent by the Artist.*
 Note.—Illustrated in official catalogue. Now in the possession of
 the Scottish Modern Arts Association.

55. OFF LOWESTOFT. *Lent by the Dublin Municipal Art Gallery.*
 Note.—Illustrated in official catalogue.

56. ERRIS, CO. MAYO. *Lent by Sir George Brooke, Bart.*

62. SUNSET, ST. DOULOUGH'S. *Lent by Sir George Brooke, Bart.*

WHITECHAPEL ART GALLERY, LONDON, 1910.

462. PASTURAGE AT MALAHIDE. *Lent by Sir Hugh Lane.*
 Note.—Presented, subsequently, to the Municipal Gallery of Modern
 Art, Johannesburg, by Sir Hugh Lane.

INTERNATIONAL EXHIBITION, ROME, 1911.

212. COAST OF CLARE, NEAR KILKEE.

BELFAST LOAN EXHIBITION, 1911.

26. ETRETAT FORTY YEARS AGO.

121. NEAR KILKEE, CO. CLARE.

Cᴀɪsbeᴀ́ɴcᴀs ᴀɴ oɪ̃ʀeᴀ́ccᴀɪs

DUBLIN, 1911.

6.	FISHERS.	*Lent by W. P. Geoghegan, Esq.*
7.	NEAR MALAHIDE.	*Lent by Mrs. Noël Guinness.*
8.	KILKEE.	*Lent by Miss Purser.*
13.	SEA PIECE.	*Lent by Mrs. Noël Guinness.*
16.	SEA PIECE.	*Lent by John McCann, Esq.*
17.	CLIFFS, ÉTRETAT.	*Lent by C. J. McCarthy, Esq.*
112.	THE STRAND.	*Lent by Miss Griffith.*
113.	MALAHIDE.	*Lent by Miss Purser.*
118.	VIEW ON THE SEINE.	*Lent by Sir George Brooke, Bart.*
119.	OPEN COUNTRY.	*Lent by Miss Purser.*
122.	CLIFFS AND BREAKERS.	*Lent by Sir George Brooke, Bart.*
123.	NEAR PORTMARNOCK.	*Lent by Miss Purser.*
128.	A CALM DAY.	*Lent by Sir George Brooke, Bart.*
130.	ROSALIE.	*Lent by Sir George Brooke, Bart.*
136.	GORSE AND SAND.	*Lent by Miss Griffith.*

WHITECHAPEL ART GALLERY, 1913, EXHIBITION OF IRISH ART.

7.	BANKS OF THE SEINE, BOATS, BARRELS, ETC.	
		Lent by Sir George Brooke, Bart.
8.	CALM—COAST SCENE.	*Lent by Sir George Brooke, Bart.*
9.	ANTIBES AND ALPES MARITIMES.	*Lent by Sir George Brooke, Bart.*
10.	SKETCH AT MALAHIDE.	*Lent by Miss Purser, H.R.H.A.*
12.	COAST SCENE, IRELAND, WITH FIGURES.	
		Lent by Sir George Brooke, Bart.
13.	THE MIST.	*Lent by the Hon. Mary Massey.*
64.	ESTUARY.	*Lent by Miss Purser, H.R.H.A.*
102.	ROCKS AT KILKEE.	*Lent by Miss Purser, H.R.H.A.*
107.	COAST OF CLARE.	*Lent by the Artist.*

109. ERRIS, CO. MAYO. *Lent by Sir George Brooke, Bart.*
 Note.—Illustrated in this book.

111. PASTURAGE. *Lent by the Artist.*

113. SANDS OF SCHEVENINGEN. *Lent by Dermod O'Brien, P.R.H.A.*

115. BOUNDARY FENCE, FONTAINEBLEAU FOREST.
 Lent by Sir George Brooke, Bart.
 Note.—Illustrated in this book.

117. IN A CORNFIELD. *Lent by the Artist.*

APPENDIX XVI.

PICTURES, SKETCHES AND STUDIES BY NATHANIEL HONE, R.H.A., in the collection of Mrs. Hone at the time of her death ; two of which will be offered to the National Gallery of London, and the remainder, or a selection from the remainder, to the National Gallery of Ireland, by William Jameson, Esq., the Executor and Trustee named in her will.

From a catalogue prepared by Dermod O'Brien, Esq., P.R.H.A.

	Height.	*Length.*
1. GOATS AND PINE TREES : SOUTH OF FRANCE. Framed	34½ in.	x 48 in.
2. FISHING BOATS OFF THE KISH	34 in.	x 51 in.
3. BOATS ON THE NORFOLK BROADS	34 in.	x 50½ in.
4. FISHING BOATS (FOUR) RETURNING	34½ in.	x 50½ in.
5. NORFOLK BROADS : COWS GOING TO WATER	34 in.	x 48 in.
6. LOUGH SWILLY	34 in.	x 50 in.
7. "ETRETAT FIFTY YEARS AGO"	24 in.	x 36 in.
8. STORM CLOUD : LOUGH SWILLY	26 in.	x 40 in.
9. DOGES PALACE AND GONDOLAS IN FOREGROUND	27 in.	x 38½ in.

		Height.	Length.
10. VILLEFRANCHE, NEAR NICE.	Framed	24 in.	x 39 in.
11. PASTURES, MALAHIDE : RAIN CLOUD AND COWS (FOUR)	„	25 in.	x 36 in.
12. FISHING THE STREAM UNDER THE TREES	„	24 in.	x 36 in.
13. COWS UNDER THE TREES : MALAHIDE ...	„	25 in.	x 36 in.
14. ST. MARNOCKS : SAND AND SEA (FIVE COWS)	„	24 in.	x 36 in.
15. THE SPHYNX	„	25 in.	x 36 in.
16. SHEEP UNDER TREES IN AUTUMN	„	24 in.	x 38½ in.
17. MALAHIDE SANDS : EVENING	„	24 in.	x 36 in.
18. ST. MARNOCK'S SANDY PASTURES (SIX COWS)	„	24 in.	x 40 in.
19. FRANCE : CHILDREN UNDER TREES BY RIVER	„	24 in.	x 36 in.
20. BUNDORAN SANDS AND SEA : GREY WEATHER	„	25 in.	x 39 in.
21. COAST OF CLARE NEAR KILKEE. (ROME EXHIBITION, 1911)	„	24 in.	x 40 in.
22. DONEGAL COAST : SEAWEED GATHERERS ON ROCK	„	26 in.	x 40 in.
23. SEAWEED GATHERERS WITH TWO GROUPS DONKEYS	„	24 in.	x 36 in.
24. BREAKERS, CLIFF, CAVE AND SHEEP ...	„	24 in.	x 36 in.
25. SHEEP ON DONEGAL ROAD, PATCH OF HEATHER	„	24 in.	x 39 in.
26. GLENMALURE, CO. WICKLOW : SHEEP TO PASTURE	„	24½ in.	x 36 in.
27. ST. MARNOCK'S SANDS AND FRAGMENT OF WRECK	„	26 in.	x 39½ in.
28. THE FAIRY MARSH, FONTAINEBLEAU ...	„	25½ in.	x 39½ in.
29. SANDY PASTURES, THREE COWS, HORSE AND CART APPROACHING	„	19½ in.	x 30 in.
30. ST. DOULOUGH'S OLD CHURCH	„	36 in.	x 28 in.
31. VISTA THRO' TREES : COWS IN SUNLIGHT APPROACHING	„	39½ in.	x 32½ in.
32. FEEDING PIGEONS AT HOUSE IN BARBIZON	„	28 in.	x 22½ in.

Note.—Probably the picture exhibited at the Royal Academy in 1869.

			Height.	*Length.*
33.	GLEANERS' STOOKS AND TREES ...	Framed	23 in.	x 28 in.
34.	TWO FISHING BOATS : HOMING	,,	25 in.	x 36 in.
35.	THE GREY GREEN BREAKER	,,	19½ in.	x 30½ in
36.	MAN, HORSE AND CART, LOAD OF SEAWEED ON SANDS	,,	17 in.	x 25 in.
37.	MULE CART IN STREET OF CAP ST. MARTIN	,,	16½ in.	x 25 in.
38.	THE BAY OF NICE	,,	14 in.	x 28 in.
39.	THE BAR AT MALAHIDE : ONE COW ...	,,	16 in.	x 24½ in.
40.	BREAKING WAVES	,,	17 in.	x 27 in.
41.	THE FISHING FLEET, SCHEVENINGEN ...	,,	14 in.	x 28 in.
42.	RUINED CHURCH AND ROUND TOWER ...	,,	24 in.	x 19½ in.
43.	BOATS ON SHORE AT ÉTRETAT	,,	14 in.	x 21 in.
44.	BROWN WEEDS ON SAND LINKS, ST. MARNOCK'S	,,	12 in.	x 18½ in.
45.	THREE TREE TRUNKS IN AUTUMN FOLIAGE	,,	13 in.	x 18 in.
46.	HAYFIELD, MALAHIDE	,,	12½ in.	x 19 in.
47.	MALAHIDE SANDS	,,	11½ in.	x 18 in.
48.	SUNSET : MALAHIDE.	,,	11 in.	x 17¼ in.
49.	SUNSET : ST. DOULOUGH'S	,,	11 in.	x 17½ in.
50.	STUDY FOR FAIRY MARSH, FONTAINEBLEAU	,,	11½ in.	x 17½ in.
51.	STUDY FOR PIGEON FEEDING. NO. 32 ...	,,	18 in.	x 14½ in.
52.	SEA AND SKY AND ST. MARNOCK'S SANDS	,,	11 in.	x 17½ in.
53.	STUDY : FISHING BOAT, " F. 912 "	,,	20 in.	x 16 in.
54.	STUDY : STREAM UNDER TREES, COTTAGE IN DISTANCE	,,	13 in.	x 17½ in.
55.	SANDY ROAD WITH WOMAN AND CHILD ...	,,	13 in.	x 18 in.
56.	THREE TREE TRUNKS, SPRING FOLIAGE ...	,,	11½ in.	x 16 in.
57.	CARIATIDES, GREECE	,,	12 in.	x 19 in.
58.	STUDY : FRENCH BARGES ON RIVER ...	,,	9 in.	x 13½ in.
59.	STUDY OF COW	,,	12 in.	x 17½ in.
60.	STUDY : SEA-SWEPT ROCK	,,	7 in.	x 10 in.
61.	,, BUNDORAN BAY	,,	7 in.	x 10½ in.
62.	,, CLIFF AND WAVES, BUNDORAN ...	,,	7 in.	x 10 in.

	Height.	Length.
63. STUDY : OAK, ST. DOULOUGH'S : AUTUMN Framed	7 in.	x 10 in.
64. ,, TREE OVER STREAM, COW DRINKING ,,	7 in.	x 10 in.
65. ,, LOW TIDE, SUTTON ,,	7 in.	x 10½ in.
66. ,, AUTUMN TREES OVER ROAD ... ,,	7 in.	x 10 in.
67. ACROSS THE PLAIN AT PAU ,,	8 in.	x 12 in.
68. STUDY : THE STREAM, ST. DOULOUGH'S ,,	7 in.	x 10 in.
69. ROSALIE AND THE GOAT ,,	11½ in.	x 17½ in.
70. STUDY : PARK, ST. DOULOUGH'S ,,	10 in.	x 13½ in.
71. THE RIVER AND VIADUCT ,,	9½ in.	x 14 in.
72. STUDY : TREES ,,	5 in.	x 7 in.
73. SKETCH OF PYRENNEES ,,	10¾ in.	x 17½ in.

UNFRAMED CANVASES STRETCHED.

	Height	Length
74. CONSTANTINOPLE	34 in.	x 48 in.
75. HAY WYNDS	31 in.	x 43 in.
76. THE POOL BEFORE RAIN, FOUR COWS	34 in.	x 44 in.
77. UNFINISHED PICTURE FROM SKETCH NO. 74 ...	34 in.	x 50 in.
78. WAVE AND CAVE	24 in.	x 36 in.
79. HASTINGS : EARLY	24 in.	x 36 in.
80. ERRIGAL, CO. DONEGAL	24 in.	x 36 in.
81. VENICE : DOGES PALACE, WITH SHIPS UNDER SAIL	24 in.	x 36 in.
82. SEAWEED GATHERER WITH DONKEY PANNIERS ...	24 in.	x 36 in.
83. YACHTS HOMING UNDER SPINNAKERS	24 in.	x 36 in.
84. FROM THE CASTLE KEEP	24 in.	x 36 in.
85. FOUR SAILING FISHING BOATS	24 in.	x 36 in.
86. SANDS AT SCHEVENINGEN	24 in.	x 36 in.
87. UNFINISHED COWS IN TREE SHADOWS	24 in.	x 36 in.
88. UNFINISHED HARBOUR, CONSTANTINOPLE ...	24 in.	x 36 in.
89. DRIVING COWS HOME THROUGH THE BENT ...	24 in.	x 36 in.
90. COWS (THREE) BY STREAM, CLOUDY DAY ...	24 in.	x 36 in.
91. THREE COWS LYING IN BENT BY SHORE	24 in.	x 36 in.
92. ROUND IRELAND'S EYE WITH SPINNAKERS ...	24 in.	x 36 in.

APPENDIX XVI **175**

		Height.	Length.
93.	HARVEST : CARTING THE STOOKS	24 in.	x 36 in.
94.	THE LITTLE HARBOUR	24 in.	x 40 in.
95.	THREE COWS AND THE LITTLE CLIFF	24 in.	x 40 in.
96.	THE OAT FIELD, ST. DOULOUGH'S	24 in.	x 40 in.
97.	MISTY EVENING : GLENMALURE	24 in.	x 40 in.
98.	THE MILKY SEA	24 in.	x 40 in.
99.	CATTLE RESTING IN THE SAND DUNES	26 in.	x 39 in.
100.	UNFINISHED AUTUMN TREES	26 in.	x 39 in.
101.	SUNSET AND THE WINDING ROAD	25 in.	x 36 in.
102.	DRYING THE SAILS : SCHEVENINGEN BEACH	25 in.	x 36 in.
103.	SHADOWS CAST FROM TREES	25 in.	x 36 in.
104.	THE POOL UNDER THE WILLOW	25 in.	x 36 in.
105.	THE BEACH	25 in.	x 36 in.
106.	THE ISLAND, MALAHIDE	24 in.	x 42 in.
107.	THE ROAD DOWN TO THE PLAIN	36 in.	x 29 in.
108.	THREE PALMS : GATHERING COCOANUTS	26 in.	x 20 in.
109.	SHEEP AND SHEPHERD BY THE SEA	18 in.	x 27 in.
110.	COWS CROSSING THE SAND	17 in.	x 27 in.
111.	GORSE AND COWS BY THE SEA	17 in.	x 27 in.
112.	BOYS BATHING ON SANDY SHORE	17 in.	x 27 in.
113.	TWO CHILDREN IN THE SAND HILLS	16 in.	x 27 in.
114.	THE BIRCH TREE	24 in.	x 20 in.
115.	COWS ON THE SHADOWED ROAD	24 in.	x 20 in.
116.	TWO COWS AND ONE : GREY DAY	20 in.	x 24 in.
117.	SAND HILLS, GORSE AND THREE COWS	25 in.	x 17 in.
118.	THE AVENUE : AUTUMN	25 in.	x 17 in.
119.	THE OAK TREE IN THE PARK	25 in.	x 17 in.
120.	BEECH TREES OVER THE STREAM	25 in.	x 17 in.
121.	UNDER CLIFFS : ÉTRETAT	25 in.	x 17 in.
122.	THE BOAT DRAWN UP FROM THE TIDE	25 in.	x 17 in.
123.	CAP ST. MARTIN	16¾ in.	x 21 in.
124.	MILKING COWS UNDER THE TREES	18 in.	x 24 in.

	Height.	Length.
125. THE STREAM, ST. DOULOUGH'S: AUTUMN EVENING	18 in.	x 24 in.
126. COWS RESTING IN THE PARK	18 in.	x 24 in.
127. THE DOUBLE-PEAKED CLOUD	15 in.	x 21 in.
128. SANDS AND LAMBAY ISLAND	14 in.	x 21 in.
129. THE GAP IN THE CLOUDS	14 in.	x 21 in.
130. CORNSTOOKS BY THE SHORE	14 in.	x 21 in.
131. THE ROCKY BARRIER	14 in.	x 21 in.
132. THE LAST BOAT IN	13 in.	x 21 in.
133. THE STRANDED FISHING FLEET SCHEVENINGEN	13 in.	x 21 in.
134. THE CORN FIELD AT NIGHTFALL	13 in.	x 21 in.
135. SKETCH IN DUNES	13 in.	x 18 in.
136. A SKETCH IN THE EAST: CORFU	13 in.	x 18 in.
137. THE DROPPING CLOUD	13 in.	x 18 in.
138. DUTCH FISHING BOATS	13 in.	x 18 in.
139. BUILDING THE HAYSTACK	15½ in.	x 19½ in.
140. THE DOUBLE CLOUDS OVER SEA AND SHORE ...	12 in.	x 18 in.

CANVASES FORMERLY STRAINED.

	(Size for Strainer.)	
141. ST. DOULOUGH'S OLD CHURCH	39 in.	x 32 in.
142. THE WAVE	26 in.	x 40 in.
143. RIVIERA (Damaged)	24 in.	x 40 in.
144. FRENCH SCENE: THE FERRY	24 in.	x 40 in.
145. THE SLUICE	24½ in.	x 36 in.
146. EMPTY HAY CART, FIELD AND TREES ...	17 in.	x 25 in.
147. THE WILLOW ABOVE THE STREAM ...	18 in.	x 27 in.
148. THE STREAM TO THE SEA	19 in.	x 30 in.
149. FRENCH BARGES FROM STUDY 58	19 in.	x 30 in.
150. SHEEP UNDER THE TREES	20½ in.	x 29 in.
151. THE BATHER AND THE BLUE SEA (Crumpled)	17¾ in.	x 26¾ in.

(*Size for Strainer.*)

152. HILLS BEHIND TWO TREES 17 in. x 25 in.
153. SHEEP IN THE PARK 16½ in. x 24½ in.
154. AFTERNOON : COWS ON SHORE 14¼ in. x 20¾ in.
155. COWS AND GORSE ON THE LINKS 14 in. x 21 in.
156. LIGHT IN THE SKY AND ON THE HILL 14 in. x 22 in.
157. THE BLUE BAY, RIVIERA 14 in. x 24 in.
158. THE WELL AT ST. DOULOUGH'S 17 in. x 25 in.
159. MAKING THE STRAW RICKS 17 in. x 25 in.
160. AUTUMN FOLIAGE 19½ in. x 26 in.
161. COWS IN SUNLIGHT 13¼ in. x 18½ in.
162. THE SHOWER COMING 12 in. x 16 in.
163. AFTER THE SHOWER 13 in. x 18 in.
164. THE PASSING SHOWER 12½ in. x 17½ in.
165. COWS AND A SUNNY VISTA 12¼ in. x 18 in.
166. THE TWO COWS 12½ in. x 17¾ in.
167. THE HEDGE OVER THE HILL 14½ in. x 17½ in.
168. SUNSHINE AT NOON 14 in. x 20 in.
169. SUNSHINE AND A WINDY SKY 13 in. x 18 in.
170. A POOL OF LIGHT 14 in. x 20 in.
171. STUDY : SEA AND SKY AND LOWLAND	... 12 in. x 18 in.
172. SUNSET OVER SANDS 12 in. x 18 in.
173. SANDY PLAIN AND A WINDY SKY 11¼ in. x 18¼ in.
174. THE BANK OF TREES 7 in. x 10½ in.
175. SHEEP ON THE CLIFFS 10½ in. x 16 in.
176. RUMINATING COWS 9 in. x 13½ in.
177. CHEWING THE CUD 9½ in. x 12 in.
178. GREEN PASTURES BOUNDED BY TREES	... 9 in. x 13 in.
179. THE TERRA COTTA CLOUD 10 in. x 13 in.
180. JAMESON'S COWS 8½ in. x 13½ in.
181. HEMLOCKS AND MEADOW 19½ in. x 30 in.
182. IN THE VINEYARD 21 in. x 28 in.

(*Size for Strainer.*)

217. STUDY : ACROSS THE FIELDS measures about 8 in. x 10 in.
218. ,, THE SEINE ,, ,, 10 in. x 14½ in.
219. ,, ÉTRETAT ,, ,, 10 in. x 14½ in.
220. ,, THE SEINE ... ,, ,, 10 in. x 14½ in.
221. ,, SAND HILLS : ST. MARNOCK'S ,, ,, 10 in. x 14½ in.
222. ,, THE SEINE ,, ,, 10 in. x 14½ in.
223. ,, CORN STOOKS AND TREES ,, ,, 10 in. x 14½ in.
224. ,, DARK SEA AND SEAWEED GATHERERS 10 in. x 14½ in.
225. ,, SAND AND SKY ... ,, ,, 10 in. x 14½ in.
226. ,, GLENMALURE ,, ,, 10 in. x 14½ in.
227. ,, BOATS : EARLY ,, ,, 10 in. x 14½ in.
228. ,, CORNSTOOKS BY THE SEA ., ,, 10 in. x 14½ in.
229. ,, SAND HILLS AND SEA , ,, 10 in. x 14½ in.
230. ,, SEA AND BRIG ,, ,, 10 in. x 14½ in.
231. ,, SHORE AND SKY ,, ,, 10 in. x 14½ in.
232. ,, PARK : LATE EVENING ... ,, ,, 10 in. x 14½ in.
233. ,, HAYSTACKS BY SEA ... ,, ,, 10 in. x 14½ in.
234. ,, FROM SHORE 9½ in. x 13 in.
235 and 236. STUDY : SHORE 9½ in. x 13 in.
237. STUDY : PASTURE AND SKY 9½ in. x 13 in.
238. ,, SMALL HARBOUR AND BOATS 9½ in. x 13 in.
239. ,, HAY AND A ROLLING SKY 9½ in. x 13 in.
240. ,, SEA FROM SHORE : EARLY 9½ in. x 13 in.
241. ,, ROCKY SHORE 9½ in. x 13 in.
242. ,, SHORE AND FIGURES 9½ in. x 13 in.
243. ,, PARK : ST. DOULOUGH'S 9½ in. x 13 in.
244. ,, PARK : ST. MARNOCK'S 9½ in. x 13 in.
245. ,, SAND AND SKY 9½ in. x 13 in.
246. ,, WINDING ROAD AND COTTAGES ... 11½ in. x 14 in.
247. ,, BIRCH TREES BY ROAD 10¾ in. x 14½ in.
248. ,, HILL AND LAKE, DONEGAL 10¾ in. x 14½ in.
249. ,, GIRL KNITTING BY BOATS : EARLY ... 10¾ in. x 14½ in.
250. ,, PASTURE AND SKY 10¾ in. x 14½ in.

(Size for Strainer.)

251. STUDY :	FRENCH FARM : EARLY 10¾ in. x 14½ in.		
252. ,,	PASTURE AND SKY 10¾ in. x 14½ in.		
253. ,,	GIRL BY WELL : EARLY 10¾ in. x 14½ in.		
254. ,,	FIELD, ST. DOULOUGH'S : EVENING	... 10¾ in. x 14½ in.		
255. ,,	PINE TREES IN PARK 10¾ in. x 14½ in.		
256. ,,	LIFTING SKY 14½ in. x 10¾ in.		
257. ,,	GATHERING SEAWEED 10¾ in. x 14½ in.		
258. ,,	GATHERING FUEL IN COPPICE : FRENCH	10¾ in. x 14½ in.		
259. ,,	FRENCH LANDSCAPE : EARLY 10¾ in. x 14½ in.		
260. ,,	THE INLET 8 in. x 12½ in.		
261. ,,	BOATS FISHING : KISH 8 in. x 12¼ in.		
262. ,,	SUNSET OVER CANAL 8 in. x 12½ in.		
263. ,,	CUMULUS AND SEA 8 in. x 12½ in.		
264. ,,	SHORE 8 in. x 12½ in.		
265. ,,	WAVE BREAKING ON ROCK 8 in. x 12½ in.		
266. ,,	SHORE AND A WINDY SKY 8 in. x 12½ in.		
267. ,,	MAN ON SAND HILLS 8 in. x 12½ in.		
268. ,,	SEA 8 in. x 16 in.		
269. ,,	PLAINS OF DONEGAL : EARLY 6 in. x 12½ in.		
270. ,,	ROCK, SEA AND SAILING BOAT ...	7½ in. x 12½ in.		
271. ,,	SCHEVENINGEN : SANDS AND			
	BOAT 7¼ in. x 13 in.		
272. ,,	SHORE AND SEA 8 in. x 14 in.		
273. ,,	SANDY SHORE AND BREAKING WAVE ...	8½ in. x 14 in.		
274. ,,	FERRY UNDER THE HILL 7¼ in. x 12½ in.		
275. ,,	GORSE AND STORMY SKY 7½ in. x 12½ in.		
276. ,,	FRENCH FISHING VILLAGE 7 in. x 12½ in.		
277. ,,	BOY LYING DOWN 7¼ in. x 12½ in.		
278. ,,	LINKS 6½ in. x 12½ in.		
279. ,,	SHORE AND TWO BOATS 8 in. x 14 in.		
280. ,,	CURVED SHORE 9 in. x 15 in.		
281. ,,	SUNSET OVER FIELD AND WOOD	... 9 in. x 15 in.		
282. ,,	VENICE : GRAND CANAL 15 in. x 18 in.		

283.	STUDY :	TREE IN COURTYARD	13 in.	x 16 in.
284.	,,	SHORE AND SEA WRACK	12 in.	x 16 in.
285.	,,	DARK LANDSCAPE : EARLY	15 in.	x 22½ in.
286.	,,	EGYPTIAN	14 in.	x 21½ in.
287.	,,	HARVEST AND A BLUE SEA	... Circa.	11½ in.	x 18 in.
288.	,,	BENT ,,	11½ in.	x 18 in.
289.	,,	DARK EVENING ,,	11½ in.	x 18 in.
290.	,,	BUNDORAN : SAND AND SEA HOLLY ,,		11½ in.	x 18 in.
291.	,,	BALDOYLE INLET ,,	11½ in.	x 18 in.
292.	,,	GIRLS HARVESTING	... ,,	11½ in.	x 18 in.
293.	,,	SHORE AND A DARK BLUE SEA	,,	11½ in.	x 18 in.
294.	,,	FISHER GIRL (DUTCH) ON SHORE	,,	11½ in.	x 18 in.
295.	,,	HARVEST FIELD BY SEA	... ,,	11½ in.	x 18 in.
296.	,,	WIND OVER BENT	... ,,	11½ in.	x 18 in.
297.	,,	WINDING RIVER AND DARK HILLS	,,	11½ in.	x 18 in.
298.	,,	MEADOW ,,	11½ in.	x 18 in.
299.	,,	STRAND AND A FLOATING CLOUD	,,	11½ in.	x 18 in.
300.	,,	ACROSS THE BENT	... ,,	11½ in.	x 18 in.
301.	,,	THE SEA ,,	11½ in.	x 12 in.
302.	,,	GORSE AND ROCKS	... ,,	11½ in.	x 12 in.
303.	,,	TWO FIGURES BY SEA	... ,,	11½ in.	x 12 in.
304.	,,	SUNSET AND A CLUMP OF TREES	,,	13 in.	x 18 in.
305.	,,	SILHOUETTED TREES ,,	13 in.	x 18 in.
306.	,,	SHORE AND BOATS, SCHEVENINGEN	,,	13 in.	x 18 in.
307.	,,	LOW CLIFF OVER SAND AND SEA	,,	13 in.	x 18 in.
308.	,,	EVENING : ST. MARNOCK'S	... ,,	13 in.	x 18 in.
309.	,,	TWO HAY STACKS AND MEN	,,	13 in.	x 18 in.
310.	,,	FARM BUILDINGS BY TREES	... ,,	13 in.	x 18 in.
311.	,,	SAND HILL AGAINST SKY ,,	13 in.	x 18 in.
312.	,,	IRELAND'S EYE ,,	13 in.	x 18 in.
313.	,,	FISHING BOAT ,,	13 in.	x 18 in.
314.	,,	STANDING CORN AND TWO TREES	,,	13 in.	x 18 in.
315.	,,	THREE COWS UNDER AUTUMN TREES	,,	17 in.	x 15 in.

316. STUDY : HARVESTING	15 in. x 20½ in.	
317. „ TREES	7½ in. x 9½ in.	
318. „ TREES	9½ in. x 7½ in.	
319 and 320. STUDY : TREES	9½ in. x 12½ in.	
321, 322, 323, and 324. STUDY : TREES	10 in. x 14 in.	
325. STUDY : TREES	11 in. x 15 in.	
326 to 336. STUDY : TREES	12 in. x 16 in.	
337. STUDY : TREES AND WINDING ROAD ...	12½ in. x 19 in.	
338, 339, 340, 341 and 342. STUDY : TREES ...	15½ in. x 19 in.	
343. STUDY : FOLIAGE AND WALL	8½ in. x 13½ in.	
344. „ TREE AND WELL : ST. DOULOUGH'S	8½ in. x 12½ in.	
345. „ SHEEP IN THE PARK	7½ in. x 10 in.	
346, 347 and 348. STUDY : SHEEP IN THE PARK Circa.	10 in. x 14½ in.	
349, 350 and 351. STUDY : SHEEP IN THE PARK „	13 in. x 17 in.	
352. STUDY : CORN STOOKS BY SEA	5½ in. x 9 in.	
353. „ ROAD, GATE AND TREES	9½ in. x 7½ in.	
354. „ HORSE IN CART	7½ in. x 9½ in.	
355. „ HAYSTACK AND HORSE CART ...	8½ in. x 11 in.	
356. „ HAYSTACK AND HORSES	12 in. x 16 in.	
357. „ HORSES	13 in. x 18 in.	
358. „ DONKEY	10 in. x 7½ in.	
359. „ SHEEP	8 in. x 12 in.	
360. „ SHEEP	8 in. x 15½ in.	
361. „ COWS	7½ in. x 9½ in.	
362. „ COWS	7 in. x 10½ in	
363. „ TWO COWS IN LANDSCAPE ...	8 in. x 12 in.	
364. „ COWS	8 in. x 12 in	
365. „ TWO COWS IN LANDSCAPE ...	8½ in. x 12 in.	
366. „ TWO COWS AND A TREE	10 in. x 14 in.	
367. „ TWO COWS IN FIELD	8 in. x 12½ in.	
368. „ COWS	9 in. x 12 in.	
369. „ THREE COWS IN FIELD	9½ in. x 13 in.	
370. „ COWS	9 in. x 12½ in.	

					(Size for Strainer.)
371. STUDY :	WHITE COW IN FIELD		9½ in. x 14 in.
372.	,,	TWO COWS	10½ in. x 14 in.
373.	,,	COWS	10½ in. x 14 in.
374.	,,	COWS	8¾ in. x 13 in.
375.	,,	COWS	10 in. x 14 in.
376.	,,	COWS IN A FIELD	9 in. x 13½ in.
377.	,,	COWS IN LANDSCAPE	10½ in. x 15½ in.
378.	,,	COWS IN LANDSCAPE	...		10½ in. x 18 in.
379.	,,	COWS IN A FIELD	13 in. x 16 in.
380.	,,	COWS IN A FIELD	13 in. x 18 in.
381.	,,	COWS IN PARK	13 in. x 18 in.
382.	,,	COWS IN FIELD	13 in. x 18 in.
383 and 384. STUDY : COWS		14 in. x 18 in.
385. STUDY : TWO COWS BY TREES			14 in. x 20 in.
386 and 387. STUDY : COWS IN A FIELD			...		14 in. x 21 in.
388, 389, 390, 391 and 392. STUDY : COWS			...		14 in. x 21 in.
393. STUDY : COWS LYING ON SANDS : EARLY					16 in. x 25 in.

				Height.	*Width.*
394.	,,	IRELAND'S EYE : STORMY	Canvas on board	10 in. x 12 in.	
395.	,,	STUDIES ON BOTH SIDES	,,	10 in. x 12 in.	
396.	,,	PARK	,,	10 in. x 12 in.	
397.	,,	BOATS ON SHORE	,,	10 in. x 12 in.	
398 and 399. STUDY : PARK				10 in. x 12 in.	
400. STUDY : FRENCH RIVER SCENE ...			,,	7 in. x 10 in.	
401.	,,	THE BAY	,,	7 in. x 10 in.	
402.	,,	KILKEE	,,	7 in. x 10 in.	
403.	,,	SEA	,,	7 in. x 10 in.	
404.	,,	SAND AND SEA	,,	7 in. x 10 in.	
405.	,,	COWS IN LANDSCAPE ...	,,	7 in. x 10 in.	
406.	,,	SHEEP AND HEATHERY ROCK	,,	7 in. x 10 in.	
407.	,,	AVENUE AND FARMYARD ...	,,	7 in. x 10 in.	
408.	,,	FIELDS, SKY AND SEA ...	,,	7 in. x 10 in.	
409.	,,	SEA AND CLIFF	,,	7 in. x 10 in.	
410.	,,	SAND, SEA AND TREES ...	,,	7 in. x 10 in.	

				Height.	Width.
411.	STUDY :	ON THE BROADS	Canvas on board	7 in.	x 10 in.
412.	,,	BOAT OFF SHORE	,,	7 in.	x 10 in.
413.	,,	FISHING BOATS	,,	7 in.	x 10 in.
414.	,,	PARK SCENE	,,	7 in.	x 10 in.
415.	,,	BOAT AT SEA	,,	7 in.	x 10 in.
416.	,,	BOAT AT SEA OFF SHORE	,,	7 in.	x 10 in.
417.	,,	BOAT AT SEA	,,	7 in.	x 10 in.
418.	,,	SHRIMPERS	,,	8 in.	x 12 in.
419.	,,	MOUNTAIN ROAD : RIVIERA	,,	8 in.	x 12 in.
420.	,,	CONSTANTINOPLE	,,	8 in.	x 12 in.
421.	,,	KILKEE : WAVES ...	,,	8 in.	x 12 in.
422.	,,	KILKEE : CLIFFS	,,	8 in.	x 12 in.
423 and 424.	STUDY :	GEORGE'S HEAD	,,	8 in.	x 12 in.
425.	STUDY :	RIVER AND POPLAR ...	,,	8 in.	x 12 in.
426.	,,	SHIP SAILING UP INLET ...	,,	8 in.	x 12 in.
427.	,,	KILKEE	,,	8 in.	x 12 in.
428.	,,	SHRIMPING WOMEN ...	,,	8 in.	x 12 in.
429.	,,	BOATS SAILING	,,	8 in.	x 12 in.
430.	,,	KILKEE	,,	8 in.	x 12 in.
431.	,,	KILKEE : LOOK-OUT CLIFF	,,	8 in.	x 12 in.
432.	,,	SANDS	,,	8 in.	x 12 in.
433.	,,	COAST (GREECE) AND CASTLE	,,	8 in.	x 12 in.
434.	,,	KILKEE	,,	8 in.	x 12 in.
435.	,,	THE BROADS	,,	8 in.	x 12 in.
436.	,,	REFLECTIONS	,,	8 in.	x 12 in.
437.	,,	BROADS	,,	8 in.	x 12 in.
438.	,,	PARK	,,	9 in.	x 12 in.
439.	,,	OFF THE KISH	,,	9 in.	x 12 in.
440.	,,	KILKEE	,,	9 in.	x 12 in.
441.	,,	SUNSET	,,	9 in.	x 12 in.
442.	,,	SANDS AND CLOUDS ...	,,	9 in.	x 12 in.
443.	,,	PARK	,,	9 in.	x 12 in.
444.	,,	HARVEST	,,	9 in.	x 12 in.

				Height.	*Width.*
445.	STUDY :	PARK	Canvas on board	9 in.	x 12 in.
446.	,,	FISHING BOAT	,,	9 in.	x 12 in.
447.	,,	TREES	Canvas.	7 in.	x 10 in.
448.	,,	SAILING BOAT AND WINDMILL ...	,,	7 in.	x 11 in.
449.	,,	TWO CORNFIELDS	,,	8 in.	x 10 in.
450.	,,	COWS	,,	8 in.	x 12½ in.
451.	,,	TWO CORNFIELDS	,,	8 in.	x 13 in.
452.	,,	PARK	,,	10 in.	x 14 in.
453.	,,	THRESHING CORN	Board.	10 in.	x 14 in.
454.	,,	LANDSCAPE	,,	11½ in.	x 18 in.
455.	,,	GATHERING SEAWEED	,,	13 in.	x 24 in.
456.	,,	SEA SHORE	Canvas.	13 in.	x 18 in.
457.	,,	LANDSCAPE : TWO FIGURES ...	,,	16½ in.	x 21½ in.
458.	,,	FRENCH PEASANT GIRL	,,	15½ in.	x 9½ in.
459.	,,	TWISTY FIG TREE	,,	6 in.	x 10 in.
460.	,,	BUILDING	,,	9½ in.	x 6½ in.
461.	,,	CHURCH WINDOW	,,	9 in.	x 6½ in.
462.	,,	EVENING REFLECTION	,,	6 in.	x 9½ in.
463.	,,	TREES IN A PARK	,,	6½ in.	x 10 in.
464.	,,	TWO COWS	,,	9 in.	x 6½ in.
465.	,,	SANDY PLAIN	Paper.	5 in.	x 7 in.
466.	,,	PARK	,,	5 in.	x 7 in.
467.	,,	STREAM IN PARK	,,	5 in.	x 7 in.
468.	,,	AUTUMN TREES	,,	5 in.	x 7 in.
469.	,,	PARK	,,	5 in.	x 7 in.
470.	,,	TREE	,,	5 in.	x 7 in.
471.	,,	EVENING LIGHT	,,	5 in.	x 7 in.
472.	,,	PASTURE	,,	5 in.	x 7 in.
473.	,,	PARK : GREY	,,	5 in.	x 7 in.
474.	,,	FOR BIG HAYSTACK PICTURE No. 76	,,	5 in.	x 7 in.
475.	,,	PARK	,,	5 in.	x 7 in.
476.	,,	COWS IN PARK	,,	5 in.	x 7 in.
477.	,,	COWS GOING TO WATER	,,	7½ in.	x 10½ in.

478.	STUDY :	STREAM IN THE PARK Paper.	7½ in. x 10½ in.	
479.	,,	SHEEP UNDER TREES ,,	7½ in. x 10½ in.	
480.	,,	TOP OF THE HILL ,,	7½ in. x 10½ in.	
481.	,,	TREES IN AUTUMN FOLIAGE	...	,,	7½ in. x 10½ in.	
482.	,,	COWS AND TREES ,,	7½ in. x 10½ in.	
483.	,,	TREES BLOCKED OUT AGAINST SKY	,,	7½ in. x 10½ in.		
484.	,,	ASH TREES ,,	7½ in. x 10½ in.	
485.	,,	KILKEE ,,	7½ in. x 10½ in.	
486.	,,	BROADS ,,	7½ in. x 10½ in.	
487.	,,	ON THE BOYNE ,,	7½ in. x 10½ in.	
488.	,,	BUNDORAN : STORMY ,,	7½ in. x 10½ in.	
489.	,,	AUTUMN TREE IN PARK ,,	7½ in. x 10½ in.	
490.	,,	ROCKS BY SHORE ,,	7½ in. x 10½ in.	
491.	,,	PARK TREES ,,	7½ in. x 10½ in.	
492.	,,	PARK : LATE DARK.				
		(Damaged) ,,	7½ in. x 10½ in.	
493.	,,	PARK ,,	7½ in. x 10½ in.	
494.	,,	AUTUMN TREES ,,	7½ in. x 10½ in.	
495.	,,	PARK ,,	7½ in. x 10½ in.	
496.	,,	COWS UNDER TREES ,,	7½ in. x 10½ in.	
497.	,,	PARK : EVENING ,,	7½ in. x 10½ in.	
498.	,,	SAND HILLS : DARK FOREGROUND	,,	7½ in. x 10½ in.		
499.	,,	ROCK, SEA AND SAND HILLS	... ,,	7½ in. x 10½ in.		
500.	,,	SHEEP UNDER AUTUMN TREES	,,	7½ in. x 10½ in.		
501.	,,	TREE OVER STREAM ,,	7½ in. x 10½ in.	
502.	,,	TWO FIGURES LOOKING SEAWARD	,,	7½ in. x 10½ in.		
503.	,,	PARK ,,	7½ in. x 10½ in.	
504.	,,	SAND AND SHORE ,,	7½ in. x 10½ in.	
505.	,,	SAND HILL AND GREEN SEA	... ,,	7½ in. x 10½ in.		
506.	,,	SEA SHORE; AND ON REVERSE, KILKEE	,,	7½ in. x 10½ in.		
507.	,,	COWS IN PASTURE ON HILL TOP	,,	7½ in. x 10½ in.		
508.	,,	FOREST GLADE ,,	7½ in. x 10½ in.	
509.	,,	SKETCH FOR VIEW FROM CASTLE KEEP	,,	7 in. x 10 in.		

				Height.	*Width.*

510. STUDY : BROADS Paper. 7 in. x 10 in.
511. ,, THE DUGGANA ROCKS, KILKEE ,, 7 in. x 10 in.
512. ,, THE INTRINSIC ROCKS, KILKEE ,, 7 in. x 10 in.
513. ,, WET SANDS AND BOATS ,, 7 in. x 10 in.
514. ,, PARK ,, 7 in. x 10 in.
515. ,, PARK : EVENING ,, 7 in. x 10 in.
516. ,, TREES : AUTUMN ,, 7 in. x 10 in.
517. ,, SAND HILLS AND COWS ,, $7\frac{1}{4}$ in. x $10\frac{3}{4}$ in.
518. ,, FONTAINEBLEAU : EARLY ... ,, $7\frac{1}{2}$ in. x $11\frac{1}{2}$ in.
519. ,, FONTAINEBLEAU : SUNSET... ... ,, 7 in. x $11\frac{1}{2}$ in.
520. ,, { STREAM ACROSS SANDS ... / SANDS AND SKY AND STRIP / OF SEA : LATE EVENING } ... ,, $6\frac{1}{4}$ in. x 12 in.
521. ,, TREES IN PARK : AUTUMN ... ,, $7\frac{1}{2}$ in. x $10\frac{1}{2}$ in.
522. ,, RIVIERA MOUNTAINS ,, $9\frac{3}{4}$ in. x 14 in.
523. ,, THATCHED FARM BUILDING ... ,, 9 in. x 12 in.
524. ,, MEADOW GRASS ,, 14 in. x 10 in.
525. ,, FONTAINEBLEAU : DARK :
 EARLY : FOREST : AUTUMN ... ,, 11 in. x $13\frac{3}{4}$ in.
526. COPY OF PICTURE BY COROT ,, $12\frac{1}{2}$ in. x 16 in.
527. WOODED PATH BY THE SEA ,, 7 in. x 10 in.

PICTURES BROUGHT FROM MOLDOWNEY.

528. CATTLE AT MOLDOWNEY Canvas. 24 in. x 39 in.
529. CATTLE ON SAND DUNES ,, 26 in. x 38 in.
530. BOATS ON NORFOLK BROADS ,, 25 in. x 36 in.
531. COAST OF KILKEE. , 24 in. x 38 in.
 NOTE.—Illustrated in this book.
532. CATTLE ON DUNES, WALKING TOWARDS SEA ,, $24\frac{1}{2}$ in. x $35\frac{1}{2}$ in.
533. ON THE BANKS OF THE SEINE ,, 24 in. x 40 in.
534. VILLEFRANCHE ,, $28\frac{1}{2}$ in. x 24 in.
535. LANDSCAPE, WITH CATTLE ,, $28\frac{1}{2}$ in. x 23 in.

		Height.	Width.
536. MENTONE Canvas.		17 in.	x 25 in.
537. SKETCH OF A BIRCH TREE AND HILL SIDE ... ,,		10 in.	x 14 in.
538. CONSTANTINOPLE ,,		12 in.	x 18 in.
539. NEAR KATWYCK ,,		9 in.	x 15 in.
540. STUDY OF CATTLE AND PARK ,,		9½ in.	x 14 in.
541. CARRICK HILL COTTAGE IN TREES ,,		12 in.	x 18 in.
542. SAND HILLS AT MOUTH OF VAR : NICE ... ,,		7 in.	x 11½ in.
543. VILLA MONTICELLO, NICE ,,		10 in.	x 14 in.
544. VILLA MONTICELLO, WITH MRS. HONE SEATED ,,		8 in.	x 12½ in.
545. STUDY OF WAVES ,,		6½ in.	x 15 in.
546. STUDY OF A COW ,,		7½ in.	x 10 in.
547. ROAD WITH OVERHANGING TREES ,,		9½ in.	x 11½ in.
548. WOMAN WITH PARASOL ON STRAND ... ,,		8½ in.	x 13 in.
549. GIRL ON PATH THROUGH TREES ,,		13¾ in.	x 10½ in.
550. SANDS AND SEA ,,		13 in.	x 18 in.

PORTRAIT OF MR. JAMESON, AFTER THE PICTURE BY RAEBURN, AT ST. MARNOCK'S.

PORTRAIT OF MRS. JAMESON, AFTER THE PICTURE BY RAEBURN, AT ST. MARNOCK'S.

SIX DOUBTFUL.

WATER-COLOURS.

		Height.	Length.
1. STUDY : APPLE IN BLOSSOM		7 in.	x 10 in.
2. ,, CLUMP OF TREES AGAINST SKY ...		7 in.	x 10 in.
3. ,, PARK : CLUMP OF TREES		7 in.	x 10 in.
4, 5 and 6. STUDY : PARK		7 in.	x 10 in.
7. STUDY : TWO TREES		7 in.	x 10 in.
8. ,, FLAMING TREES		7 in.	x 10 in.
9. ,, TREE, BLUE DISTANCE		7 in.	x 10 in.
10. ,, PLAIN, SEA AND HILL		7 in.	x 10 in.

			Height.	Length.
11.	STUDY :	ST. DOLOUGH'S PARK	7 in.	x 10 in.
12.	,,	PARK : WINDY SKY	7 in.	x 10 in.
13.	,,	GATHERING CLOUDS	7 in.	x 10 in.
14.	,,	PARK : AUTUMN	7 in.	x 10 in.
15.	,,	TREES AGAINST SKY	7 in.	x 10 in.
16.	,,	LANDSCAPE	7 in.	x 10 in.
17.	,,	BANK OF TREES	7 in.	x 10 in.
18.	,,	PLAIN	7 in.	x 10 in.
19.	,,	PLAIN AND SKY	7 in.	x 10 in.
20.	,,	THE CLUMP OF TREES	7 in.	x 10 in.
21.	,,	LANDSCAPE	7 in.	x 10 in.
22.	,,	(a) LANDSCAPE : EVENING	7 in.	x 10 in.
		(b) SINGLE TREE OVER PLAIN ...	7 in.	x 10 in.
23.	,,	HAYFIELD AND TREES	7 in.	x 10 in.
24, 25, 26 and 27.	STUDY : PYRENEES	6 in.	x 9½ in.	
28. STUDY :	PYRENEES : BIG PLAIN	6 in.	x 9½ in.	
29.	,,	ST. JEAN DE LUZ—18TH MAY, '89 ...	6 in.	x 9½ in.
30.	,,	BUILDINGS AND CLIFFS	6 in.	x 9½ in.
31.	,,	KILKEE CLIFFS	6 in.	x 9½ in.
32.	,,	(a) IN THE PLACE	6 in.	x 9½ in.
		(b) GREEN HILL BY SEA	6 in.	x 9½ in.
33.	,,	(a) GREEN OCEAN	6 in.	x 9½ in.
		(b) KILKEE CLIFFS	6 in.	x 9½ in.
34.	,,	PARK	6 in.	x 9½ in.
35.	,,	AMONG THE MOUNTAINS	6 in.	x 9½ in.
36.	,,	CLIFFS OF MOUNTAINS : PYRENEES ...	6 in.	x 9½ in.
37.	,,	ROADWAY BELOW CLIFFS	6 in.	x 9½ in.
38.	,,	(a) PLAIN ; and (b) REVERSE ...	6 in.	x 9½ in.
39.	,,	(a) SANDS AND SEA	6 in.	x 9½ in.
		(b) CLIFF, TREES AND RIVER ...	6 in.	x 9½ in.
40.	,,	CLIFFS AND DISTANT MOUNTAIN ...	6 in.	x 9½ in.
41.	,,	(a) STOOKS BY SEA (NOTE OF TONE) ...	6 in.	x 9½ in.
		(b) TWO COWS IN FIELD	6 in.	x 9½ in.

			Height.	Length.
42. STUDY :	(a) SAND DUNES AND SEA (NOTE OF TONE)		6 in.	x 9½ in.
	(b) SAND DUNES AND SEA	6 in.	x 9½ in.
43. ,,	(a) ST. MARNOCK'S GOLF LINKS	6 in.	x 9½ in.
	(b) PARK	6 in.	x 9½ in.
44. ,,	(a) ST. DOLOUGH'S PARK	6 in.	x 9½ in.
	(b) PYRENEES : GOLF LINKS	6 in.	x 9½ in.
45. ,,	(a) PYRENEES	6 in.	x 9½ in.
	(b) SKY	6 in.	x 9½ in.
46. ,,	PYRENNEES : GOLF LINKS	6 in.	x 9½ in.
47. ,,	(a) HARVEST FIELD	6 in.	x 9½ in.
	(b) ABOVE THE SEA	6 in.	x 9½ in.
48. ,,	(a) SUNSET	6 in.	x 9½ in.
	(b) SEA FROM SANDS	6 in.	x 9½ in.
49. ,,	(a) SAND HILLS	6 in.	x 9½ in.
	(b) SAND HILLS	6 in.	x 9½ in.
50. ,,	SANDY PLAIN	6 in.	x 9½ in.
51. ,	ST. DOLOUGH'S	6 in.	x 9½ in.
52. ,,	HARVEST : MOWING AND STOOKING	...	6 in.	x 9½ in.
53. ,,	AUTUMN FIELDS	6 in.	x 9½ in.
54. ,,	UPLANDS	6 in.	x 9½ in.
55. ,,	(a) LANDSCAPE	6 in.	x 9½ in.
	(b) LANDSCAPE	6 in.	x 9½ in.
56. ,,	(a) SEA AND SANDS	6 in.	x 9½ in.
	(b) SANDS AND SKY	6 in.	x 9½ in.
57. ,,	(a) SHORE	6 in.	x 9½ in.
	(b) STOOKS	6 in.	x 9½ in.
58. ,,	(a) STOOKS	6 in.	x 9½ in.
,,	(b) SKY	6 in.	x 9½ in.
59. ,,	(a) LANDSCAPE	6 in.	x 9½ in.
	(b) LANDSCAPE	6 in.	x 9½ in.
60. ,,	CUTTING CORN	6 in.	x 9½ in.
61. ,,	(a) LANDSCAPE AND SKY	6 in.	x 9½ in.
	(b) LANTRY	6 in.	x 9½ in.
62. ,,	CORN STOOKS	6 in.	x 9½ in.

		Height.	Length.
63. STUDY : SHEEP BY TREES		6 in.	x 9½ in.
64. ,, (a) GREEN SAND PASTURES BY SEA ...		6 in.	x 9½ in.
(b) LANDSCAPE		6 in.	x 9½ in.
65 and 66. STUDY : PLAIN		6 in.	x 9½ in.
67. STUDY : DARK GREY GREEN PLAIN		6 in.	x 9½ in.
68. ,, SMOOTH ROCKS BY THE SEA		6 in.	x 9½ in.
69. ,, GREEN SEA AND A SHIP AT ANCHOR ...		6 in.	x 9½ in.
70. ,, COW BY SHORE		6 in.	x 9½ in.
71. ,, HARVESTING		6 in.	x 9½ in.
72. ,, STOOKS : EVENING		6 in.	x 9½ in.
73. ,, STOOKS AND TREES		6 in.	x 9½ in.
74. ,, HARVEST FIELD AND TREES		6 in.	x 9½ in.
75. ,, SHORE, SEA AND SKY		6 in.	x 9½ in.
76. ,, SHORE : FIGURES BATHING		6 in.	x 9½ in.
77. ,, PLAIN		6 in.	x 9½ in.
78. ,, (a) PLAIN AND CATTLE		6 in.	x 9½ in.
(b) SEA		6 in.	x 9½ in.
79. ,, SANDY PASTURES BY SEA		6 in.	x 9½ in.
80. ,, SAND BUNKER		6 in.	x 9½ in.
81. ,, SAND DUNES AND IRELAND'S EYE ...		5 in.	x 6¾ in.
82. ,, SAND DUNES AND IRELAND'S EYE ...		5 in.	x 6¾ in.
83. ,, CLIFF, SEA AND LANTRY		5 in.	x 6¾ in.
84. ,, LITTLE BAY, SEA AND LANTRY		5 in.	x 6¾ in.
85. ,, CLIFFS AND SEA		5 in.	x 6¾ in.
86. ,, ROCKY PROMONTORY		5 in.	x 6¾ in.
87. ,, CLIFFS BY SEA		5 in.	x 6¾ in.
88. ,, (a) CLIFFS BY SEA		5 in.	x 6¾ in.
(b) CLIFFS BY SEA		5 in.	x 6¾ in.
89. ,, ROCKY COAST		5 in.	x 6¾ in.
90. ,, INLET : LOW TIDE		5 in.	x 6¾ in.
91. ,, ROCKY COAST AND LANTRY		5 in.	x 6¾ in.
92. ,, SANDS AND BLUE HILLS		5 in.	x 6¾ in.
93. ,, ROCKY COAST AND SHOWERY OVER SEA		5 in.	x 6¾ in.

			Height.	Length.
94 and 95. STUDY : LOUGH SWILLY : DRIVING SHOWER			5 in.	x 6¾ in.
96. STUDY :		SANDY CLIFFS AND MOUNTAINS BY SEA	5 in.	x 6¾ in.
97.	,,	SANDY BAY : ROCKY FOREGROUND ...	5 in.	x 6¾ in.
98.	,,	(a) DARK BLUE SEA	5 in.	x 6¾ in.
		(b) SEA COAST	5 in.	x 6¾ in.
99.	,,	(a) SEA COAST	5 in.	x 6¾ in.
		(b) SEA COAST	5 in.	x 6¾ in.
100.	,,	(a) SHADOW FROM SEA CLIFFS ON SANDS	5 in.	x 6¾ in.
		(b) SEA AND ROCKY COAST	5 in.	x 6¾ in.
101.	,,	ROCKY COAST : SHIP ON HORIZON ...	5 in.	x 6¼ in.
102.	,,	CLIFFS AND SEA. (Damaged)	5 in.	x 6¼ in.
103.	,,	ROCKS AND BREAKERS	5 in.	x 6¼ in.
104.	,,	DUGGANA ROCKS	5 in.	x 6¾ in.
105.	,,	ROCKS AND SEA	5 in.	x 6¾ in.
106.	,,	(a) ROCKS AND BREAKERS	5 in.	x 6¾ in.
		(b) COAST SCENE	5 in.	x 6¾ in.
107.	,,	ROCKS AND SEA	5 in.	x 6¾ in.
108.	,,	ROCKS, A BAY AND BREAKERS, BLUE SEA	5 in.	x 6¼ in.
109.	,,	ROCKS : SEA ON RAINY DAY	5 in.	x 6¾ in.
110.	,,	CLIFFS HIGH OVER SHORE, WITH BATHING BOXES	5 in.	x 6¼ in.
111.	,,	CLIFFS : DONEGAL	5 in.	x 6¾ in.
112.	,,	CURVING PIER AND COAST	4½ in.	x 6¼ in.
113.	,,	COAST	4½ in.	x 6¼ in.
114.	,,	COAST, GREEN SHORES	4½ in.	x 6¼ in.
115.	,,	DARK RIVER AND TREES	4½ in.	x 6¼ in.
116.	,,	COAST, SAND AND CLIFFS	4½ in.	x 6¼ in.
117.	,,	COAST : DONEGAL	4½ in.	x 6¼ in.
118.	,,	MOUNTAINS AND COAST	4½ in.	x 6¼ in.
119.	,,	(a) MOUNTAINS AND COAST AND SANDY BAY	4½ in.	x 6¼ in.
		(b) MOUNTAINS AND COAST	4½ in.	x 6¼ in.
120.	,,	(a) COAST	4½ in.	x 6¼ in.
		(b) COAST	4½ in.	x 6¼ in.

Height. Length.

121.	STUDY : SANDY BAY	4½ in. x 6¼ in.	
122.	„ (a) COAST	4½ in. x 6¼ in.	
	(b) COAST	4½ in. x 6¼ in.	
123.	„ SANDY BAY AND HILLS	4½ in. x 6¼ in.	
124.	„ COAST	4½ in. x 6¼ in.	
125.	„ ISLAND AND DARK SEA	4½ in. x 6¼ in.	
126.	„ ISLAND AND DARK SEA	4½ in. x 6¼ in.	
127.	„ COAST	4½ in. x 6¼ in.	
128.	„ COAST AND MOUNTAIN	4½ in. x 6¼ in.	
129.	„ SEA AND MOUNTAIN	4½ in. x 6¼ in.	
130.	„ SEA AND ROCKY HEADLAND	4½ in. x 6¼ in.	
131.	„ SANDY BAY AND HILLS	4½ in. x 6¼ in.	
132.	„ ROCKS AND SAND	4½ in. x 6¼ in.	
133.	„ CLIFF BY SEA	4½ in. x 6¼ in.	
134.	„ SEA HILLS ON A RAINY DAY	4½ in. x 6¼ in.	
135.	„ SANDS, HILLS, AND A RAINY SKY	...	4½ in. x 6¼ in.	
136.	„ (a) SANDY BAY	4½ in. x 6¼ in.	
	(b) SANDY BAY	4½ in. x 6¼ in.	
137.	„ SANDY BAY	4½ in. x 6¼ in.	
138.	„ LITTLE LANDING PIER	4½ in. x 6¼ in.	
139.	„ SWEEPING BAY	4½ in. x 6¼ in.	
140.	„ SEA AND SAND	4½ in. x 6¼ in.	
141.	„ SEA AND ROCKY HEADLAND	4½ in. x 6¼ in.	
142.	„ GREEN BANK AND CURVING BAY	...	4½ in. x 6¼ in.	
143.	„ RIVER AND PLAIN	4 in. x 7 in.	
144.	„ LANDSCAPE	4 in. x 7 in.	
145.	„ MEADOW AND PLAIN	4 in. x 7 in.	
146, 147 and 148. STUDY : DONNYBROOK : 14TH MAY, '87			4 in. x 7 in.	
149. STUDY : PASTURE AND COWS		4 in. x 7 in.	
150.	„ LANDSCAPE	4 in. x 7 in.	
151 and 152. STUDY : LANDSCAPE AND COW		4 in. x 7 in.	
153. STUDY : LANDSCAPE		4 in. x 7 in.	
154.	„ (a) TREE IN PARK	5½ in. x 9 in.	
	(b) RIVER	5½ in. x 9 in.	

			Height.	Length.
155.	STUDY :	RIVER SCENE	5½ in.	x 9 in.
156.	,,	PARK	5½ in.	x 9 in.
157.	,,	RIVER	5½ in.	x 9 in.
158.	,,	PLAIN, POPLARS (THREE) AND HILLS	5½ in.	x 9 in.
159.	,,	SHIP UNDER HILL	8 in.	x 10 in.
160.	,,	SHIP BY QUAY	8 in.	x 10 in.
161.	,,	QUAY AND BRIG	8 in.	x 10 in.
		SHIP AND PIER : LOW TIDE	8 in.	x 10 in.
162.	,,	STRANDED SHIP	8 in.	x 10 in.
163.	,,	BREAKING WAVES. (Damaged)	9½ in.	x 15½ in.
164.	,,	BREAKING WAVES ROCK	9½ in.	x 15½ in.
165.	,,	CORN STOOKS, TREES AND SEA, AND REVERSE	8 in.	x 11 in.
166.	,,	SUNBURNT GRASS, TREES AND SEA ...	8 in.	x 11 in.
167.	,,	DARK RIVER : LEIXLIP (?) RIVER BANK	8 in.	x 11 in.
168.	,,	MOOR IN DONEGAL	8 in.	x 11 in.
169.	.,	SANDY ROAD AND TREES	8 in.	x 11 in.
170.	,,	HEATHER AND HILL	7½ in.	x 10 in.
171.	,,	ROAD BETWEEN TREES	7½ in.	x 10 in.
172.	,,	WOMAN STANDING IN CORN	10 in.	x 7 in.
173.	,,	PYRENNEAN CONTADINA	9½ in.	x 5¾ in.
174.	,,	STANDING BOY : PYR	9 in.	x 5½ in.
175.	,,	STANDING WOMAN : PYR	9¾ in.	x 6½ in.
176.	,,	VENICE : SMALL CANAL BETWEEN HOUSES	9 in.	x 5½ in.
177.	,,	STUDIES OF BOATS	7 in.	x 10 in.
		,, ,, ,,	7 in.	x 10 in.
178.	,,	AMPHITHEATRE, KILKEE	5 in.	x 8½ in.
179.	,,	TREES	5 in.	x 7¾ in.
180.	,,	HOUSE ON RIVIERA	5½ in.	x 7¾ in.
181.	,,	ST. DOLOUGH'S HOUSE. Mounted on Card	10 in.	x 12½ in.
182.	,,	ST. DOLOUGH'S WELL	10 in.	x 12½ in.
183.	,,	BANKS OF SEINE	11½ in.	x 15½ in.
184.	,,	SHIPS AT QUAY SIDE, SAILS DRYING ...	10 in.	x 11¾ in.
185.	,,	SOUTH OF FRANCE. (Slightly Damaged)	12 in.	x 9¾ in.

			Height.		*Length.*
186.	STUDY :	BLOWN TREES AND HILL SIDE	7½ in.	x	11 in.
187.	,,	HEATHERY MOOR AND MOUNTAIN ...	7½ in.	x	11 in.
188.	,,	TRACK THROUGH TREES	8 in.	x	6¼ in.
189.	,,	TWO BOYS...	6¼ in.	x	8 in.
190.	,,	PLAIN AND SKY	4½ in.	x	7½ in.
191.	,,	PASTURE, HILL AND SKY	4½ in.	x	7½ in.
192.	,,	OVER THE PLAIN	4½ in.	x	7½ in.
193.	,,	GREEN UPLANDS AND ROLLING SKY ...	4½ in.	x	7½ in.
194.	,,	DUBLIN PLAIN	4½ in.	x	7½ in.
195.	,,	WOOD AND SKY	4½ in.	x	7½ in.
196.	,,	PLAIN	4½ in.	x	7½ in.
197.	,,	(a) SANDY SHORE AND SKY	4½ in	.x	7 in.
		(b) SANDY SHORE AND SKY	4½ in.	x	7½ in.
198.	,,	CLIFF, BAY AND SAND HILLS. (Damaged)	4½ in.	x	7½ in.
199.	,,	(a) and (b) BALTADE, CO. CLARE ...	5 in.	x	8½ in.
200.	,,	A WRECK	5 in.	x	8½ in.
201.	,,	BEGUN	5 in.	x	8½ in.
202.	.,	A CLIFF	5 in.	x	8½ in.
203.	,,	A LINE OF CLIFFS	5 in.	x	8½ in.
204.	,,	GEORGE'S HEAD. (Oil stained) ...	5 in.	x	8½ in.
205.	,,	SEA AND ROCKY SHORE, SAND AND GRASS.			
		(Stained)	5 in.	x	8½ in.
206.	,,	GEORGE'S HEAD FROM INTRINSIC ROCKS	5 in.	x	8½ in.
207.	.,,	INTRINSICS	5 in.	x	8½ in.
208.	,,	FIGURES AND CANOES UPTURNED ON			
		ROCKS. (Oil stained)	5 in.	x	8½ in.
209.	,,	ROCKS AND FIGURES	5 in.	x	8½ in.
210.	,,	PILED SEAWEED	5 in.	x	8½ in.
211.	,,	GEORGE'S HEAD FROM DUGANNA ROCKS	5 in.	x	8½ in.
212.	,,	DUGANNA ROCKS AND FOAM	5 in.	x	8½ in.
213.	,,	SEA	5 in.	x	8½ in.
214.	,,	ROCKS AND SEA	5 in.	x	8½ in.
215.	,,	DUGANNA POOL AND BREAKING WAVES.			
		(Oil stained)	5 in.	x	8½ in.

			Height.	Length.
216. STUDY : ROCKY POINT AND SEA			5 in.	x 8½ in.
217 and 218. GEORGE'S HEAD FROM AMPHITHEATRE ...			5 in.	x 8½ in.
219. STUDY : SEA ON SANDS, WITH FIGURES. (Oil stained)			5 in.	x 8½ in.
220.	,,	(a) and (b) ROCK AND SEA. (Both sides)	5 in.	x 8½ in.
221.	,,	ROCK, SPRAYS AND FIGURES (TWO) ...	5 in.	x 8½ in.
222.	,,	DUGANNA ROCKS : HIGH TIDE ...	5 in.	x 8½ in.
223.	,,	KILKEE SANDS WITH FIGURES	5 in.	x 8½ in.
224.	,,	RUSHING SEA	5 in.	x 8½ in.
225.	,,	SEA AND CLIFF	5 in.	x 8½ in.
226.	,,	A BAY	5 in.	x 8½ in.
227.	,,	SANDY SHORE WITH SEA BEYOND ...	5 in.	x 8½ in.
228.	,,	ROCKS AND STORMY SEA. (Oil stained) ...	5 in.	x 8½ in.
229.	,,	ROCK AND SEA. (Blotted)	5 in.	x 8½ in.
230.	,,	GEORGE'S HEAD : DUGANNA FOREGROUND	5 in.	x 8½ in.
231.	,,	ROCKS : LOW TIDE	5 in.	x 8½ in.
232.	,,	GEORGE'S HEAD	5 in.	x 8½ in.
233.	,,	CLIFFS OF KILKEE	5 in.	x 8½ in.
234.	,,	AVENUE UNDER TREES	3 in.	x 5 in.
235.	,,	ROADWAY BY RIVER	5 in.	x 8 in.
236.	,,	ST. MARNOCK'S LINKS TOWARDS SUGAR-LOAF MOUNTAIN	5 in.	x 8 in.
237.	,,	HARVEST FIELD, TREES AND DARK BLUE SEA	5 in.	x 8 in.
238.	,,	ON THE NILE	4¾ in.	x 7½ in.
239.	,,	EGYPT : ROCKY HILLS, TWO TREES ...	4¾ in.	x 7½ in.
240.	,,	,, ROCKY HILLS, PALMS AND NILE	4¾ in.	x 7½ in.
241. (a) and (b) STUDY : EGYPT : ROCKY HILLS ; R. : ... MOUNTAIN AND PLAIN			4¾ in.	x 7½ in.
242. STUDY : EGYPT : TREE-CROWNED BLUFF ON NILE			4¾ in.	x 7½ in.
243.	,,	,, BUILDINGS AND TREES ON POINT IN NILE	4¾ in.	x 7½ in.
244.	,,	,, BLUE-SHADOWED MOUNTAINS ON NILE	4¾ in.	x 7½ in.

Height. Length.

245. (a) and (d) STUDY: EGYPT: MOUNTAINS RE-
FLECTED IN NILE; R.:
A BOAT 4¾ in. x 7½ in.
246. STUDY: EGYPT: SKETCH 4¾ in. x 7½ in.
247. (a) and (b) STUDY: EGYPT: BOATS AT BANK OF
NILE; R.: MOUNTAIN ... 4¾ in. x 7½ in.
248. STUDY: EGYPT: SAND AND SKY AND DISTANT
HILLS 4¾ in. x 7½ in.
249. ,, ,, SUNBAKED HILLS AND WATER 4¾ in. x 7½ in.
250. ,, ,, SKETCH 4¾ in. x 7½ in.
251. ,, ,, SKETCH ON NILE 4¾ in. x 7½ in.
252. ,, ,, OASIS IN DESERT 4¾ in. x 7½ in.
253. ,, ,, SUNLIT HILL, FOREGROUND IN
SHADE 4¾ in. x 7½ in.
254. ,, ,, TWO LION-HEADED SEATED
STATUES 4¾ in. x 7½ in.
255. ,, ,, TOMB AND PALMS 4¾ in. x 7½ in.
256. ,, ,, BOATS AND FIGURES ON NILE
BANK 4¾ in. x 7½ in.
257. ,, ,, MOUNTAIN AND PLAIN, FIGURES
AND ASS 4¾ in. x 7½ in.
258. ,, ,, HILL AND WOODED POINT ON
NILE 4¾ in. x 7½ in.
259. ,, ,, NILE AND BOATS 4¾ in. x 7½ in.
260. (a) and (b) STUDY: EGYPT: VIEW ON NILE;
R.: VIEW ON NILE:
SUNSET 4¾ in. x 7½ in.
261. STUDY: EGYPT: VIEW ON NILE 4¾ in. x 7½ in.
262. ,, ,, ROCKY HILLS ABOVE NILE 4¾ in. x 7½ in.
263 and 264. STUDY: EGYPT: SKETCH ON NILE ... 4¾ in. x 7½ in.
265. STUDY: EGYPT: MOUNTAINS OVER NILE ... 4¾ in. x 7½ in.
266. ,, ,, PYRAMIDS (TWO), STRONG
SHADOW 4¾ in. x 7½ in.

P

Height. Length.

267. STUDY : EGYPT : PYRAMIDS, SEEN FROM TREE-
 SHADED ROAD $4\frac{3}{4}$ in. x $7\frac{1}{2}$ in.

268. ,, ,, SPHYNX BETWEEN PYRAMIDS ... $4\frac{3}{4}$ in. x $7\frac{1}{2}$ in.

269. ,, ,, PALMS $4\frac{3}{4}$ in. x $7\frac{1}{2}$ in.

270. ,, ,, PLAIN, PALMS AND DISTANT
 HILLS $4\frac{3}{4}$ in. x $7\frac{1}{2}$ in.

271. ,, ,, PALMS AND OASIS $4\frac{3}{4}$ in. x $7\frac{1}{2}$ in.

272. (*a*) and (*b*) STUDY : EGYPT : PYRAMIDS SEEN
 FROM UNDER TREES ; R. :
 PYRAMIDS AND PALMS ... $4\frac{3}{4}$ in. x $7\frac{1}{2}$ in.

273. (*a*) and (*b*) STUDY : EGYPT : NILE FROM UNDER
 TREES ; R. : ONE PYRAMID $4\frac{3}{4}$ in. x $7\frac{1}{2}$ in.

274. STUDY : EGYPT : EVENING ON NILE.

275. ,, ,, FIGURES ON BANK OF NILE, HILLS.

276. ,, ,, BOATS BY THE BANK OF NILE.

277. ,, ,, A JUMBLE OF BOATS BY THE BANK.

278. ,, ,, MOUNTAIN REFLECTED.

279. ,, ,, PALM TREES AND BUILDINGS.

280. (*a*) and (*b*) STUDY : EGYPT : SKETCH : BOATS, SAND AND HILLS ;
 R. : UPRIGHT. PALMS.

281. STUDY : EGYPT : SHADOWED HILLS, NILE, FIGURE ON HORSE.

282. ,, ,, PALMS $7\frac{1}{2}$ in. x $4\frac{3}{4}$ in.

283. ,, DARK TREES AGAINST SKY 5 in. x $8\frac{1}{4}$ in.

284. ,, MOUNTAINS ABOVE SEA : STORMY SKY ... 5 in. x $8\frac{1}{4}$ in.

285. ,, CLOUDS RESTING ON DARK MOUNTAIN ... 5 in. x $8\frac{1}{4}$ in.

286. ,, ROCKS AND SEA : KILKEE (?) 5 in. x $8\frac{1}{4}$ in.

287. ,, ROCK AND SEA AND HILL. (Stained) ... 5 in. x $8\frac{1}{4}$ in.

288. ,, CATTLE IN WATER, DARK MOUNTAINS ... 5 in. x $8\frac{1}{4}$ in.

289. ,, DARK MOUNTAINS AT HEAD OF BAY ... 5 in. x $8\frac{1}{4}$ in.

290. ,, MOUNTAIN AND TARN OR DARK DAY ... 5 in. x $8\frac{1}{4}$ in.

291. ,, CLOUDS DROPPING ON MOUNTAIN OVER
 SEA OR LAKE 5 in. x $8\frac{1}{4}$ in.

292. ,, BOAT AND ROCKY PROMONTORY ... 5 in. x $8\frac{1}{4}$ in.

			Height.	Length.
293.	STUDY :	DARK HEADLAND, SEA AND DISTANT MOUNTAINS	5 in.	x 8¼ in.
294.	,,	SKETCH	5 in.	x 8¼ in.
295.	,,	GREEN PASTURES, CATTLE AND TREES ...	5 in.	x 8¼ in.
296.	,,	COWS RESTING UNDER TREES	5 in.	x 8¼ in.
297.	,,	WAVES ON A RAINY DAY	4¾ in.	x 7¾ in.
298.	,,	SKETCH BY THE SEA	4¾ in.	x 7¾ in.
299.	,,	DARK CLIFFS FROM BELOW : LOW TIDE	4¾ in.	x 7¾ in.
300.	,,	SEA RUNNING INTO CAVE	4¾ in.	x 7¾ in.
301 and 302.	STUDY :	A SKETCH	4¾ in.	x 7¾ in.
303.	STUDY :	INVADING TIDE	4¾ in.	x 7¾ in.
304.	,,	A SKETCH BY THE SEA	4¾ in.	x 7¾ in.
305.	,,	SAND, FIELDS AND BAY AND HIGH SAND HILLS	4¾ in.	x 7¾ in.
306.	,,	CLIFF, SEA AND SAND HILLS	4¾ in.	x 7¾ in.
307.	,,	WAVES BREAKING INTO CAVE	4¾ in.	x 7¾ in.
308.	,,	SEASCAPE. (Damaged)	4¾ in.	x 7¾ in.
309.	,,	ROCK, POOL AND FOAMING SEA	4¾ in.	x 7¾ in.
310.	,,	RISING TIDE, FOAM AND ROCKS ...	4¾ in.	x 7¾ in.
311.	,,	ROCKS, POOL, SEA AND HEADLAND ...	4¾ in.	x 7¾ in.
312.	,,	TUMBLING SEAS	4¾ in.	x 7¾ in.
313.	,,	SKETCH OF SEA	4¾ in.	x 7¾ in.
314.	,,	CLIFF, SEA AND HIGH SAND HILLS : BUNDORAN	4¾ in.	x 7¾ in.
315.	,,	HEADLAND OVER SEA, MOUNTAINS BEYOND	4¾ in.	x 7¾ in.
316.	,,	BAY AND SAND HILLS : BUNDORAN (?) ...	4¾ in.	x 7¾ in.
317.	,,	BAY AND BLOWING CLOUDS	4¾ in.	x 7¾ in.
318.	,,	WHITE WAVE AND OPEN SEA	4¾ in.	x 7¾ in.
319.	,,	CLIFFS AND TUMBLING SEA	4¾ in.	x 7¾ in.
320.	,,	HEADLAND AND GREEN SEA	4¾ in.	x 7¾ in.
321.	,,	SKETCH : SEA AND DISTANT MOUNTAINS	4¾ in.	x 7¾ in.
322.	HEADLAND, SEA AND DASHING SPRAY		4¾ in.	x 7¼ in.
323 and 324.	STUDY :	SPRAY ON HEADLAND	4¾ in.	x 7¾ in.

325. STUDY : BROWN ROCKS AND SEA, BROWN SAILED
BOAT 4¾ in. x 7¾ in.

326. ,, SAND, SEA AND SKY. (Damaged) ... 4¾ in. x 7¾ in.

327. ,, PURPLE ROCKS, GREEN SEA AND GREEN
HEADLAND BEYOND 4¾ in. x 7¾ in.

328. ,, BAY WITH SMALL BOAT, GREY CLOUD
REFLECTED 4¾ in. x 7¾ in.

329. ,, YOUGHAL : JUNE, 1902 4¾ in. x 7¾ in.

330. ,, HEADLAND AND ROCKY PROMONTORY,
ROAD UNDER TREES 4¾ in. x 7¾ in.

331. ,, SMALL KEEP ABOVE ROCKS, ENTRANCE
TO YOUGHAL,

332 ,, BROWN SAILED BOAT LEAVING YOUGHAL,
ROCKS IN FOREGROUND 4¾ in. x 7¾ in.

333. ,, LIGHT THROUGH BROWN-STEMMED TREES 4¾ in. x 7¾ in.

334. ,, ROCKS, SAND AND BAY, CLIFFY HILL
BEYOND 4¾ in. x 7¾ in.

335. (*a*) and (*b*) SAND, TWO FIGURES INDICATED,
ROCKS AND SEA 4¾ in. x 7¾ in.

336. ,, SAND, ROCKS WITH ROAD ABOVE, TREES,
SEA. (See 330) 4¾ in. x 7¾ in.

337. ,, SAND, PURPLE ROCKS, SEA 4¾ in. x 7¾ in.

338. ,, PURPLE ROCKS, SEAWEED AND FIGURE,
ENTRANCE TO YOUGHAL 4¾ in. x 7¾ in.

339. ,, RUINED CHURCH, STUDY FOR OIL 43 ... 4¾ in. x 7¾ in.

340. ,, THREE-MAST VESSEL LEAVING YOUGHAL 4¾ in. x 7¾ in.

341. ,, YOUGHAL, ROCKS, SAND, FIGURES, BOATS,
STORMY SKY 4⅝ in. x 7¾ in.

342. ,, YOUGHAL : SAND, FIGURES, BREAKING
WAVE, SEA AND HEADLAND 4⅝ in. x 7¾ in.

343. ,, YOUGHAL : LOW TIDE, ROCKS, SEA AND
BOAT AND HEADLAND, GREY DAY ... 4⅝ in. x 7¾ in.

344. ,, (*a*) YOUGHAL : POINTED ROCKS, SEA AND
HEADLAND 4⅝ in. x 7¾ in.

(*b*) R. : SAND CARTS, ETC. 4⅝ in. x 7¾ in.

		Height.	Length.
345. STUDY : YOUGHAL : CARTING SEAWEED, BROWN SHORE AND SEA		4⅝ in.	x 7¾ in.
346. ,, YOUGHAL : POINTED ROCKS (as 344), RAINY DAY		4⅝ in.	x 7¾ in.
347. ,, ROCKY FOREGROUND, WITH WAVES BREAKING AGAINST LOW HEADLAND ...		4⅝ in.	x 7¾ in.
348. ,, LISMORE CASTLE, RIVER AND BRIDGE (WHITE) ON LEFT		4⅝ in.	x 7¾ in.
349. ,, RIVER AND BRIDGE AND LISMORE CASTLE ABOVE		4⅝ in.	x 7⅞ in.
350. ,, BROWN RIVER, BRIDGE ON LEFT, TREES AND LISMORE CASTLE ...		4⅝ in.	x 7¾ in.
351. ,, TREES IN A PARK		4⅝ in.	x 7¾ in.
352. ,, TWO TREES TURNING BROWN, IN PARK, AFTERNOON SUNLIGHT		4⅝ in.	x 7¾ in.
353. ,, YELLOW PASTURES, TWO TREES, CATTLE IN SHADOW		4⅝ in.	x 7¾ in.
354. ,, GREY GREEN PASTURES, LARGE TREES ON LEFT		4⅝ in.	x 7¾ in.
355. ,, TEMPLE AND TWO COLUMNS UNDER ACROPOLIS		4⅝ in.	x 7¾ in.
356. ,, CORFU : SEA AND MOUNTAIN, BOATS INDICATED		4¾ in.	x 7¾ in.
357. ,, ARGOS : SEA, CASTLE ON PROMONTORY AND MOUNTAIN		4⅝ in.	x 7¾ in.
358. ,, PLAIN, MOUNTAINS AND BIG WHITE CLOUD, GREECE		4⅝ in.	x 7¾ in.
359. ,, GREECE : PLAIN OF DEMOSTHENES		4⅝ in.	x 7¾ in.
360. ,, TEMPLE, DARK BLUE SEA AND SKY		4⅝ in.	x 7¾ in.
361. ,, OCTAGONAL TOWER IN TREES UNDER FORT. (See Drawing, back of 360)		4⅝ in.	x 7¾ in.
362. (a) and (b) STUDY : THE PARTHENON ; REVERSE : GORSY HILL ABOVE SEA		4⅝ in.	x 7¾ in.

Height. Length.

363. STUDY : SAND HILLS, DARK SEA AND A TOWERING
CLOUD 4⅝ in. x 7¾ in.

364. ,, SHADOWED GREEN HILL, SUNLIT PLAIN,
HILLS FAR 4⅝ in. x 7¾ in.

365. ,, GREEN PLAIN, HILLS, AND A BIG SKY ... 4⅝ in. x 7¾ in.

366. ,, PORTMARNOCK LINKS, BAY AND SUGAR-
LOAF 4⅝ in. x 7¾ in.

367. ,, SHADOWED GREEN PLAIN AND STORMY
SKY 4⅝ in. x 7¾ in.

368. ,, CORFU : TWO CYPRESSES, TILED CHURCH,
SEA AND HILLS 4⅝ in. x 7¾ in.

369. ,, ADRIATIC (?) : HILLS IN LIGHT AND
MOUNTAINS IN SHADE 4⅝ in. x 7¾ in.

370. ,, SKETCH ON A QUAY SIDE : EVENING
(R. : " PATRAS ") 4⅝ in. x 7¾ in.

371. ,, BACK OF PARTHENON : STRONG LIGHT AND
SHADE 4⅝ in. x 7¾ in.

372. (a) and (b) ANGLE OF PARTHENON FROM BELOW ;
R. : ACROPOLIS AND CYPRESSES ... 4⅝ in. x 7¾ in.

373. (a) and (b) STUDY : PARTHENON ; R. : PARTHEN
FROM BELOW 4⅝ in. x 7¾ in.

374. STUDY : CORNER OF TEMPLE, DARK AND DARK
PLAIN 4⅝ in. x 7¾ in.

375. ,, PARTHENON. (Damaged sketch) ... 4⅝ in. x 7¾ in.

376 (a) and (b) PARTHENON. (Damaged) ; R. :
TEMPLE OF CARYATIDES 4⅝ in. x 7¾ in.

377. STUDY : GREY GREEN PASTURES, DARK HORIZON 4⅝ in. x 7¾ in.

378. ,, THE ACROPOLIS FROM THE STADIUM ... 4⅝ in. x 7¾ in.

379. ,, ACROPOLIS : PARTHENON, BLUE
MOUNTAINS 4⅝ in. x 7¾ in.

380. ,, TWO COLUMNS, TEMPLE, AND DARK
MOUNTAIN 4⅝ in. x 7¾ in.

381. ,, VISTA THROUGH SUNLIT TEMPLE,
PARTHENON 7¾ in. x 4⅝ in.

Height. Length

382. STUDY: A TEMPLE, DARK BLUE SEA AND HILLS
BEYOND 4⅝ in. x 7¾ in.

383. ,, CORNER COLUMNS OF PARTHENON, BLUE
SKY 7¾ in. x 4⅝ in.

384. ,, PARTHENON, FOUR LIGHTS BETWEEN
COLUMNS 4⅝ in. x 7¾ in.

385. (a) and (b) STUDY : CORFU : ROCKY COAST, TOWER
ABOVE TREES ; R. : ROAD BY SAME
COAST 4 in. x 7 in.

386. STUDY : CORFU : MOUNTAIN COAST AND BLUE SEA 4 in. x 7 in.

387. ,, CORFU : A WASH BEGINNING OF COAST
SCENERY 4 in. x 7 in.

388. ,, TWO PYRAMIDS, STRONG SHADOW
REFLECTED, TREES ON RIGHT ... 4 in. x 7 in.

389. ,. SANDY DESERT WITH STREAK OF GREEN
OASIS 4 in. x 7 in.

390. ., SANDY PLAIN AND AVENUE OF TREES.
MURA HOTEL, NOTED, 2ND MARCH,
1892 4 in. x 7 in.

391. ,, TWO PYRAMIDS IN SHADOW, CAMEL
GROUP 4 in. x 7 in.

392. , DARK TENT (?) ON SANDS BY SEA OR NILE ;
R. : SEA 4 in. x 7 in.

393. ,, DARK TENT (?) ON RISING GROUND ABOVE
SEA 4 in. x 7 in.

394. ,, A WASH OF WATER, HILLS AND SKY,
BOATS INDICATED 4 in. x 7 in.

395. ,, NILE : BOATS, SUNLIT HILLS : EVENING 4 in. x 7 in.

396. (a) and (b) STUDY : TWO PYRAMIDS REFLECTED :
EVENING SUN ; R. : SCENE ON NILE 4 in. x 7 in.

397. ,, NILE : EVENING, ROSY HILLS, DARK
NOTE OF TREES 4 in. x 7 in.

398. ,, NILE : EVENING, TWO SAILS, BLUE WATER 4 in. x 7 in.

<div align="right"><i>Height. Length.</i></div>

399. STUDY: NILE: PALMS AND SHADOWED MID.
DISTANCE, HILLS 4 in. x 7 in.

400. ,, NILE: TWO TREES ABOVE BUILDING IN
SHADOWED MID. DISTANCE, LIGHT
HILLS 4 in. x 7 in.

401. ,, NILE: A WASH (FADED) DRAWING OF
CAMEL 4 in. x 7 in.

402. ,, NILE: EVENING, TREES AND A SAIL, HILLS
BEYOND. (Stained) 4 in. x 7 in.

403. ,, NILE: HILLS ABOVE TREES AND BOATS
IN SHADOW 4 in. x 7 in.

404. ,, BROWN DESERT IN LIGHT, PYRAMID IN
SHADOW AND ONE BEYOND 4 in. x 7 in.

405. ,, THREE PYRAMIDS; REVERSE: DRAWINGS
OF CAMELS 4 in. x 7 in.

406. ,, AVENUE OF TREES, NILE, AND DISTANT
HILLS 4 in. x 7 in.

407. ,, SANDY GRASS, GREEN SEA AND LANTRY
ISLAND. (Damaged) 4 in. x 7 in.

408. ,, ROCKY ISLAND ABOVE BREAKING SEA,
GREY 4 in. x 7 in.

409. ,, SAND AND DARK RISING GROUND, BLUE
SEA BEYOND 4 in. x 7 in.

410. ,, PORTMARNOCK LINKS, INLET AND SEA 5½ in. x 8 in.

411. ,, RIVER, TREES ON BANK OVERHANGING
LIT TREES AT BACK 5¼ in. x 8 in.

412. (a) and (b) STUDY: HARVEST FIELD, TREES AND
BLUE SEA; R: Ditto 5¼ in. x 8 in.

413. STUDY: TWO OLIVE TREES, SHADOWED VALLEY,
BLUE SEA AND DISTANT HILLS,
RIVIERA 5 in. x 9 in.

414. (a) and (b) STUDY: HALF PAGE: VISTA UNDER
TREES, TO TOWN BY SEA; R.:
DRAWING HILL COAST 5 in. x 9 in.

Height. Length.

415. STUDY : GREEN TREES AGAINST BLUE SKY, STEMS LIGHT 5 in. x 9 in.

416. ,, OLIVE TREES, TILED ROOF AND SEA BEYOND 5 in. x 9 in.

417. ,, PORTMARNOCK SAND HILLS, CATTLE INDICATED, SEA AND SKY 5 in. x 7 in.

418. ,, PURPLE RED SHORE, BREAKERS, WHITE-TOPPED CLOUD 5 in. x 7 in.

419. (a) and (b) STUDY : GREEN HILL IN LIGHT ; R. : DARK PASTURE, WOOD, AND A STORMY SKY 5 in. x 7 in

420. (a) and (c) STUDY : LOW HILLY 'SCAPE AND LIGHT, CLOUDY SKY ; R. : CATTLE ON BENT 5 in. x 7 in.

421. STUDY : SANDS BEHIND BENT, INLET AND DISTANT HILLS 5 in. x 7 in.

422. (a) and (b) STUDY : SANDS BEHIND BENT, BOAT ON INLET ; R. : GREEN PASTURE AND HILLS. (Damaged) 5 in. x 7 in.

423. ,, SANDS INLET AND SKY 5 in. x 7 in.

424. STUDY : BROADS : SAIL BOAT (CENTRE) REFLECTED, SAIL BEHIND WOODY POINT 5 in. x 7 in.

425. ,, BROADS : SAIL BOAT (RIGHT) REFLECTED, TREE AND SAIL BEHIND 5 in. x 7 in.

426. ,, BROADS : BLACK BROWN SAIL, TREES, DISTANT SAIL 5 in. x 7 in.

427. ,, WINDMILL ON DARK GREEN HEIGHT ... 5 in. x 7 in.

428. ,, BROADS : GREEN BANKS, TREES AND THREE SAILS 5 in. x 7 in.

429. ,, BROADS : EVENING GREEN BANK, SAIL, TREES BEYOND 5 in. x 7 in.

430. ,, BROADS : SAILING BARGE, LOW BANK, AND TREES IN BACKGROUND 5 in. x 7 in.

Height. Length.

431. STUDY: BROADS : RIVER, FIGURES INDICATED, TREES AND A BRICK HOUSE ON RISING GROUND 5 in. x 7 in.

432. „ BROADS : RIVER, DARK TREES ON RIGHT, DARK BLUE HILLY DISTANCE, MAST (Stained)... 5 in. x 7 in.

433. „ WHITLINGHAM, 31ST MAY, '91, SAIL AND SPIRE OF CHURCH IN TREES 5 in. x 7 in.

434. „ BROADS : RIVER, DARK SAIL REFLECTED, DARK TREES IN BACKGROUND. (Stained) 5 in. x 7 in.

435. „ BROADS : A SKETCH : ADEN. (Badly Stained) 5 in. x 7 in.

436 and 437. STUDY : SANDS, SEA WITH BOATS INDICATED AND SKY : ADEN. (Badly stained) ... 5 in. x 7 in.

438. „ HILLSIDE : ONE TREE, COW INDICATED, CLOUDY SKY ; R. : RED SAILED BOAT, ADEN, BROWN SEA 5 in. x 7 in.

439. „ SANDY SHORE, ADEN (?), FIGURES IN-DICATED, SEA, DARK LINES ON HORIZON 5 in. x 7 in.

440. „ CROMER : SANDS AND GREY GREEN SEA 5 in. x 7 in.

441. „ CROMER : DARK FOREGROUND, SAND, SEA, FIGURES INDICATED 5 in. x 7 in.

442. „ ADEN (?) : SANDS WET, WITH BOATS AND FIGURES INDICATED 5 in. x 7 in.

443. (a) and (b). CROMER : 26TH MAY, '91 ; R. : ADEN (?) : SEA AND DISTANT STEAMER 5 in. x 7 in.

444. „ ADEN (?) : SANDS, SEA AND SKY, RAPID BLOT. (Stained) 5 in. x 7 in.

445. „ ADEN (?) : SANDS, FIGURES INDICATED, SEA, VESSELS IN PENCIL 5 in. x 7 in.

446. „ DARK LOW CLIFFS AT LOW TIDE ... 5 in. x 8½ in.

Height. Length

447. STUDY : ROCKS, CURVING SANDS AND GREEN
PROMONTORY, RAINY DAY 5 in. x 8½ in.

448. ,, SANDS WITH FIGURE INDICATED, RISING
TIDE, ROCK AND SEA 5 in. x 8½ in.

449. ,, SANDS NEARLY COVERED, ROCK AND
BREAKING SEA 5 in. x 8½ in.

450. ,, SANDS : FIGURES INDICATED, BREAKERS,
DARK PROMONTORIES AND SEA ... 5 in. x 8½ in.

451. ,, ROAD OVER MOOR, DARK HILL AND WET
SKY 5 in. x 8½ in.

452. ,, MOOR AND DISTANT DARK BLUE
MOUNTAIN, GREY CLOUDS DESCENDING 5 in. x 8½ in.

453. (a) and (b) HIGH CLIFFS (MOHER [?]) AND SEA, WET
DAY ; R. : Ditto 5 in. x 8½ in.

454. ,, WOODS, CANNES AND ESTURIALS (?)
R. : DRAWING OF SAME 5 in. x 8 in.

455. ,, TWO OLIVE GREEN TREES, RIVIERA (?) ... 5 in. x 8 in.

456. ,, BROWN HILL IN LIGHT, CATTLE IN-
DICATED, RIVIERA (?)... 5 in. x 8 in.

457. ,, LIGHT HARVEST FIELD ON HILL, GREEN
FOREGROUND, CATTLE INDICATED,
TREE ON RIGHT 5 in. x 8 in.

458. ,, RED SANDS BEHIND GREEN SAND HILLS,
SEA, BALDOYLE (?) 5 in. x 8½ in.

459. ,, ROCK AND SAND, SHORE, GREEN SEA,
BLUE CLOUDY SKY 5 in. x 8½ in.

460. (a) and (b) SAND AND ROCKY POINT, BREAKERS,
GREEN SEA AND SANTRY (?) ; R. :
CURVING STRAND 5 in. x 8½ in.

461 ,, PASTURES, SHEEP ABOVE MALAHIDE (?),
SEA AND PURPLE HORIZON 5 in. x 8½ in.

462. ,, SANDS, ROCKS, BLUE SEA, BANK OF
CLOUDS ON HORIZON 5 in. x 8½ in.

463. STUDY : LIGHT GREEN PASTURES AND LIGHT CLOUDS 5 in. x 8½ in.

464. ,, PASTURES WITH CATTLE, BIG WHITE AND DARK CLOUDS ON BLUE 5 in. x 8½ in.

465. ,, GRASS AND SANDY WASTE, FIGURE AND COTTAGE INDICATED, WHITE AND DOVE CLOUDS ON BLUE 5 in. x 8½ in.

466. ,, ROCKY SHORE, LIGHT GREEN SEA, DARK CLOUD AND SHADOW 5 in. x 8½ in.

467. ,, GREEN BANK OVER SEAWEEDY SHORE, CURVING SANDS, SUGARLOAF 5 in. x 8½ in.

468. ,, BROWN GREEN PASTURE, COWS IN-DICATED, DARK HORIZON, CLOUDS ON BLUE 5 in. x 8½ in.

469. ,, SHORE, GREEN LIGHT AND SHADOWED SEA, DARK HORIZON, DISTANT CLOUDS 5 in. x 8½ in.

470. ,, WARM SANDS, ROCKS AND BREAKING GREEN SEA, BLUE HORIZON 5 in. x 8½ in.

471. ,, LOW CLIFF, SEA AND ROCK, BLUE SEA AND SKY 5 in. x 8½ in.

472. (a) and (b) STUDY : PASTURE AND THREE TREES : R. : HIGH BANK OVER STREAM, WOODS ON HORIZON 5 in. x 8½ in.

473. STUDY : HAY WYNDS AND A DARK HILLSIDE BEYOND, SWEEPING CLOUDS 5 in. x 8½ in.

474. ,, UPLAND MEADOW, WOODS AND BLUE DISTANCE, MALAHIDE (?) 5 in. x 8½ in.

475. ,, SAND DUNES AND STRIP OF BLUE SEA, WARM CLOUDS 5 in. x 8½ in.

476. ,, TRACK THROUGH SANDS AND BENT, BROWN SHORE, DARK BLUE SEA ... 5 in. x 8½ in.

477. (a) and (b) STUDY : BENT GRASS, SANDS WITH LITTLE STREAM, BLUE SEA ; R. : SANDS, BLUE INLET, DUNES 5 in. x 8½ in.

Height. Length.

478. STUDY : DARK PASTURES AND SILHOUETTED
 WOODS, CLOUDS AND BLUE SKY ... 5 in. x 8½ in.

479. ,, BENT GRASS, SANDS, BREAKING SEA
 GREEN WITH PURPLE SHADOWS ... 5 in. x 8½ in.

480. ,, DUNES, SHORE AND BLUE SEA BELOW ... 5 in. x 8½ in.

481. ,, MEADOW, DARK SILHOUETTED TREES AND
 CLOUDS ON BLUE 5 in. x 8½ in.

482. ,, RED, GREEN UPLAND, WHITE CLOUD ON
 BLUE 5 in. x 8½ in.

483. ,, PATH UNDER GREEN TREES, SUNLIGHT
 STRIKING THROUGH 10 in. x 7 in.

484. ,, HAYSTACK, FIGURES INDICATED AGAINST
 DARK GREEN TREES 7 in. x 10 in.

485. ,, BROWN-LEAFED GROUND BELOW TREES
 IN SPRING 7 in. x 10 in.

486. ,, HOWTH HARBOUR AND IRELAND'S EYE ... 7 in. x 10 in.

487. (a) and (b) STUDY : TWO TREE TRUNKS STANDING
 ON AUTUMN LEAVES, SPRING : R. . Do. 10 in. x 7 in.

488. STUDY : GREEN FIELDS AND CLUMPS OF TREES.
 A WASH 7 in. x 10 in.

489. ,, TWO TREES (AUTUMN) OVER STREAM
 THROUGH PASTURES 7 in. x 10 in.

490. ,, YELLOW PASTURES, BROWN HILL WITH
 HEDGE AND TWO TREES, SKY ... 6 in. x 9½ in.

491. ,, LITTLE TOWN, SLENDER WHITE TOWER,
 CYPRESSES, HIGH CRAGGY HILLS ;
 R. : KONIGSEE 4 in. x 6¾ in.

492. ,, BRIDGE OVER WIDE RIVER, PURPLE
 SHADOWS ON GREEN HILLS 4 in. x 6¾ in.

493. ,, LAKE OR DANUBE : GREEN HILL RE-
 FLECTED, BOATS INDICATED ; R. :
 DRAWING OF BRIDGE 4 in. x 6¾ in.

494 (a) and (b) DANUBE, NEAR RUSTCLINK ; R. : Ditto
 washed in 4 in. x 6¾ in.

		Height.	*Length.*
495 STUDY: Probably the same. Slight		4 in.	x 6¾ in.
496. (*a*) and (*b*) STUDY: EVENING ON DANUBE (?); R.: SUNSET		4 in.	x 6¾ in.
497. (*a*) and (*b*) STUDY: WIDDIN: CLUMP OF TREES ON BANK; R.: EVENING ON RIVER		4 in.	x 6¾ in.
498. (*a*) and (*b*) ,, DANUBE: DARK HILL, SHIPS INDICATED; R.: EVENING ON RIVER		4 in.	x 6¾ in.
499. (*a*) and (*b*) ,, DANUBE: DARK CLUMPS OF TREES ON RIVER; R.: GREEN PLAIN AND PEAKS		4 in.	x 6¾ in.
500. STUDY: GREY GREEN SAND DUNES, WARM SANDS AND GREEN SEA, PORTMARNOCK ...		4 in.	x 6¾ in.
501. (*a*) and (*b*) STUDY: CLUMPY TREES AGAINST BLUE MOUNTAIN IN CLOUD; R.: TOWN, TREES AND SNOWY MOUNTAINS ...		4 in.	x 6¾ in.
502. (*a*) and (*b*) STUDY: DARK-CLOUDED MOUNTAIN OVER GREEN PLAIN; R.: SAND DUNES AND SKY		4 in.	x 6¾ in.
503. STUDY: BALDOYLE PASTURES AND SUGARLOAF ...		4 in.	x 6¾ in.
504. ,, BENT GRASS ON SAND HILLS, SANDS AND SEA		4 in.	x 6¾ in.
505. ,, SHIPS IN BLUE HARBOUR, CONSTANTINOPLE (?)		4 in.	x 6¾ in.
506. ,, HARBOUR, SHIPS AND TOWN, CONSTANTINOPLE (?). (Stained) ...		4 in.	x 6¾ in.
507. ,, SEA REFLECTING CLOUDY SKY OVER WOOD AND HILL. (Badly stained) ...		4 in.	x 6¾ in.
508. ,, SAND HILLS AND CLOUDY SKY		4 in.	x 6¾ in.
509. ,, LENZ (?), 4TH JUNE, 1888: DARK TREES AND BUILDINGS OVER WATER, TOWER-TOPPED HILL		4 in.	x 6¾ in.
510. ,, SAND HILLS, SEA, WOODS AND HILL ...		4 in.	x 6¾ in.

			Height.	Length.
511.	STUDY :	SAND DUNES AND SKY	4 in.	x 6¾ in.
512.	,,	SAND AND SEA. A Wash	4 in.	x 6¾ in.
513	,,	THE RELICS OF A SHIP IN THE SANDS ...	4 in.	x 6¾ in.
514.	,,	CURVING RIVER BANK, FRANCE (?) ...	4 in.	x 7 in.
515.	,,	DARK POPLARS, ETC., ON RIVER BANK, SEINE (?)	4 in.	x 7 in.
516.	,,	DARK BLUE RIVER WITH HIGH-WOODED BANKS, BRIDGE	4 in.	x 7 in.
517	,,	SHADOWED PASTURES, SUN AND CLOUDS ON BLUE	3½ in.	x 4⅜ in.
518.	,,	COLOUR NOTE PASTURES AND BLUE SEA AND SKY	3½ in.	x 4⅜ in.
519.	,,	SAND DUNES, SANDS, GREEN TO DARK BLUE SEA	3½ in.	x 4⅜ in.
520.	,,	COLOUR NOTE OF WARM FIELD AND CLOUD	3½ in.	x 4⅜ in.
521.	,,	COLOUR NOTE OF WARM FIELD, DARK-WOODED HORIZON AND SKY	3½ in.	x 4⅜ in.
522.	,,	COLOUR NOTE OF WARM FIELD, DARK TREES, BLUE HILL AND SKY	3½ in.	x 4⅜ in.
523.	,,	COLOUR NOTE OF SHORE, WOODS AND SKY	3½ in.	x 4⅜ in.
524.	.,	COLOUR NOTE OF PASTURE, CATTLE, WOOD AND A CLOUDY SKY	3½ in.	x 4⅜ in.
525.	,,	COLOUR NOTE OF PASTURE, WARM HILL, DARK CLOUD ON WHITE AND BLUE ...	3½ in.	x 4⅜ in.
526.	,,	COLOUR NOTE ON PASTURE, WOOD, HARVEST FIELD IN LIGHT, SKY ...	3½ in.	x 4⅜ in,
527.	,,	GREY DAY, GREEN PASTURES, TREES ON LEFT, DARK HORIZON	4⅝ in.	x 7½ in.
528.	,,	CLUMP OF FOUR TREES IN PARK	4⅝ in.	x 7½ in.
529.	,,	STREAM THROUGH PASTURES, WINDMILL AND TOWER IN DISTANCE	4⅝ in.	x 7½ in.
530	,,	STREAM THROUGH PASTURES, WINDMILL IN DISTANCE	4⅝ in.	x 7½ in.

Height. Length.

531 STUDY : GREEN PASTURES WITH TOWER IN
 DISTANCE 4⅝ in. x 7½ in.

532 ,, GREY GREEN FIELD, HAY WYNDS, DARK
 TREES AGAINST EVENING SKY ... 4⅝ in. x 7½ in.

533 ,, ORANGE CORNFIELD BEHIND GORSE,
 GREEN HILL BEYOND 4⅝ in. x 7½ in.

534 ,, ORANGE SAND AND BENT, FIGURES
 INDICATED, SEA, STEAMER ON HORIZON 4⅝ in. x 7½ in.

535 ,, STRANDED FISHING BOAT WITH FIGURES,
 TWO SAILS UP, SEA AND BOATS ... 4⅝ in. x 7½ in.

536 ,, STRANDED BOAT, NETS UP TO DRY, GREEN
 SEA WITH SHADOWS. (Stained) ... 4⅝ in. x 7½ in.

537 ,, STRANDED BOAT, 1 SAIL UP, 1 FIGURE,
 GREEN SEA 4⅝ in. x 7½ in.

538 ,, POLLARDED WILLOWS, TWO OVER
 RIVER, BLUE TREES ON HORIZON.
 (Stained) 4⅝ in. x 7½ in.

539. (a) and (b) STUDY : LIGHT ON GRASS PAST TWO TREE
 TRUNKS, LOW COTTAGE ROOF ; R. :
 RIVER UNDER TREES 4⅝ in. x 7½ in.

540. STUDY : TWO TREES IN PARK, DARK TREES AND
 HILL ON HORIZON. (Damaged) ... 4⅝ in. x 7½ in.

541. (a) and (b) STUDY : CORFU (?) : PERGOLA OVER
 COAST, BLUE SEA ; R. : PLAIN TREES
 AND A BIG SKY 4⅞ in. x 6¾ in.

542. (a) and (b) STUDY : CORFU (?) SANDY SHORE WITH
 BOAT INDICATED, SEA AND MOUNTAIN ;
 R. : FIELD, TREES AND SKY ... 4⅞ in. x 6¾ in.

543. (a) and (b) STUDY : CROSS-ARCHED CLOISTERS ;
 R. : GREEN PLAIN AND SKY 4⅞ in. x 6¾ in.

544. STUDY : CROSS-ARCHED CLOISTERS, CORFU (?) ... 4⅞ in. x 6¾ in.

545. CORFU (?) : TOWN ON MOUNTAINOUS
 COAST, BLUE SEA BELOW 4⅞ in. x 6¾ in.

			Height.	Length.

546. STUDY : CORFU (?) : INSIDE THE CLOISTERS, CRAG ABOVE $6\frac{3}{4}$ in. x $4\frac{7}{8}$ in.

547. „ CORFU (?) : SHORE, BOAT, BLUE SEA AND TOWN UNDER HILLS $4\frac{7}{8}$ in. x $6\frac{3}{4}$ in.

548. (a) and (b) STUDY : CORFU (?) : OVER TREES AND PROMONTORY TO SEA BLUE ; R. : UP FROM SEA TO TOWN AND CRAGS ... $4\frac{7}{8}$ in. x $6\frac{3}{4}$ in.

549. (a) and (b) STUDY : SALITA TO MONASTERY (?) : ON TERRACE OF CRAG OVER SEA ; R. : TOWN AND HILLS $4\frac{7}{8}$ in. x $6\frac{3}{4}$ in.

550. (a) and (b) STUDY : THROUGH PERGOLA TO BLUE SEA ; R. : PASTURE, TREES AND SHOWER PASSING $4\frac{7}{8}$ in. x $6\frac{3}{4}$ in.

551. (a) and (b) STUDY : PASTURE TREES AND BIG CLOUDY SKY ; R. : PARK SCENE, EVENING, SEA HORIZON $4\frac{7}{8}$ in. x $6\frac{3}{4}$ in.

552. (a) and (b) PERGOLA UNDER CRAGS, BLUE SKY ; R. : PEAKY CRAG DOWN TO SEA $4\frac{7}{8}$ in. x $6\frac{3}{4}$ in.

553. (a) and (b) STUDY : PALM TREES, WITH PURPLE SEA BEYOND ; R. : CRAG AND BLUE SKY $6\frac{3}{4}$ in. x $4\frac{7}{8}$ in.

554. STUDY : PERGOLA : SALITA ON LEFT WITH FIGURES INDICATED, TREES AND CRAG AND BLUE SEA $4\frac{7}{8}$ in. x $6\frac{3}{4}$ in.

555. „ PILLARED PERGOLA ON TERRACE ABOVE SEA $4\frac{7}{8}$ in. x $6\frac{3}{4}$ in.

556. „ SHADOWED AVENUE OF TREES, WATER REFLECTING PYRAMID $4\frac{7}{8}$ in. x $6\frac{3}{4}$ in.

557. „ SPHYNX, IN LIGHT, PYRAMID BEYOND ON LEFT. $4\frac{7}{8}$ in. x $6\frac{3}{4}$ in.

NOTE.—Illustrated in this book.

558. „ SPHYNX, HALF SHADOW, PYRAMID BEYOND ON RIGHT $4\frac{7}{8}$ in. x $6\frac{3}{4}$ in.

Q

Height. Length.

559. (a) and (c) STUDY : EGYPTIAN TEMPLE, WITH
 COLUMNS ; R. : PASTURE, BAY AND
 HILL. (Spotted) 4⅞ in. x 6¾ in.

560. STUDY : EGYPTIAN TEMPLE, FROM UNDER ITS
 SHADOW 6¾ in. x 4⅞ in.

561. ,, EGYPTIAN TEMPLE FROM WITHIN,
 FIGURES INDICATED 6¾ in. x 4⅞ in.

562. ,, FOUR EGYPTIAN COLUMNS, FIGURES AND
 BOATS INDICATED, HILL BEYOND ... 4⅞ in. x 6¾ in.

563. (a) and (b) STUDY : THREE SKETCHES ON NILE,
 ORANGE HILLS AND FIGURES INDICATED 4⅞ in. x 6¾ in.

564. (a) and (b) STUDY : EGYPT, TWO ROWS OF
 COLUMNS ; R. : NILE AND ROCKY
 HILL 4⅞ in. x 6¾ in.

565. STUDY : INSIDE A TEMPLE, SHADOW CAST ACROSS
 INTERIOR 4⅞ in. x 6¾ in.

566. ,, EGYPT : TWO ROWS OF COLUMNS, SQUARE-
 HEADED GATEWAY BEYOND 4⅞ in. x 6¾ in.

567. ,, EGYPT : AMONG THE COLUMNS, HALFWAY
 UP, GATEWAY BEYOND 4⅞ in. x 6¾ in.

568. (a) and (b) STUDY : EGYPT : TWO ROWS COLUMNS
 AND GATEWAY, ALL IN SHADE ; R. :
 PASTURE, TREES AND SKY 4⅞ in. x 6¾ in.

569. STUDY : LIGHT, SANDY SHORE, FIGURES, BOATS,
 PALMS, HILLY HEADLAND, DARK
 GREEN SEA 4⅞ in. x 6¾ in.

570. ,, PALM TREES, WITH FIGURES BELOW ... 4⅞ in. x 6¾ in.

571. ,, PALM TREES WITH FIGURES BELOW, SAND
 HILLS BEYOND 6¾ in. x 4⅞ in.

572. ,, FIGURES NEAR A WELL (?) IN THE SAND,
 PALM TREES. 4⅞ in. x 6¾ in.

NOTE.—Illustrated in this book.

573. COTTAGES AND TREES : A BEGINNING ... 8¾ in. x 8¼ in.

574. STUDY : STUDY OF FRENCH PEASANT BOY STAND-
ING, SUNLIGHT 8¾ in. x 6 in.

575 . SIDE WALL OF FARM, CULVERT IN FRONT,
STAIRS, POPLARS 11 in. x 8¼ in.

576. ,, OF FRENCH BOY LYING ON THE GRASS,
SUN 8½ in. x 5 in.

577. ,, A ROAD WITH BIG TREE ON LEFT, MID.
DISTANCE, BIG TREE ON RIGHT ... 5¼ in. x 8¾ in.

578. ,, BOY SEATED ON GRASS, SUN 5¼ in. x 7½ in.

579. (*a*) and (*b*) CRAGGY RAVINE FROM ABOVE ; R. :
DARK MOOR AND HILL 3⅝ in. x 6¾ in.

580. (*a*) and (*b*) GREY, GREEN AND BROWN HILL
AGAINST SKY ; R. : MOORS DOWN
TO ROAD 3⅝ in. x 6¾ in.

581. STUDY : ROAD BY HEATHERY HILL, FIGURES
INDICATED 3⅝ in. x 6¾ in.

582. ,, BANK OF TREES ABOVE RIVER, GREEN
PASTURES AND HIGH HILLS 3⅝ in. x 6¾ in.

583. (*a*) and (*b*) STUDY : STONES, GRASS AND HEATHER
ON HILL TOP ; R. : HALF SHEET,
DARK RIVER BELOW TREES 3⅝ in. x 6¾ in.

584. STUDY : A BEGINNING LANDSCAPE OF RIVER,
FIELD AND HILLS 3⅝ in. x 6¾ in.

585. ,, A ROAD : FIGURE WITH SHEEP (?) IN-
DICATED, SLOPE OF HILL WITH BIRCH
TREES ON RIGHT 3⅝ in. x 6¾ in.

586. ,, GLENMALURE (?) ROAD IN LIGHT, DARK
HEATHERY HILL BEYOND 3⅝ in. x 6¾ in.

587. ,, A BEGINNING OF RIVER, FIELDS AND
HILLS AND BROWN TREES IN A CLUMP 3⅝ in. x 6¾ in.

588. ,, GREEN FIELDS AND EVENING SKY.
(Spotted) 3⅝ in. x 6¾ in.

589. ,, RIVER UNDER DARK HEATHERY HILL,
GREEN BANKS ON RIGHT 3⅝ in. x 6¾ in.

Height. Length.

590. STUDY: DUTCH FISHING BOATS LEAVING SHORE, SCHEVENINGEN 3⅞ in. x 7 in.

591. „ DUTCH FISHING BOATS ON SANDS, COTTAGES ON LEFT 3⅞ in. x 7 in.

592. „ DUTCH FISHING FLEET, SOME WITH SAILS SET, OTHERS NOT: SAND. (Stained) ... 3⅞ in. x 7 in

593. „ DUTCH FISHING FLEET ON SANDS, BLUE SKY 3⅞ in. x 7 in

594. „ SAND DUNES, WITH FIGURES ON SHORE BELOW FISHING FLEET 3⅞ in. x 7 in.

595. „ A NOTE OF FIGURES ON SAND AND WADING TO BOAT WITH SAIL 3⅞ in. x 7 in.

596. (a) and (b) STUDY: SOME GRASS, FALLING SANDS TO PALE SEA; R.: FISHING BOATS ... 3⅞ in. x 7 in.

597. (a) and (b) STUDY: GROUP OF BROWN-SAILED BOATS ON SANDS; R.: TWO BOATS ON SAND 3⅞ in. x 7 in.

598. STUDY: SANDY SHORE, A FEW FIGURES AND A BOAT, SAILS HALF SET, BREAKERS ... 3⅞ in. x 7 in.

599. „ SANDY GRASS, DARK HORIZON, LOW HILL, WARM GREY SKY 4 in. x 6¼ in.

600. „ GREEN WOODS REFLECTED IN WATER, SLENDER TREE IN FOREGROUND ... 4 in. x 6¾ in.

601. „ DARK SLOPING HILL TO SHORE AND SEA, BLUE CLOUD 4 in. x 6¾ in.

602. „ DARK ROCKY FOREGROUND AND RED SANDS, ORANGE LIGHT, BLUE DISTANCE 4 in. x 6¾ in.

603. „ ISTRIA 11 in. x 15½ in.

604. „ SEA BAY 11 in. x 15½ in.

605. (a) and (b) STUDY: OLD RUINED ABBEY; REVERSE: TREES AND STREAM 11 in. x 15½ in.

606. STUDY: SHEET OF TWO STUDIES 11 in. x 15½ in.

607. „ TREES AND PALMS 11 in. x 15½ in.

608. „ BARGES ON SEINE... 11 in. x 15½ in.

			Height.	Length.

609. STUDY : SEINE : POPLAR AND OTHER TREES ... 11 in. x 15½ in.
610. ,, SANDS AND SEA, RIVIERA 11 in. x 15½ in.
611. ,, CORFU 11 in. x 15½ in.
612. ,, SHEET OF TWO SHORE STUDIES... ... 11 in. x 15½ in.
613. (a) and (b) STUDY : TOP OF THE CLIFF ; REVERSE :
THE CLIFF 11 in. x 15½ in.
614. (a) and (b) STUDY : SHEET OF THREE COAST
SCENES ; REVERSE : COTTAGE ... 11 in. x 15½ in.
615. STUDY : OUTSIDE PARIS, '83-'84 11 in. x 15½ in.
616. (a) and (b) STUDY : ÉTRETAT : FRONT AND BACK 11 in. x 15½ in.
617. STUDY : CORFU ; REVERSE : A HOUSE AND LAWN 11 in. x 15½ in.
618. ,, HILL AND STREAM, DONEGAL 11 in. x 15½ in.
619. ,, CLIFFS AND SEA 11 in. x 15½ in.
620. (a) and (b) STUDY : RIVER AND HILL ; REVERSE :
CLIFFS AND SEA 11 in. x 15½ in.
621. (a) and (b) STUDY : THE SEINE VALLEY ; RE-
VERSE : Ditto 11 in. x 15½ in.
622. (a) and (b) SHEET OF THREE STUDIES ... 11 in. x 15½ in.
623. STUDY : HOUSES UNDER WOODED HILL... ... 11 in. x 15½ in.
624. ,, SHEET OF TWO, ROCKS AND SEA, ETC. ... 11 in. x 15½ in.
625. ,, SANDY BAY AND REFLECTIONS. (Tinted
Paper and Gouache) 10 in. x 15½ in.
626. ,, ROCKS OVER BAY, FIGURES. (Tinted
Paper and Gouache) 10 in. x 15½ in.
627. ,, ROCKS AND A CAVE IN THE CLIFF.
(Tinted Paper and Gouache) 10 in. x 15½ in.
628. ,, MOUNTAIN COAST. (Tinted Paper and
Gouache) 10 in. x 15½ in.
629. ,, RISING TIDE, CLIFFS AND SAND. (Tinted
Paper and Gouache) 7 in. x 15½ in.
630. ,, HILLY SHORE, WOMEN ON SANDS (Tinted
Paper and Gouache) 9½ in. x 14 in.
631. ,, RIVER, BRIDGE AND MOUNTAIN 9¾ in. x 12 in.
632. ,, OLD CHURCH IN VALLEY 9¾ in. x 11 in.

		Height.	Length.
633. STUDY: ORANGE TREES AND PATH IN SUNSHINE		$9\frac{3}{4}$ in.	x 11 in.
634 and 635. STUDY OF TREES		$11\frac{1}{2}$ in.	x $10\frac{1}{2}$ in.
636. (a) and (b) STUDY: PEOPLE UNDER OLIVE TREES.			
OLIVE TREES		10 in.	x 12 in.
637. STUDY: PASTURES AND HORSES		9 in.	x 11 in.
638. ,, SHORE BELOW CLIFFS		9 in.	x 11 in.
639. ,, BOAT AND TREE AND LAKE		8 in.	x 11 in
640. ,, HOUSES BY BAY		8 in.	x 11 in.
641. ,, FISHING BOATS IN LITTLE HARBOUR ...		8 in.	x 11 in.
642. ,, CLIFFS AND SHORE		8 in.	x 11 in.
643. ,, SHEET WITH LITTLE PYRENNEAN SKETCH		8 in.	x 11 in.
644. ,, LOCK ON RIVER		8 in.	x 11 in.
645. ,, THREE STUDIES OF WOMEN		8 in.	x 11 in.
646. ,, STUDY OF PLOUGHMAN; REVERSE: STUDY		8 in.	x 11 in.
647. ,, MOOR AND TREE		8 in.	x 11 in.
648. (a) and (b) STUDY: OLD CHURCH IN VALLEY;			
REVERSE: VALLEY		8 in.	x 11 in.
649. (a) and (b) STUDY: TWO BOYS BY BOATS; R.			
DRAWING OF VILLAGE		8 in.	x 11 in.
650. (a) and (b) STUDY: DRYING THE NETS; R.: SKETCH			
BEGUN		8 in.	x 11 in.
651. (a) and (b) THE SUGARLOAF; R.: STUDY OF			
TREE		8 in.	x 11 in.
652. (a) and (b) STUDY: CORN STOOKS; R.: Ditto.		8 in.	x 11 in.
653. (a) and (b) STUDY: THE WEIR; R.: DUBLIN			
PLAIN		8 in.	x 11 in.
654. STUDY: FISHING BOATS, ÉTRETAT		8 in.	x 11 in.
655. ,, CLIFF BY SHORE		8 in.	x 11 in.
656. ,, HILLSIDE		8 in.	x 11 in.
657. ,, ROCKS AND BAY		8 in.	x 11 in.
658. ,, DRYING THE NETS; R.: SANDS ...		8 in.	x 11 in.
659. ,, RIVER BANK AND TREES		8 in.	x 11 in.
660. ,, WAVES		8 in.	x 11 in.
661. ,, BLUE SEA AND SANDS		8 in.	x 11 in.

			Height.	Length.
662.	STUDY:	FISHING BOATS IN HARBOUR	8 in.	x 11 in.
663.	,,	CLIFFS ABOVE SEA	8 in.	x 11 in.
664.	,,	BAY AND SANDS	8 in.	x 11 in.
665.	,,	SHIP WITH SAILS SET	8 in.	x 11 in.
666.	,,	MOOR	8 in.	x 11 in.
667.	(a) and (b) STUDY: GLENMALURE ROAD; R. HILLS		8 in.	x 11 in.
668.	STUDY: FIELD AND TREES AND SEA		6 in.	x 10¼ in.
669.	(a) and (b) STUDY: PASTURE AND CORNFIELD; R.: PARK		6 in.	x 10¼ in.
670	STUDY: LAND-LOCKED BAY		6½ in.	x 11 in.
671.	,, MOUNTAIN HEADLAND		6½ in.	x 11 in.
672.	,, HOUSE AND STAIRWAY		10 in.	x 7 in.
673.	,, BOYS IN FISHING BOATS, EARLY (?) ...		6½ in.	x 10 in.
674.	,, LANE IN VILLAGE, EARLY (?)		6½ in.	x 10 in.
675.	,, TREES AND A VISTA, EARLY (?)		6½ in.	x 10 in.
676.	,, THE APPROACH TO THE SHORE. (Tinted Paper)		8 in.	x 10 in.
677.	,, VILLAGE OVER SEA. (Tinted Paper) ...		8 in.	x 10 in.
678.	(a) and (b) STUDY: SAND AND SEA; R.: CLIFFS AND SEA		8 in.	x 10 in.
679.	STUDY OF BOAT		8 in.	x 10 in
680.	,, ROCK OVER SEA		8 in.	x 10 in.
681.	,, FORT OVER SEA. (Tinted Paper)		8 in.	x 10 in.
682.	,, TWO STUDIES OF PEASANT GIRLS. (Tinted Paper)		8 in.	x 10 in.
683.	,, FISHING FLEET. (Tinted Paper)		8 in.	x 10 in.
684.	,, BOATS SAILING. (Stained.) (Tinted Paper)		8 in.	x 10 in.
685	,, HORSES AND CART UNLOADING SHIP. (Tinted Paper)		8 in.	x 10 in.
686.	,, STREET SCENE		7¾ in.	x 5 in.
687.	,, BOY		5 in.	x 8 in.
688.	,, BAY, ROCKS AND A DISTANT BOAT ...		5 in.	x 8 in.
689.	,, LITTLE STREET: ABROAD		8 in.	x 5 in.

			Height.	Length.
690.	STUDY:	CAP ST. MARTIN	5½ in.	x 8¼ in.
691.	,,	CHURCH, TREES AND STREAM	9 in.	x 6 in.
692.	,,	ROCKY COAST	5½ in.	x 8¾ in.
693.	,,	PINE TREES BY SEA	5½ in.	x 8¾ in.
694.	,,	CASTLE ON HILL	5½ in.	x 8¾ in.
695.	,,	CLIFF AT ÉTRETAT	5½ in.	x 8¾ in.
696.	,,	CURVED SHORE AND TREES	5½ in.	x 8½ in
697.	,,	NEEDLE ROCK AND BAY	5½ in.	x 8½ in.
698.	,,	SEAWEED GATHERING, KILKEE ...	5½ in.	x 8½ in.
699.	,,	BLACK CLIFFS ON COAST	5½ in.	x 8½ in.
700.	,,	TOP OF CLIFFS OVER BAY	5½ in.	x 8½ in.
701.	,,	ROCKY STREAM	5½ in.	x 8½ in.
702.	,,	SKETCHERS : PARIS ENVIRONS	8 in.	x 12 in.
703.	,,	OVERLOOKING BAY FROM CLIFFS ...	8 in.	x 11 in.
704.	,,	HILLY LANDSCAPE	5 in.	x 8 in.
705.	,,	FISHING BOATS ON SCHEVENINGEN SHORE	5 in.	x 7 in.
706.	,,	BUILDINGS AND PALM TREE	5 in.	x 7 in.
707. and 708.	STUDY :	FISHING BOATS AT SCHEVENINGEN	5 in.	x 7 in.
709.	STUDY:	OLD WALL AND OLIVE TREES	5 in.	x 7 in.
710.	,,	BOATS ON SHORE, BOAT ENTERING HARBOUR	7½ in.	x 11 in.
711.	,,	WIDE BAY AND SKY	7½ in.	x 11 in.
712.	,,	THREE STUDIES OF WOMEN	7½ in.	x 11 in.
713.	,,	SAND AND SEA	7½ in.	x 11 in.
714.	,,	FISHING BOAT WITH BOY	7½ in.	x 11 in.
715.	,,	ROCKY SHORE, MAN WADING	7½ in.	x 11 in.
716.	,,	CORN FIELD, TREES AND BAY	7½ in.	x 11 in.
717.	,,	STRANDED BOAT AND HOUSE	7½ in.	x 11 in.
718.	,,	TWO GIRLS UNDER TREES	7½ in.	x 11 in.
719	,,	SHORES OF LAKE UNDER HEATHERY MOUNTAIN	7½ in.	x 11 in.
720.	,,	HILLSIDE AND WINDING STREAM ...	7½ in.	x 11 in.
721.	,,	CORN STOOKS	7½ in	x 11 in.

Height. Length

722. (a) and (b) STUDY : SANDY BAY ; R. : BIG TREE
OVER STREAM 7½ in. x 11 in.
723. STUDY : OF TWO BOYS 7½ in. x 11 in.
724. ,, FISHING BOAT, SHORE AND CLIFF ... 7½ in. x 11 in.
725. ,, WINDING PATH ALONG CLIFF 7½ in. x 11 in.
726. ,, TWO TREES 7½ in. x 11 in.
727. ,, MENTONE : R. : TREES 7½ in. x 11 in.
728. ,, HASTINGS ; R. : HASTINGS 7½ in. x 11 in.
729. ,, SUNLIT PATH THRO' TREES 7½ in. x 11 in.
730. ,, GIRL SEATED UNDER TREE ; R. : SKETCH 7½ in. x 11 in.
731. ,, CLIFFS OF MOHER 10 in. x 8 in.
732. ,, TWO STUDIES OF BOYS 9 in. x 10 in.
733. ,, OVERHANGING TREES 11 in. x 15 in.
734. ,, POPLARS AND TREES 11 in. x 15 in.
735 and 736. STUDY : TWO SKETCHES : BARGES AND
SEINE 11 in. x 15 in.
737. STUDY : REFLECTIONS ON RIVER 12½ in. x 11 in.
738. ,, THREE TREES AND FIELDS 8½ in. x 12 in.
739. ,, OF HORSE AND CART AND TWO BOYS ... 9½ in. x 12 in.
740. ,, OF HORSE IN FIELD 9½ in. x 12 in.
741. ,, OF TWO STONE PINES 12 in. x 10 in.
742. ,, SHEET WITH LANDSCAPE STUDY.
743. ,, STUDY OF FRUIT TREE 7 in. x 12 in.
744. (a) and (b) STUDY : AVENUE OF TREES ; R. : PARK 8¼ in. x 10¼ in.
745. STUDY : SKETCH : WOODED BANK (Tinted Paper) 8 in. x 9¾ in.
746. ,, HORSES AND CART UNLOADING BOAT.
(Tinted Paper) 8 in. x 9¾ in.
747. ,, FISHING BOATS. (Tinted Paper) ... 8 in. x 9¾ in.
748. ,, SCHOONER. (Tinted Paper) 8 in. x 9¾ in.
749. ,, SANDY BEACH. (Tinted Paper)... ... 8 in. x 9¾ in.
750. ,, STRANDED SCHOONER. (Tinted Paper) ... 8 in. x 9¾ in.
751 ,, FISHING BOAT UNDER TREES. (Tinted
Paper) 8 in. x 9¾ in.

		Height.	*Length.*
752. (*a*) and (*b*) STUDY: BAY AND CLIFFS; FISHING BOAT. (Tinted Paper)		8 in.	x 9¾ in.
753. STUDY: RIVER LOCK; R.: Ditto		8 in.	x 9¾ in.
754 and 755. STUDY: NOTES OF HORSES AND CARTS. (Tinted)		8 in.	x 9¾ in.
756. STUDY: TWO STUDIES OF BOYS (Tinted)		8 in.	x 9¾ in.
757. ,, STUDY OF A BOY		9 in.	x 6 in.
758. ,, PYRENNEES		5½ in.	x 9 in.
759. ,, WINDING COAST ROAD UNDER MOUNTAIN		5½ in.	x 9 in.
760. ,, STUDY OF BOY		9 in.	x 5½ in.
761. ,, LAKE, TREES AND HILL		5½ in.	x 9½ in.
762. ,, HEADLAND		5½ in.	x 9½ in.
763. (*a*) and (*b*) STUDY: TREES ON CLIFF; R.: SAND AND SEA		5½ in.	x 9½ in.
764. ,, ABOVE THE SEA		5½ in.	x 9½ in.
765. ,, FROM GARDEN AT MALAHIDE (?) ...		9½ in.	x 5½ in.
766. ,, FISHING BOATS ON SHORE AT ETRETAT ...		5½ in.	x 9 in.
767. ,, FIVE PINE TREES		9 in.	x 5½ in.
768. ,, ROCKY CLIFF		5 in.	x 8½ in.
769. ,, BOY WITH BOATS		4½ in.	x 7½ in.
770. ,, CARNAC (?)		7½ in.	x 4¾ in.
771. ,, LANDSCAPE		5 in.	x 8 in.
772. ,, TREE TRUNKS		5 in.	x 8 in.
773. ,, SEA COAST		5 in.	x 8 in.
774. ,, BOAT ON SANDS		5 in.	x 8 in.
775. ,, FISHING BOATS ON SAND		5 in.	x 8 in.
776. ,, HOUSE, TERRACE AND TREES		5 in.	x 8 in.
777. (*a*) and (*b*) STUDY: LANDSCAPES		3½ in.	x 5 in.
778. STUDY: STUDY OF TWO HORSES AND CART. (Tinted Paper)		4 in.	x 5½ in.
779. (*a*) and (*b*) STUDY: UNDER TREES ON TOW PATH; R.: DARK PASTURE, WOOD AND SKY		4⅝ in.	x 7½ in.
780. STUDY: SAND HILLS, INLET, LIGHT SANDS. CLOUDY SKY. (Dirty)...		5½ in.	x 9 in.

Height. Length.

781. STUDY : COLOUR NOTE OF GREEN HILL AND
 BRIGHT CLOUDY SKY 3½ in. x 5 in.

782. (a) and (b) STUDIES OF THE SUGARLOAF 5½ in. x 9 in.

783. STUDY : INSIDE COVER OF SKETCH BOOK : PAS-
 TURE, PARK AND SKY... 7 in. x 10 in.

784. ,, SAND, SEA AND SKY : A BLOT AT SCHE-
 VENINGEN 4 in. x 7 in.

785. ,, RIVER, BANK OF TREES AND SKY ... 4 in. x 7 in.

786. ,, ROAD AND BIG TREES, COTTAGE TO RIGHT
 BELOW ROAD 3⅝ in. x 6¾ in.

787. ,, A BEND OF THE RIVER BOYNE (?) BELOW
 WOODED BANK 4 in. x 7 in.

788. ,, REEDS, A RIVER, HILL AND SKY ... 4 in. x 7 in.

789. ,, STUDY OF LONG-HAIRED DOG BEGGING 4 in. x 7 in.

790. ,, SEA AND SKY : A NOTE OF COLOUR.
 (Rather damaged) 4⅞ in. x 6¾ in.

791. ,, PASTURE, TREE AND WOODS, SWEEPING
 CLOUDS 4⅞ in. x 6¾ in.

792. ,, PASTURE, BIG TREES AND WOODS,
 CLOUDS 4⅞ in. x 6¾ in.

793. ,, GREY GREEN PASTURES, WITH CATTLE
 INDICATED, CLUMPS OF TREES ... 4⅞ in. x 6¾ in.

794. ,, TWO WILLOWS OVER POOL, PASTURE,
 WOODS, CLEAR SKY 4⅞ in. x 6¾ in.

795. ,, SHEEP RESTING IN SHADOW UNDER TREE,
 LIGHT BEYOND 4⅞ in. x 6¾ in.

796. ,, BIG TREE IN FRONT OF WOODS, PASTURE
 AND EVENING SKY 4⅞ in. x 6¾ in.

797. ,, TREE TO TOP, WOODS, SEA AND
 IRELAND'S EYE 4⅞ in. x 6¾ in.

798. ,, SPREADING TREES IN PARK, WOODS
 BEYOND 4⅞ in. x 6¾ in.

799. ,, THREE TREES IN PASTURE, WOODS
 BEYOND 4⅞ in. x 6¾ in.

			Height.	Length.
800	STUDY :	PASTURE, CATTLE INDICATED, CLUMP OF WOODS, BIG BROWN CLOUDS	4⅞ in.	x 6¾ in.
801.	,,	(a) SIX TREES IN CLUMP IN PASTURE, WOODS AND SKY. (b) LOOKING INTO A DARK VALLEY, CLEAR SKY, EVENING AND CLOUDS	4⅞ in.	x 6¾ in.
802.	,,	BROWN-TOPPED HILL AGAINST SKY ...	4⅛ in.	x 6¾ in.
803.	,,	SLOPING PASTURES AND BIG TREES ...	4⅛ in.	x 6¾ in.
804.	,,	A ROAD TO GATE OR STILE, TREES OVERHANGING	4⅞ in.	x 6¾ in.
805.	,,	TWO TREES ABOVE RIVER, PASTURE AND HILL BEHIND	4⅞ in.	x 6¾ in.
806.	,,	CATTLE IN LIGHT AND SHADE UNDER TREE OVERHANGING RIVER.	4⅞ in.	x 6¾ in.
807.	.	HILLY PASTURES, TREES ON FENCE, HIGH HILLS BEYOND.	4⅞ in.	x 6¾ in.
808.	,,	PASTURE WITH TIMBERED HEDGE SLOPING UP TO HEATHERY HILL 	4⅞ in.	x 6¾ in.
809.	,,	SLIGHT STUDY OF SAME SUBJECT AS 801 (b)	4⅞ in.	x 6¾ in.
810.	,,	HILLY LANDSCAPE, A BLOT 	4⅞ in.	x 6¾ in
811.	,,	PASTURE ON HILL, WOODS BEYOND. (Stained in sky). 	4⅞ in.	x 6¾ in.
812.	,, .	ROAD OR AVENUE UNDER GROUP OF TREES TO LIGHT PASTURE. 	4⅞ in.	x 6¾ in.
813.	,,	BIG TREE TRUNKS (2) LIGHT PASTURES, SHADOWED WOODS 	4⅞ in.	x 6¾ in.
814.	,,	PATH UNDER TREES, A BLOT 	6¾ in.	x 4⅞ in.
815.	,,	PASTURE WITH CATTLE, WOODS AND SKY	4⅛ in.	x 6¾ in.
816.	,,	ROAD TO CLOUDED PURPLE HILL. (Damaged) 	5 in.	x 8½ in.
817.	,,	A COLOUR NOTE OF GREEN BANK ABOVE BROWN SHORE, LIGHT SAND AND SEA	3½ in.	x 4¾ in.
818.	,,	A COLOUR NOTE, BENT SEA, AND DISTANT ISLAND, LANTRY 	3½ in.	x 4¾ in.

			Height.	Length.
819.	STUDY :	PINES IN A FOREST, PATH BELOW ...	8 in.	x 5¼ in.
820.	„	GROUP OF PINE STEMS RISING FROM GREEN	8 in.	x 5¼ in.

STUCK INTO ALBUM.

			Height.	Length.
821.	STUDY :	ROW OF BIG TREES IN SUN, DARK HORIZON	7½ in.	x 11 in.
822.	„	ROAD OVER MOOR AND PLAIN TO DISTANT BLUE MOUNTAINS	7¾ in.	x 11 in.
823	„	TWO BIG TREE TRUNKS IN PARK, SUN-SHINE	7½ in.	x 11 in.
824.	„	EVENING LIGHT, THREE TREES IN SHADOW, COTTAGE, WOODS AND SEA ...	6¾ in.	x 10 in.
825.	„	SLENDER TREE STEMS AND GREEN FOLIAGE, SHADOW ON SAND, BLUE SEA AND BOAT	5 in.	x 7¾ in.
826.	„	" LIME KILN, VILLEFRANCHE "	7½ in.	x 11 in.
827.	„	BOY IN BLOUSE, HALF LENGTH, WITH RIGHT ARM STRETCHED OUT	3¼ in.	x 6½ in.
828.	„	ROAD BY RIVER LEADING TO HILLY VALLEY. (Damaged)	5½ in.	x 8½ in.
829.	„	" EZA " TOWN ON HILL, WOODED SLOPES	5½ in.	x 8½ in.
830.	„	PATH THROUGH FIELD BY HIGH WALL WITH TREES OVERHANGING WOMAN ...	6½ in.	x 8 in.
831.	„	GRASSY SLOPES TO RIVER, BRIDGE AND CASTLE IN WOODS	6¾ in.	x 10 in.
832.	„	LADY WITH PARASOL ON PATH DESCENDING TO VALLEY, RIVER, BRIDGE AND HILL	5⅝ in.	x 8⅜ in.
833.	„	PATH OR ROAD DESCENDING BY WALL THRO' OLIVES TO COAST	12 in.	x 9¼ in.
834.	„	BROWN-SAILED BOAT AND TWO OTHERS ON SHORE, GREEN SEA TO BLUE. (Spotted)	12 in.	x 9¼ in.

			Height.	Length.

835. STUDY: DARK MOOR RISING TO GREEN AND ROCKY HILLS 5 in. x 7¾ in.

836. „ SAND AND SMOOTH ROCKS, SEA AND HEADLAND WITH LIGHTHOUSE. (Spots) 5 in. x 11 in.

837. „ GREEN FIELD, TREES AND CRAGGY MOUNTAIN BEYOND 5 in. x 7¾ in.

838. „ BAY WITH BUILDINGS (CAP ST. MARTIN) AND TREES REFLECTED. (Spotted) ... 9 in. x 11½ in.

839. „ SANDS, TOWN ON POINT, SEA WITH BOAT, MOUNTAINS 5⅝ in. x 8⅝ in.

840. „ SANDY SOIL, UMBRELLA PINES AND MOUNTAIN 9¼ in. x 11¼ in.

841. „ ROAD, SHADOWED BY SHORE, BLUE SEA AND HIGH HEADLAND 5 in. x 7¾ in.

842. „ SHADOWED HILLSIDE DOWN TO BAY, HILLS BEYOND. (Faded and dirty) ... 7¼ in. x 10¼ in.

843. „ TWO DUTCH BOATS ON SHORE, THATCHED ENTRANCE AT STERN 8½ in x 11½ in.

844. „ STONY HILLSIDE ABOVE SEA. ONE PINE. (Spotted) 7½ in. x 11 in.

845. „ THREE PALM TOPS OVER WALL, SEA BEYOND. (Spotted) 11 in. x 7⅝ in.

846. „ BY BALDOYLE ACROSS INLET AND BAY TO SUGARLOAF 5⅝ in. x 8¼ in.

847. „ COTTAGE IN WOOD, TREE SHADOWS CAST ON WALL 9¼ in. x 11½ in.

848. „ ROCKY SHORE, BAY AND WOODED POINT. (Spotted) 5 in. x 7¾ in.

849. „ SANDY GRASS, BROKEN AQUADUCT, BLUE MOUNTAINS 7½ in. x 10¾ in.

850. „ DRIED BED OF RIVER, FIGURES, MONASTERY UNDER WOODY HILL 6¾ in. x 10 in.

851. „ SHADOWED GRASS BELOW TREES. (Spotted) 9 in. x 11½ in.

Height. Length.

852.	STUDY :	CALM SEA, BUILDINGS AND LOW POINT, BOATS, EVENING, RIVIERA	5½ in. x 8¼ in.
853.	,,	SANDS WITH WINDLASS (?) AND BOATS HAULED UP FROM BLUE SEA	5½ in. x 8½ in
854.	,,	SANDS WITH CATTLE, BENT AND SEA, PORTMARNOCK	5½ in. x 8¼ in.
855.	,,	SANDY POINT DARK WITH BOATS REFLECTED ON BLUE SEA	4¼ in. x 9¾ in.
856.	,,	PATH WITH YELLOW REEDS AGAINST LIGHT BUILDING, HILL AND TREES ...	5 in. x 7¾ in.
857.	,,	LIME KILN, VILLEFRANCHE, PALM TOPS, FIGURE INDICATED, WATER	5 in. x 7½ in.
858.	,,	DARK BOAT, BROWN POINT, SEA AND CRAGGY HILLS, LIT	5 in. x 7¾ in.
859.	,,	THREE BOATS DRAWN UP UNDER SHADOWED BANK, TWO BOYS, LIGHT BEYOND	7¾ in. x 11 in.
860.	,,	AMONG BIG BEECH TREES, SUNLIGHT BEYOND	11 in. x 8¼ in.
861.	,,	WOMAN ON PATH BY VINES, TREES ON LEFT, SEA BEYOND. (Dirty)	9 in. x 11½ in.
862.	,,	STUDY OF BROWN MONK WITH FOLDED ARMS	10¼ in. x 6½ in.
863.	,,	FISHING BOAT DRAWN UP FROM SEA. (Oil Spot in Sky)	6¼ in. x 5½ in.
864.	,,	SHORE, SEA AND HIGH HEADLAND ...	5 in. x 7¾ in.
865.	,,	PONT DE GARDE, HILL BEYOND	5 in. x 7¾ in.
866.	,,	BOY LYING ON HIS BACK IN SUN, RIGHT HAND OVER EYES	4¾ in. x 7¾ in.
867.	,,	ROAD BETWEEN HIGH TREES IN SHADOW. (A Blot)	7 in. x 10 in.
868.	,,	ROAD BETWEEN HIGH TREES, SUN AND SHADE. (A Blot)	10 in. x 7 in.

Height. Length.

869. STUDY : GREEN GRASS, GREEN SEA, GREEN BANK
 AND BLUE DISTANCE 4⅝ in. x 7⅝ in.

870. ,, BREAKERS AGAINST LOW SHELVING ROCKS 4⅝ in. x 7⅝ in.

871. ,, BUILDINGS, TOWER AND VALLEY DOWN
 TO SEA, RIVIERA 9¼ in. x 12 in.

872. ,, BENT, LOW WET SANDS AND SEA, HIGH
 SAND HILLS BEYOND 4½ in. x 7½ in.

873. ,, ROCKS AND GRASS, SANDS AND SEA, HIGH
 SAND HILLS BEYOND 4½ in. x 7½ in.

874. ,, TWO SHIPS AT ANCHOR IN WOODY
 ESTUARY 3⅝ in. x 6½ in.

875. ,, SHIP AT ANCHOR NEAR PIER, GREEN HILL
 BEHIND 4¼ in. x 4 in.

876. ,, LOW SANDS WITH SHALLOW SEA BREAKING
 DARK HORIZON 5 in. x 8¼ in.

877. ,, SAND IN SUN, GRASSY HILL WITH TOWER
 ON IT, SEA TO RIGHT 4⅝ in. x 7⅝ in.

878. ,, SAND DUNES IN SUNSHINE, SEA BEYOND
 AND ABOVE 4⅝ in. x 7⅝ in.

879. ,, GREY GREEN PLAIN TO SUGARLOAFS.
 (Spotted) 5½ in. x 8¾ in.

880. (a) and (b) SAND DUNES, SEA AND SKY 4 in. x 6¼ in.

WATER-COLOURS BROUGHT FROM MOLDOWNEY, ALL FRAMED AND GLAZED.

881. SUSPENSION BRIDGE OVER MENAI STRAITS 11 in. x 15 in.

882. ROADSIDE CHAPEL, NICE 9¾ in. x 7¼ in.

883. BANKS OF RIVER SEINE 10½ in. x 15 in.

884. HOUSE AND " SALITA," NEAR NICE ... 9½ in. x 12 in.

885. HOWTH HILL, ROCKS AND HEATHER
 (Cork, '84). 6¾ in. x 9¾ in.
 Note.—I cannot trace the catalogue
 of the exhibition (if any) in which this
 was shown.

886. St. Marnock's Churchyard 5¼ in. x 8 in.
887. Rocky Coast, Sea and Distant Head-
 land 6½ in. x 9¾ in.

DRAWINGS.

1 Charcoal : Peasant Girl, French 18 in. x 11 in.
15 Studies of Horses, Oxen, People, etc. 8 in. x 9½ in.
1 Sheet of Brush Drawings of Goats 7½ in. x 11 in.

APPENDIX XVII.

A SELECTION OF THE PRICES REALISED FOR WORKS OF NATHANIEL HONE, R.H.A., AT AUCTION SALES.

Messrs. Bennett and Son's Sale, Dublin, May 11th, 1911.
(From the collection of Sir Thomas Deane.)
Coast Scene, Fishing Boat and Figures £12 0 0

Messrs. Bennett and Son's Sale, Dublin, April, 1914.
(From the collection of Canon Harris.)
Fishing Boats £30 0 0

" Christie's " Red Cross Sale, April 23rd, 1915.
The Dutch Coast, 11 in. x 17½ in. £3 3 0
(Presented by the artist.)

Messrs. Bennett and Son's Sale, Dublin, December 3rd, 1915.
(Sale in Aid of Irish Prisoners of War.)
View from the Portmarnock Coast £37 16 0

R

Messrs. North and Son's Sale, Dublin, May, 1917.
(From the collection of the Right Hon. Mr. Commissioner Bailey, C.B.,P.C.
FISHING SMACKS. 24 in. x 36 in. £85 0 0
Note.—Now in the collection of Henry MacDermott, Esq., K.C.

Messrs. Bennett and Son's Sale, Dublin, February 4th, 1918.
SEAPIECE WITH ROCKY COAST AND FIGURES £105 5 0

" Christie's " Red Cross Sale, April, 1918.
OFF THE KISH £136 10 0
Note.—Presented by Mrs. Hone. Now in the collection of Dermod
O'Brien, Esq., P.R.H.A.

*The Mammoth Auction in aid of the Dublin Fusiliers' Fund, held in the
Dublin Mansion House in the Summer of* 1918.
LANDSCAPE, WITH CATTLE. 24 in. x 36 in. £94 10 0
Note.—Presented by Mrs. Hone.

Messrs. Bennett and Son's Sale, Dublin, October 15th, 1918.
SEASCAPE, WITH FISHING BOATS (SMALL) £55 0 0

Messrs. Bennett and Son's Sale, Dublin, March 20th, 1920.
A BREEZE OFF PORTMARNOCK (SMALL) £45 3 0

INDEX TO PREFACE AND TEXT.